THE PRIVATE
MARY CHESNUT

THE PRIVATE MARY CHESNUT

The Unpublished Civil War Diaries

C. Vann Woodward
Elisabeth Muhlenfeld

New York Oxford
OXFORD UNIVERSITY PRESS

Library of Congress Cataloging in Publication Data
Chesnut, Mary Boykin Miller, 1823–1886.
The private Mary Chesnut

Includes index.
1. Chesnut, Mary Boykin Miller, 1823–1886.
2. United States—History—Civil War, 1861–1865—Personal
narratives, Confederate. 3. Confederate States of America
—History. 4. Southern States—Biography. I. Woodward,
C. Vann (Comer Vann), 1908– . II. Muhlenfeld,
Elisabeth, 1944– . III. Title.
E487.C525 1984 973.7′82 84-12219
ISBN 0-19-503511-9
ISBN 0-19-503513-5 (pbk.)

Printing (last digit): 9 8 7 6 5

Printed in the United States of America

Acknowledgments

Both collaborators in this venture brought to it experience of previous work on Mary Chesnut, one as her biographer, the other as the editor of her major writing. Since the common work on this volume has profited greatly from the collaboration, our first acknowledgment must be one of mutual indebtedness. By rights, our separate acknowledgments in our earlier works on Chesnut ought also to stand here, for what we bring to this edition of the war diaries is dependent upon the help we received in those projects as well.

For the complete freedom we have enjoyed in editing these diaries, we owe much to the heirs of Mary Chesnut and the proprietors of her papers. This freedom and the trust implied in allowing it can be fully appreciated only by the reader of the diaries who grasps the candor of the author's self-revelations and who understands that she kept them privy from her own family and never intended them for the public.

Especial thanks are due to student assistants who have helped with many parts of the work on this volume. At the Yale end of the enterprise, Donna Dennis has contributed greatly, both in research and in intelligent insight in the annotation of the text. She also prepared the index to the volume. At Florida State University, Susan Thurman's skill in proofreading the text at every stage provided us with another sharp editorial eye. Janet Horton and Daphne Liedy handled an exacting typing task accurately and with enthusiasm.

A grant from the Program for Editions of the National Endowment for the Humanities, an independent federal agency, has assisted work on this volume.

June 1984 C.V.W.
 E.M.

Contents

Introduction

The Civil War diaries of Mary Boykin Chesnut appear here in print for the first time. For a writer who gained posthumous fame as a diarist and has long been acclaimed the most brilliant diarist of her period, this is a curious anomaly. Heretofore, her work has been known to the public only through one celebrated book that she wrote in the early 1880s. This work has appeared in three quite different editions, published in 1905, 1949, and 1981.[1] The first two, each heavily cut and carelessly edited, were published under the same title, *A Diary From Dixie*. This was not a title chosen by the author, who left her manuscript without a title or preface and died long before it was published. Because her book was written in the form of a diary, however, and is now known to have been based primarily on actual diaries, and because the first two editions were misleadingly entitled "diary" and represented as such, important questions immediately arise. Since these include questions about the integrity of the author and her book as well as about the intentions and integrity of her editors and publishers, we shall turn to them first. The best way to address these questions at the outset would seem to be a comparison of the diaries she kept in wartime with the book she wrote some twenty years later.

Some important differences between the diaries and the book arise directly from the contrasting circumstances under which the two manuscripts were written. The diaries were written from 1861 to 1865, the busiest, most hectic and trying four years of Mary Chesnut's life, years that were also the most exciting, distracting, and demanding. Rarely settled and seldom even alone for long, she moved back and forth from

1. Isabella D. Martin and Myrta Lockett Avary, eds., *A Diary From Dixie, as Written by Mary Boykin Chesnut* . . . (D. Appleton and Company, New York, 1905); Ben Ames Williams, ed., *A Diary From Dixie by Mary Boykin Chesnut* (Houghton Mifflin Company, Boston, 1949); and C. Vann Woodward, ed., *Mary Chesnut's Civil War* (Yale University Press, New Haven, 1981). The last-named edition contains clearly identified excerpts from the diaries, comprising a little more than ten of its 836 pages of text.

Camden to Columbia, Charleston to Montgomery, Richmond to North
Carolina, and eventually from one place of refuge to another as a fu-
gitive from military invaders. Living out of her trunk in hotels or rented
rooms, constantly on call for social and other duties, much in demand
by men and women seeking her company, her counsel, or her influ-
ence, she enjoyed little privacy or time for reflective writing. Often ill
or emotionally upset, she resorted at times to opium, prescribed by
doctors for relief. She sometimes wrote in bed when no desk was at hand.
It was usually all she could do to set down essentials: the events of a
day, the names of those present, snatches of conversation, a note here,
a fact there, an anecdote or an intrigue in outline. But rarely was there
time for careful thought or elaboration such as she later gained when
writing her book. Nor was there any need in the diaries for describing
or fully characterizing people she had long known or saw frequently,
whether they were slaves or famous men. Both the need and the op-
portunity for that came with the book.[2]

Another circumstance that shaped the distinctiveness of diaries and
book was the readership intended for each. While the book was written
for publication, the diaries were written for herself, and for her eyes
alone. She kept them under lock and key, out of sight even from her
husband James. There were obvious reasons for these precautions. She
allowed herself complete candor and her caustic vocabulary free rein
in writing of friend and foe, great and near-great, neighbors, house-
hold, and relatives, in-laws, immediate family, and husband. In the di-
aries appeared people of power and influence, some with whom her
relations were once strained and later intimate (such as President and
Mrs. Jefferson Davis) and others once admired and later despised.

Mary Chesnut could be and often was charitable and even generous
in her estimates, but when the mood was on her she could be acid. The
governor of the state was several varieties of a nitwit, his professional
belle of a wife "silly & affected." A party at which the political elite of
the new-born Confederacy gathered in Montgomery was "one mass of
vulgarity & finery & horror," a reception at the new White House
"stale —flat — & unprofitable." The most popular hotel was a "den of
abominations." One socially conspicuous lady was ticked off as "fat &
stupid," another as "ugly as sin," and famous generals were labeled in-
competents, malingerers, or worse. For her mother-in-law she ex-
pressed both admiration and intense exasperation; the same for her fa-

2. The present editors have drawn freely upon their previous publications: Elisabeth
Muhlenfeld, *Mary Boykin Chesnut: A Biography* (Louisiana State Univ. Press, Baton
Rouge, 1981); C. Vann Woodward, "Mary Chesnut in Search of Her Genre," *The
Yale Review,* Winter 1984, pp. 199–209; and introductory essays in *Mary Chesnut's Civil
War.*

ther-in-law, but when she thought of his brood of children fathered upon a slave woman, Mulberry Plantation became "a horrid nightmare to me."

What she wrote about others was enough to account for secrecy, but what she wrote about herself was surely an even greater cause for concern. A proud, ambitious, widely read, and intelligent woman, she was inclined to regard herself as superior to many she encountered, including some of greater pretensions. Quite conscious of this trait, she once admonished herself: "I sometimes fear I am so vain, so conceited—think myself so *clever* & my neighbours such geese that pride comes before a fall."[3] Reading old letters reminded her of the "meek, humble little thing I was" compared with "the self sufficient thing I am now," and made her wonder if "I had grown insufferable with my arrogance."[4]

None of these reflections, however, seemed to inhibit her from pouring into her diaries abundant evidence of the very pride, ambition, vanity, and arrogance she despaired of. Unabashed, she recorded with obvious pleasure the compliments, praise, and flattery she received, the sensation she created at a party, her success as a hostess, the charm of her dress, her ability to monopolize the attention of an important guest. She especially enjoyed (and recorded) her triumphs as a conversationalist and raconteur and her skill at repartee—often discounting much of the attention she received, but seldom erasing or obliterating her record of it.

More particularly she took pride and pleasure in the appeal she had for men — the way they gathered around, sought her out, sent her gifts, quoted her remarks, or boasted of her company. She delighted in seeing old suitors and admirers return and linger on and new ones appear, and she was not above relishing the jealousy she thus provoked among both wives and men. Especially she took malicious glee in the fuming and occasional explosions of her usually quiet and self-controlled husband, though once she seems to have carried the game too far for her own happiness.

The indiscreet revelations in the diaries, in addition to their intrinsic interest, tell much about their author we would not otherwise know and lend yet further reason for publication. They disclose the private Mary Chesnut. They also illustrate a marked difference between the diaries and the book later based upon them. For while the book is remarkable for its candor in many respects, it does not go far toward disclosure of the embarrassing personal revelations characteristic of the diaries. That was one of several problems the author later deliberately confronted about using the diaries for the book.

3. September 17, 1861, below, p. 156.
4. December 7, 1861, below, p. 214.

Mary Chesnut began her diaries in February 1861 with a keen sense of historical drama in the making and of her opportunity to record the experience. As the drama turned into tragedy, and as the realization grew upon her that this was the most poignant moment in the history of her people and the most profound experience of her own life, she determined that she would find some way of bringing those years to life in literary form. The question she grappled with at the end of the war was what form, what genre, to use. Her search for a satisfactory answer to that question went on for sixteen years until, after many unsuccessful experiments, she finally found the genre she sought.

She started the search and the experiments with no apparent preconception of the outcome and no model in mind. Fiction, memoir, autobiography, essay, history, satire, or one of them in the guise of another — all seemed possible for her purpose. Even poetry, at which she occasionally tried her hand, was a possibility. For a time, she intended to write a biography of her husband. Rich source materials for any or all of these were at hand. Besides her wartime diaries (many more than now available), there were her own letters, those of her husband, and a large collection of documents and clippings. Richest of all was her memory, teeming with scenes, events, vignettes, anecdotes, and perceptions for which there had not been time for more than mention or sketch, or for any record at all in her harassed diary-writing years.

She seems to have tried fiction first — a war novel and an autobiographical tale of her girlhood — but before she had gotten very far, the pull of the old diaries reasserted itself. Putting aside the novels, she returned to the diaries ten years after her last entry in them and made an extended effort, some 400 pages of which survive, to adapt them to her purpose. This experiment took the form of a rather simple revision to eliminate indiscreet, embarrassing, or trivial parts, round out incomplete notes, fill in gaps, and smooth out the prose. While the revision was faithful enough to her original perceptions, it did not succeed in bringing to life her Civil War experience or in fulfilling her purpose.

In 1876 Mary Chesnut dropped the diary revision experiment and returned to fiction. In the next four or five years she worked at revising the first two novels and wrote a third, again a novel set in wartime and drawing on her own war experiences.[5] The surviving drafts and revisions for the fiction are interesting evidence of a writer seeking to establish a narrative voice, shape a style, master dialogue, and come to

5. Manuscript drafts and draft fragments of these fictional experiments are in the South Caroliniana Library, Univ. of South Carolina. For edited versions of them, see Elisabeth S. Muhlenfeld, "Mary Boykin Chesnut: The Writer and Her Work" (Ph.D. dissertation, Univ. of South Carolina, 1978).

terms with her subject matter. While her efforts were serious and she learned much about her craft in this belated apprenticeship, the novels were clearly unsuccessful. No evidence exists that she sought publication for them or even finished them. Instead she lost interest, put them aside, and continued her search for the elusive genre that would suit her real purpose.

What she needed was a form for which there seemed to be no precedent. It would have to permit her to write, not about fictional characters and events, but about real flesh-and-blood people caught up in the turmoil and anguish of a real historic crisis and about herself as a participant. It must permit her to be both witness and narrator and to convey the immediacy of first-hand experience, and it must allow such flexibility as to accommodate the sporadic nature of personal and random experience and appropriate reflection. The desired genre would enable her to speak in her own colloquial and ironic style, to be analytical and opinionated, and to express her responses to events in ways that fiction did not permit, but yet it must also allow the events themselves, rather than her own emotional peaks and valleys, to predominate. It should enable her to speak in the mood and tone that prevailed during the war rather than in the fashion prevailing when she was writing a generation later, after the curtain of Confederate myth and romance had fallen over the past. Ideally the elusive form would give full play to her talent for characterization and her genius for metaphor, as well as ample opportunity to transmute into literature the crude materials of experience and memory.

She eventually discovered what she sought in the form with which she had begun and later tried unsuccessfully to adopt—the diary form, in which her richest source materials appeared. Its conventions would not only allow her to make the most direct use of those materials, but also would open to her, in ways no other genre would, the unique combination of opportunities and liberties she required. Finally committing herself to the diary form in 1881 when she set to work on her book, she adhered consistently to its conventions and demands. Only once did she depart from them, and then briefly. In her treatment of fifteen months in 1862–63, for which, she said, she had destroyed her wartime diaries, she would "fill up the gap from memory." This part she clearly labeled "Memoirs"; having completed it, she returned to the diary form.

In adopting the diary as her genre, in respecting its conventions, Mary Chesnut did no more than other writers who chose different genres — memoir, autobiography, letters, or fiction — to give their experience full literary expression. Was she, then, guilty, as she has lately been charged, of perpetrating a "hoax," and producing "one of the most audacious

frauds in the history of American literature"?[6] If so, she certainly proceeded in a bungling and self-defeating way. She lived and worked in a goldfish bowl during the years she was writing the book. Seeking the advice of friends near and far, she was open about what she was doing and she left behind her a rough first draft in pencil, written in notebooks clearly dated by the manufacturer as having been produced in 1881. As if that were not enough, she preserved the clinching evidence: the manuscript of her wartime diaries. Diaries, rough draft and manuscript, she directed, should in the event of her death be given to Isabella Martin, a friend whom she had asked to oversee the publication of the book — and who was eventually responsible for the first edition in 1905. In short, if she intended to perpetrate a fraud, this woman who in every other respect was so intelligent and worldly-wise displayed an astonishing stupidity and naiveté. The indictment is ridiculous.

Misrepresentation certainly occurred, but the accusing finger should point not to the author but to the editors of the first two editions. With all of these materials available to them, each editor (whether innocent of fraudulent intent or not) nevertheless entitled the work a "diary," and in their introductions each told the reader that Mrs. Chesnut had "transcribed" the original text, but neither of them indicated the extensive and essential differences in origin, character, and content between the two works. How the author might have presented or described her book in a preface we will never know. Because she died before she had polished the book to her own satisfaction, she never wrote an introductory note or even entitled her work. Given the above evidence and what we know of her character, we may confidently put aside as irresponsible charges of deceit, fraud, and hoax on her part.

The publication of the wartime diaries will enable readers to determine how they differ from *Mary Chesnut's Civil War*, written in the 1880s. In mining and adapting the diaries for her book, the author completely omitted some things, transcribed long entries with little change, and added to others meanings, implications, and emotional responses not spelled out in the diaries. She elaborated extensively on briefly noted facts in order to construct character, context, and significance, and sometimes introduced entire episodes unmentioned in the diaries.

Typical of omissions are items revealing personal vanity, weaknesses, and humiliations. Examples are found in diary entries from March 15 to March 18, 1861, where she is writing of a party in Montgomery. There she recounts the doting tributes of three admirers ("any woman might

6. Kenneth S. Lynn, "The Masterpiece That Became a Hoax," *The Air-line to Seattle: Studies in Literary and Historical Writing about America* (Chicago, 1983), p. 51, revised from *New York Times Book Review*, April 26, 1981.

have been proud of my three attendants that night. . . . Wonderful"), the jealousy of a fourth, and the envy of the wife of a fifth (who "actually shed tears"). She added, then erased, the remarkable statement, "I can make any body love me if I choose. I would get tired of it." There evidently ensued an unrecorded scene with her husband, for she awoke two mornings later "nearly frantic with all my own thoughts after that one glimpse of certain misery, hoping nothing, believing nothing. . . . Fearing all." She had "refused to accept overtures for peace & forgiveness," abandoned any "hope for peace & tranquil domestic happiness," and shed tears that *"scald* my cheeks & blister my heart." She resorted to doses of opium, "and *that* I kept up."

Also in the entry of March 18, 1861, is a paragraph beginning, "I wonder if it is a sin to think slavery a curse to any land. Sumner said not one word of this hated institution which is not true." This passage may be the strongest indictment of slavery ever written by a Southerner. (Indeed, few Northerners could match Charles Sumner on this subject.) Chesnut omitted it from her later version. However, Ben Ames Williams included it in his 1949 edition without identification of its origin. Thus, because the Woodward edition of 1981 revealed that this antislavery passage from the diary did not appear in the 1880s version, the omission has been cited as evidence that Chesnut had softened or romanticized her views. Actually the later version contains more examples of the injustice and inhumanity of slavery than do the diaries. Nothing in them can match the horror of the story she told in the 1880s version of Adam McWillie, "a savage" who put slaves in hogsheads with nails driven in all around and rolled them down hill[7] — certainly not the stuff of which Thomas Nelson Page was constructing his nostalgic picture of slavery at about the same time.

In fact, Chesnut's 1880s version repeatedly expressed her loathing for the hated institution. She included in various places all the components of her indictment of slavery found in the omitted passage of 1861 except the sentence pronouncing the views of Charles Sumner sound. That passage, she knew, had been written at the same sitting in which she had recorded what seemed to her an irreparable break with her husband. Pouring out her anger and misery so many years before, Mary had been aware that three months earlier, James had delivered the South's blistering reply to Sumner in the U. S. Senate. When she worked on her book in the early 1880s, she knew that what she had written about Sumner on slavery would damn James utterly. In any case, the break with her husband had long been patched up, so Sumner was put

7. *Mary Chesnut's Civil War*, p. 776.

aside. That the passage was ever written at all helps to put forever to rest the suspicion that her postwar antislavery stand was an afterthought or a product of hindsight. That she later omitted the passage does not indicate any softening of her opinions about slavery; what had softened was her relationship with her husband.

To demand that in expressing views on subjects of modern interest Mrs. Chesnut measure up to present-day attitudes and fashions is, of course, unfair. Mary Chesnut was a mid-nineteenth century woman nurtured in a thoroughly patriarchal slave society, and her heresies should be understood in that perspective. Her abhorrence of slavery and her welcome of its abolition were quite genuine and most extraordinary in her time and place. But her views on race were more closely aligned with those of her fellow Southerners (and, for that matter, Northerners) than was her attitude toward slavery. Hence, she could without contradiction match stories of brutal masters and rebellious slaves with accounts of paternalistic benevolence and slave loyalty more in line with the romantic legend, stories included not so much to defend the system as to prove, as she put it, that "we were not as much of heathens down here as our enlightened enemies think." Similarly, her outspoken defense of women and their rights against male dominance, injustice, and outrage in a patriarchal slave society was forthright. But modern feminists cannot expect her to share their definitions of equality and their reluctance to compromise.

While consistency generally prevails between views expressed in the diaries and those of the later book, an occasional uncharacteristic discrepancy creeps in. In 1861 she reports an anecdote of overseer Team about a cruel owner whose slave woman strapped her baby to her back and deliberately drowned herself and the infant. In the diary the woman is said to have been "driven to despair by the driver," and Team is quoted as exclaiming, "The man who caused it was not hung!" But in the book, Team's explanation of the tragedy is that the woman was "so lazy" that "She said she did not mean to work — nor should her child after her." The context of this later version makes clear that Chesnut has changed the point of Team's story to sketch instead a conversation about the evils of slavery — among them the undermining of both societal "goods" such as the work ethic and natural maternal instincts. Nevertheless, the story was changed.[8]

Discrepancy, however, is the exception. In remarkable ways, consistency is the rule. One might suspect influences of hindsight and self-

8. Cf. below, December 8, 1861, p. 214 and *Mary Chesnut's Civil War*, December 7, 1861, p. 256.

serving, for example, in her 1880s account of her reaction to the Union invasion of South Carolina at Port Royal and the capture of Beaufort, for there she dramatically contrasts her own stricken awareness of the peril and its strategic consequences with the flatulent complacency of her Camden kin and neighbors, who go about matching ribbons, boasting of their crops, swapping jokes, and talking politics while their world crumbles. A comparison with her diary account, however, reveals that, if anything, her anguish and her contempt for the blindness of her relatives and fellow townspeople were more strongly expressed in 1861.[9] A comparison of the two accounts of the murder of cousin Betsey Witherspoon by her own slaves is similarly reassuring. The main differences between them lie in the collection of scattered bits of information, recorded in 1861 as they were learned, into somewhat more sustained and coherent passages, and in the rounding out of incidents revealing the impact of the murder on the Chesnut household — how it shattered confidence, stirred old anxieties and nightmares, and transformed relations between mistress and slave.

Often what appear in the diaries as bare scraps of narrative are put to creative uses for characterization, portraiture, metaphor, humor, irony, or satire in the book. Thus the diary account of her life as a refugee in February 1865 mentions briefly the shock of her servant Ellen in her first encounter with a lower class of whites and slaves. Recounted in Ellen's dialect in the book, the incident is expanded into a scene of comic satire that not only characterizes Ellen and her white and black antagonists but serves also as an ironic and hilarious picture of class and race relations on both sides of the racial and class division. In this manner abstractions and archetypes become individuals and life and war in the old regime take on three-dimensional reality.

In *The Great War and Modern Memory* (1975), Paul Fussell has pointed out that the writers of the 1920s "who have most effectively memorialized the Great War as a historical experience" found their daily diaries inadequate. "The significancies belonging to fiction are attainable only as 'diary' or annals move toward the mode of memoir, for it is only the ex post facto view of an action that generates coherence or makes irony possible."[10] Mary Chesnut made this discovery on her own two generations earlier. The writers of the First World War turned to memoir, autobiography, or fiction. Chesnut retained the diary form itself and its conventions, but she adapted them to precisely the same creative purposes of which Fussell speaks.

9. Cf. below, pp. 194–207 and *Mary Chesnut's Civil War*, pp. 228–247.
10. Pp. ix, 310.

To accomplish this she took many liberties with her original wartime diaries. She turned third-person narrative into dialogue, put her own thoughts in the mouths of others, telescoped or expanded entries, occasionally shifted dates and often rearranged incidents to heighten dramatic impact. Virtually every extended description of people or places, including many of the finest passages in the 1880s version, are unique to that book; there had been no need in 1861 or 1865 to describe for herself her homes, friends, or relatives. Revelation of these differences between diaries and book has come as a shock to a few of those who had been taught for generations to regard and use the famous work as a literal diary. But once the source of this misconception is understood, the author's achievement can be assessed and valued as it might be had it taken the form of memoir, autobiography, or fiction, or had Mary Chesnut herself lived to give her work a title or preface.

Now that we have before us what survives of her original diaries and can compare them with what evolved from them, we are better able to appreciate both the author and her literary problems and achievements. The intrinsic values of the diaries themselves more than justify publication. When juxtaposed against the book they gave rise to, the diaries also provide a rare opportunity for us to gain insight into the process by which history and life experience are transmuted into literature, which in turn bestows form upon life. The diaries, then, should help us understand how Mary Chesnut, in evoking the epic experience of the South in the Civil War, surpassed every novelist and memoirist who addressed the subject in her time.

Mary Chesnut: 1823–1886

A brief look at Mary Boykin Chesnut's life helps to explain her importance today as the preeminent writer of the Confederacy. On the one hand, she was representative of her class and time. The outline of her life accords with stereotyped notions of the Southern belle moving comfortably from the pillars of the plantation house to the promenades of city life, and the impoverished patrician of Reconstruction days carefully preserving threadbare dresses. On the other hand, her life was unrepresentative. She was a woman blessed with an unusually rigorous mind, comparative leisure, luck, charm, and an ironic wit. Trained from birth to be politically astute and socially secure, she was also intellectually open and aware of the vicissitudes of history.

Born on March 31, 1823, in Statesburg, South Carolina, Mary was the eldest child of Mary Boykin and Stephen Decatur Miller, a lawyer and former U. S. Congressman then serving as a senator in the South

Carolina legislature. Miller was a strong proponent of Nullification, and when Mary was five, he was elected governor of South Carolina; at his term's end, he won a seat in the U. S. Senate. Thus Mary's childhood was permeated by politics, and despite the absences occasioned by political office, Miller remained a strong influence in his daughter's life. Equally strong was a vast network of kin — a brother and two sisters born during her first eight years and her mother's large family, headed by her grandmother, Mary Whitaker Boykin, who took her little namesake under her wing and instructed the child in the arts and duties of running a large plantation.

Mary Miller was educated first at home, and then in a day school in Camden seven miles away, where she stayed with an aunt and uncle (Aunt Betsey and Judge Withers of the diaries) during the week, returning home on weekends. Officially because of ill health, though more likely because of his desire to be with his growing family, Miller resigned his Senate seat in 1833 and returned to South Carolina. Two years later, he sold his property in Statesburg and determined to move to Mississippi, where he owned cotton plantations. Mary, now twelve, was sent to Madame Talvande's French School for Young Ladies in Charleston. The school was a fortunate choice. There she was duly taught the "accomplishments" so necessary for a well-bred young woman of her day, but she also received solid instruction in French (which she came to speak fluently), German, English literature, history, rhetoric, and natural sciences. At Madame Talvande's, Mary excelled academically and apparently moved promptly and naturally into a position as social leader, occasionally having to extricate herself from the consequences of highjinks she had instigated. She would throughout her life retain an enormous respect for the intellectual and organizational abilities of gifted women, a love of cities, a pleasure in literary talk, and a . delight in music, the theater, in all things French, and in novel-reading as a treasured secret diversion—all fondnesses nourished at Madame Talvande's.

Mary remained at boarding school little more than a year, however, before being withdrawn and taken to her father's Mississippi plantations. Rumor had linked her name with James Chesnut, Jr., newly graduated from Princeton and eight years her senior, with whom she had been seen walking on the Charleston Battery in the moonlight. After several months in rural Mississippi, a land so primitive that wolves sometimes howled under the house, Mary, now fourteen, was returned to Madame Talvande's school in 1837 for an additional year or so of formal schooling. Her childhood ended abruptly in 1838 with the death of her father. After a trip back to Mississippi with her mother to help

settle the estate, she returned to Camden and agreed to a formal en-
agement to James Chesnut. On April 23, 1840, just three weeks after
her seventeenth birthday, she married him and went to live at Mul-
berry, his family's plantation three miles south of Camden.

The new Mrs. Chesnut came to Mulberry expecting, in due course,
to assume her prescribed role as wife, mother, and mistress of the
household. James Chesnut, Jr., only surviving son of one of the state's
wealthiest land- and slaveowners, was heir to a large fortune, and his
parents were both in their mid-sixties. But the senior Chesnuts, an in-
domitable pair, lived on for twenty-five more years and retained vig-
orous control of lands and household. Mary's anomalous role in the
Chesnut family was made more difficult by her failure to have children.
Thus, the first twenty years of her marriage provided her with few out-
lets for her creativity, and fewer still for her passionate nature which
too frequently erupted in outbursts of temper. Reading was a favorite
means of escape; so, less reliably, were brief trips to Charleston or Co-
lumbia, or to the fashionable springs at Saratoga and Newport. Once,
she managed to spirit James to Europe to see for herself the land of
Dickens and Thackeray and the haunts of Balzac and Dumas. But too
often she felt useless, and though whenever possible she indulged her
maternal instincts by borrowing her nieces, nephews, and young cous-
ins for long visits, she was periodically unhappy in Camden. Occasional
bouts of depression and illness plagued her throughout her young
adulthood.

Her husband, a lawyer by training, spent the years between 1840 and
1860 in public service, serving in the state legislature and eventually be-
coming its president. In 1858 he was elected to the United States Sen-
ate. Mary Chesnut found herself in her element in Washington. She
had for years involved herself in her husband's world, serving as his
hostess and secretary and taking an outspoken interest in the issues of
the day. Now she could put her political acumen to work on a grander
scale. During her years in Washington she came to know many of the
prominent politicians of the day and formed friendships with numer-
ous southern legislators and their wives who would soon become the
military and political elite of the Confederacy. Her wit, her reputation
as a "literary" lady, and her skill as a conversationalist all worked to-
gether to make her sought after at social gatherings. Such gatherings,
in turn, gave her an opportunity to be in the thick of things.

Not surprisingly, therefore, Mary was less willing than her husband
to bring the Washington years to a close. As hostility between North
and South grew in the fall of 1860 following Lincoln's election, James
resigned his seat in the Senate and returned to South Carolina to help

draft an Ordinance of Secession. His wife's comment was succinct: "I am not at all resigned."[11] In spite of her love for the nation's capital, she quickly cast her lot with her state and became an ardent supporter of the South and of Jefferson Davis, whose wife, Varina, had become a friend when both husbands served in the Senate. Regretting that she had not done so earlier, she began to keep a diary in February 1861.

Mary Chesnut knew she was in an excellent position to cover the war. Early in 1861, the Chesnuts went to Montgomery, where James attended the Confederate Provisional Congress, and where Mary's hotel quarters served as the first of her wartime salons in which the men engaged in forming the new government and their wives congregated to gossip, to plot and plan, or simply to relax. In Montgomery, Mary renewed her friendship with Varina Davis, a friendship that, except for a quarrel in early July 1861, would deepen throughout the war. From Montgomery, the Chesnuts returned to Charleston. James, an aide to Beauregard, participated in negotiations over Fort Sumter, and Mary, from her vantage point on a rooftop, recorded the attack on the fort. Most of the next several months were spent in Richmond. There, she waited with Mrs. Davis for news of the battle at Manassas, visited the first sick and wounded of the war, and heard over and over the dreaded "dead march," whose sad strains would never again leave her consciousness for long. And always she wrote in her journal, sometimes expressing there her fears for her country and her outrage over the antics of the men in positions of authority. By August, when her husband seemed unable to decide whether to go into the army or stand for reelection to the Confederate Senate, she exploded in her diary, "Jeff Davis ill & shut up — & none but *noodles* have the world in charge."[12]

As a woman, Mary could neither join the army nor hold office, so she was of necessity dependent upon her husband's position. Her ambitions for James frequently found their way onto the page. "Oh," she moaned in April 1861, "if I could put some of my reckless spirit into these discreet, cautious, lazy men."[13] James seemed disinclined to military glory, so she hoped he would be appointed minister to France; failing that, she wanted him to be reelected senator, not least to avoid having to go home to Mulberry. At one point, she wrote, "I wish Mr. Davis would send *me* to Paris."[14] But appointment to Paris was not forthcoming, and the Chesnuts found themselves back in Camden, where her cool, reserved husband's apparent indifference to the war raging

11. Cf. below, p. 10.
12. September 1, 1861, below, p. 151.
13. April 25–27, 1861, below, p. 63.
14. August 12, 1861, below, p. 122.

in Virginia infuriated her: "*Now,* when if ever man was stirred to the highest for his country & for his own future—he seems as utterly absorbed by Negro squabble, hay stealing, cotton saving. . . . If I had been a man in this great revolution — I should have either been killed at once or made a name & done some good for my country. Lord Nelson's motto would be mine—Victory or Westminster Abbey."[15]

James lost his bid for a seat in the Confederate senate and agreed to serve instead as chairman of a wartime executive council headquartered in Columbia, empowered to oversee the military and defense concerns of the state. Mary was ill during most of 1862 with a sickness she attributed to "hospital fever" contracted in her hospital visits in the summer of 1861. After a slow recovery, she was ready, late in 1862, to encourage her husband to seek a more central position in the war. In December, Chesnut accepted an appointment as colonel and went to Richmond as Davis's aide. This suited Mary perfectly. She managed to rent quarters close to the White House of the Confederacy and thereafter the two families visited almost daily. Mary's skill as a hostess assured that she had a constant round of visitors; genteel guests of any rank were certain of a hearty welcome, good food, lovely women, and interesting conversation, much of which must have found its way into her diaries that no longer survive for this period.

Mary Chesnut enjoyed her stay in Richmond as heartily as she could, for this was life magnified, speeded up. Despite the grief she increasingly felt inside, she could at least play an important role as supporter — of the Davises, of the young women for whom she was a mentor and friend, of the soldiers who came to Richmond to recover from wounds, to bring the bodies of fallen comrades, or simply to rest. As pain was heightened, so play was exaggerated. But the pitch of excitement, the chaos of an inflation-wracked city, the bitter political quarrels took their toll on James, who arranged in April 1864 to be reassigned to South Carolina, where he could be closer to his recently widowed father, now ninety-three, blind, and alone. General and Mrs. Chesnut delayed their departure to attend the funeral of five-year-old Joe Davis, killed in a fall, and then left once again for Columbia.

As the South fought on to defeat, Mary Chesnut was forced into exile early in 1865, first to Lincolnton, North Carolina. There, while Sherman burned Columbia, she felt despair for a time: "I do not care ever to see another paper," she wrote on February 23. "Shame — disgrace — misery. . . . The grand smash has come." As word came of Robert E. Lee's surrender, she moved again, to three vacant rooms in

15. October 17, 1861, below, pp. 179–180.

Chester, South Carolina. And as usual she kept open house; old friends were drawn to her as if to a magnet. Lacking beds, everyone slept on the floor and shared one table and six chairs. Generals, governors, senators, relatives, and friends came. One of the last visitors was Varina Davis with her four small children, utterly exhausted and fleeing arrest.

Once again in Camden, Mary and James too were utterly exhausted. They arrived lacking even enough cash to pay the ferryman to take them across the Wateree River. Mulberry had been ravaged by marauding Yankee forces, the last reserves of cotton had been burned, and yet the land remained, encumbered by huge debts which, during the Reconstruction years, the Chesnuts were unable to repay. To Virginia Clay, a friend of Washington and Richmond days, Mary wrote: "There are nights here with the moonlight, cold & ghastly, & the whippoorwills, & the screech owls alone disturbing the silence when I could tear my hair & cry aloud for all that is past & gone."[16]

As weeks and months passed, however, the healing balm of natural good spirits reasserted itself in Mary; she began to view the tasks before her as challenges to be met and mastered. And there were pleasures still to be savored. James and Mary, often at odds during the war years, found peace in their marriage and deep companionship in each other's company. Now a brief absence brought Mary a love letter: "Solitary & disconsolate I write at your own little table with your person full in my mind's eye — and your self, whom alone I love on Earth, deep in my heart."[17] And at last, Mary had children under her care: first Miller, the oldest son of her beloved sister Kate, and then his younger brother David (Daby of the diaries).

Although she suffered increasingly from a heart condition of long standing, Mary took over the responsibilities of running the household and the cottage industries which supplied the plantation, assisted in overseeing farming affairs and keeping plantation records, and enlarged the butter-and-egg business she and her maid Molly had been running on shares. Because she lacked the ready cash with which to buy the books and magazines so necessary to her existence, she formed a book cooperative with relatives and friends, in which money was pooled to buy current publications that the women passed among themselves. Mary's watchful eye on every penny paid off, at least to the extent of allowing occasional trips to escape the summer heat or visit relatives, but the Chesnuts' fears of poverty were never far from mind.

16. MBC to Virginia Caroline Tunstall Clay, *ca.* April 1866, C. Clement Clay Papers, William R. Perkins Library, Duke Univ.

17. JC to MBC, July 13, 1867, Chesnut Family Papers, State Historical Society of Wisconsin, Madison.

A central worry was for Mary's security. James's father, who died in 1866, had stipulated in his will that all the Chesnut lands must pass at James's own death to Chesnut grandsons. Should he predecease Mary, then, she would be left homeless — forced to live on the sufferance of relatives. Accordingly, in the early 1870s, land in Camden was purchased in Mary's name and the large kitchen buildings at Mulberry were torn down to provide bricks for a new house to be Mary's alone. Sarsfield was designed with her heart condition in mind — her bedroom and a spacious library complete with the bay windows she loved were on the first floor.

The move back into Camden made life considerably easier for Mary. Now, in the evenings, friends dropped by to talk. And early in the morning and late at night, in whatever spare time she could find, Mary Chesnut slipped off to her library and experimented with literary projects. She tried her hand at fiction, which in addition to its possible suitability as a way for her to record her experiences also seemed a potential source of funds. The fiction and a first extended attempt to revise the wartime diaries occupied much of her time in the mid-1870s. But time was a precious commodity, and the emotional energy to write was depleted by concerns over crop failures, by worry over James's frustration as he and other members of the old guard tried unsuccessfully to effect political reform, by shock and grief over the deaths in 1876 first of her sister Kate and then Kate's daughter Serena — Enie of the diaries — whom Mary had dearly loved. Her mother came to live with the Chesnuts, numerous relatives in serious financial straits came for extended visits, and Miller Williams returned to assist his uncle with running the plantations. Soon, Miller's young wife and babies were in and out of Sarsfield too. With the increase in responsibilities came a decrease in the amount of time she could find to write. On the back of one scrap of paper, she expressed her frustration: "I have been interrupted three times in trying to *accomplish* this sentence." Nevertheless, between 1881 and 1884 she substantially completed the book based on her wartime diaries.

When James Chesnut fell fatally ill in late 1884, his wife put aside her book to care for him, and for her mother, who succumbed to a final illness less than three weeks later. Mother and husband died within a week of each other early in 1885, leaving Mary herself drained and ill from the two-month ordeal. Before she could begin to recover from the loss of the two people closest to her, she found herself embroiled with lawyers and financial entanglements. James had died so deeply in debt that even her dower lands were seized against the estate. Sarsfield was hers, but she was now dependent upon her little dairy business and

forced to spend inordinate amounts of time tending to four Jersey cows.

Anxious to put her husband's papers in order and perhaps to publish them, she could not yet return to her own book in earnest, though friends encouraged her to do so. From William Henry Trescot came the assurance that her own recollections would be far more interesting than those of "a dozen generals," and from Varina Davis the same message, followed by a caustic aside: "Between us no one is so tired of Confederate history as the Confederates — they do not want to tell the truth or to hear it."[18] Mary Chesnut had never been afraid of truth — had, in fact, told it fearlessly in the book written from 1881 to 1884 based on her diaries. But before she could see to its publication she died, on November 22, 1886, victim of a last severe heart attack.

The Text

The diaries Mary Chesnut wrote during the war and later drew on for the incomparable book by which we remember her have their own history, a history that extends for a century beyond their writer's lifetime down to the present. The volumes, as they increased in number and bulk, apparently shared the wartime travels and harried life of their author. She seems to have taken them along with her wherever she went, mainly to assure their safety and secrecy. Their present condition shows wear and tear. She writes of destroying some of them when Richmond was threatened by Union forces in May 1863. On February 23, 1865, while a refugee from Sherman's path and traveling with few possessions, she speaks of having before her "*10* volumes of memoirs of the times I have written here lie my treasures ready for the blazing hearth." She did not burn them, but adds "and still I write on."

Of the unknown number of volumes she wrote in all, seven of widely varying size now survive, five bound and two unbound. One of these unbound volumes contains a duplication of the entry dated February 25, 1861, apparently a brief, abortive wartime attempt to copy the diary in good form. Besides the seven volumes, two homemade booklets survive, of poor quality paper bradded together, containing three entries bearing the earliest dates of the diary. The first volume is the largest. Its 293 pages are bound in red leather, decorated in gold leaf stamping, and fastened with a brass lock. The last volume is a makeshift affair, converted from an old recipe book. Together they include entries from February 18 through December 8, 1861, late January through

18. William Henry Trescot to MBC, December 6, 1884; Varina Davis to MBC, March 25, 1885, Williams-Chesnut-Manning Collection, South Caroliniana Library, Univ. of South Carolina.

February 23, 1865, and May 7 through June 26, 1865, comprising in all about 100,000 words. Mary Chesnut undoubtedly had these parts of her diaries before her when she was writing her book for publication in the early 1880s. But internal evidence suggests that she had much more, perhaps twice as much as now survives. What happened to the missing volumes we can only surmise.

After Mary's death in 1886 the diaries became the property of David R. Williams III, her favorite nephew who had lived with her at Sarsfield during the last years of her life. It was David to whom she left her house and the bulk of her meager estate, and it is probable that the diaries remained there in his care until they were entrusted to Isabella D. Martin, one of the young women Mary had befriended during the war years. Mary had charged Isabella, now a schoolmistress in Columbia, South Carolina, with bringing her book to print. Accordingly, the manuscript of the book and the diaries themselves were placed in her hands at some point after Chesnut's death. In collaboration with Myrta Lockett Avary (and with an editor of D. Appleton and Company doing most of the work), Martin did produce a bowdlerized and much foreshortened edition of the 1880s manuscript in 1905. The title, *A Diary From Dixie,* was supplied by the *Saturday Evening Post,* which published a series of excerpts before book publication.

The diaries may have been in Martin's possession for as long as nineteen years, though in a 1904 letter she speaks of having had them for "over ten years." Some light on how they fared in those years is cast by a letter from Isabella Martin to David Williams, March 27, 1905, on returning the diaries and the book manuscript to their owner. She remarked casually that "unaccountably two or three numbers have got mislaid. I think considering all their journeyings and the handlings it is well there were not more."[19] Since all the manuscripts for the book are accounted for, the "mislaid" numbers would appear to have been from the diaries, though they may have turned up later.

After their return to David Williams, the diaries remained in his hands and those of his heirs until 1934 when, along with other family papers ("the accumulation of 100 years or more"), they were placed on deposit in The Southern Historical Collection at the library of the University of North Carolina. In 1940, however, the proprietors withdrew the "Chesnut diaries" and directed that they be sent to them at Fort Bragg, North Carolina. Before returning them, the staff of the library prepared the first known itemized list of the manuscripts. The list of sixty-six bound and unbound items identified by dates obviously makes no distinction

19. Letter in private possession.

between the actual diaries and the manuscripts for the book in its various versions. It includes, however, all but two small numbers of the diary; one of these was found by the present editors inside a volume of the book manuscript, and the other may have been embraced in the item, "miscellaneous sheets of diary."

In the late 1940s the diaries and the manuscripts for the book were temporarily entrusted to the novelist Ben Ames Williams, who employed a typist to copy them in preparation for his edition of what he chose to call a "diary." Since he did include a few quotations from the diaries in his edition of 1949 without identifying them as such, he clearly had possession of the surviving parts. Then in 1961 the proprietors placed all these manuscripts on deposit in The South Caroliniana Library of the University of South Carolina, where the present editors used them and where they remain today.[20] The list of them prepared on receipt by the South Caroliniana librarian is identical with that of 1940 prepared by the North Carolina Library.

Editorial Problems and Procedures

The diaries present special problems. Foremost among them has been determining what Chesnut wrote and when. Some passages are nearly illegible, written in light pencil or at a time when the author was tired, upset, ill, or particularly rushed. Words and whole passages have been scratched out, blotted, or erased. Some have been carefully cut from the volumes themselves, thereby destroying whatever material appeared on the back of the offending passage. A few pages have been torn out. All of these mutilations seem to have been Chesnut's.

In the text which follows, editorial interventions are enclosed in straight brackets (i.e., [*illegible*]). Occasionally a sentence or a phrase is extremely awkward. Sometimes what she wrote is confusing or even cryptic. Where we can clear up confusion, we do so in a note; often we cannot. We have silently omitted words accidentally repeated at the end of one page or line and the beginning of the next, and words or beginnings of words which Chesnut lined through to correct a false start or an error in spelling. All other effaced words have been recovered wherever possible or identified as illegible. Those crossed out appear in single angle brackets (i.e., ⟨stupid⟩); those which have been erased appear in double angle brackets (i.e., ⟨⟨stupid⟩⟩). Marginal and interlinear words and phrases have been run into the text at the point indicated by the author. Most

20. A transcript of the surviving portions of the original diaries prepared by Elisabeth Muhlenfeld and Thomas E. Dasher is available at the South Caroliniana Library, the Library of Congress, and the Yale University Library.

of them seem to have been made at the time the entry was written, and of those which appear to have entered later, most were made during the war, relatively close to the time of composition. It was Chesnut's practice to read over a volume as she finished it; some marginal notes were likely made during these periodic re-readings. Where evidence suggests that an insertion or marginal note was added after the entry was completed, we have so indicated in a bracketed editorial insertion. Notations unquestionably written after she stopped keeping the diary are few and Chesnut clearly dated them ("What a fool I was 1866"). Such late additions are mentioned in the notes.

At times Chesnut used the diaries as daybooks, filling as many as ten or more manuscript pages with quotations from her reading. The editors, mindful of the private nature of the diaries and aware that what Chesnut chose to copy out may reveal much about her state of mind, have retained almost all of these quotations. But in several instances where the copied passage is irrelevant, overly long, or readily familiar, we have omitted all or part of a quotation. We have also omitted accounts and lists kept on the flyleaves of two volumes. Every such omission is identified in the notes. Where the author has, in haste, written something other than she intended (i.e., "in in" for "in an"; "one own's" for "one's own"; "They" for "The"), we have silently emended and have recorded such emendations in a table keyed to page and line numbers following the text itself.

Regarding spelling and abbreviations, we have preserved inconsistencies but corrected errors. Chesnut usually spelled names by ear until she learned the correct spelling. Thus, McClellan was "McLelland" until August 1861, and Manassas was sometimes "Manassa," "Manassah," or "Manasseh." We have corrected all proper names. Similarly, we have corrected misspelled words, but we have not attempted to regularize variant spellings where both represent acceptable nineteenth-century usage ("color" and "colour"; "everybody" and "every body"). We have supplied accents for French words whenever Chesnut omitted them.

All of Chesnut's manuscripts confirm that she was unsure of rules governing the formation of plurals and possessives; she used apostrophes with remarkable abandon — sometimes correctly, more often not. We have corrected errors of this kind. She also recorded numbers oddly, generally employing decimal points or dashes instead of commas, and grouping zeroes in groups of two rather than three (i.e., 10.00 or 10-00 rather than 1,000). We have regularized numbers to accord with standard notation.

In most cases, we have supplied periods after abbreviations when, as sometimes happened, Chesnut omitted them. But some initials she seems

to have used as nicknames (she almost always referred to her husband as JC, and often called close friends by initial: Mr. Ould was Mr. O; Mrs. Browne was Mrs. B). These we have allowed to stand without periods. The minor matter of whether or not a word is capitalized in the manuscript has often had to be decided rather arbitrarily. For more than two-thirds of the alphabet, Chesnut's capitals and lower case letters are often indistinguishable. We have italicized titles of newspapers, periodicals and books, and names of ships; all other italicized words in the edited text represent words Chesnut underlined in the diaries.

Chesnut's hand is such that it is difficult to tell when a dash is intended to be a period, a comma, or simply a dash, and the editors have brought to bear on this task their experience with other manuscripts including her fiction and the book of the 1880s. We have supplied punctuation where meaning is unclear without it, but we have done so conservatively; the resulting text retains rather more fragments and dashes than the norm, even for Chesnut. In determining where punctuation other than the ubiquitous dash was needed, and what sense Chesnut intended, we have been helped by her own revisions, including that of the 1870s and the rough drafts and final draft of the 1880s book.

The editors have not attempted to duplicate or approximate in print characteristics of the holograph document. We have lowered superscript letters (M^{rs}) and followed them by periods. Dashes varying widely in length have been regularized as have indentations and irregular spacings on the page. In addition, we have substituted for her erratic method of dating a consistent one, supplied in brackets preceding each entry.

Notes appear at the foot of the page and include historical annotation, identification of people, literary allusions and quotations, and information of textual interest. Identification of individuals mentioned in the text is keyed to the first reference. Where the first reference is not followed by a note, we have been unable to identify the person in question.

THE PRIVATE
MARY CHESNUT

[The following segment of the diary bears the earliest date of any part of it. The entry is written in a small unbound booklet of fifteen folded sheets of paper, fastened by a staple.[1]]

[February 18, 1861]
Conecuh, Em's.[2] I do not allow myself vain regrets or sad foreboding. This southern Confederacy must be supported now by calm determination — & cool brains. We have risked all, & we must play our best for the stake is life or death. I shall always regret that I had not kept a journal during the two past delightful & eventful years. The delights having exhausted themselves in the latter part of 1860 & the events crowding in so that it takes away one's breath to think about it all. I dare say I might have recorded with some distinctness the daily shocks — "Earthquakes as Usual," Lady Sale[3] — but now it is to me one night mare from the time I left Charleston for Florida where I remained two anxious weeks amid hammocks & everglades oppressed & miserable & heard on the cars returning to the world that Lincoln was elected & our

1. Although there can be little doubt that this entry was made during the war years, the editors suspect that it was not written as early as it is dated. Strongest evidence is internal: first, the tone of the first several pages of the entry — that of a conscious, introductory essay — differs considerably from that of the remaining 1861 entries; second, Chesnut's general discussion of the coming war suggests that she may be writing after the war has started; third, the entry is written almost entirely in past tenses. External evidence includes the poor quality paper used for this segment similar to paper used by Chesnut later on. In spite of this evidence, we place this segment — as Chesnut clearly intended — as the first entry.
2. Conecuh County is in southern Ala., where her mother, Mary (Boykin) Miller, whom she sometimes called "Em," lived with Stephen Decatur Miller, MBC's younger brother, on his plantation.
3. This phrase appears in *A Journal of the Disaster in Affghanistan, 1841–1842* (1843) by Lady Florentia (Wynch) Sale, who was with her husband, Maj. Gen. Robert Sale, during the ill-fated British attempt to conquer Afghanistan.

fate sealed. Saw at Fernandina a few men running up a wan Palmetto flag & crying, *"SC* has seceded."[4] Overjoyed at the tribute to SC, I said, "So Florida sympathises." I inquired the names of our *few* but undismayed supporters in Florida. Heard Gadsden, Holmes, Porcher, &c, &c — names as inevitably *SC's* as Moses or Lazarus are Jews. When we arrived in Charleston my room was immediately over a supper given by the city to a delegation from Savannah — & Col. Bartow, the Mayor of Savannah,[5] was speaking in the hot, fervid, after supper southern style. They contrived to speak all night & to cheer, &c. I remember liking one speech so much — *voice,* tone, temper, sentiments & all. I sent to ask the name of the orator & the answer came, "Mr. Alfred Huger."[6] He may not have been the wisest or wittiest man there—but certainly when on his legs he had the best of it that night.

After such a night of impassioned southern eloquence, I travelled next day with (in the first place a racking nervous headache & a morphine bottle & also) Col. Colcock,[7] formerly member of Congress & of U.S., Judge Magrath[8] — of whom likenesses were suspended in the frightfullest sign post style of painting across various thoroughfares in Charleston. The happy moment seized by the painter to depict him while Magrath was in the act most dramatically of tearing off his robes of office in rage & disgust at Lincoln's election.

My father was a South Carolina Nullifier — Governor of the state at the time of the *N* row[9] & then U.S. Senator. So I was of necessity a rebel born. My husband's family being equally pledged to the Union party rather exasperated my zeal — as I heard taunts & sneers so constantly thrown out against the faith I had imbibed before I understood any thing at all about it. If I do yet.

I remember feeling a nervous dread & horror of this break with so great a power as U.S.A. but I was ready & willing — S C had been so rampant for years. She was the torment of herself & every body else. Nobody could live in this state unless he were a fire eater — come what would I wanted them to fight & stop talking. South Carolina — Bluff-

4. In fact, S.C. did not secede until Dec. 20, 1861.
5. Francis Stebbins Bartow was a delegate to the Ga. secession convention, member of the Provisional Confederate Congress, and colonel in the C.S.A., but never mayor of Savannah.
6. A planter and prominent Unionist serving as postmaster of Charleston.
7. William Ferguson Colcock, Collector of the Port of Charleston.
8. Andrew Gordon Magrath, former judge of the U.S. District Court for S.C., was a delegate to the state secession convention from St. Michael's and St. Philip's Parishes, Charleston.
9. The nullification controversy of 1832–33 between S.C. and President Andrew Jackson.

ton Rhetts, &c[1] — had exasperated & heated themselves into a fever that only bloodletting could ever cure — it was the inevitable remedy. So I was a Seceder — *but* I dreaded the future. I bore in mind Pugh's[2] letter, his description of what he saw in Mexico when he accompanied an invading Army. My companions had their own thoughts & misgivings doubtless, but they breathed fire & defiance.

> Their bosoms they bared to the glorious strife
> & their oaths were recorded on high —
> To prevail in the cause that was dearer than life
> or crushed in its ruins to die.[3]

Consequently they were a deputation from Charleston risen against tyrants to her representatives in Columbia telling them they were too slow, to hurry up, dissolve the Union or it would be worse for them — there was a fire in the rear of the hottest.

At Kingsville I met my husband; he had resigned his seat in the Senate U.S. & was on his way home.[4] Had burned the ships behind him. No hope now — he was in bitter earnest. I thought him right — but going back to Mulberry to live was indeed offering up my life on the altar of country. Secession was delayed — was very near destroyed. The Members were rushing away from Columbia; that band of invincibles certainly feared small pox, but they adjourned to Charleston & the decree was rendered there. Camden was in unprecedented excitement. Minute men arming with immense blue cockades & red sashes, soon with sword & gun, marching & drilling.

I spent Christmas at Combahee[5] — a most beautiful country seat. Live oaks in all their glory, Camellias as plentiful on the lawn as the Hawthorn in an English hedge. Mrs. Charles Lowndes was with us when the secession ordinance came — we sat staring in each other's faces. She spoke first, "As our days so shall our strength be."[6] I am truly glad I

1. The Bluffton Movement of 1844 attempted to nullify the Tariff of 1842. Its leader, Robert Barnwell Rhett, Sr., then a congressman representing Beaufort and Colleton districts, went on to become S.C.'s most prominent secessionist agitator and a member of the S.C. delegation to the Montgomery convention. His son, Robert Barnwell Rhett, Jr., had edited the influential Charleston *Mercury* since 1857.
2. U.S. Senator George Ellis Pugh of Ohio, a pro-Southern Democrat who had been a member of the Chesnuts' "mess" at Brown's Hotel in Washington.
3. Paraphrased from the first four lines of "Stanzas on the Threatened Invasion, 1803" by the Scottish poet Thomas Campbell (1777–1844).
4. James Chesnut, Jr. (his wife usually identified him as JC) resigned on Nov. 10, 1860.
5. The Combahee River rice plantation of William Lennox Kirkland, who married MBC's first cousin Mary Miles Withers.
6. Sabina Elliott (Huger) Lowndes, wife of Combahee River planter Charles Tidyman Lowndes. The passage in quotation marks is an allusion to Deuteronomy 33:25.

have seen those lovely Combahee places — they are so exposed they will doubtless suffer from invasion.

We soon returned to Charleston. At Mrs. Gidiere's[7] we had a set of very pleasant people. Our rage for news was unappeasable — & we had enough. One morning Mrs. Gidiere, coming home from market, announced Fort Sumter seized by the Yankee garrison. Pickens our Governor[8] sleeping serenely. One of the first things which depressed me was the kind of men put in office at this crisis. Invariably some sleeping dead head long forgotten or passed over. Young & active spirits ignored. Places for worn out politicians seemed the rule — when our only hope is — to use *all* the talents God has given us. This thing continues. In every state as each election comes on they resolutely put aside every thing but the inefficient. To go back to Pickens the 1st & South Carolina. Very few understood the consequences of that quiet move of Major Anderson[9] — at first it was looked on as a misfortune. Then as we saw that it induced the seizure of U.S. Forts in other states — we thought it a blessing in disguise. So far we were out in the cold alone. And our wise men say if the President had left us there to fret & fume a while with a little wholesome neglect we would have come *back* in time — certainly nobody would have joined us. But Fort Sumter in Anderson's hands united the cotton states — & we are here in Montgomery to make a new confederacy — a new government, constitution, &c, &c.

I left them hard at it & came on a visit to my mother.

I have seen, heard & forgotten so much — that again I must regret not keeping a daily record.

Today I have taught Mattie[1] to make a new dish & read Mary Miller a story so interesting for the first time in her life she asked for the book to finish it herself. From which small beginning the fond parents hope a love for literature will arise. While we were at dinner Stephen brought in some soldiers from an encampment near here, "The Montgomery Blues."

The poor fellows said "very soiled blues." They have been a month

7. Mrs. P. R. Gidiere ran a Charleston boarding house.
8. Francis Wilkinson Pickens, former congressman and U.S. minister to Russia, was elected governor three days before S.C. seceded as part of a last-minute compromise between radical and moderate secessionists in the state legislature.
9. Major Robert Anderson's decision to move the Federal garrison from Fort Moultrie to less vulnerable Fort Sumter. Governor Pickens, like other Southern governors, viewed the action as a violation of Federal assurances that the status of Southern forts would remain unchanged.
1. Wife of MBC's brother Stephen.

before Fort Pickens & not allowed to attack it. Col. Chase,[2] who commanded there the Alabama troops, they accused of too great affection for the Fort. He built it himself, & could not bear it should be proved not impregnable. Col. Lomax telegraphed Gov. Moore[3] if he might not try, "Chase or no Chase." Governor of Ala. inexorable. Now they say we have been down there & worked like "niggers" & as soon as the fun & fighting begins we are replaced by regulars. Sadly discomfited they are. My Mother is packing a huge hamper of eatables for the Colonel & the subalterns are amiably taking a game of billiards. I dare say they would fight as they *eat*, like Trojans.

They have an immense amount of powder along. And as they came the axle tree of the car on which it was took fire. An escape indeed!

Col. Chase blazed out a road behind them. The Montgomery Blues who had gone there to take Fort Pickens — & here was a road ready for them to *retreat* if they were attacked. They resented the insulting insinuation they scented in the "blazing" of that road. Indeed it was not needed — if they felt an inclination to run. Stephen took a servant there who had never seen any thing larger than a double barrel shot gun. When they fired the evening gun he dashed off for home[4] & got there by day break next day — cured of all tendency towards soldiering for ever.

It is hard for me to believe these people are in earnest. They are not putting the young, active, earnest, efficient in place any where. When ever there is an election they hunt up some old fossil ages ago laid on the shelf.

There never was such a resurrection of the dead and forgotten. This does not look like business. My first doubts came when I saw that efficiency was never thought of, but political manoeuvring still ruled ——

[*The following segment of eight pages, covering the period February 19 through February 20, 1861, is written in a scrawling hand, in a small booklet of four leaves. If the preceding entry was written later than February 1861, as the editors suspect, these are the first of the continuous entries Chesnut made.*]

2. William H. Chase, a retired U.S. Army Corps of Engineers officer who held a military commission from the state of Fla.
3. Col. Tennent Lomax, commander of the Montgomery Blues, was a lawyer and newspaper editor born in S.C. Andrew Barry Moore was governor of Ala.
4. Remainder of entry added at a later date. Apparently a page was torn out which MBC copied over on the following page.

[*February 19, 1861*]

We had some terrible matrimonial squalls last night — being away in the woods does not bring *peace*. To day letters came from Kate[5] which only partially relieves me. Mrs. Matheson died of a tumour in the stomach. May God avert all harm from that poor child. Yesterday was the inauguration of Jeff Davis — which I ought to have seen — & Friday we are to have another gala show. I know I did right to come here instead of remaining to see it all.

I told yesterday Toombs' hit at Gen. Scott[6] about the red headed man & South Carolina wanting to be introduced — selon les règles. My husband writes every day in good spirits very contradictory news. The Toombs story is this. He was dining with Gen. Scott — who seasoned every dish & every glass of wine by the tiresome refrain "Save the Union." "The Union must be preserved," &c, &c. Toombs said, "I know why you are so anxious about the Union. I read a story of a steamboat explosion & as the passengers struggled in the water a woman wildly ran up & down the bank shrieking, 'Save the red headed man.' The red haired man was saved & his preserver noticing how little the woman seemed interested in him after he was landed, asked her why she had made all that outcry. She answered, 'He owed me ten thousand dollars.' "

Cecil's saying of Sir Walter Raleigh, "I know he can toil terribly," is an electric touch. Clarendon's portraits:[7]

> Hampden — who was of an industry & vigilance not to be tired out or wearied by the most laborious, & of parts not to be imposed on by the most subtile & sharp, & of a personal courage equal to his best parts. Falkland who was so severe an adorer of truth that he could as easily have given himself leave to steal as to dissemble.
>
> ———
>
> But — nature never spares opium or nepenthe, whenever she mars her creature with some deformity or defect lays her poppies plentifully on

5. MBC's younger sister, Catherine Boykin (Miller) Williams of Alachua County, Fla., and Society Hill, Darlington Dist., S.C. Kate's husband, planter David Rogerson Williams, II, was a nephew of JC.
6. Robert Augustus Toombs of Ga., a disappointed aspirant for the Confederate presidency, resigned his seat in the U.S. Senate early in Feb. and became Confederate secretary of state at the end of the month. Winfield Scott, a native of Va. and an unsuccessful Whig presidential candidate in 1852, was general-in-chief of the U.S. Army.
7. MBC took this line and the two following paragraphs from Ralph Waldo Emerson, "The Uses of Great Men," *Representative Men* (1850). Emerson himself had paraphrased the descriptions of Hampden and Falkland found in Edward Hyde, Earl of Clarendon, *The True Historical Narrative of the Rebellion and Civil Wars of England* (1702–4), book 7. Four additional quotes from Emerson's *Representative Men* dealing with the individuality of man, the selfish disregard of leaders during war for the lives of the masses, the indebtedness of the man of genius to his forerunners, and man's inability to know his afterlife are omitted here.

the bruise, & the sufferer goes joyfully through life ignorant of the ruin, & incapable of seeing it tho all the world point their finger at it every day — Emerson

We keep each other in countenance & exasperate by emulation the frenzy of the time. The shield against the stinging of conscience is the universal practice, of our contempories — Emerson

[*February 20, 1861*]

Spent yesterday afternoon over a dull book. Today had a pleasant drive to Sparta where I saw a drunken man altho it was barely eleven in the morning — read all day Emerson & then Burton's *Encyclopedia of Wit & Humour*[8] — found a funny Alabama story by Johnson J. Hooper,[9] Secretary of the *Seceding* Convention, in which he calls Nullification *"treason"* & Calhoun worse than Arnold, &c. Spent the evening talking Washington to Mother & Mattie — described a dinner at Cobb's,[1] the Secretary of Treasury — where I went alone & Vice President Breckinridge[2] accompanied me home — & told how I blushed at entering alone & they said that was a phenomenon — & of the dinner at the President's, at which I sat by & translated for Mr. Buchanan & a Spaniard in not very good French — & how the Spaniard & I became so engrossed in our conversation we forgot the President & old Buck told me to translate, "Shine on your own side," to the Spaniard. I cut out of the papers to day the inaugural of Jeff Davis — not altogether to my taste — *too* despondent — this thing "our necessity *not choice*," as if the Union party ⟨was to be propitiated still⟩ cared for our [*illegible word*].[3]

[*This segment of Chesnut's diary, containing entries dated February 25 through August 3, 1861, is recorded in a book bound in red leather with decorative stamping in gold leaf, and fastened with a brass lock. On the flyleaf of the book, Chesnut wrote:*

8. William Evans Burton, *The Cyclopedia of Wit and Humor; Containing Choice and Characteristic Selections from the Writings of the Most Eminent Humorists of America, Scotland, and England* (1858).
9. Chap. 7 in Johnson Jones Hooper, *Some Adventures of Captain Simon Suggs* (1845). Hooper was in fact secretary of the Provisional Confederate Congress, but won no other office.
1. Howell Cobb, a former congressman, governor of Ga., and secretary of the treasury in the Buchanan administration, was chairman of the Montgomery convention and president of the Provisional Confederate Congress.
2. John Cabell Breckinridge of Ky. was Buchanan's vice-president from 1857 to 1861. Though supporting secession, he served as neutral Ky.'s representative to the U.S. Senate from March to Sept. 1861.
3. A year after the war MBC added here the following: "what a fool I was 1866."

November 10th 1860
James Chesnut, Jr., resigned his seat in the U.S.A.
Senate — "burnt the ships behind him." The first
resignation — & I am not at all resigned.
The notation was probably made sometime after she began using the book as a diary.]

[*February 25, 1861*]

Monday. Since I last wrote in my journal I have left my dear mother in Conecuh. We had a shocking day on the road — bad roads & hot cars. Sunday morning it seemed like a dream that I was here, I had been so ill all night. I found my husband well — apparently glad to see me — & working so hard. I could hear scratch scratch go the pen as I would wake in the night.

After church Captain Ingraham[4] called — he left me so uncomfortable. What a noble soul he is — & he dared express his regret that he had to give up the Navy. He was in the Mediterranean for two years, where he likes best to be. Was to take his daughters for a year to Florence — when here comes this horrid black republican ogre Lincoln & he must leave all for South Carolina. He takes not the most sanguine view of our taking Fort Sumter. We want every thing in the way of *naval* gear. After dinner Judge Withers[5] *raved* & abused the congress, Toombs, Cobb, Davis, &c. One cause of complaint was the giving Davis a house — but corruption was the cry. Every body wants office & every body raises an outcry at the corruption of those who get the offices. After that John L. Manning[6] came — the handsome ex Governor. Says he thought it a great thing to be ambassador to Louisiana but Slidell[7] called him contemptuously one of those "itinerate commissioners" & Bonham[8] said he was not to be fobbed off with such trash. While we were making merry over our woes Gov. Moore of Alabama came in &

4. Duncan Nathaniel Ingraham of Charleston resigned as a U.S. Navy commander in Jan. 1861 and was commissioned captain in the Confederate States Navy (C.S.N.) in March.
5. Common-law judge Thomas Jefferson Withers of Camden, a delegate to the S.C. secession convention and a member of the Provisional Confederate Congress, was MBC's uncle by marriage and guardian after her father's death.
6. John Laurence Manning of Clarendon Dist., governor of S.C. from 1852 to 1854, was one of the wealthiest men in the South. The owner of 648 slaves on plantations in S.C. and La., he valued his holdings at more than two million dollars in 1860. He served in the S.C. state legislature and secession convention and went to La. to urge that state to join the Confederacy.
7. John Slidell, former U.S. sena
8. Milledge Luke Bonham of Ed
 gress in Dec. 1860.

asked Gov. Manning if McQueen[9] & himself were disappointed office seekers!

At night Mr. Henry Marshall[1] came in — his eldest daughter, Mrs. Mary Furman, recently dead, & Judge Withers began again. Said he had a contempt for the people who sent him here; they were knaves & fools &c, both in South Carolina & in Kershaw District — when Mr. Chesnut's patience gave way & he said, "Then you ought to go home — if I thought as you do of my constituents I would not keep office an hour. I would not represent such people." Angry words went on — & I felt frightened to death. It is such a pity the Judge will be so harsh — & abusive of every body.

To day breakfasted with Constitution Browne[2] who goes to night for twenty four hours to Washington — offers to do any thing for me. I send by him a letter to Mary Stevens[3] with five dollars for bonnet ribbons. We begged him not to go as he might be captured as a traitor — & be the cause of civil war — for we would have to rescue him. Mr. Chesnut told him not to be a Bone of Contention. After a lively time with him I went to walk. Met Mr. C & we looked over a capital book shop. What a place for me when I get through those books I have with me. A Mr. Martin came in & said Pickens had telegraphed to know what he was to do — a war steamer laden with reinforcements lay off the bar of Charleston — & Jeff Davis telegraphs back to do as his own discretion dictates. *Pickens' discretion!* Trescot[4] writes that on the 22nd Anderson fired 34 guns for all the original United States — in utter scorn of our "Confederate States" — the insolent wretch!

I will not write to Trescot because he was too *frenchy* in some of his anecdotes to me — & he writes frantically "to know why I do not answer his letters — that Mr. Chesnut is the most tyrannical of men & prevents my writing or I am the most ungrateful of women," but my silence is for ever.

9. John McQueen of Marlboro Dist., S.C., resigned from the U.S. Congress in Dec. 1860 and served as a commissioner to Texas to secure that state's secession.
1. Henry Marshall, born in S.C., had served in the La. senate and state secession convention, and was elected to the Provisional Confederate Congress.
2. William Montague Browne of Washington, D.C., was the Irish-born editor of the Buchanan administration newspaper, the Washington *Constitution*. His commission as a colonel in the C.S.A. and his post as assistant secretary of state were the result of his friendship with Howell Cobb and Jefferson Davis.
3. The daughter of JC's cousin, Edwin Stevens of N.J., she had lived with the Chesnuts in Washington the year before her marriage to Congressman Muscoe Garnett of Va. in 1860.
4. William Henry Trescot of Beaufort Dist., S.C., a slaveholder, historian, and author of *The Position and Course of the South* (1850), had resigned as U.S. assistant secretary of state but remained in Washington as an unofficial adviser to the S.C. commissioners negotiating the fate of the Federal forts at Charleston.

They tell me the Inauguration was grand. I wish I could have seen it — the Judge harping on Davis being drawn by six white horses — which I think all right. Mrs. Fitzpatrick[5] made herself conspicuous by sitting (the only female) among the congressmen — & then poking Jeff Davis in the back with her parasol before the assembled multitude to make him speak to her. What a woman. I met Mrs. Winston Hunter, wife of my old admirer.[6] She is coming to see me. He goes tonight to Portland where he has a brother ill. Met Mally Howell[7] & Tom Taylor.[8] The latter asked me when we would go away. I said "when this thing breaks up" & he called out "treason" but I said "never mind — we South Carolinians are staunch — we do not mind saying what we please. You touch & go Alabamans might well be tender footed." Trescot has written for an office for that clever John McCrady.[9] I wonder so wonderfully cultivated a man — naturalist, mathematician, &c, should want to be Captain in the Army. Poor Jeff Davis this day if Fort Sumter is *attacked* his troubles begin. The Judge *raves* that "we should have a *military despotism* — any thing but a triumph to the Yankees." I agree to that. He will allow no despot but himself.

I cannot write in this book without thinking of the happy days when I sat & read & heard the scratching of my darling Mary Stevens' pen as she scribbled her love nonsense in a red book like this. Wrote today to Mother — & to Louisa Hamilton[1] — to thank her for my caps which have arrived. Read *Framley Parsonage* in the December number of the *Cornhill Magazine*[2] — a very disappointing chapter. My thoughts are with the young lovers — & this chapter is made up of the tiresome love story of Dr. Thorne & Miss Dunstable — began to day Thackeray's new novel.[3]

5. A friend of the Chesnuts from their days in Washington, Aurelia (Blassingame) Fitzpatrick was the second wife of former governor and U.S. Senator Benjamin Fitzpatrick of Ala.

6. Fountain Winston Hunter, a native of Sumter Dist., S.C., had joined the C.S.A. as captain of the Metropolitan Guards of Montgomery. His wife was Sallie (Harrison) Hunter.

7. Jesse Malachi Howell, a planter with interests in Richland Dist., S.C., and Miss., was Thomas B. Taylor's second cousin.

8. Thomas B. Taylor, a physician who moved from Richland Dist., S.C., to Ala. in the 1830s. Taylor's uncle John Taylor, governor of S.C. from 1826 to 1828, was married to JC's Aunt Sarah Cantey (Chesnut) Taylor. One of Taylor's first cousins, James Madison Taylor, was the husband of MBC's Aunt Charlotte (Boykin) Taylor. MBC probably calls Taylor "Alabama Tom" to distinguish him from his cousin Thomas Taylor of Richland Dist., whom she encounters later.

9. A professor of mathematics and zoology at the College of Charleston, who served as an engineer in the C.S.A.

1. Wife of John Randolph Hamilton, a former U.S.N. lieutenant.

2. Anthony Trollope's *Framley Parsonage* (1861) appeared as a serial in the English *Cornhill Magazine* in 1860–61.

3. William Makepeace Thackeray's "Lovel the Widower" appeared in *Cornhill* but was not published separately.

How much of the pleasure of my life I owe those reviled writers of fiction — [*following word added later:*] amnesty.

[*February 26, 1861*]

Found Thackeray very dull. "Vanitas vanitatum" used up by him. *Vanity Fair* the best he has ever done yet — nothing new in him since then. Mrs. Scota Holt called — the image of poor Theodore Lang.[4] Took a walk — & came home. Mr. Chesnut returned from what he called a perfectly delightful dinner with the Louisiana delegates. Stephen came in — ecstatic. The Montgomery Blues had presented him with a silver dipper — as a grateful offering for his kindness to them when they camped near Sparta. The report about Charleston contradicted — Jeff Davis has sent Whiting & Evans as officers to command there.[5]

Constitution Browne has been appointed assistant Secretary of State & so does not go to Washington — breakfasted again with us. Also the man named _____ who advertised for a wife & the wife along who had answered the advertisement. She was ugly as sin. Today we are to dine at Mr. Pollard's — & are also invited to a party at Judge Bibb's[6] — *one* will satisfy me. Went with Martha to have her likeness & the baby's taken & patience exhausted. Read the *Herald*[7] — filled with Lincoln — they seem to have forgotten *us* entirely. Lincoln took his stand before Washington's picture, taken by the *Herald* as a *sign* he means well. They must be frantic for a sign. Mr. Barnwell[8] showed Mr. Chesnut a letter from Wigfall[9] — giving a terrible rasping to Barnwell Rhett. The letter was addressed to Jeff Davis — & he was requested to read it to Mr. Chesnut & R. B. Rhett. The *Mercury* by his folly [*one or two illegible words*] the border states coming in — they believe SC is going to secede again.[1]

4. Apparently a member of the Alabama branch of the Langs, a S.C. family distantly related to the Chesnuts.
5. William Henry Chase Whiting and Nathan George "Shanks" Evans, both of S.C., resigned their commissions in the U.S.A. and joined the C.S.A. in Feb. 1861.
6. Charles T. Pollard, a prominent Montgomery merchant and railroad owner. Benajah Bibb was a Montgomery County court judge.
7. The New York *Herald,* a paper with Southern leanings.
8. Robert Woodward Barnwell, a senior member of the S.C. delegation to the Provisional Congress, was a moderate rather than a fire-eater like his cousin, Robert Barnwell Rhett, Sr. He had served as U.S. congressman, U.S. senator, president of S.C. College, and member of the S.C. secession convention from St. Helena's Parish, Charleston.
9. Louis Trezevant Wigfall, a South Carolinian, moved to Texas after a duel and became an important secessionist agitator and a U.S. senator from 1859 to 1861. With the approval of Jefferson Davis, Wigfall remained in Washington after the secession of Texas to buy arms and recruit men for the Confederacy.
1. The Charleston *Mercury* had opposed the Provisional Confederate government from the beginning, fearing that it would become a vehicle for sectional reconciliation. When the Provisional Congress voted to prohibit the slave trade and retain a protective tariff —

Mr. Rhett defends himself, says he is right. Mr. Chesnut & the Judge made peace — Mattie goes to day at 4 o'clock.

> "Charitably take him aside & whisper in his ear, that little comes of real knowledge, but increased modesty, doubt, & suspicion."

[*February 27, 1861*]

Camden DeLeon[2] called — says Gen. Scott does all he can to keep officers from resigning, promising never to send them South. Captain Ingraham says if they take the government pay they ought to fight wherever there is fighting! Finds Montgomery *triste*. Dined at the Pollards' — very pleasant. I can give a better dinner than that! Mr. Pollard as usual very kind — had out our old quarrel: South Carolina "sayings," Georgia, "doings." Mr. Robert Barnwell took me to dinner. Sat next a Mr. Robert Smith[3] who had a pretty wife opposite. He told me several funny tales, is very handsome, but told me he was a *little* tight when something happened! I always feel as if a man had no moral sense of right or wrong or even decency when he alludes to his own *intoxication*.

Had a pleasant chat with Captain Ingraham & Dr. Taylor — came home & found Judge Withers & Gov. Moore ready for a party at Judge Bibb's. Hurried & got ready to join them, Mrs. Watson[4] helping me. Had a delightful time at the party. Walked & talked with Mr. Sid Wilson,[5] an old college friend of Mr. Chesnut — then Mr. Pollard, then Crawford,[6] Toombs, the *two* Cobbs,[7] Constitution Browne, Mrs. Hunter telling as a joke that Mr. C was sorry I had come back. They say Clayton[8] has come — & says we are to have *no war*. Mr. Curry[9] also talked to me — & the Bibbs did not want us to come away before supper but we *did*. Mr. Chesnut wrote until quite late.

measures designed to attract support in still undecided border states — the *Mercury* charged that its fears were confirmed.

2. David Camden DeLeon, a native of Camden, had resigned as a U.S. Army surgeon the week before and soon became the first surgeon general of the Confederacy.
3. Robert Hardy Smith, delegate from Mobile to the Provisional Confederate Congress.
4. Wife of Hugh P. Watson, adjutant-general of Ala. militia.
5. William Sidney Wilson of Miss., delegate to the Provisional Congress.
6. Martin Jenkins Crawford of Ga., an ex-U.S. congressman, also a delegate to the Provisional Congress.
7. Howell Cobb and his brother Thomas Reade Rootes Cobb, delegates from Ga. to the Provisional Congress.
8. Phillip Clayton of Ga. had resigned as assistant secretary of the U.S. treasury. He held the same post in the Confederate government.
9. Jabez Lamar Monroe Curry of Ala., a member of the Provisional Confederate Congress, had belonged to the Chesnuts' Washington mess while serving in the U.S. Congress.

Late breakfast to day — alone. Then bought a *Herald*. A Mrs. Saxon came & abused South Carolina, found I was a Carolinian & took the other tack. Spoke of her letters being printed — but used "incredulous" for "incredible" — & "was" for "were" —*fine* writer she must have been. Miss Evans, the authoress of *Beulah*,[1] was at the party last night — but I did not see her. Mr. Wilson told me my friend Anthony Kennedy, Senator from Maryland,[2] spoke to Lincoln. Lincoln hurried through Baltimore in the night — afraid to come in the day — & Mr. Brewster[3] says the head of the police in Baltimore said it was true it would have been very dangerous for him to have risked not only him self but his cortège there. Mr. Brewster says the specks of war are increasing — & that even in Virginia much less at the North nobody believes we are doing any thing but sulking down here — & Davis & Stephens[4] are only acting a little comedy. The Virginia delegates were insulted Saturday night at the Peace Conference[5] — but Mr. Brewster says they would soon make it up. Virginia has stood so many kicks. We laughed over the piece in the *Herald* to day — which said James Chesnut, Jr., was the only son of one of the wealthiest Carolinians. His father owned a thousand ne-groes & could not in a day ride over his lands![6]

Today had a letter from Mrs. Garnett. She says Garnett wishes him self here twenty times a day. She makes so many inquiries about Mont-gomery I suppose she will come here if Virginia secedes. Brewster says every word the papers tell of Lincoln's vulgarity is true — that it is worse than we can conceive — & his wife & son as bad. I asked him how Wig-fall liked being left to the blacks. He said Wigfall could never bear the restraints of *civil* life — & therefore rather liked being with people he could snub & be as rude to as he pleased — & that he indulged himself to the fullest extent. Brewster said I looked better than he ever saw me.

All the morning I was paying calls. Mrs. Judge Reas, a cousin of Mrs.

1. Augusta Jane (Evans) Wilson, born in Ga., was an ardent supporter of secession and the author of moralistic novels. *Beulah* was published in 1859.
2. A Unionist member of the U.S. Senate from March 1837 to March 1863.
3. Born in S.C., Henry Percy Brewster became secretary of war of the Texas Republic and a prominent lawyer in Texas and Washington.
4. Former Ga. congressman Alexander Hamilton Stephens was elected vice-president of the Confederacy on Feb. 6.
5. On Feb. 4, a peace conference requested by the Va. legislature brought representa-tives from twenty-one of the thirty-three states to Washington in a last attempt to find a solution to the sectional crisis. The "insult" to the Virginians was apparently the se-lection as temporary chairman of Christopher Walcott, Ohio's attorney general, who had allegedly moved to adjourn a state court in honor of John Brown.
6. This sketch of James Chesnut, Jr., and his father appeared in the New York *Herald*, Feb. 23, 1861. The owner of 448 slaves in 1860, old Mr. Chesnut was indeed one of the wealthiest men in S.C. and the South. But James, Jr., shared little of this in his own name.

Boyce,[7] Mrs. ⟨*illegible name*⟩ who was fat & stupid, said her husband's
first wife was a cousin of Mr. Chesnut's, Mrs. Mays, who was a Mrs.
Glascock & knew me in my youth & knew Mr. Chesnut when he was
an aide to Gov. Noble.[8] I called at the Bibbs' & saw the Judge — & my
excuses were made for my hasty exit last night. I think the number of
frightful pictures in every room where I called I did not know the art
of portrait painting could get *so low.* Also at a Mrs. Willaims', whose
husband was a friend of my father's & she was a Mrs. Lem Reed. I am
certain there was a slander about one of the two but no distinct recol-
lection. Paid the hack driver 2 dollars for this brilliant morning's
work ——

[*February 28, 1861*]

Yesterday after dinner a Mrs. Lafayette Borland Harris called — a
beautiful woman. I met her twenty years ago when I was coming back
from Mississippi — on the Alabama river — a *tearing* belle just from Mrs.
LeVert's[9] — & I remember now her amazement that Robert Campbell
remained devoted to me in spite of her attractions. [*Following sentence
added later:*] I never was handsome. I wonder what my *attraction* was for
men did fall in love with me wherever I went [*one word added later:*] then.
A Mrs. Reese was with her — said she was a relation of mine.

Then I went to supper with Governor Moore, not the best company
to be in as they say the old sinner has been making himself ridiculous
with that little actress Maggie Mitchell.[1] Keitt[2] called & told me what a
beast that Edmund Rhett[3] is — writes articles for the *Mercury* abusing
every body & calling them submissionists *but* his father. Keitt is won-
derfully friendly once more. Then Mr. Mallory[4] called — a man in spite
of his unpleasant ⟨personal offenses⟩ that I liked. He is witty — &
seemed to have so high an opinion of me — but Captain Ingraham told
Mr. Chesnut that he was so notoriously dissolute that a woman was
compromised to be much seen with him. The Judge admired him more

7. Wife of the ex-congressman and delegate from Edgefield, S.C., to the Provisional
 Confederate Congress, William Waters Boyce.
8. Mrs. Eliza Ann (Glascock) Mays, widow of Montgomery planter and judge, Thomas
 Sumter Mays. Patrick Noble was governor of S.C. from 1838 until his death in 1840.
9. Granddaughter of a signer of the Declaration of Independence, Octavia (Walton) LeVert
 maintained a fashionable salon in Mobile and had written a popular account of her
 experiences in Europe, *Souvenirs of Travel* (1857).
1. Margaret Julia Mitchell, a light comedy actress from N.Y., who was touring the South
 with her hit play *Fanchon.*
2. Lawrence Massillon Keitt of Orangeburg, S.C., was an ex-U.S. congressman and a del-
 egate to the Montgomery convention.
3. A brother of Robert Barnwell Rhett, Jr.
4. Stephen Russell Mallory of Fla. had resigned from the U.S. Senate in January.

than any one he has met with. I met Mr. Mallory on the steps just now. I am afraid he has not been confirmed, he looked so sad — or preoccupied ——

Tom Lang[5] called before we were up to day — wanted a place for his cousin-in-law Tom Holt. DeLeon wants to be Surgeon General. Col. Blewitt called & took me to the capitol. I had hardly recovered from the effort of climbing the stairs when we were turned out. Was introduced to Commodore Rousseau.[6] Old Blewitt was an old friend of my father's — *but* is such a simpleton about marrying again. A Mrs. Bell called who talked me to death about Miss Evans the authoress — then the Woods & Picketts[7] again — that little man has been so attentive to me. Walked this morning to the Book Shop immediately after breakfast — bought *Evan Harrington* & two numbers of *Blackwood's*[8] — & passed Edward Taylor[9] twice. Fortunately he did not know me. Constitution Browne offers again to take my letter to Mary Garnett — he risks him self in Washington. The cry now is peace. They say Mr. Henry Marshall made a capital speech yesterday. The Judge is certainly crazy on the subject of Jeff Davis. Clayton made assistant Secretary of the Treasury.

What a pity — these men have brought old hatreds & grudges & spites from the old Union. Already we see they will willingly injure our cause to hurt Jeff Davis.

[*March 1, 1861*]

Dined yesterday with Hill of Georgia, the man who refused to fight Stephens & his wife was so proud of him for doing so.[1] Found him very pleasant. Supped with a son-in-law of Gov. Moore. Read immense numbers of newspapers — & cut out the offensive articles in the *Mercury*. Old Barny[2] volunteered to tell Mr. C they should be counted. Mr.

5. Thomas Lang, Jr., of Dallas County, Ala., a second cousin of JC and the son of a wealthy Kershaw planter.
6. Capt. Lawrence Rousseau of La., who had just resigned his commission in the U.S.N., was in Montgomery to assist in forming the Confederate navy.
7. Martha (Pickett) Woods and Michael L. Woods, formerly a state representative and currently a private in the Montgomery True Blues; Laura (Holt) Pickett and William R. Pickett, a Montgomery planter.
8. George Meredith's *Evan Harrington; or, He Would Be a Gentleman* (1860) and *Blackwood's Edinburgh Magazine*.
9. Edward Fisher Taylor, whose brother married MBC's aunt, Charlotte Boykin.
1. During a debate in 1856, Benjamin Harvey Hill called Alexander Stephens "Judas Iscariot." Challenged, Hill declined to face "a man who has neither conscience nor family." Hill, who was married to Caroline (Holt) Hill, served as a delegate to the Montgomery convention even though he opposed secession.
2. Robert Barnwell Rhett, Sr.

Mallory not confirmed. Browne gone. Went to church to day. Sat with the Elmores.[3] Came home, excused myself to company. Afterwards dressed & went down to see Mrs. W. Taylor,[4] Mr. James, & made an appointment to drive this afternoon with the latter & Frank Campbell, left my watch at the jeweller's & bought fruit. Commenced *Evan Harrington*. Read two *Blackwood's* yesterday — read the *Herald* — which still madly look[s] to *reconstruction*.[5]

[*March 2, 1861*]

A.M. Dined with Mr. Hill & Judge Withers [who] joked each other after the fashion of elderly persons about telling their wives of their flirtations. Drove with Jessie James — picked up a Mrs. Willie Knox[6] whose husband beats her — & she was wishing he would go to Pensacola & be shot! Paid a visit to Scota Holt — & Jessie wondered all the time why she lived in so small a house — the reason obvious — can't afford a larger. Came home with Frank Campbell.

Mr. Mallory called, then Mr. Hill, Judge W and my husband in the room. We sat for several hours — Mr. M doing the delightful — told wonderfully funny tales — but of [*two illegible words*]. Gov. Moore came in & I got up & slipped away. Went to bed after a chat with JC — which after all is the best fun — but was sorry to have missed Captain Ingraham by my early hours.

Northrop sent Judge Withers a Hymn to the Virgin — as the Patron Saint of America, Holy Mother of God, &c. Frank Campbell came to day for a regular siege — heard the actress woman[7]; she does not speak good English! & her "Honeymoon" was a failure. Met Mr. Robert Smith delighted, as the papers say Virginia now will go out. He carried me to Mrs. Jeff Davis'[8] room — where she met me with open arms. What a chat that was, *two* hours. She told me all Washington news — gave me

3. Mary Jane (Taylor) Elmore and Albert Stanley Elmore, a planter and clerk of the Ala. house of representatives from 1855 to 1864.
4. Mary Elizabeth (Hails) Taylor, wife of Montgomery planter William Henry Taylor, both natives of Columbia, S.C.
5. That is, restoration of the Union by compromise to avoid war.
6. Anne Octavia (Lewis) Knox, community activist, teacher in a Methodist Sunday school for blacks, and wife of Montgomery merchant and banker William Knox.
7. Margaret Mitchell.
8. Varina Anne (Howell) Davis of Miss., a granddaughter of a governor of N.J. during the Revolutionary War, became Davis's second wife in 1845. A socially accomplished woman, she was an ambitious supporter of her husband. Her relationship with MBC began in Washington when their husbands were in the U.S. Senate and was to become an intimate friendship and alliance.

a graphic description of the prince's visit[9] — The Earl of St. Germans[1] telling her who Sydney Smith & Sir Henry Holland[2] were, & that Mr. Calhoun was not considered a statesman in England, &c. How that cross eyed Flora Levy asked Hon. some thing Elliott[3] if he were a relation of the Carolina Elliotts! & how the Marchioness of Chandos[4] remarked upon the extravagance of Mrs. Gwin[5] with her velvet *pinked,* saying she never could use it again! — & the Prince said "uncommon fine" to every thing, &c, &c. We discussed the world & his wife & I could only get away by promising to come back every day. Then called & saw at Mrs. Martin's Dr. Manly,[6] who took great interest in me when he found I was old Mrs. Boykin's grand daughter.[7]

Met Captain Ingraham & Mr. Mallory. The latter reproached me with being *bored* by him last night. Constitution Browne is of lordly descent & his wife's one of the best families in England. The *Herald* gives the most preposterous accounts of the attempt to assassinate Lincoln which nobody believes.

[*March 3, 1861*]

Dined with the usual *mess.* Brewster in addition — all in fine spirits, all having spoken in Congress to their own satisfaction & after dinner the Judge took me out to deliver a panegyric upon my husband — thinking him the proper person for a foreign mission.

The Montgomery Blues drilled, I cannot but think for our benefit, before Montgomery Hall. I saw all my friends among the officers. After tea — Mr. Mallory & Captain Ingraham called & sat until half past nine. The Judge thinks Mr. Mallory is attentive to me to propitiate Mr. C & himself — as if he were half as attentive to me as he used to be in

9. In 1860 Queen Victoria sent her son Edward Albert on a tour of Canada and the United States. Mrs. Davis probably saw the Prince in Washington where he stayed three days at the White House.
1. Edward Granville Eliot, third earl of St. Germans and Lord Steward of the Royal Household.
2. Sydney Smith was a founder of the *Edinburgh Review* and Canon of St. Paul's until his death in 1845. Sir Henry Holland, a fashionable London doctor and physician to Queen Victoria, was Smith's son-in-law.
3. Lord St. Germans.
4. Caroline Harvey, wife of the keeper of the privy seal to the Prince of Wales. Her title was the Marchioness of Chandos.
5. Mary (Bell) Gwin was the second wife of William McKendree Gwin, U.S. senator from Calif.
6. Basil Manly, Sr., a native of S.C., was pastor of the First Baptist Church in Montgomery and chaplain at the inauguration of Jefferson Davis.
7. Mary (Whitaker) Boykin, second wife of Burwell Boykin.

Washington — for the best reason. I will not let him be since I have heard of his ⟨bad⟩ character. He told me a thing I before suspected from what I saw my self, the affair between Holt & Mrs. Phillips[8] — what a mad, bad woman she is. Captain Ingraham is better by himself. He seems to like me so much. Mrs. Fitzpatrick & her son Elmore Fits, the man who jilted Sally Elmore Taylor,[9] called & stayed until nearly eleven. Mrs. Fits finer than ever but so cordial — wants me to go to see her in the country. What a jolly old girl it is.

Today went to church. Saw the President & Mrs. Davis — communion Sunday. Captain Ingraham a member of the church. I feel so sorry Mr. Chesnut will not go to church — he is better than these men. Dined with Hill, Brewster, Mallory, the Judge & Mr. Chesnut. Merry pleasant dinner, these men are so clever & witty — no wonder the solemnities & trifles of Mulberry bore me so. I have to smooth things among them sometimes. Saw Jere Clemens & Nick Davis, the antisecession leaders.[1] Geo. Sanders & Geo. Deas[2] were here — the latter says we are not ready to take Fort Sumter & that we have a noble band there to be sacrificed — so ready to run their heads against that stone wall that nothing but science can take. The peace congress measures have passed the house — too late my friends.[3] Walked from church with Scota Holt — she is so like poor Theo Lang. Tom Lang has gone home — I wonder what brought him here!

[*March 4, 1861*]

I saw something to day which has quite unsettled me. I was so miserable — ⟨*several illegible words*⟩ that one character in the world is

8. Joseph Holt of Ky., U.S. secretary of war, and Eugenia (Levy) Phillips, wife of Washington lawyer and former Ala. congressman, Philip Phillips.
9. Elmore Fitzpatrick, a Montgomery lawyer and the son of a former Ala. governor and U.S. Senator Benjamin Fitzpatrick. Mrs. Aurelia (Blassingame) Fitzpatrick was his stepmother. Sally (Elmore) Taylor of Columbia, S.C., was a first cousin of JC, a daughter of former U.S. Senator Franklin H. Elmore, and the wife of Thomas Taylor of Richland Dist., S.C.
1. As upcountry allies in the Ala. secession convention, Jeremiah Clemens and Nicholas Davis, Jr., opposed withdrawal from the Union without a popular referendum and simultaneous secession by other slave states, but vowed to defend Ala. in any event. Clemens, a distant cousin of Mark Twain, was a former U.S. senator; Davis, a planter and former state legislator.
2. George Nicholas Sanders of Ky. mingled idealism and fraud as a promoter of European revolutionaries of 1848 and a founder of the nationalistic, expansionist "Young America" movement of the 1850s. He became a Confederate agent in Canada and Europe. Former U.S. Army officer George Allen Deas, a distant relative by marriage of the Chesnuts, was acting adjutant-general of the Confederacy.
3. On March 2 the Thirty-sixth Congress ended with a futile gesture toward sectional reconciliation as the Senate adopted a House resolution calling for a constitutional amendment which would prohibit congressional interference with slavery in the states.

lost — it knocks away the very ground I stand on — but away night mare ——

Yesterday I dined with Brewster, Mallory, Hill, Mr. C & the Judge. What a merry dinner it. I introduced Mallory & Hill at last. After dinner slept until evening — the same dish at evening. Until half past ten, Mallory, Hill, Frank Campbell, Brewster, Gov. Moore, the Judge, Mr. C, I the only lady. I must say the stories 'tho' rich & rare were rather strongly spiced for my presence. Mr. Mallory's were the best. 'Tho' they say his mother was a washer woman, he is the most refined in the group who surround me here except my husband. Mallory told the tale here of Judge Butler[4] in the Senate — giving way to "flounce tail." I understand now some of Mrs. Clay's[5] jokes.

Frank Campbell told me Dallas had refused to allow Buchanan to visit his house in Philadelphia[6] — & Buchanan was afraid to recall Dallas for fear of ripping up the old story. Sat at home this morning eating my own heart — but knew that would never do. So rushed, first got my watch, left a card for Mrs. Davis, called a Mrs. Farley who lives in a beautiful house —& then left a card at the top of a high hill for Mrs. Fitzpatrick. Came home in a more sane state of mind with a bunch of flowers. Had a letter from Kate Withers[7] — she improves evidently. Says she can sing.

I saw to day a sale of Negroes — Mulatto women in *silk dresses* — one girl was on the stand. Nice looking — like my Nancy — she looked as coy & pleased at the bidder. South Carolina slave holder as I am my very soul sickened — it is too dreadful. I tried to reason — this is not worse than the willing sale most women make of themselves in marriage — nor can the consequences be worse. The Bible authorizes marriage & slavery — poor women! poor slaves! —— "Still — slavery tho art a bitter draught disguise it as we will & ten thousands have drunk," &c. See Sterne![8] I find two English reviews with not at all a tempting list of articles. My book *Evan Harrington* is splendid. One sentence: "Like a

4. Andrew Pickens Butler, former U.S. senator from S.C.
5. Virginia (Tunstall) Clay, wife of former U.S. senator from Ala., Clement Claiborne Clay, a friend of MBC since Washington days.
6. George Mifflin Dallas of Pa. was vice-president under Polk and minister to England under Buchanan. Though a bitter enemy of Buchanan within the Pa. Democratic party, Dallas publicly supported his rival's successful bid for the presidency and was rewarded with the ministry to England. Privately, hostility between the two men persisted.
7. Katherine Withers, a daughter of Judge Thomas J. Withers.
8. In Laurence Sterne, "The Passport. The Hotel at Paris," *A Sentimental Journey through France and Italy* (1768), Mr. Yorick, reasoning away the evils of captivity in the Bastille, hears a caged starling say, "I can't get out — I can't get out." Yorick struggles unsuccessfully to free the bird and concludes, "Disguise thyself as thou wilt, still slavery!"

true English female she believed in her own inflexible virtue utterly — but never trusted her husband's out of sight."[9]

Henningsen the filibuster[1] is here. Mr. Chesnut remarked how gone he was — he is introduced to Mr. C every day, has a pleasant chat, & shows no symptom of knowing him ten minutes later. One of the gentlemen said he saw by the papers of that evening that it was *Modesty* — he is so modest. The *Herald* repaid me to day for my ten cents — it says Lincoln will not drive in his carriage because it is not *bomb* proof — & that a breas[t] pin had been sent him of two flags & a bundle of *sticks* — the latter for us. The English are quite unhappy as to our family quarrels. The Virginia delegates have called on Lincoln. I do not believe that! See Captain Ingraham wandering like a lost sheep about the house.

[*March 5, 1861*]

Yesterday dined with the mess. Don't remember any thing they said, but they are all ways witty. Brewster called Madame Bodisco a Leviathan of Loveliness.[2] Mr. Chesnut came for me — & Curry & Mr. Mallory & ourselves stood in the Balcony & saw the flag of the Confederate States go up — amid the roar of cannon. To day Captain Ingraham told me a Miss Sanders, sister or daughter of the famous George Sanders, told him it was a lifeless crowd & no cheering or enthusiasm in the *mob.* Our mobs are gentlemen. The men who make the row in the northern cities are here hoeing cotton. Still I am sorry the idea is abroad that we have no pride & joy in this thing.

The Band was delightful. They were playing "Massa's in the cold, cold ground."

Last night Major Deas & DeLeon called — the former very agreeable — talks & looks like an Englishman. Says the New York clubs are made disagreeable now for southern men; [he is] going to live at Mobile. Looks like Dr. Lynch Deas & Col. James Deas[3] — more agreeable than either. Heard a great deal of my father's family from Wasson. Went to bed. Mr. C sent for to a supper by Mallory.

While we were in the Balcony looking at the hoisting of the flag, Mr. Chesnut announced to Mallory that he was confirmed Secretary of the Navy — & he went on (I mean Mr. Mallory) talking to me, as I sup-

9. A paraphrase from chap. 22.
1. Charles Frederick Henningsen of Ga., author, professional soldier, and adventurer, had participated in William Walker's expedition to Nicaragua in the mid-1850s.
2. Harriet Beall (Williams) Bodisco, the American-born widow of a Russian envoy to the U.S., had married Capt. Douglas Gordon Scott. Brewster's comment was a common one.
3. Lynch Horry Deas, a Camden physician, and James Sutherland Deas, brother-in-law of JC.

posed, without stopping. My back was to him. After a while, I asked Mr. Mallory if he had heard the thing before — & he said *no*. I then asked if he took no notice when Mr. Chesnut spoke, & Mr. C replied, "Yes, he made me a profound bow." *I did* Mr. Mallory some good in this canvass. Florida was against him.

Today Captain Ingraham came & showed me a letter in *verse* from a Boston girl who wept over him when she remembered Koszta[4] — & was ready to hang him now. He introduced me to a commodore — but I did not catch the name. He was however a jolly old sea dog & laughed immoderately at my small jokes.

Then Mrs. Hunter came & to my room — found me trimming a bonnet. Said her husband wanted to drive me out. I hope he does not want any office. Then I went to see Mrs. Davis. Mrs. Powell called & carried me in her carriage. There I assisted at a Levee. No end of men — Commodore Tattnall,[5] Captain Randolph, &c, &c. Mr. Josselyn,[6] the poet, says I look younger & better than I did in Washington. I wonder if in the thousand compliments I hear there is one *grain* of truth. Gov. Fitzpatrick came & we had a great joke because in Washington he was so hospitable & here he tells us the roads are so bad. It is idle to enumerate the men & women I saw there. Mrs. Davis' brother[7] tells me she made a speech on the balcony at New Orleans to a mob. She denies the soft impeachment but owns to sending them bouquets & a flag out — & *bows* of the deepest. A nice young man this Howell. President Davis came & shamed me for running at his foot step always. Read Lincoln's inaugural. Means he war or peace. An insidious villain, I fear he only means, if he can, to get away from us the border states. A Miss Tyler,[8] daughter or grand daughter of the President, ran up the flag yesterday.

Captain Ingraham wanted me to go to the Capitol with him — but I

4. Martin Koszta took part in the Hungarian revolution against Austria in 1848 and fled to the U.S. in 1850. Traveling to Turkey three years later, he was kidnapped and held prisoner aboard an Austrian man-of-war off Smyrna. Duncan Ingraham, commander of the U.S.S. *St. Louis*, forced Koszta's release with an ultimatum on July 2, 1853. This exploit, occurring at a high point of American sympathy for the revolutionaries of 1848, made Ingraham a national hero.
5. Josiah Tattnall of Ga., a career U.S. naval officer who resigned his commission in Feb. and became a captain and senior flag officer in the C.S.N. Victor M. Randolph had resigned his captain's commission in January.
6. Robert Josselyn of Miss., author of *The Faded Flower, and Other Songs* (1849), was Jefferson Davis's private secretary.
7. Mrs. Jefferson Davis had two younger brothers, Jefferson Davis Howell and Beckett Kempe Howell.
8. Letitia Christian Tyler was the daughter, not of former President John Tyler, but of his son, Robert Tyler of Philadelphia.

did not. Tomorrow I am to go with Mrs. Fitzpatrick. Mrs. Davis told how poor Mrs. Davenport's reputation was joked away. At the dinner to the Prince, Lord St. Germans wanted to know what was the corresponding term for men as caryatides. They asked Mr. Trescot, not understanding exactly what the question was, "What are Caryatides?" & he pointed to a gilt candleabrum & said those three *guilty* women. Next day some body asked what kind of woman Mrs. D was & the answer with a laugh, one of Mr. Trescot's caryatides.

Found a review of Motley's *United Netherlands*[9] very dull yesterday. Perhaps Mrs. Davis will have a reception tomorrow. She asked me to assist if she does. I have had a perfectly glorious morning. I have laughed myself weak. Heard from Miss Sally Chesnut[1] today — her mother not well.

[*March 6, 1861*]

Yesterday evening Mrs. Fitzpatrick, Scota Holt & Mrs. Elmore called. Mrs. F noisy as ever, taking me to [t]ask for saying she received with Jeff Davis. Then Judge Withers introduced me to Judge Hale[2] a congressman, but the man listened to Mr. Mallory. I wish Mr. Mallory would not tell me so much of his flirtation with Mrs. Phillips. I do not think it as innocent as he pretends, but it's none of my business. Mr. Mallory told tales & amused us until half past ten — when, he & I being left alone, I came up stairs. So much for a man's having a bad *reputation*.

Today went first to the Congress, found the doors closed, then tried the convention — a rough, common looking set of men. Did the agreeable to Reid,[3] an editor, & several others — had a long talk with Keitt & then called at the Jesse Taylors'.[4] Mad people — the row was actually so great I came away with a head ache. Saw Frank Campbell there & an old acquaintance, a Mr. Oldham. Was introduced in the Convention to *Hilliard*.[5] Saw Yancey[6] also to day but was not introduced.

Dressed for Mrs. Fitzpatrick & waited one hour — bonneted. That horrid woman. So went in an ill humour to Mrs. Davis' reception too late, where I expected so much pleasure. Saw no end of people — liked

9. John Lothrop Motley, *History of the United Netherlands,* vols. 1 and 2 (1860).
1. Sarah Chesnut, forty-seven, was an older sister of JC. Mrs. Chesnut sometimes calls her "Miss S. C."
2. Stephen Fowler Hale, a Confederate congressman from Greene County, Ala.
3. Samuel Gersham Reid, editor and part owner of the Montgomery *Advertiser.*
4. William Jesse Taylor, JC's first cousin and a Richland Dist. planter.
5. Henry Washington Hilliard, lawyer, Ala. congressman from 1845 to 1851, and lay Methodist preacher.
6. William Lowndes Yancey, former U.S. senator, radical secessionist, and member of the Ala. secession convention.

a nice little man named King. Found it all, from having a head ache & ill humour, stale, flat, & unprofitable. Dr. DeLeon brought me home. Now I am to go at four & a half to drive with Mrs. Reese. I shall make her take me to Mrs. Lafayette Borland's.

The cry to day is *war.* Still I do not believe it. Such *contradictory* opinions men have. I find so many kind people — but the present never satisfies. I must write to my mother. That man Yancey, to say he is like *Isaac* Hayne[7] — a common creature & Isaac Hayne so thorough bred. I wonder why I see nothing further of the Goldthwaites[8] — oh what a shabby set those Alabama men were. A.M.

[*March 7, 1861*]

Dinner as usual except a quantity of Alabama Convention folks present & the Judge ridiculing every body by name & not knowing who were present. Drove out with Mrs. Reese & Mrs. Borland Harris. Told me horrid tales of Mrs. Fair & Seibels[9] — that they were counting the time for her baby to be born with dreadful suspicions — poor old Young Fair. Sad is your fate. Came home & found my room *blazing* — got into a [*one illegible word*] for many reasons. Went to tea & met Mr. Barnwell, Miles[1] & Captain Ingraham.

Miles read us comic poetry. Several others came in & after a pleasant hour the congressmen departed. Talked there with Reid & Page, & Mrs. Watson annoyed me beyond measure by saying Missouri said she made the fire in my room for *me* — & expressed such amazement at the idea that I was out. The Hotel women are curious creatures. Sat up until the Judge, Mr. Hill & Mr. C came home — when, after a long laugh & talk, they went to supper & I went to Mrs. Watson's room & made Missouri's Indian blood rage by interrupting her, reading aloud to her a love letter from Macon. The laugh was against the Judge who is always vaunting his own probity & honesty beyond every body else's. Simon Suggs,

7. Isaac William Hayne, grandson of Revolutionary War hero Isaac Hayne, was attorney general of S.C. and a member of the state secession convention from Charleston Dist. In Jan., Governor Pickens sent Hayne to Washington to demand the surrender of Fort Sumter.

8. Olivia Price (Wallach) Goldthwaite and George Goldthwaite, chief justice of the Ala. supreme court.

9. Martha (Wyatt) Fair, wife of Montgomery lawyer Elisha Young Fair, who is referred to here by his middle name as "poor old Young Fair." John Jacob Seibels, also of Montgomery, was a diplomat to Belgium under the Buchanan administration and a colonel in the C.S.A. during 1861.

1. William Porcher Miles, a member of both the S.C. secession convention and the Provisional Confederate Congress, had been a mathematics professor at the College of Charleston, mayor of Charleston, and a U.S. congressman from 1857 until his resignation in Dec. 1860.

after cheating in a horse trade, went off muttering, "Integrity is the post I tie to."[2] We won't hear any more of the Judge's superior probity for a while.

To day went calling with Mrs. Mays who was a Miss Glascock. Saw a quantity of dowdy, common place women who always ask me how do you like Montgomery & express unbounded satisfaction at my candid & *unexpected* answer that it is *charming*. Mrs. Mays handsome & *pleasant* & affected after the manner of Mrs. McWillie.[3] Says Bonham is here & has been made commander in chief of the South Carolina Army — wonderful if true. Called on Mrs. Reese; Mr. Reese, an old friend of my father's, says that the Judge is considered *erratic* — & my husband the leader of our delegation. So mote it be.

Dr. Tom Taylor was saying how stiff it was at the reception yesterday until I got there — & I went in like a ray of warmth & sun shine — pretty good for a woman of my years. Saw a flag with stars & stripes floating in the breeze — & told Miss Tyler, as she seemed head of the flag committee, to have it taken down.

Mr. Chesnut came home to dinner; dined with the Judge & Mr. Hill. Mr. Chesnut left me to speak to Mr. President Davis for DeTreville,[4] Kershaw, Baker, & my friend Robert *Rutledge*[5] — for the latter I begged hard. He took a long walk with the President & I hope [for] his application. All honor for South Carolina; her sons have asked no offices but in the Army or Navy — the right to fight. Bonham has not the commander in chief's place. Those men seemed amused at the idea.

I walked & saw afar off Mr. Josselyn, Major Deas, &c, & got tired in two squares. Longed for a carriage of my own & came home. Just as I got in, Jessie James came for me to drive.

Never again will I trust appearances. These women talk of Washington, Mrs. Reese saying she hoped we would not make this the Capital, it was so corrupting to *Morals*. Yesterday it was Mrs. Fair. Well, I have made a blunder — that fair, pure, gentle woman I took about with me

2. In chapter 3 of Johnson Jones Hooper's *Some Adventures of Captain Simon Suggs* (1845), Simon fleeces a fellow land speculator and observes: "But Honesty's the best policy . . . Ah yes *honesty*, HONESTY's the stake that Simon Suggs ALLERS ties to! What's a man without his inteegerty." For Simon's remark to his wife and his camp-meeting adventure, see chap. 10.

3. Catharine (Anderson) McWillie, wife of William McWillie, a former governor of Miss., who was born in Camden.

4. Probably Richard DeTreville, a Charleston lawyer and former lieutenant governor of S.C. who became colonel of the Seventeenth S.C. Volunteers.

5. Joseph Brevard Kershaw of Camden, a lawyer, former state legislator, and delegate to the S.C. secession convention, shortly became colonel of the Second S.C. Volunteers. Robert Smith Rutledge of Charleston, son of planter John Rutledge, had enlisted as a private in Thomas Baker's company the day before.

today! She was so disgusted at fashionable follies, was glad Mrs. Le-Vert was afflicted,[6] hoped it might be sanctified to her. So saintly was her talk. Mrs. James said she was *talked* about — that her affair with the *Methodist* preacher *Hilliard* was *notorious*. He converted her, prays with her, & finally stayed with her! & when I came home, I asked Mrs. Wasson about her, & she hesitated, but after I told her I had heard *something*, told me the same story — but added that Mrs. Hilliard hated this *woman* beyond — & that her baby was born too soon when she married Judge Mays.[7] Was there ever such a world.

Mr. Mallory said the folly of a man meddling with women's names. George Sanders had denounced Mrs. Linn Boyd[8] in his newspaper. When Mr. Buchanan nominated him for a high office, all was well — *but* some man got up & read in the Senate the piece he published against Mr. Boyd, & immediately they refused to confirm him. That was crime enough, to drag a woman's name before the public. The age of chivalry is not over!

Mrs. James & I picked up Frank Campbell who was looking better, but with a green thing in his button hole given him by a young lady. The villain — & he engaged in Charleston. "Men are deceivers ever."

> Now all is done that men could do,
> And all is done in vain,
> My love, my native land, adieu,
> For I must cross the main, my dear,
> For I must cross the main.
>
> He turned him right & round again,
> Upon the Irish shore,
> He gave his bridle reins a shake,
> Said adieu for ever more, my dear,
> Adieu for ever more.
>
> The Soldier fraie the war returns,
> The sailor fraie the main,
> But I have parted from my love,
> Never to meet again, my dear,
> Never to meet again.
>
> When day is gone & night is come,
> And a' folk bound to sleep,
> I'll think on him that's far away

6. Her "affliction" was the recent death of her mother and the illnesses of her father and husband.
7. Mrs. (Bedell) Hilliard, the wife of Henry Washington Hilliard. The woman suspected of having an affair with him was Eliza Ann (Glascock) Mays, whom Hilliard later married.
8. Anna (Dixon) Boyd, wife of former U.S. congressman from Ky., Linn Boyd.

The lee lang night & weep my dear,
The lee lang night & weep.
Scotch Ballad

[*March 8, 1861*]

Today got up late & was quite late at church. Walked home with Mrs. Elmore, had a pleasant chat with her until twelve. She spoke so affectionately of Kitty Boykin & Edward.[9] A Mrs. Bugby came & Miss Benson, nieces of Judge Campbell, who say *Lay* has positively resigned & Judge Campbell![1] Mr. Bugby says the reconstructionists[2] are busy in the Convention. Mrs. Elmore said she was afraid to meet me, she heard so much of the charming Mrs. Chesnut. Wonderful! I am interrupted by a beautiful bouquet from Mrs. Bell.

I wanted Mr. Chesnut to tell Gov. Cobb that we saw him playing "Romeo & Juliet" on the balcony — but he would not.

Yesterday I met Mr. DeSaussure['s][3] run away William. He dodged into a shop — but I saw him peeping at me from behind the door. He looked old & weather beaten & the very expression of his face has changed for the worse. Interrupted by a call from Mrs. Mary Anne Taylor,[4] rolling her eyes *madly* & saying Jesse was in love with me & a world of nonsense. Then to my surprise, as his family hate me so, Eugene McCaa.[5] Abused Mr. Lyon[6] — & said we had every thing to fear from the reconstructionist[s] in Ala. Jere Clemens, Nick Davis & a Mr. Jemison[7] are the conspirators. Mrs. Taylor says Wirt Adams[8] was offered the Post Master Generalship in the place of Reagan[9] & he would not accept. Poor Mrs. Fitzpatrick wanted it so badly for the Governor.

9. Katherine Lang Boykin, MBC's second cousin, and her brother, Dr. Edward Mortimer Boykin, a Camden physician.
1. The resignation of John Archibald Campbell of Ala., an associate justice of the U.S. Supreme Court since 1853, was falsely reported in early March; he did not resign until April. George William Lay, son-in-law of Campbell, soon became a captain in the C.S.A.
2. Those who hoped that secession, by showing the North the necessity of compromise with the South, would bring sectional reconciliation.
3. Camden planter John McPherson DeSaussure.
4. Probably a sister-in-law of William Jesse Taylor.
5. A member of the Camden family of this name related by numerous marriages to the Chesnuts and Boykins.
6. Francis Strother Lyon, chairman of Ala.'s delegation to the 1860 Democratic convention at Charleston, where he withdrew along with the other Southern delegates.
7. Robert Jemison, Jr., of Tuscaloosa, Ala., a wealthy planter, member of the state legislature, and Unionist delegate to the state secessior convention.
8. William Wirt Adams, a former Miss. legislator who had been commissioner to La. to encourage that state's secession.
9. John Henninger Reagan was a Democratic congressman from 1857 to March 3, 1861, a delegate to the Texas secession convention, and a member of the Provisional Confederate Congress. He had twice refused the postmaster generalship before accepting it.

[*March 9, 1861*]

Last night Governor Moore carried me[1] into his room to see cartridge bags. Mr. C & I & several others. While there Judge Brooks[2] came, who used to live next us at Statesburg. Praised my father to such a degree. Said he had learned every thing from him. Said my brother (he was the merriest grig) staid with them two years — used to sit by him at a large bowl of bread & milk *giggling* & eating. Jolly times — & the happiest time of his life was when he danced at the dancing school with "pretty little Mary Miller." We would have had a delightful time but the Judge came in more disgusted than ever — & abused every body & every thing until I was wearied. Mr. Mallory came in when I was wearied out & I only remained with him a few moments.

Today Dr. Edward Boykin came, one of the friends of my young days. We had a pleasant talk & walk to the capitol. There Eugene McCaa joined us & pointed out the celebrities. Saw my old (childhood's years) friend Judge Brooks in the chair. Came home, discussed Charlotte,[3] the Dr.'s daughter. Told all the news I could muster of politics & Jessie James came. Had a nice drive & paid calls, rested until dinner. Mr. C & Mr. Hill & Mr. Chesnut & Dr. Boykin dined together. The Judge raved as usual against the corruptions. To day two ladies called who hoped the government might not be here — its influence was so *corrupting*.

After tea, Mr. [and] Mrs. Childs[4] were introduced to me. She was Mary Anderson, he an artillery officer. She had her head done up in an extraordinary fashion but was very pretty & very interesting. Sweet voice & manner — just from the Texan frontier, & in a real South Carolina rebellious spirit.

Dr. DeLeon called & gave me a miniature silver gondola he had bought in Venice & bored us to death. Dr. Boykin said he had been drinking because he repeated so every thing, over & over. Dr. Boykin seemed in a daze; he scarcely spoke. Mr. Mallory came in from a dinner at the Pavells' — inclined to be very merry & tell funny tales — but the Judge returned from the Congress & wanted Florida Land papers. Mr. Mallory said, "Do you think I am going to leave Mrs. Chesnut for *that*? I came in here to talk to her & be invigorated & exhilarated," but I knew better & fled from the room to leave the Judge fair play. Had a delightfully affectionate long letter from my husband's father — refreshing to find he likes me so well.

1. That is, "escorted" in Southern idiom.
2. Born in the Sumter Dist. of S.C., William McLin Brooks moved to Ala. in the 1830s and became a prominent attorney and judge.
3. Charlotte Boykin of Camden, a daughter of Dr. Edward Mortimer Boykin.
4. Mary Hooper (Anderson) Childs, sister of C.S.A. Gen. Richard Heron Anderson, was the wife of Northern-born Frederick Lynn Childs, who shortly became a captain in the C.S.A.

[*March 10, 1861*]

A.M. Today went to church. Sat with the Elmores. Took my husband with me. All seemed glad to see him & he was *bored*. Dined at table with the Judge, Mr. C & a man named Herndon. A tall individual came in with no hair on the top of his head & that below *plastered up* — in full uniform. From the laughter, found him in *full* masquerade; he had no right to a uniform. After dinner went into a room to see Mrs. Browne.[5] Mr. Browne & Mr. Clayton came in — discussed Montgomery.

Mrs. B says Washington was disgusted with the meanness of the Yankees. Mrs. Lincoln reduced every thing, told the superintendent at once to economize, for Mr. Lincoln was poor & they meant to save twelve thousand a year of his salary. Nice people to put there! The farewell to Mr. Buchanan much handsomer than the inauguration of Mr. Lincoln. Mrs. Gwin sheds tears — but won't come South. The Brownes delightful people. Mr. Hill gone — & most of the Georgians. Mr. Wright[6] dined with us to day — a politician & a *Methodist* parson. Thomas Cobb, who has passed for a *sabbatarian* because he advocated so violently the not running cars on Sunday, went off *to day* to attend a Georgia Convention. Consistency!

Wrote to Mother today.

[*March 11, 1861*]

Last night quite a party in the parlour: Reids,[7] Pages, &c, the Judge & the Governor. The latter told the story of John C. Calhoun letting all travellers stay at his house free of cost. He was very pious & had prayers. One traveller sat amusing himself while the family were at prayers & when Mr. Calhoun saw it, he said to the servant, "Saddle that man's horse; he shall go," & would take no excuse from the man, but put him out. I told the story of Abraham & the Angel, which old Franklin stole from Jeremy Taylor[8] & the Judge said, "*Aptly* quoted!" in approbation.

Abraham turned out a traveller for blaspheming the Lord. In the morning an angel came who said, "Where is the traveller who was with thee?" Abraham replied, "I sent him forth for blaspheming thy name," & the angel said, "Thus saith the Lord: Have I borne with this man this many years & could you not bear with him this one night?" Tolerance preached there & *sacred* rites of hospitality! Our brides were made to

5. The English-born wife of William Montague Browne.
6. Augustus Romaldus Wright of Ga., an ex-U.S. congressman and a delegate to the Provisional Congress.
7. Samuel Gersham Reid and Clara (Gerald) Reid of Montgomery.
8. Seventeenth-century English bishop and theological and devotional writer.

feel shockingly by a tale of the Judge's of a pair who quarrelled on a bridge & the man said, blubbering, "Nancy, take the baby; I will drown myself." But she said, "No, take the baby with you. I want none of your breed left!" What a tale.

Mr. Mallory came, & I said to him be seated — Florida land claims shall not prevent a little chat to night. The others soon left & the Judge stayed as usual — & had most of the talk, but Mr. Mallory told of the effect upon him of a beautiful woman in Washington who had a claim against Government. "Cato's a proper person to trust a love tale with," so I left him to his ill chosen confidante. He must have been intoxicated to have told such a tale either before me or the Judge — tho he said very little, his story might mean a quantity.

Mr. Chesnut making such a stamping over head, I knew his patience at my long stay was exhausted. We had a long discussion of the Divorce law — these women had studied it thoroughly. One especially seemed to have so exact a knowledge of its various provisions in every state, her husband seemed to dislike the suspicion such knowledge cast upon her. To day walked with Mrs. Browne to see Mrs. Scott[9] of California. Saw a beautiful woman at the Exchange with Mrs. Wall. Mrs. Scott is handsome too.

Was introduced to George Sanders & his daughter — the latter very agreeable but so little handsome that I could not be flattered that the gondola was given me because I was handsomer than Miss Sanders, for my "Superior pulchritude" as Dr. DeLeon phrased it. George Sanders said the news today was *pacific*, "the serpent Seward[1] being in the ascendant." We were amused at the Hypocrite Sanders talking so. They said Miss Lane[2] was privately married to Carlisle,[3] the man with those two fearful *Mothers* he takes every where with him. They said Miss Lane did not care so much for the three children as she did for the ogresses, his Mother & Mother in law. Mrs. Bowne & Mrs. Scott said Mr. Ledyard called on Mrs. Lincoln to request they would keep the present door keeper who has had the place since Jackson's time, the man having asked

9. Anne (Vivian) Scott of Ala. was the wife of Charles Lewis Scott, a Va.-born congressman from Calif. Early in March, Scott left Congress, went to Ala. with his wife, and enlisted as a private in the C.S.A.
1. William Henry Seward of N.Y., Lincoln's secretary of state.
2. Orphaned in 1841, Harriet Lane was raised by her uncle, James Buchanan. When he became secretary of state and then president, she presided over his household and reigned as a Washington fashion-setter.
3. Probably James Mandeville Carlisle, a prominent lawyer, Washington socialite, and intimate friend of James Buchanan. The rumor of marriage between him and Harriet Lane was untrue; Lane's first marriage was in 1866 to Baltimore banker Henry Elliot Johnston.

Mr. L to intercede for him. Mrs. Lincoln said no. She had brought her
help with her & required no more except perhaps a *girl*. She intended
to save at least twelve thousand a year out of Mr. Lincoln's salary. &
whenever Dr. Blake asks any thing about the Establishment, Mrs. Lin-
coln answers, *"Remember,* I shall not spend half the salary. We are poor;
we must save! So make your calculations." That money was given by
the people of the United States that their president should appear with
becoming dignity to his high position as their *chief* — & to steal the money
for her private purse is an *infamy.*

I find Mrs. Browne charming. She gave me her history & how she
defended Mr. Browne last summer from the attacks of his relations at
home, & how they laughed at her as a "Yankee girl" & her vain efforts
to prove to them that 'tho' this count[r]y was now *hers,* she scorned to
be called a Yankee. We stopped & saw another woman sold, & she did
not seem as much shocked as I am always.

Gave Mrs. Browne the beautiful bouquet Mrs. Mays sent me. For a
woman who thinks she knows a little, have I not made blunders. Mrs.
Goldthwaite finding fault with Isaac Hayne for opposing his daughter's
marriage, I said, "Surely you would not want him to be *delighted* at mar-
rying the son of a man in the asylum." It was one of those things like
first cousins marrying that might be borne but could not be sought. Lo
Mrs. G has her mother in the asylum. Then the Lafayette Borland
woman, who seemed a little quiet when I expatiated on the folly of a
woman's leaving her husband, she had left hers several years. Here after
I deal in generalities!

Mr. Chesnut hurt because Mr. Hill said he kept his own counsel. Mr.
C, thinking himself an open, frank, confiding person, asked me if he
was not. Truth required me to say that I knew no more what Mr. C
thought or felt on any subject now than I did twenty years ago. Some-
times I *feel* that we understand each other a little — then up goes the
Iron Wall once more. Not that for a moment he ever gives you the
impression of an *insincere* or even a cold person — *reticent* — & like the
Indian too proud to let the world know he feels.

I spoke to Mr. Mallory for John Rutledge[4] — & I must speak to the
President if I dare for Robert Rutledge. I saw the President to day but
my heart failed me. I read yesterday an account of the Inauguration
ball. Only three Washington families. The Parkers, Tylers, & Greens.
The Parkers were our *grocers* in Washington — & they were spoken of
as the *Elite* — poor Washington.[5] Mrs. Browne does not like my friend

4. A U.S. Navy lieutenant the month before, Rutledge was serving as a lieutenant of the
 S.C. navy and acting inspector general of the batteries at Charleston.
5. The families of George Parker, a grocer, and Samuel Tyler, a lawyer, were described
 by the New York *Herald* as among "the elite" of Washington society.

Smith Lee.[6] I shall find out what is the matter. Says Mary Garnett so lovely in black & Garnett so proud of her. Hemphill has come — bless his old dry bones. I wonder if he brings any news — Mrs. Clay's Gutta Percha Man.[7]

Mrs. Browne surprised me in regard to Mrs. Thompson — I mean Mr. & Mrs. Jaque, Secretary of the Interior. I fancy Mrs. T was so astonished at her position in the cabinet she could never be sufficiently grateful for it. What a coarse couple they were. I shall never forget her making me shudder when I first went to Washington, saying, "My son can't git shut of the chills." & she, then & there, covered with diamonds. [*One illegible word*] — there was in that correspondence between Mr. Buchanan & Mr. Thompson[8] evidently a point of *veracity*, each accusing the other of a false statement, & Mr. Browne of the *Constitution* was congéed by the President for asserting the truth of Mr. Thompson's side. Yet, after having been so treated, Mr. Thompson & his wife spent the evening & dined with the President the day before they left Washington. As much as acknowledging that the President was right in calling him a _____ .

Mrs. Browne said she was at Mrs. Thompson['s] & Mr. Thompson told her they were going to dine at the White House. Mrs. Browne said, "I am glad you have told me yourself, for if any other person had said so, I should have denounced it as a falsehood." Mrs. T said she felt so ashamed of it she hoped no one would hear of it but Miss Lane & Buchanan, knowing the light that fact would cast upon the controversy proclaimed it to every one.

What nonsense I write here — however, this journal is intended to be entirely *objective*. My subjective days are over. No more *silent* eating into my own heart — making my own misery when without these morbid phantasies I could be so happy ——

I was amused how they laughed at the man's story who did not know how to speak to Lord Morpeth.[9] Whether to say "My lord," "the Lord,"

6. Sydney Smith Lee, elder brother of Robert E. Lee, was in Washington, as chief of the U.S. Navy's Bureau of Coast Survey. When the Va. convention voted to secede in April, Lee resigned his commission, sold all his possessions, and began an undistinguished career in the C.S.N.

7. John Hemphill, former chief justice of the Texas supreme court and a U.S. senator, was a member of the Provisional Congress. "Gutta Percha" refers to Hemphill's physiognomy.

8. In Jan., after Buchanan ordered the *Star of the West* to supply Fort Sumter, former Miss. congressman Jacob Thompson resigned from the cabinet, claiming that the President had led him to believe that no such action would be taken. Buchanan, though he promptly accepted the resignation, insisted that the plan to supply Sumter had been made at an open cabinet meeting and that Thompson had been fully informed.

9. George William Frederick Howard, who was known by the courtesy title of Lord Morpeth before becoming seventh earl of Carlisle in 1848, traveled in the U.S. and Canada in 1842.

or "Oh Lord!" but ended after a half a dozen republican cocktails by slapping him on the back & saying "Moppy."

Mr. Chesnut says Stephen & Mattie have gone to Mobile without a word to me. Edward Boykin told him he met them on the boat. He did not tell me, but from being awake all night he seemed to say very little & be half asleep all the time.

I think this journal will be disadvantageous for me, for I spend the time now like a spider spinning my own entrails instead of reading as my habit was at all spare moments.

[*March 12, 1861*]

They say positively Fort Sumter is to be relieved.[1] Too good to be true. Yesterday at dinner Judge Withers told me Dr. Boykin's youngest child Amanda died last Thursday night. Poor fellow — what a shock. What a home he goes to. Several other of his children ill. I had a letter from David Williams.[2] Kate still ill — tho the letter was a fortnight old, still I feel miserable. I could not shake off the depression produced by these sad stories.

Mr. & Mrs. Browne dined with us & added very much to the pleasure of the dinner. Lincoln came through Baltimore locked up in Adam's express car! Noble entrance into the Government of a free people. Yesterday afternoon Miss Bethea[3] called to ask me to a party at her house & a Mrs. Molton & Miss Amos — the latter was covered with diamonds in a morning *dress*. Mrs. Browne told me a long story of what her brother in law, or rather a man who was engaged to her sister — but her sister died, Lord Southesk, said of jewelry in the morning. It is the only time she has mentioned a title in any of our conversations. At tea Mrs. Browne & I were under the care of Mr. Wright & he joked about widows & the stupid old style. I said, as Mrs. Jeff Davis once said to me, "If you could do no better when you were fresh & young, &c, you had better not want a chan[g]e no[w] you are old," & all such nonsense.

After tea the usual circle, Mr. Mallory by me, & going in to the philosophy of compliments. Knew Miss Sanders was over twenty then by the quick way she appropriated an implied compliment. Mrs. Browne told us what a wretch Mrs. Thistle of Mystic Hall had turned out to be. By the by, they do say George Sanders brought his daughter here to *protect* him — a woman is still a sacred thing in these parts. Mr. Mallory, Mr. Chesnut & Mr. Browne went to Davis reception. Mr. Chesnut came

1. MBC must have meant the fort would be evacuated.
2. David Rogerson Williams, Jr., JC's nephew and close friend, married MBC's sister Kate.
3. Eugenia (Bethea) Bethea, wife of Montgomery planter and politician Tristram B. Bethea.

home early, fearing being called on to speak. Said he left Miles to an-
swer for South Carolina. I told Mr. Browne I thought this aversion to
public speaking a promising sign for the young republic. Stephen &
Mattie came to day. She went with us to the capitol. Gov. Cobb put Mr.
Chesnut in the chair & came to us. We had a royal joke over the Romeo
& Juliet scene in the Balcony. How jolly he is. Mr. Smith & Mr. Mar-
shall came to speak to us, & Mr. Boyce[4] with his studied compliments.
We were soon turned out, to Cobb's great delight, & strolled home by
a number of pretty places. Mrs. Browne's cottage ornée with three
thousand a year — would that suffice me.

Mrs. Reid said naively, "I hate little Banks[5] because he nearly *whipped*
Mr. Reid." Every body laughed. She joined us in the hope the little trai-
tor would be hung. We saw George Sanders & Jere Clemens walking
apart for a traitorous talk to day.

Captain Ingraham *shirks* work. He won't go to Pensacola. I am so sorry.
The *Mercury* has come out with an explanation worse than the original
offence.

Every body persists in opening conversation by saying, "How do you
like Montgomery?" & I, hideous Hypocrite, answer, "charmed." Read-
ing *Edinburgh Review* all day, & seeing visitors. We may adjourn tomor-
row. The pay of the Congress scant, for fear the Hotel keepers may
demand it all.

Gov. Cobb spoke of the Judge in the highest terms. The Alabama
Convention sits to day upon the Constitution. I read that respectable
article last night.

If there be no war, how triumphant Mr. Chesnut will be — he is the
only man who has persisted from the first that this would be a *peaceful*
resolution.

Heaven grant it may prove so.

Mr. & Mrs. Scott of California called — how contradictory on all tales.
He says Lincoln is a good humoured fellow such as usually sit on shop
boxes & whittle sticks, & the rage for telling vulgar tales is only natural
to his class. We had a very animated discussion touching all the stirring
events of the hour, & among other things he said, "the purse strings
are the way to pull at a Yankee's heart." A sharp voice came from be-
hind him, saying, "The Yankees are no more close & stingy than the
Southerners *I know* — they are quite as good."

Poor Mr. Scott turned half aside in utter bewilderment & tried to [say]
some thing to excuse himself, which however was bad[l]y received, &

4. William Waters Boyce of Edgefield, S.C., an ex-U.S. congressman and a delegate to
the Montgomery convention.
5. A. D. Banks, the Washington correspondent for the Cincinnati *Enquirer*.

the vinegar faced, oily headed Yankee specimen *harangued* for several minutes. Mrs. S & I giggled. Mr. S & Mrs. B listened in polite silence. Finally the lady rose in a rage & walked with the stride of a tragedy queen out of the room — altogether a most comical scene. Such cattle had better go home. Of course, *now if I* persisted in staying North, I should expect to hear my country abused & not make a disturbance.

At dinner Hemphill gave me a shock. He asked me if I was related to Emily Boykin & Mattie & first told me such an atrocious slander I feared he alluded to that. Fortunately he only wanted to express his admiration.

The Judge has been tormenting a woman to play "doodle with out the Yankee." To day was one of his most *brilliant* displays; I have never heard him so happy. Mrs. Watson came to tell me her husband was made adjutant general, but *she* did not like it! Old women you are too silly — Mrs. Davis did not like her husband being made President.

Wright of Georgia stopped me in the parlour. How funny he is suddenly, so wonderfully civil when, 'tho' we have lived in the same house three weeks, I have never seen him until two days ago. Every body astonished at Wigfall — the *inevitable* Wigfall. George Sanders was heard to say by Mrs. Scott, "Oh, this is only a fuss got up by a mob in Carolina." Toombs asked him to show his passports — suspicious characters ought not to travel with out them. Last evening Jessie James & Frank Campbell came. The Judge came in & such a mad talk Jessie carried on with him.

Mr. Mallory as usual spent an hour in animated chat with the Judge & me. Mrs. Browne & Mr. Browne took me to tea. There Mr. Hemphill sat by me & tried to make me talk all the time of his marrying. Mr. B talked in an under tone with Jere Clemens. Mr. C went into a solitary parlour & sat alone. Mr. Browne & I threw open the folding doors & behold a couple — a tableau, a young lady reclining in the arms of a man. We laughed so at the unexpected sight, we could not close the doors. They proved to be a girl from boarding school & her *cousin* — he a married man. Poor thing, she thought it very fine, but he knew better & ought to have been ashamed of him self.

Mr. Browne told that the Alabama Convention would pass the Constitution today. No further news from Fort Sumter. The woman who attacked Mr. Scott so savagely is a Boston old maid & partly insane. Gov. Moore came & prated until I *yawned* myself out.

We may go home in two days. Mr. C gives me my choice to go to Conecuh now or when I come in May. I take the latter —— that I may come in May & that I may go & see Kate while he is at the Charleston

convention. Today went shopping, bought bonnet trimmings for Mattie & then trimmed her bonnet, bought a pile of New Music for Kate Withers. Came home, undressed & excused myself to several visitors. Reading Lever's *One of Them*[6]; disgusted already with his *exaggerated* Yankee. Mrs. Watson's children make so much noise, I cannot remain in my room in peace. She told me to day one of Missouri's virtues. She often took her baby, seven month[s] old, & was gone from breakfast until dark. Nice mother.

Mr. Browne told me a shabby story of Mr. Jacob Thompson. He wrote a letter to the President after the President had called him a *falsifier,* to say how distressed he was that any thing should have occurred in his conduct while in Mr. B's employ to displease him. *Servile* to the core. George Sanders says he has written to Douglas[7] that this is the *true* nation, to join us, & also says Pugh wants to join us. I should be so glad to see Mrs. Pugh beyond any of the others I met in that city of enchantments, Washington. I continue to make extracts from the newspapers. That little wretch Carry Watson is imitating the shouts & screams of a mob & a stump speaker, so I can remember nothing. *Smith Lee* wishes South Carolina blown out of water! — the horrid traitor! Blessed old Smith!

Dined with Browne, Withers, & Chesnut [who] talked unintelligible stuff about their secret session. Mr. Browne prides himself upon catching Sumner[8] in a forgery from Macaulay. Hemphill came in later & says news more warlike. Judge Brooks, President of the Convention, met me & gave a glorious account of the passage by the Convention of the Constitution of the Confederate States. Browne was talking last night of Miss Lily McAlister & Bergmans' marriage — she old, ugly, red haired, clever & an heiress, he handsome, worthless, young, with only twelve hundred dollars a year. She only lets him waltz with *her* — hangs on his arm all the time.

Browne says if ever a man earned his money, Bergmans does! Eats his bread Bible wise — or, as the Bible says.

The question is shall I go to Bethea's today or Ware's tomorrow night or maybe both, quien sabe? Mr. Marshall spoke of his domestic tragedies to the Judge. I asked the Judge if he did not suffer exceedingly in recalling such scenes, & he answered, "Yes, the torture of the damned." The Judge seemed to feel for him to the depths of his heart. Mattie

6. Charles James Lever, *One of Them* (1861).
7. Stephen A. Douglas, U.S. senator from Ill.
8. Charles Sumner, U.S. senator from Mass.

Miller busy shopping. Received a letter from Wm. Shannon asking a place for Sam,[9] & one from old Mr. Chesnut saying his wife is ill.

> Remember, besides, that in the world we live in, they who wreck character are not the calumnious, they are simply the idle — the men & women who, having nothing to do, do mischief.
>
> *One of Them*

[*March 14, 1861*]

I did *nuthin*. I staid at home. I had a delightful drive with Mrs. Reid in her coupé, & came home in fine glee for the party, but really had no one to go with me. Mr. C refused out right. Mr. Mallory had an engagement with the President, &c. However I had a pleasant evening — except a feeling of irritation all the time against Mr. Chesnut for being so selfish — or was I selfish? To day Mr. C left me alone with a red headed man at the table who tried to enter in a conversation, but I was short, sharp, & decisive — & the thing dropped. I wonder what Mrs. Fits thinks of me.

Hemphill was worse last night than usual — stupider, & Mr. Mallory *funnier*. His imitations of Holt in love, as an old Pelican slightly ill from eating too much fish, was exquisite — but I did not like to stay. Mr. C prefers to sleep twelve hours & so I could not venture to keep him awake.

Found Mattie was going to keep me company, so proposed a walk. Went to the Jesse Taylors. Such a scene, Mary Anne vowing she had a frightful scene with Rosa, & Rosa answering she was a lone woman, no husband, &c, but wishing God might strike her dead if she said otherwise, &c, &c. Got off, promised to go back Friday night but must excuse myself as we go home on Saturday to C, as Aunt Charlotte[1] comes to night. Tonight I shall go with Mr. & Mrs. Browne. Mr. Chesnut persists in not going. Poor Mattie, poor Mattie! each heart knoweth its own bitterness.

Dined with Governor Moore & the Judge renewed his acquaintanc[e] with the cloudy bottoms, &c. Wrote to Susan Rutledge[2] & Louisa Hamilton about the applications in the Navy. Must give Mr. Mallory a talk to give them a *good* thing. Read *One of Them,* but so many tiresome interruptions. The Taylors say the Harrisons are not comme il faut. That was plain enough. Poor Mr. [*illegible name underlined*] is shocking, but who is not? Congress adjourns tomorrow. No news by the telegraph. Mr. C said in Charleston in January that Fort Sumter would fall into

9. William McCreight Shannon and his brother Samuel Davis Shannon. Both served in the Kirkwood Rangers, and Sam became an aide to Gen. Richard Heron Anderson.
1. Charlotte (Boykin) Taylor, wife of James Madison Taylor. "C" refers to Camden.
2. Susan Rose Rutledge, sister of Robert Smith Rutledge.

their laps like a ripe pear — & they were furious! Suppose it happens.
I pray it may. Tomorrow I must pay calls & *pack* — that fearful work.

[*March 15, 1861*]

Walked to see Mrs. Bethea with Mr. Chesnut who, however, rushed
home & left me at the door. Met the Jesse Taylors on the way home &
Mr. C did not find Rosa as absurd as he expected. Saw nothing the matter
with her legs, 'tho' he told me they did so comically from a weakness in
them. Went to the party with the Brownes. At first we stood alone &
were gazed at — not pinched, as the Prince. I know my dress was the
prettiest in the room. Then we saw Mr. Clayton, & the remark was made,
"What a *party*, when we are glad to see Mr. Clayton!"

Then Mr. Curry walked off with Mrs. Browne. Mr. B & I had a good
time. All sorts of stupid people came to interrupt us. Woods, Cobbs,
Winston Hunter, &c. The latter said, "My chil*dan* will go with me. They
say, 'I will go with Pappy — he never hit me a lick in his life,' " &c, then
he referred to his having been once in love with me, but the men said,
"Never, Never such as he." I went of[f] with Mr. Clayton, & Major Deas
joined me. We remained together all the time afterwards. He is vastly
pleasant. Mr. Hilliard, the Jesuit, came & said a female friend had said
he must know me — Mrs. Mays! O Tempora, O Mores! The old ladies
are all so afraid of corrupting — in a place where I have *seen* & heard
so much! It can't be injured.

Mrs. Elsbury & her wedding finery seemed so strange. She was so
stern & hard & large & strong! & such fribble & light stuff for clothes.
She never spoke, but only calmly unhitched herself when she was caught
on every side by the tags of her drapery.

General Waul[3] raved of my father. Mr. Hilliard knew him very well
& praised him.

The cry last night was war! George Deas in a glee — in three weeks
we would be in Washington, &c. To day Halcott Green[4] says no truth
in the report, & Mr. Mallory says the ships named are not the kind to
drop into Charleston harbour. He thinks they are ordered to Texas.

To day I called with Mrs. Browne on the Wares. Saw a plain, middle
aged bride there to see Mrs. Brooks,[5] but she had gone there. The driver
did not know where the people lived. Adjourned to the Jesse Taylors,

3. Thomas Neville Waul, member of the Provisional Confederate Congress from Texas.
 It is not clear why MBC calls Waul "General" at this time.
4. Halcott Pride Green of Columbia, S.C., helped his mother, Mrs. Allen J. Green, Sr.,
 run the family plantations. His wife, Virginia (Taylor) Green, was the daughter of Sally
 Webb (Coles) Taylor and thus a distant relation of JC, Jr.
5. Ann (Terrell) Brooks, whose husband, William McLin Brooks, presided over the Ala.
 seceding convention.

where the old lady preached, & Rosa stopped it by saying she came in & heard Mr. Marshall reading *Don Juan* to her. Aunt Charlotte agreed with me Montgomery could not be *corrupted*.

Edward Taylor left a card. I dare say he was ashamed of himself. If he only knew how utterly I have lost faith in humanity, he need not trouble himself. Had a race with Jessie James because I say her husband is a *Myth!* I never see him. I want to tell Mrs. Browne that the effect upon me last night was not unlike the impression made by my first visits to Washington. The people, I thought one mass of vulgarity & finery & horror. How differently I felt when I had been there long enough to separate the wheat from the tares.

Beau Brummell.

Mr. Mallory & Gov. Moore, &c.

Mr. Browne really undertook to tell me who Beau Brummell was, & told a story of the Beau when he was invited to dine in the city, saying he would do so with pleasure but would they tell him where he was to change horses! Mr. Mallory this last night was so evidently entertaining with his recitations from *Ingoldsby Legends & Rejected Addresses* & even *Dr. Syntax*[6]: "As sparks are prone to upwards fly, so man is born to misery!" &c, &c, I think old Governor Moore was jealous. He said quite pettishly that he must take lessons in the art of pleasing from Mr. M. Poor Mrs. Browne. How she hated my coming — actually shed tears. ⟨⟨I can make any body love me if I choose. I would get tired of it. Mr. B too. How excessively complimentary he was that night at the party,⟩⟩ & so nicely done any woman might have been proud of my three attendants that night, ⟨⟨Goodwyn, Browne, & Hilliard!!! Wonderful.⟩⟩

Poor Mattie loves me best yet. Aunt Charlotte & Jessie came to say good bye, but I was worn out mind & body, ⟨⟨my poor heart crushed out⟩⟩.

[*March 17, 1861*]

⟨⟨I got up nearly frantic with all my own thoughts after that one glimpse of certain misery, hoping nothing, believing nothing that *this world* can now bring! Fearing all.⟩⟩ I dare say those Floyd people thought me sadly ungrateful. Hemphill escorted me to the cars & I made an effort to talk to him & begged him to be kind to Mrs. Browne. I told all those women

6. *The Ingoldsby Legends: or, Mirth and Marvels,* a popular collection of comic tales by Anglican priest Richard Harris Barham, appeared in three different versions in the 1840s. *Rejected Addresses; or the New Theatrum Poetarum* (1812), parodies of such poets as Wordsworth and Coleridge, was written by James Smith in collaboration with his brother Horace (or Horatio) Smith, a London businessman and author. In English satirist William Combe's *The Tour of Dr. Syntax in Search of the Picturesque* (1812), Canto 21, Dr. Syntax preaches a sermon using Job 5:7 as his text.

she had lost three children. I knew that would be of service to her. Every body (women I mean) despise a childless old woman. In the gall of bitterness once more. The Trail of the Serpent is over it all.

[*March 18, 1861*]

Yesterday on the cars we had a mad woman raving at being separated from her daughter. It excited me so, I quickly took opium, & *that* I kept up. It enables me to retain every particle of mind or sense or brains I ever have, & so quiets my nerves that I can calmly reason & take rational views of things otherwise maddening. Then a *drunken* preacher began to console a "bereaved widow." He quoted more fluently scripture than I ever have heard it — the beast! My book *(after* the opiate) I read diligently. He misses in attempting to describe Yankee character after an elaborate trial, & his women are detestable failures. Still, it made the time *glide* rapidly for me. Here I am for Sunday ⟨⟨& have refused to accept overtures for peace & forgiveness. After my stormy youth, I did so hope for peace & tranquil domestic happiness. There is none for me in this world. "The peace this world⟩⟩ cannot give, which passeth all understanding."

Today the papers say peace again. Yesterday the *Telegraph* & the *Herald* were warlike to a frightful degree. I have just read that Pugh is coming down South — another woman who loved me, & I treated her so badly at first. I have written to Kate that I will go to her if she wants me — dear, dear sister. I wonder if other women shed as bitter tears as I. They *scald* my cheeks & blister my heart. Yet Edward Boykin "wondered & marvelled at my elasticity. Was I always so bright & happy, did ever woman possess such a disposition, life was one continued festival," &c, &c, & Bonham last winter *shortly* said, "it was a *bore* to see any one always in a good humour." [*Following sentence written over unrecoverable erasure:*] Much they know of me — or my power to hide trouble.

> This is full of strange vicissitudes, & in nothing more remarkably than the way people are reconciled, ignore the past, & start afresh in life, to incur more disagreements, & set to bickering again.
>
> *One of Them.*

This long dreary Sunday in Augusta. If I can, I will try to forget it forever.

Mr. Wright traveled with us. I found him quite pleasant. He is a *preacher* & a politician, & he was travelling Sunday, too. Last night at Atlanta I did not leave the cars. The Hotel, it seems, is kept by a Dr. Thompson who married an old school friend of mine, Elizabeth Briggs, & he came down & seemed offended that I did not go up to his house.

I was amused. Said Elizabeth was his *present* wife. Whether he had had several before or meant to have several afterwards, I do not know.

I am afraid Mr. C will not please the democracy. He said aloud in the cars he wished we could have separate coaches like the English & get away from those whiskey drinking, tobacca chewing rascals & *rabble.* I was scared somebody might have taken it up, & now every body is armed. The night before we left Montgomery, a man was shot in the street for a trifle, & Mr. Browne expressed his English horror, but was answered — it was only a cropping out of the right temper! The Lord have mercy on our devoted land.

Mrs. Mary Anne Taylor continued her good offices to the last. Sent me a tray of good things to travel on.

I wonder if it be a sin to think slavery a curse to any land. Sumner said not one word of this hated institution which is not true. Men & women are punished when their masters & mistresses are brutes & not when they do wrong — & then we live surrounded by prostitutes. An abandoned woman is sent out of any decent house elsewhere. Who thinks any worse of a Negro or Mulatto woman for being a thing we can't name.[7] God forgive *us*, but ours is a *monstrous* system & wrong & iniquity. Perhaps the rest of the world is as bad. This *only* I see: like the patriarchs of old our men live all in one house with their wives & their concubines, & the Mulattoes one sees in every family exactly resemble the white children — & every lady tells you who is the father of all the Mulatto children in every body's household, but those in her own, she seems to think drop from the clouds or pretends so to think[8] —— Good women we have, *but* they talk of all *nastiness* — tho they never do wrong, they talk day & night of ⟨⟨*six unrecoverable words, apparently a quote*⟩⟩. My disgust sometimes is boiling over — but they are, I believe, in conduct the purest women God ever made. Thank God for my country women — alas for the men! No worse than men every where, but the lower their mistresses, the more degraded they must be.

My mother in law told me when I was first married not to send my female servants in the street on errands. They were there tempted, led astray — & then she said placidly, "So they told *me* when I came here — & I was very particular, *but you see with what* result." Mr. Harris said it was so patriarchal. So it is — flocks & herds & slaves — & wife Leah does not suffice. Rachel must be *added*, if not *married*.[9] & all the time they

7. The phrase "a thing we can't name" was written over an unrecoverable erasure.
8. The part of this sentence beginning "father of all" and ending with "pretends so to think" is also written by MBC over an unrecoverable erasure.
9. In Genesis 29–30, Jacob, unhappy with his wife Leah, also marries her sister Rachel. He has children by both women and by their handmaidens as well. MBC apparently believed old Mr. Chesnut had children by a slave whom she calls "Rachel" (p. 82). She shows no such suspicions of her husband.

seem to think themselves patterns — models of husbands & fathers.

Mrs. Davis told me "every body described my husband's father as an odd character — a Millionaire who did nothing for his son whatever, left him to struggle with poverty," &c. I replied, "Mr. Chesnut Senior thinks himself the best of fathers — & his son thinks likewise. I have nothing to say — but it is true, he has no money but what he makes as a lawyer," &c. Again I say, my countrywomen are as pure as angels — tho surrounded by another race who are — the social evil!

[*March 19, 1861*]

Arrived at home, found the carriage waiting for us. All hands glad to see us.

Slept & bathed & eat & talked. Heard Kate was better & hope to be spared the journey to Florida. Hope renewed that the Fort may be given up.

19th Really ill with backache & neuralgia of the face. Breakfasted in my room — pure white house linen, cream in coffee, & good coffee, *luxuries* when one comes out of a *den* of abominations such as we have lived in at Montgomery Hall. Make a list of the people I owe calls to in Montgomery.[1]

The snow a foot deep now after a winter like May & June. What a climate.

[*March 20, 1861*]

Yesterday all day Mr. C was riding like mad to prevent a duel between Wm. Shannon, one of the best & purest men that ever lived — good husband, good father, good master, good friend, good citizen[2] — with a ⟨troublesome upstart⟩ man named Leitner[3] who had insulted & struck Wm. Shannon on a Negro trial,[4] Wm. Shannon defending the poor negro, the ⟨other wretch⟩ prosecuting. Blair[5] is Wm. Shannon's second, Cuty Goodwyn,[6] Leitner's. Joe Kershaw, Dr. Boykin & others

1. Omitted is MBC's list of fifteen women to whom she owed calls in Montgomery, among them: the wife of Confederate congressman William Lowndes Yancey and the wives of several leading members of Montgomery's planting and professional classes.
2. Here MBC later added a question mark in pencil, presumably sometime after 1863. By the end of the war, she had come to disapprove of Shannon heartily, at least in part because he avoided military service and profited as a banker. Saved from this duel, Shannon died July 5, 1880, in a much-publicized duel, reputedly the last fought in S.C.
3. William Zacariah Leitner, first lieutenant in the Second S.C. Volunteers.
4. Washington, a slave charged with attempting to raise a slave insurrection, was sentenced to hang. It is curious that MBC does not mention the nature of the trial here.
5. L. W. Rochelle Blair, a captain in the C.S.A., had been defended by JC against a murder charge in 1853.
6. Artemas Darby Goodwyn of Richland Dist., adjutant of the Second S.C. Regiment.

are trying to make it up. I wonder the sheriff did not arrest the parties. Mr. C *wondered* why Judge Withers did not arrest the parties — so I wrote John[7] a note at once to go & tell the Judge & not to let Mr. C know any thing about it.

Made a mistake & blistered myself so with chloroform ointment I can scarcely stand or walk. Still nothing can divert me from thinking of the folly of a man like Wm. Shannon getting himself shot — with a wife & the children dependent on him. To day at eleven is the time appointed for the meeting. I hope John & the Judge will be in time. John is a good creature — put two half negroes in jail for selling whiskey to his negroes & stealing his corn. Went to the jail & saw how wretched they looked lying on the bare floor, his heart failed him — ended by giving them five dollars & a pair of shoes to *run away* from justice. Had a delightful long letter from Susan Rutledge. She had been to see the Kirkpatricks & Frosts[8] & old Mr. Williams.[9] None of them had heard Kate was ill.

[*March 21, 1861*]

Dined yesterday at Judge's. Made himself eminently disagreeable. Abusing every thing & every body. Came back & in Camden had a tooth pulled — home miserable with pain — found Mrs. Reynolds[1] who told me Kitty Boykin[2] is engaged to Mr. Savage Heyward, a man twice married & ten children. I do not believe it. Talked all night — *exhausted.* & nervous & miserable today — raked up & dilated & harrowed up the bitterness of twenty long years — all to no purpose. This bitter world.

Downstairs is my attached nephew James Chesnut who has named his son John McCaa.[3]

Mrs. Chesnut was bragging *to me* with exquisite taste — me a childless wretch, of her twenty seven grandchildren, & Col. Chesnut, a man who rarely wounds me, said to her, "*You* have not been a *useless* woman in

7. John Chesnut, IV, an 1858 graduate of S.C. College, was the son of JC's elder brother, John Chesnut, III, deceased. The fourth John Chesnut was the favorite in-law of MBC; she usually calls him "Johnny," "John C," or "the Captain."
8. The family of J. L. Kirkpatrick, a Presbyterian minister in Charleston, and the family of Edward Frost of Charleston. Frost was a former circuit court judge, president of the Blue Ridge Railroad, and secretary of the treasury in the S.C. Executive Council.
9. John Nicholas Williams of Society Hill, S.C., Kate Williams' father-in-law.
1. Mary Cox (Chesnut) Reynolds, widow of Dr. George Reynolds, was the sister of James Chesnut, Jr.
2. Katherine Lang Boykin, MBC's second cousin and the sister of Dr. Edward M. Boykin, would shortly marry Thomas Savage Heyward, a Charleston commission merchant and grandson of a signer of the Declaration of Independence. At the time, eight of Heyward's twelve children by his first wife were alive.
3. James Chesnut, IV, the older son of JC's brother, John Chesnut, III, was married to MBC's first cousin, Amelia (McCaa) Chesnut.

this world" because she had so many children. & what of me! God help me — no good have I done — to myself or any one else — with the [power] I boast so of — the power to make myself loved. Where am I now. Where are my friends. I am allowed to have none. *(He did not count his children!!)*[4]

> Happy is he who heareth
> The signal of his release
> In the bells of the Holy City
> The chimes of eternal peace!
> Whittier[5]

[*March 22, 1861*]

> Every man that striveth for the mastery is temperate in all things; now they do it to obtain a corruptible crown, but we are incorruptible.
> Corinthians[6]

Last night the Reynolds girls[7] were here. I shocked them I dare say with my Montgomery tales. Mr. & Mrs. Henry DeSaussure[8] dined here — both silly & affected.

Kitty Boykin to be married on the 10th of April to Mr. Savage Heyward. The ways of this world are never to be divined. No body understands the under current of unseen motives — I wish you all happiness my old friend, tho we have been *un*friends for so long. Received a long letter from Jack Hamilton[9] in answer to one from me to his wife. I wonder if Sue King's[1] story be true — & she can not read & write! She is a dear little thing all the same. Much good the reading & writing have done me.

[*March 23, 1861*]

Well — after breakfast yesterday I went up in John's buggy to Kirkwood[2] — passed Dr. B, & forgetting he had lost a child since I saw

4. Presumably a reference to those MBC believed Col. Chesnut fathered upon a slave woman.
5. Omitted here are two stanzas of "The Red River Voyageur" by John Greenleaf Whittier, the last stanza of which we do include. Also omitted here, following the Whittier, are two brief and apparently irrelevant quotes, one about Maurice of Nassau and one about Henry of Navarre from John Lothrop Motley, *The Rise of the Dutch Republic*, Vol. I.
6. I Corinthians 9:25.
7. Mary (Cox) Reynolds had four daughters, nieces of JC.
8. John McPherson DeSaussure's son, Henry William DeSaussure, and his wife, Mary (Reynolds) DeSaussure, a daughter of Mary (Chesnut) Reynolds and a niece of JC.
9. John Randolph Hamilton.
1. Susan (Petigru) King, daughter of James L. Petigru and a classmate of MBC at Madame Talvande's school. Her husband Henry was a lawyer.
2. A fashionable suburb of Camden.

him last, bowed to him, all smiles, thinking only of Kitty & her engagement — & I got a grave touch of the hat. The Judge was more intolerable than ever. Kate let slip that he said Mr. Barnwell was the only honest man in our delegation — how sad when disappointed vanity will so ruin a man. I have never seen a man so utterly his own enemy.

I think I answered *him* several times very much to the purpose — but I am sorry for it. Mr. Chesnut is such a friend as he will never have again. Yet he has evidently been belittling him to Aunt Betsey & Mary.[3] Mary's letter says Kate Williams is well — joyful news. Coming home, John told me Mary Hammy[4] snubs him because she thinks him engaged to Kate Withers & Aunt Charlotte is the busy body who started that tale. Read Lord Dundonald[5] — at first so charmed till the shock came — a man must not *cheat* — & expect to be a hero.

To day very ill with my blister — & all sorts of things. Miss McEwen sent word by Munroe to Aunt Betsey that her father was behaving shamefully — disgracing them.[6] Two months ago they gave him some brandy when he was ill — & he has never been sober since — had not tasted brandy for 14 years — but could not resist the first taste. A queer tale to tell on one's own father ——

[*March 24, 1861*]

Sunday in spite of my wounds & bruises I went to church. Mr. C went also. Was stirred to the depths of my soul by Mr. Hanckel.[7] Dined at the Judge's who was as paradox[ic]al, &c, as usual. Came home, had a little confidential chat with John — who evidently don't know his own mind. Aunt B & Kate wanted the latter to go with me but I did not press it. Some how I am not so fond of responsibility as of old. Uncle H[8] to go with us to day. I wrote a note to K. B. & sent her a pattern

3. Elizabeth (Boykin) Withers, the wife of Thomas Jefferson Withers, and their daughter Mary (Withers) Kirkland, MBC's first cousin and wife of the planter, William Lennox Kirkland.

4. Mary Whitaker Boykin, the daughter of Alexander Hamilton Boykin and Sarah (DeSaussure) Boykin, was MBC's first cousin. MBC probably attached "Hammy" to Mary's name to distinguish her from similarly named members of the Chesnut and Boykin families. The "John" referred to is MBC's nephew, John Chesnut.

5. Thomas Cochrane, tenth earl of Dundonald, *The Autobiography of a Seaman* (1860–61). Dundonald was a British naval hero accused of involvement in a stock exchange fraud in 1814.

6. Dinah "Denie" McEwen and Susan (McEwen) Tweed ran a Camden milinery shop. Their father was James McEwen, an 83-year-old Scots-born merchant. Munroe was the Withers' coachman.

7. James Stewart Hanckel, a professor at the Episcopal Seminary in Camden.

8. Alexander Hamilton Boykin of Kershaw Dist. was MBC's "Uncle Hamilton" even though he was only eight years older than she. A member of the S.C. senate, Boykin owned 193 slaves and other property valued at $296,000 in 1860.

chemise — got an answer that she always regarded me as her dearest friend — which quite surprised me. We have seen so little of each other of late.

[*March 25, 1861*]

To day, forlorn & weak & miserable, I am slowly packing to be off to Town.[9] Betsy helping. So good she is. Yesterday all my household servants came to see me. They evinced such affection — & the earnestness with which they begged me to come home & stay there I am sure is disinterested.

[*March 26, 1861*]

Came down on the cars yesterday with an immense crowd. John Manning asked me to save him a seat by me for a young lady. The young lady proved himself. He told me by way of warning that hereafter all elections in this state would be unexpected. The state was cut up into cliques which were very polite to each other but would let none but themselves be elected. Found every thing in confusion here — a violent party opposing the Constitution.

The old story; the outs want to be in — Gen. Adams[1] among the worst. Mrs. Adams very friendly. Saw at dinner.

We have a round table together — Mr. Langdon Cheves,[2] Mr. Trescot, the Judge & Mr. C. Mr. Trescot was too smart for me — it was a lively time. Drove on that beautiful battery with Susan Rutledge. Am to walk there this afternoon with Robert Rutledge. So many nice people — & beautiful equipages & fine horses. If I ever came here in Spring must bring the carriage. Louisa Hamilton took me shopping. Then to Quinby's, bought 2 dozen of cartes de visite of all the celebrities. Hartstene[3] was introduced to me yesterday. I must have made a favorable impression. Sent me a beautiful bouquet in the evening — & called at night & we walked up & down the passage & talked an hour. He spoiled all by telling me I reminded him of Mrs. LeVert. To day —

9. Charleston.
1. James Hopkins Adams, a wealthy Richland Dist. planter, was governor of S.C. from 1854 to 1856, a brigadier general in the state militia, and a member of the secession convention. His wife was Jane Margaret (Scott) Adams.
2. Langdon Cheves, Jr., son of the former Speaker of the U.S. House of Representatives and president of the U.S. Bank, was a planter and delegate to the S.C. secession convention from St. Peter's Parish.
3. Henry Julius Hartstene, a commander of the C.S.N. and an aide to Beauregard charged with guarding the defenses to Charleston Harbor. As an officer of the U.S. Navy, Hartstene had been honored by Queen Victoria in 1856 for delivering the lost Arctic discovery ship *Resolute* to England. MBC spelled his name "Hartstein," as it was spelled in a clipping of hers about Hartstene's reception.

breakfast with John Manning & Edward Noble. Gen. Means[4] then called & afterwards Robert Rutledge. The latter said Captain Ingraham was a humbug! News to me who like him so much. Went to Russell's yesterday & got two *Cornhill's* — but feel too stupid to read any thing. Some thing wrong in the atmosphere here for me — it enervates & destroys me.

Mr. Robert Gourdin[5] sent me the most glorious bunch of roses I have ever beheld — with a note & compliments. A nice discriminating place Charleston is!!! I am to have my carte de visite made.

Saw Mrs. Sumonton yesterday; her husband has been on the Island since December. Said a week ago she went on the Island & he begged her to stay — but she said she had no night clothes but to be with him she did not mind that. So she stayed two nights & tied her petticoats round her neck. & she carried him some flannel drawer[s] which [she] thought would be a mile too wide — but as he dressed he showed them to her. They fit exactly, he had fattened so. Wonderfully delicate subjects to make the staple of discourse to a woman she had only a moment before been introduced to!!

> Yesterday is gone. Yes — but very well remembered; & we think of it the more now we know tomorrow is not going to bring us much.
>
> Thackeray

[*March 28, 1861*]

Yesterday dined with Trescot & the Judge, &c. Merry as usual — the men raving of Mrs. Joe Heyward[6] who smiled back amiably. Went to walk with Robert Rutledge — but received orders that I was not to walk any more with men on the battery. Is not all this too ridiculous at my time of life.

Drove home with Susan Rutledge. Met on the battery Inglesby[7] — who Robert R pronounced a snob — grandfather was a tailor. Found the cards of Susan Alston & her brother.[8] Then sat with Mrs. Adams.

4. John Hugh Means, a prosperous Fairfield Dist. planter and governor of S.C. from 1850 to 1852, was a delegate to the S.C. secession convention and colonel of the Seventeenth S.C. Regiment.
5. Robert Newman Gourdin of Charleston was a lawyer, merchant, and delegate to the S.C. secession convention.
6. Maria Henrietta (Magruder) Heyward was the Virginia-born wife of Joseph Heyward, the son of a Colleton Dist., S.C., rice planter.
7. Probably Charles H. Inglesby, a prominent Charleston lawyer.
8. Susan Elizabeth and Thomas Pinckney Alston, a member of the First Regiment of S.C. Volunteers stationed in Charleston.

Took tea with Trescot & Dr. Gibbes.[9] The latter told a silly tale & Trescot made faces.

Mr. C made a speech which is badly reported — he never takes the trouble to look over his speeches. Miles called but the Frasier Mattheweses came at the same time & so we had no conversation. Mrs. James Robinson came & I saw some people I knew named Jeter. Spoke to Mr. Drayton, breakfasted with Baxter Springs[1] & Mr. Manning. The latter dressed to have his picture taken.

Made Mr. C dress & go with me — had his taken. Bought an album. Gen. Means gave me his. Met at the artist's rooms Hal Frasier & his sister, Mrs. Frederick Frasier, Mr. Manning & Gen. Simons.[2] Mr. M promised me his likeness. Saw there also Miss Susan Alston & her brother. Sally Rutledge walked up with me — & I met Mrs. Keitt,[3] so affected & absurdly dressed.

Came home. Warren Adams,[4] a nice boy, brought my things. Am spending too much — must haul in. Sally Rutledge came & the Pringle girls. The latter said they were jealous of me last winter — Edward stayed so long in Washington.[5] Then Mama wants to see me so badly — but she does not visit. I am to go one day next week with Sally Rutledge to visit Drayton Hall & dine on my way home at Runnymeade, the Pringle place.[6]

Dr. Gibbes says things are in a snarl. This war began a War of Secession. It will end a War for the Succession of Places. Met Dr. Smith[7] — says Kate is getting well.

[*March 29, 1861*]

Dined yesterday with Mr. Cheves — he is so nice & polite & agreeable. After dinner, Mr. Chesnut made himself eminently absurd by ac-

9. Robert Wilson Gibbes of Columbia, a physician of national reputation, was also a writer, former mayor of Columbia, owner of the *Columbia Daily South Carolinian* and the *Weekly Banner*, and an ornithologist. During the war, he served as surgeon general of S.C.
1. Thomas Fenwick Drayton, a Beaufort (S.C.) Dist. planter and former U.S. Army officer, named a brigadier general on Sept. 28, 1861. Andrew Baxter Springs represented York Dist. in the S.C. secession convention.
2. Brig. Gen. James Simons, soon to take command of S.C. troops on Morris Island.
3. Sarah Henrietta Rutledge was the daughter of Frederick Rutledge, a physician and planter of Charleston. Susanna (Sparks) Keitt was the wife of Laurence M. Keitt.
4. Son of former S.C. governor James Hopkins Adams.
5. Rebecca, Susan, and Edward Jenkins Pringle were the children of planter William Bull Pringle of Charleston and Georgetown Dist. Edward, a San Francisco lawyer, had stayed with the Chesnuts in Washington during the winter of 1859–60.
6. Drayton Hall (still standing) was the home of Thomas Drayton at his plantation on the Ashley River, and Runnymeade stood on William Bull Pringle's plantation.
7. Thomas Smith, a large slaveowner and physician in Society Hill.

cusing me of flirting with John Manning, &c. I could only laugh — too funny! Judge Whitner called — & then the Capers — & then Mr. & Mrs. Isaac Hayne — & then Tom Frost[8] — & then the Rutledges came for me to go to drive on the battery & then I took tea there & Robert brought me home. Yesterday was one of the pleasantest days of my life.

When I came home at eleven I met William Haskell.[9] So glad to see me. The pale, thin student of last summer a stout, robust young soldier — camping out for three months has worked wonders. Went to church with Mrs. Capers, then drove to Magnolia Cemetery with Mrs. Tom Middleton[1] & Mrs. C. Saw the VanderHorst tomb.[2] Dreadful. & saw William Taber's broken column.[3]

Came home exhausted — & found my side more inflamed than ever. What shall I do. Got my carte de visite. Mr. Chesnut very good — mine like a washer woman.

Yesterday morning had a long talk with Sam S & showed great diplomacy in putting him off from a visit to Mary K.[4] In the afternoon walked to see Mrs. Izard[5] — but she had been to see me in the morning & wanted to take me driving with her.

Came home with the worst attack of the blues from that grave yard business in the morning — fortunately Mrs. Adams came in & made me get up & dress. Dr. Smith called & gave me glycerine for my blister. Gov. Adams liked my calling him Marshal Pelissier.[6] Mr. Hayne &

8. Joseph Newton Whitner of Anderson Dist., a former solicitor of the western judicial circuit of S.C., was a delegate to the S.C. secession convention. Charlotte Rebecca (Palmer) Capers was the wife of Ellison Capers, a professor at the Citadel serving as a major of light artillery. Mrs. Hayne was Alicia Paulina (Trapier) Hayne, wife of Isaac William Hayne, and Thomas Frost was a Charleston clerk related to the Chesnuts by marriage.
9. William Thomson Haskell of the First S.C. Volunteers was the son of Sophia (Cheves) and Charles Thomson Haskell of Abbeville, S.C.
1. Eweretta (Barnewall) Middleton, second wife of Charleston merchant Thomas Middleton. For nearly two centuries, members of the Middleton family had been wealthy planters and prominent figures in S.C. and American politics.
2. The VanderHorsts were an old S.C. family that included the patriarch Arnoldus VanderHorst, governor of the state from 1792 to 1794.
3. In 1856, William Robinson Taber, editor of the Charleston *Mercury*, died in a duel with Edward Magrath, whose brother had been attacked in a *Mercury* article by Taber's first cousin, Edmund Rhett, Jr. Edmund's brother Robert Barnwell Rhett, Jr., became the editor of the *Mercury*.
4. Sam Shannon and Mary Miller (Withers) Kirkland, wife of Charleston rice planter William Lennox Kirkland.
5. Probably Rosetta Ella (Pinckney) Izard, the widow of wealthy Georgetown Dist., S.C., planter Ralph Stead Izard.
6. Aimable Jean Jacques Pelissier, duc de Malakoff, was a French general known for his exploits in the Algerian and Crimean wars.

Chancellor Carroll[7] called to induce me to go on their excursion today but I am too ill from this horrid blister. We had a lively evening — the Judge talking the most.

[*March 30, 1861*]

To day, the 30th — I *had* to get up & write a note to Chancellor Carroll — to decline. Mr. C gave me his *cheek* for farewell — & I hoped Anderson would not catch him. When I came from breakfast found a most exquisite bouquet from S. Rutledge — & John Manning at my door pretending he thought it was Rice's. He is going with me now to Quinby's. I think my likeness is too horrid! Miss Adams sent me hers.

Mr. Manning took me to Quinby's — where I met Gov. Richardson[8] & Col. Beaufort Watts & Hal Frasier. Had a good time. Left Mr. M & went to Watts' to try on a dress. Then we drove to Mrs. Izard's & talked art, &c. Saw pictures & all sorts of foreign things. Then called on the Pringles. Then came home to rest — hemmed a silk handkerchief for Mr. C. Sally Rutledge came & stayed until three. Now to dinner with Gov. Manning & then for a drive to the battery with Sally R. ⟨⟨I wonder whether Mr. C will keep [*one or more illegible words*] this John Manning. Is it not too funny —&⟩⟩ he is so *prosy*.

[*April 1, 1861*]

Dined on Saturday with Gov. Manning & Mr. Theodore Stark.[9] The former had evidently ordered a nice dinner for me. Drove Saturday evening with Mrs. St. Julien Ravenel[1] & Sally Rutledge. William Mazyck[2] called. ⟨⟨Mr. C came home so enraged with my staying at home, he said to flirt with John Manning, that I went to bed in disgust.⟩⟩ Several gentlemen called afterwards. *Also* Beauregard.[3]

Sunday morning at breakfast had a world of fun with Gen. Harlee[4] & Mr. Stark, Gov. Means, &c, about the sand in their eyes the day be-

7. James Parsons Carroll of Edgefield, chancellor of the S.C. court of equity, was a delegate to the secession convention.
8. John Peter Richardson of Clarendon Dist. was governor of S.C. from 1840 to 1842 and a member of the secession convention.
9. Theodore Stark, keeper of the state house in Columbia.
1. Harriott Horry (Rutledge) Ravenel, wife of St. Julien Ravenel.
2. Probably William St. Julien Mazyck, a Charleston cotton factor; his wife appears on the next page in the diary.
3. Pierre Gustave Toutant Beauregard of La., a career officer in the U.S. Army, was appointed a brigadier general of the C.S.A. on March 1, 1861, and given command of the Confederate forces at Charleston.
4. William Wallace Harlee of Marion Dist. was lieutenant governor of S.C., delegate to the secession convention, and a major general in the state militia.

fore. Went to church at St. Philips with Susan R. Saw the old Negroes take the communion in their white turbans. [*Following sentence added later:*] Why don't they all take it together, white and black.

Came home & dined with Orr[5] & Dr. Smith — fun as usual. Slept like a top till tea time when John Witherspoon[6] came. Kate is getting well. Dr. Smith then — & Mr. Theo Stark — then Dr. Morrow[7] & Dr. Gibbes. Then Mr. Miles. Then Sam Shannon — then John Manning — then Gov. Means. ⟨⟨J. M. would whisper to me to the disgust of Mr. C.⟩⟩ Today breakfasted with the Pierce Butlers[8] — Fanny Kemble's daughter. Took her a bouquet of flowers. Went to Mrs. Wigfall's[9] room. Said Pickens was rewarded for treachery; he sneered at secession in Washington. So did Trescot — the villain. Now to prepare to call with Susan Rutledge on the Ingrahams, &c.

[*April 2, 1861*]

Had a perfectly delightful visit to the Ingrahams. Mrs. Wm. Roper asking if I was little Mary Miller. Then to Isaac Hayne's, every body else from home. Finished my shopping. Came home, dined with Langdon Cheves. Judge Withers came back in a shocking humour. After dinner — John Witherspoon & Mary. Dr. Gibbes & I sauced him. Then the Frost girls — then Nannie Mazyck[1] — then Sally Rutledge — then Tom Frost. Then Warren Adams — then John Manning — then Beaufort T. Watts, chamois goat.

Then Gov. Adams — & then Gov. Richardson — & then a *powerful* talk with Mrs. Wigfall — her story of Mrs. Jeff Davis. Jeff Davis no disunionist, &c.

Fleur de *luce*.

Royal purple eyes — Mrs. Pickens' heroine ——

Mrs. Pickens[2] called here. Some of those horrid men told her what I said I knew.

⟨⟨Breakfasted to day with John Manning. Mr. C restive because I said

5. James Lawrence Orr of Anderson Dist. was a U.S. congressman from 1848 to 1859, and a member of the S.C. secession convention.
6. John Witherspoon of Society Hill, who was married to JC's niece, Mary Serena Chesnut (Williams) Witherspoon, sister of David Williams.
7. Probably James Morrow of Charleston, a physician who was medical officer on Matthew Perry's expedition to Japan.
8. Pierce Butler, a Georgia planter, and one of his daughters from his marriage to English actress Frances Kemble, whom he divorced in 1849.
9. Charlotte Maria (Cross) Wigfall, the daughter of a wealthy Providence, R.I., family, had married her second cousin Louis T. Wigfall in 1841.
1. Anne Wyche "Nannie" (Taylor) Mazyck, wife of William St. Julien Mazyck and daughter of Sally Webb (Coles) Taylor.
2. Lucy Petway (Holcombe) Pickens of Texas became Francis Pickens's third wife in 1858. Her beauty inspired a S.C. regiment to call itself the Holcombe Legion, and the Confederate government to engrave her portrait on its currency; her extravagance helped drive her husband deep into debt.

I did not tell him every thing.⟩⟩ Then John Manning brought me a bunch of violets. Now for Sally Rutledge. The papers say Mr. Chesnut made the best shot on the Island. Saw John Waties,[3] Mrs. Shackelford.

[*April 3, 1861*]

Sally R had a good time. Went to see old Miss Pinckney. Said Mr. C's grandfather was very handsome — & had a picture of C. C. Pinckney like the one at Mulberry.[4] Met Mrs. Carroll at the Allstons'[5] — had a charming time at the St. Julien Ravenels'. Sally R ran up twice to Quinby's for me. My likeness uglier than ever. Called on Louisa Hamilton & found Mrs. Carson. Came home barely in time for dinner. Dr. Gibbes wanted to sit with Mrs. Wigfall & me but I would not let him, determined to undress & rest — but as soon as I was undone, here comes Mrs. Robertson, then Mrs. Richard Roper — then Mary Ford.[6] Then I may say Mrs. Wigfall & I had a reception. The Cheves girls & Mr. Langdon Cheves, Mrs. D. Hamilton,[7] Captain J. R. Hamilton & Louisa, Mr. Edmund Rhett — to whom Mr. Wigfall made a stump speech, Mr. Hanckel — very pleasant man, Mr. Hayne, Jack Cunningham, Mr. Sprate — Congo Sprate, Maxcy Gregg,[8] Mr. William Martin,[9] Dr. Gibbes, &c, &c. Such a merry time. I talked too much I fear but the people were so complimentary. To night we are to take tea at Mr. Isaac Hayne's.

Mrs. Pickens — formerly the lovely Lucy Holcombe — called also, so affected, & me away. We are to meet her to night. Captain Hartstene & Tom Huger[1] were to take us to the forts to day — but came to say it was blowing great guns outside & so I was glad to postpone. I want

3. A Charleston lawyer and clerk of the court of appeals; later he served in Hampton's Legion at Bull Run.
4. Harriott Pinckney's father was Charles Cotesworth Pinckney a Revolutionary soldier, a delegate to the Federal Constitutional Convention, minister to France, and the unsuccessful Federalist presidential candidate in 1804 and 1808. Both JC's grandfather John Chesnut and his friend Pinckney had their portraits done by Gilbert Stuart.
5. The home of Col. Robert Francis Withers Allston, who was governor of S.C. from 1856 to 1858. Eliza Anciaux (Berrien) Carroll was probably the wife of James Parson Carroll.
6. Elizabeth (Rabb) Robertson, wife of William Ross Robertson, a delegate from Fairfield County to the secession convention. Mrs. Richard Roper was the wife of a Charleston commission merchant; Mary Mazyck (Hume) Ford was the wife of Frederick Wentworth Ford, a wealthy rice planter of Georgetown Dist.
7. Mary and Emma Cheves, daughters of Langdon Cheves, Jr.; Mrs. Daniel Heyward Hamilton, wife of a former U.S. marshal for the District of S.C.
8. John Cunningham, a colonel of the S.C. militia stationed in Charleston; Maxcy Gregg, a Charleston lawyer and veteran of the Mexican War, was commissioned colonel of the First S.C. Volunteers shortly after S.C. seceded.
9. A Methodist minister of Columbia.
1. Thomas Bee Huger of S.C. resigned from the U.S. Navy in Jan. and became a C.S.N. lieutenant. He commanded a battery on Morris Island, the stronghold which protected the entrance to Charleston Harbor on the south.

rest. Breakfasted with John Manning who made better jokes than usual. Mrs. Robinson has come for me to pay bills.

[*April 4, 1861*]

Mrs. R & I went to the bank, drew the money & paid the tradesfolks. Then visit[ed] a lot of shabby pictures at the Art Association. Came home & slept. Dined with the Wigfalls, Langdon Cheves, &c. Mrs. W says Judge Withers has a noble face. After dinner Haskell & that old goose Dr. Gibbes, who had a kind of *fez* on his head. Dr. Smith found out at dinner that the Constitution had been passed with *20* fools against it.

Dressed in my beautiful grey moire & went to the Haynes'. Was in a lively talk with Carroll & Wigfall when the latter was called away to speak to a mob before the Mills House. & I was left to talk to a ⟨stupid⟩ Miss Trapier. Old Pick was there with a better wig — & his silly & affected wife, letting Miles make desperate love to her. Poor goose, she is in the hands of the Philistines. She looking *love* into the eyes of the men at every glance, Miles begging for their violets & I so indignant. As I went to breakfast to day I met Sam Shannon waiting to give me three heart's ease — & Mr. C said I was as great a flirt as Mrs. Pickens.

Mr. Hayne amused me beyond measure with the agonies of the old husbands. Says all three of his boys are in love with Mrs. Giddings — had to move his seat at church.

Delicious little supper — paté, lobster, biscuit glacé. Came home; did not get to rest until two. A ship was fired into yesterday & went out of the port.[2] I think it a very silly business — war or peace, which is it. Today the Wigfalls & Cheves & I are to go to the Fort with Captain Tom Huger & Hartstene. The very idea is fatiguing. Wigfall gave a stirring speech last night. When he visits *"Glen Alpine"* again is to go in the *saddle.*[3]

Mrs. Pickens is very clever but affects silly, fine lady airs, for reasons of her own — & it seems to pay.

[*April 5–6, 1861*]

The day on the *Planter:*

Captain Tom Huger in command was perfectly delightful. Maxcy Gregg took charge of me. Tom Huger is a perfect specimen of a jolly

2. On April 3, the master of the *Rhoda H. Shannon,* an ice schooner from Boston, mistook Charleston harbor for Savannah and began to sail into port. The Confederate battery on Morris Island fired several warning shots before the ship sailed out of range.

3. Wigfall told his audience on the night of April 3 that war with the North was inevitable. Vowing to return to Washington "in the saddle" the next year, the former U.S. senator quoted Fitz James, the Lowland king of Scotland who subdues the rebellious Clan Alpine in Sir Walter Scott's *The Lady of the Lake* (1810): "Twice have I sought Clan-Alpine's glen/ In peace; but when I come agen,/ I come with banner, brand and bow,/ As leader seeks his mortal foe" (Canto 5).

gentleman sailor. Maj. Whiting was also very agreeable. Then Dan Hamilton[4] & William Haskell. It was blowing too hard for us to land, but we saw all the Forts —& Sumter *gloomed* on us. Came home exhausted.

Beauregard, &c, called & I would not go out — but in my room came Louisa Hamilton, Sally Weston[5] — now Mrs. Ray, & Mrs. Whitaker. Next day we went calling. Saw Arthur P. Hayne[6] at Mrs. Wm. Roper's. Mary Ford did not get in any where else, but at the Governor's she pressed my hand & looked so softly in my eyes — I felt ashamed I had laughed at her so. To day we are invited to dine with them but I prefer going with Mrs. St. Julien to see Mrs. Holbrook.[7] Last night I went to see Mrs. Nicolls & Mrs. Motil. Saw the French consul. Afterwards had the pleasantest time with John Manning & Wigfall, Dr. Gibbes, Dr. Ray, &c. Was wanted & pressed to go to the Ball but had *no clothes,* with so much at home. To day they say an engagement is *imminent.*

Mr. C has got into a decided minority in the convention. I am so sorry. He dined yesterday at Pringle Smith's.[8]

[*April 7, 1861*]
Sunday.

Yesterday it rained & we paid visits — long call at Mrs. Henry King's. At the James Legares',[9] they asked Mrs. Wigfall if she was fifty six years old & at the Gibbes' they asked me if I had ever been in Charleston before. Slept all the afternoon. War news rampant. Allen Green[10] came in all his soldier clothes to speak to me at the table. At night had Miles, Sam Shannon, Langdon Cheves, & Dr. Gibbes — quieter without the Wigfalls. To day breakfasted with Wigfall, Manning, &c. Mrs. W thinks Mr. C would have made a splendid match for herself — & now Mrs. M writes for Mr. C's likeness as she wants to begin a flirtation with him.[1]

War news all the time. Still I hope. The Judge very rude & unkind to me yesterday before those Cheves children. Went to see Aunt Lydia

4. Daniel Heyward Hamilton, U.S. marshal for the District of S.C. before the war, was lieutenant colonel of Maxcy Gregg's regiment.
5. Sarah (Weston) Ray, wife of Dr. Duncan William Ray of Richland Dist.
6. U.S. senator from S.C., Arthur Perroneau Hayne, served from May to Dec. 1858.
7. Harriott Pinckney (Rutledge) Holbrook, wife of Charleston naturalist Dr. John Edwards Holbrook.
8. John Julius Pringle Smith, a Charleston delegate to the secession convention.
9. Susan (Marchant) Legare and James Legare, a Colleton Dist. planter and Charleston bank director.
10. Allen Jones Green, Jr., a physician, planter, state legislator, and former mayor of Columbia, was captain of the Columbia Flying Artillery, stationed on Morris Island.
1. John Manning had written his wife about the flirtation with MBC and she had responded lightly with a request for Chesnut's picture and a declaration that she proposed to have a flirtation with him.

Baker who has just seen Kate Williams. She is able to be out at a dinner given at Gainesville.

A.M. The first headache I have had since I left Montgomery.

[*April 8, 1861*]

Spent yesterday in bed until tea. Went to tea with Wigfall, Carroll, Manning, & Dr. Gibbes. Mr. C offended because I did not wait for him. After tea un[t]il eleven, had Mrs. Wigfall & Dr. Gibbes & Mr. Banquet, Tom Huger. ⟨⟨[*one illegible name, probably* "Manning"] & — [*one or more illegible words*] with a hand held. He had to be dreadfully scolded when I came into my room. I was merely mad.⟩⟩ Miss Gamble was in the parlour — now Mrs. Latrobe.[2] Has had two husbands in two years.

Went visiting with Mrs. Wigfall — rather a pleasant visit to the Rutledges & a rather queer one to the Mazycks. Nannie, a plain, uninteresting person, complains of the little attention paid to women here.

Mrs. Nicolls [has] been in & gave me Hollands bitters which have worked wonders with my cold. News *so* warlike I *quake*. My husband speaks of joining the artillery. ⟨⟨That husband scold made me melancholy last night. I feel he is my all & I should go mad without him.⟩⟩ Mr. Manning read me a letter from his wife last night — very complimentary.

[*April 9, 1861*]

After packing & feeling very miserable, I sat reading Smiles' biography of Margaret Fuller Ossoli.[3] Thinking nothing could induce me to dress & go out. However, Mr. Robert Gourdin & Miles called. Mr. G had been so kind I would not excuse myself, so we went out. Mr. G wants me to go to day & see his garden. Miles bragged of his Washington intimacies with ladies.

I was sitting quietly talking to Mr. G when John Manning walked in, seated himself by me & in mock heroic style began, "Madam your country is invaded." Then as I questioned him told that six men of war were outside the *bar* — & Talbot & Chew had arrived to announce war.[4] Beauregard & Pickens were holding a council of war. I immediately told Mr. C who came in after inquiry & confirmed the story. Mr. Wigfall

2. Earlier in the year the widow Letitia (Gamble) Holliday had married Charles Hazlehurst Latrobe of Baltimore, who joined the C.S.A. as a lieutenant of engineers.

3. MBC was reading a short essay on this feminist and Transcendentalist in Samuel Smiles, *Brief Biographies* (1860).

4. The night before, Robert S. Chew, a State Department clerk, and Capt. Theodore Talbot, an officer who had served at Fort Sumter, notified Governor Pickens that "an attempt will be made to supply Ft. Sumter with provisions only." That is, Lincoln would not yield to the Confederate demands to give up the fort.

came in with "There was a sound of revelry by night."[5] All was stir & confusion. My heart beat so painfully. The men went off. Mrs. W & I retired to my room, &c, where she silently wept & we disconsolately discoursed upon the horrors of Civil War. Directly the boom of a cannon & then *shouts*. I started up & met with blanched face & streaming eyes poor Mrs. Allen Green.[6]

Dr. Gibbes maligned her. No "placidity" there. I begged to sit with Mrs. W & rushed off to hear the news. Gov. Means came out of his room in his dressing gown to tell me that Pickens, the queer goose, had ordered seven cannon to be the signal for the gathering of the 17th regiment — letting Anderson know thereby what he was about. Of course no sleep for me last night. The streets were alive with soldiers — marching, shouting, &c. Wigfall I called a "stormy Petrel" & they all seemed to think it an appropriate name. To day things seem to have calmed again somewhat. If nothing new turns up we will leave for Camden to night. The Lincoln adminis. has acted so stupidly, drawing back after making foolish advances, that I must hope yet.

Since dinner I have had a quantity to happen. My husband has accepted a position in Beauregard's staff — & to night the fight may begin. I have written the best letter I can to his father.

[April 10, 1861]

Last night Mr. & Mrs. Hayne came & sat the evening — also Louisa Hamilton. Gov. Means & Manning, Dr. Gibbes & Mrs. Hayne [who] said the only feeling she had about the War was pity for those who could not get here.

Manning was on pins to get with Gen. Beauregard's staff. Simon [*illegible name*] came in & out, finally it was arranged, & he was pleased as a boy. I took tea with Sam Shannon who is in good spirits; he is promoted to be an adjutant of Cavalry. Jack Preston, Willie Alston[7] & that set have volunteered as *privates*. What a people. Wigfall & Manning gone down with instructions to Hartstene. Chesnut had to make a report to the Convention — busy getting ready. Saw Lucy Green & Mrs. Wm. Roper. Mr. Chesnut abused me for not lending the glasses to Lucy Green. To day's *Herald* says these troops are ordered to Texas — if so how will Louis Wigfall feel. 700 men embarked for the Islands last night. The

5. From Canto III, stanza 21, of Lord Byron, *Childe Harold's Pilgrimage* (1812–18).
6. Lucy Pride (Jones) Green of Columbia, a widow with planting interests in S.C. and Ala., was the mother of Allen Jones Green, Jr.
7. John Preston, Jr., a law student, was the eldest son of the Chesnuts' friends, John Smith Preston and Caroline (Hampton) Preston of Columbia. William Algernon Alston was of a wealthy Georgetown family.

ammunition wagons were rumbling all night. Mr. Chesnut took home
Louisa Hamilton — & Manning showed her a note from Mrs. King.

[*April 11, 1861*]
 Yesterday dined with Manning, Cheves, &c, had the merriest time.
Who could imagine *war* began to day. Mr. C & Manning rushing con-
stantly to Beauregard. Gov. Means gave Mr. C a sword. Dr. Gibbes came
as usual — & the same set. We went to bed at twelve. The men came in
about 1. Pryor of Virginia[8] spoke at the Charleston Hotel.
 Companies & regiments come constantly in. Wigfall all night in the
harbour. Anderson burning blue lights as signals to the fleet. Today —
Mrs. Perkins & Cally[9] have called. Mr. Chesnut has gone in some sort
of uniform, sash & sword, to demand the surrender of Fort Sumter.[1]
Patience oh my soul — if Anderson will not surrender, to night the
bombardment begins.
 Have mercy upon us, Oh Lord! Mrs. Wigfall wants me all the time &
then Mrs. Green. If I could but know the answer of Anderson. They
have intercepted a letter from him urging them to let him evacuate —
& painting very strongly the horrors likely to ensue.[2] Poor country —
with such rulers. Old Mr. Chesnut has sent his only son, *at such a time*,
a mean, common, cold blooded brute of a horse. Old Team[3] — & John
C write offering every thing but sending nothing. What a cold hearted
set — mean.

[*April 12, 1861*]
 Anderson refused to capitulate. At dinner yesterday Theo Stark came
& Miles — it was I dare say out last merry meal. Afternoon — we were
frantic. Sue King rushed in for news. Said all the King family were on
the Island — but Mr. Henry King. Said I was a lucky woman, happy in
my husband — ought to be so grateful, &c. Mr. C came while she was

8. Roger Atkinson Pryor, an ardent secessionist who had resigned from the U.S. Con-
 gress in March, was one of Beauregard's volunteer aides.
9. Priscilla Bryan (Jumelle) Perkins was the widowed daughter of a French refugee from
 the slave rebellion on Santo Domingo; her daughter Caroline "Cally" Jumelle (Per-
 kins) Perkins had been married to Camden planter Roger Griswold Perkins.
1. On the afternoon of the eleventh, Chesnut and Capt. Stephen D. Lee, representing
 Beauregard, and Lt. Col. Alexander Robert Chisolm, representing Gov. Pickens, rowed
 to Sumter with the demand for the fort's evacuation.
2. Angered by Lincoln's decision to provision Sumter, the Confederate authorities stopped
 Anderson's mail on the eighth. A captured letter from Anderson did not request per-
 mission to surrender but questioned the strategic importance of Sumter and protested
 the decision to supply the fort. Anderson concluded, "my heart is not in the war which
 I see is to be thus commenced."
3. James Team, fifty-six, was the chief overseer for old Mr. Chesnut's plantations and
 also a planter worth $13,500 in 1860.

here — told me he had a most interesting interview with Anderson — Capt. In. & himself — & Jeff Davis had been telegraphed — & then they would know what answer to make Anderson. The men came in. Uncle Hamilton madly rushing about — tears in his eyes — with disappointment that he is not employed. Manning in his uniform. Mr. Chesnut sent off again to Anderson.[4] The live long night I toss about — at half past four we hear the booming of the cannon. I start up — dress & rush to my sisters in misery. We go on the house top & see the shells bursting. They say our men are wasting ammunition.

Mr. Chesnut rode about all night in a little open boat to order our batteries to open. He ordered the first gun fired & he resigned first.

These long hours the regular sound of the cannon roar — men & women rush in — prayers — imprecations. What scenes. To night a force will attempt to land. The *Harriet Lane* has attempted to get in — been shot — her wheel house ruined & she has put to sea.[5] Proud Carolinians — you must conquer on your own soil. The enemy must not land. ⟨⟨[*Illegible word*] beloved⟩⟩ my husband — dined with us — looked so well in his uniform & red sash — rushed off to get an order somewhere.

Today Miles & Manning breakfasted near me. Manning got up & came to me — said we must be friends & not quarrel because he was all day to be before the fire of Fort Sumter & left a message for his wife. Dined with A. H. Boykin & Theo Stark.

Good news. Nobody hurt on our side. Saw the nasty Yankee woman who is so sorry for Anderson. To night — tonight — Oh my Soul!

Mr. Kirkland came, crazy to get a place to fight too — goes back at Mr. C's advice to bring Mary. Hartstene, Pryor, &c, came to see us. Lou Hamilton as usual. I was so tired — firing continues. Mr. C asleep on the floor in Beauregard's room. Nobody hurt yet at the Forts. Louis Wigfall still at Morris Island. Mr. Cheves had to go home today — said he felt like the man who did not get killed at Thermopylae — went & hanged himself. I miss Mr. Cheves. Thank Heavens. Things are no worse. Tremendous excitement in Richmond & Washington — boom — still go those terrible guns. Saw the Richland & Fairfield troops. Saw Stark Means[6] take off his hat to his Mother as he passed — & she had a spasm of the heart — tho she said nothing.

4. Chesnut, Lee, Chisolm, and Roger A. Pryor left for Sumter at eleven o'clock on the night of the eleventh to give Anderson a final opportunity to surrender before the Fort would be attacked.
5. The *Harriet Lane*, one of the Federal steamers sent to provision Fort Sumter, remained outside Charleston Harbor and was unharmed in the bombardment.
6. Major Robert Stark Means of the Seventeenth S.C. Volunteers was the son of John Hugh Means and Sarah Rebecca (Stark) Means.

[*April 13, 1861*]

A lull after a storm. Last night we were jubilant. "No one hurt." No battery even injured — & Anderson has two guns spoiled & his fort injured. To day — the enemy's fort has been repeatedly on fire. Still his guns fire regularly. Still vessels are off the bar — & war is at our doors — but 'tho' we hear the firing we feel so differently — because we feel that our merciful God has so far protected our men — & we pray with faith.

I am miserably ill but run occasionally to Mrs. Wigfall's room & Mrs. Green's.

Mr. Manning seems quite delighted to have found out experimentally that he can be cool under fire. My husband got a good night's rest — poor fellow, he may have to rush off to Montgomery. Jeff Davis has called his Congress together. Alex Taylor[7] & his company are here. What a nation of soldiers we are.

Mr. Chesnut ordered the first gun fired. Saw Wm. Gilmore Simms[8] & did not recognise him in his white beard. Trescot is here with his glasses on the top of the house. *Rumour* that the enemy's ships are firing. Mrs. Green rushes in & out.

[*April 15, 1861*]

Saturday last was a great day. I saw my husband carried by a mob to tell Gen. Beauregard the news that Fort Sumter had surrendered — he followed Louis Wigfall to Fort Sumter after a few minutes' interval, then returned with the news of the surrender & carried fire Engines to Fort Sumter. Our men cheered madly when Anderson continued his firing after he was blazing with houses on fire. Mrs. Cheves McCord[9] & I dined together in the evening. Mrs. Joe Heyward, Mrs. Preston,[1] Mrs. Wigfall & [I] drove on the battery in an open carriage. So gay it was — crowded & the tents & cannons.

Sunday went to Church with Mr. Wm. Bull Pringle[2] & Mr. Appleton[3] of Boston. Mrs. P said I had my mother's eyes. Saw hosts of people. Walked on the battery with Mrs. Joe Heyward. Last night Jack Hamilton called ⟨⟨[*one illegible word*]⟩⟩ a hero. ⟨⟨& Edward Boykin who seemed rather annoyed that I would not give him my undivided attention. That

7. Alexander Ross Taylor of Columbia was the captain of the Congaree Mounted Riflemen.
8. The S.C. novelist, biographer, historian, essayist, and orator whose fiction includes *The Yemassee* (1835), *The Partisan* (1835), and *The Kinsman* (1841).
9. Mrs. Louisa (Cheves) McCord of Columbia, an essayist and poet, was the widow of Col. David James McCord, a lawyer and president of the Bank of the State of S.C.
1. Caroline Martha (Hampton) Preston, wife of John Smith Preston of Columbia.
2. William Bull Pringle of Charleston owned a large plantation in Georgetown Dist.
3. Probably Nathan Appleton, the New England textile manufacturer.

I will never do more to anyone if it is ever lamentable be.⟩⟩ Spent the evening gaily with Mrs. Joe Heyward, Mrs. Wigfall, Mrs. Frank Hampton[4] & Hanckel, Dr. Gibbes, &c, &c.

To day talked with Gov. Means. Mrs. Robinson & I called at Quinby's & drove on the battery. John C & Laurence are here. I am now to drive with Sally Rutledge. Had another false alarm & rushed upon the house top.

[*April 16–23, 1861*]

Monday15th — 16th — 17th — 18th — &19th — 20th,21st — 22nd — 23rd. During this time — the excitement, &c, was so great I had never a moment to write.

I drove every evening on the battery. Manning, Wigfall, John Preston,[5] &c, men without limit beset us at night. Mrs. Cheves[6] came & her sweet little girls. Mrs. Frank Hampton as perfectly charming as ever. Barnwell Heyward[7] — Mary Kirkland — every body, every thing happened. Mr. C, Manning & Miles carried Russell to the Forts[8] — & Wigfall, drunk, insulted him. Poor Mrs. W. James Simons sat under the *yellow flag* for safety. They call him hospital Jimmy.

Went with Mrs. F. H. to see the Columbia mounted rifles — had a rare time with Venable,[9] the lieut. of the Company & Professor of Mathematics in the college. Virginia is arming to a man. North Carolina. Old Clingman[1] was in Charleston. The McQueens also. She made herself disagreeable as usual.

Came up on Saturday with Mrs. F. Hampton; had a perfectly charming time. William Shannon she thought handsome. Bob McCaw[2] said

4. Sally (Baxter) Hampton, a native of N.Y., refused William Thackeray in order to marry Frank Hampton, a Richland Dist. planter.
5. John Smith Preston of Columbia, a lawyer, former state legislator, and art collector, made a fortune from his great La. sugar plantations. Living in Europe before the secession crisis, Preston returned to serve, first as a commissioner to urge Va.'s withdrawal from the Union and then as one of Beauregard's aides. He and his wife, Caroline Martha (Hampton) Preston, were old friends of the Chesnuts.
6. Charlotte (McCord) Cheves, wife of Langdon Cheves.
7. Edward Barnwell Heyward, brother-in-law of Maria (Magruder) Heyward, was a Richland Dist. cotton and rice planter with a taste for art and literature.
8. Already famous for his front-line coverage of the Crimean War, London *Times* correspondent William Howard Russell arrived in the U.S. in March 1861. He recounted his American experiences in *Pictures of Southern Life, Social, Political, and Military* (1861) and *My Diary North and South* (1863).
9. Charles Scott Venable was professor of mathematics at S.C. College. He took part in the attack on Fort Sumter as a second lieutenant with the Congaree Rifles.
1. Thomas Lanier Clingman of N.C. had resigned from the U.S. Senate on March 28.
2. Robert Gadsen McCaw, a large plantation owner of York Dist. who served in the S.C. legislature before the war.

Mr. C was to be *cheated*. Tom Warren[3] was very civil — every body laughs at John Manning's brag. Sunday dined at Kirkwood, the Judge very disagreeable — Mary very lovely.

Yesterday wanted to stay at home but Uncle H came & carried me up. Maryland in arms. What a war. Tom Boykin's[4] company ordered off to Virginia. The Hanckels[5] came in the evening.

All hands getting me ready for Montgomery. Kate is in Charleston.

[*April 24, 1861*]

A.M. Yesterday was the anniversary of my wedding day. Spent the morning most disagreeably wrangling with the Judge. Came home to dinner. Minnie Frierson[6] came back with her husband. Kate Williams in Charleston. The report by telegraph that the New York regiment is cut to pieces — at Marlboro. Tom Boykin's company went on last night. Hot as mid summer.

[*April 25–27, 1861*]

Montgomery. The first day packing — the last two spent on our way to Montgomery. Came on the cars with the Murrays & Friersons. Then they left us & Mr. Robert Barnwell joined our party — a nice old man, but reminds me of Pickwick with his benevolent spectacles. Had a talk with Gen. Owens[7] of Florida — find the Alabama people are not as certain of beating the Yankees at Fort Pickens as we were at Sumter. Must try & remember every thing about that wonderful siege & write it as soon as I have leisure.

Met a man on the cars from Baltimore who had married a Miss Forsyth — & was bringing his wife for safety to Georgia — quite *tranquilizing*, that idea. Baltimore in a blaze. Ben Huger[8] commanding there. Robert Lee in Virginia — son of Light Horse Harry Lee.[9] Won't we show

3. Thomas Warren, editor of the Camden *Journal*, who organized the Kershaw Guards of the Fifteenth S.C. Regiment.
4. Thomas Lang Boykin of Kershaw, a planter and captain of the DeKalb Rifle Guards of Gregg's Regiment, was the son of Burwell Boykin and a first cousin of MBC.
5. Sarah T. (Heyward) Hanckel and Thomas Middleton Hanckel, a planter and delegate from St. Philip's and St. Michael's Parishes to the secession convention.
6. JC's niece Mary Chesnut (Grant) Frierson was the wife of Sumter Dist. planter James J. Frierson and the daughter of William Joshua Grant and Harriet Serena (Chesnut) Grant.
7. Either James Byeram Owens or his brother, William A. Owens, both Fla. planters.
8. Benjamin Huger of Charleston, a cousin of Thomas Bee Huger, had resigned as a major from the U.S. Army on April 22 and soon became a brigadier general of the C.S.A.
9. Robert E. Lee's father, Henry Lee, fought with Washington's army in Va. and commanded an irregular company of cavalry and infantry in S.C. during the Revolutionary War.

them a brave fight with such commanders. Magruder & Charley May[1] also resigned. Mr. Chesnut had to make a speech on the cars & would not make any more 'tho' they tried to force him. The Wigfalls are staying at the President's. Mrs. Browne was very glad to see me — but the Watsons bored me with their kindness.

The 7th Regiment got safely to Washington.

The *Herald* says they are going to extinguish slavery in blood. Mr. Chesnut asleep to go at 6 o'clock with Wade Hampton[2] to see Jeff Davis. Oh, if I could put some of my reckless spirit into these discreet, cautious, lazy men.

[*April 28, 1861*]

Yesterday went down in the afternoon & saw the Brownes & Memmingers,[3] Hemphill, Gov. Moore, old uncle Ned Hanrick,[4] &c. Browne says Sam Ward[5] was a spy at Charleston. Saw Mr. Mallory a moment at his room door; he has gout, his daughter is not pretty & her husband is a Connecticut *Yankee*.[6] Saw Charley Scott to day; he has left California & is going as a private to Virginia. Saw a tremendous mass meeting in New York — & we are to [be] stricken with terror by it —so the *Herald* says.[7] Went to church. Saw Mrs. Wigfall & the Jesse Taylors. The President came & spoke to me most cordially. Saw Major Deas.

[*April 29, 1861*]

Dined with the Memmingers, Brownes, &c, talked all the time to Mr. Wilkinson — & had pleasant time. Mr. C said he [is] conceited & worthless. After dinner was lying down until six — when Mrs. James & Mrs. Raoul called. The former thought Frank Campbell was with me. She is mad about Frank Campbell. Then went to tea. The Memmingers must think me funny. Old Uncle Ned Hanrick slapped me on the shoulder & was so friendly. Gen. Owens brought me a bunch of flowers which I

1. John Bankhead Magruder of Va., and Charles A. May of Washington, D.C.
2. The inheritor of a great name, vast Miss. plantations, and vast debts, Wade Hampton, III, of Richland Dist., S.C., shortly became colonel of Hampton's Legion, a special regiment combining infantry, cavalry, and artillery.
3. Christopher Gustavus Memminger, a Charleston lawyer and secretary of the Confederate treasury, and his wife, Mary (Wilkinson) Memminger.
4. MBC spells the name of this unidentified man several ways.
5. Samuel Ward of N.Y., the elder brother of Julia (Ward) Howe, was a writer, adventurer, and society figure who became a well-known Washington lobbyist during the war.
6. Margaret (Mallory) Bishop and her husband, Henry Bishop of Bridgeport, Conn.
7. On April 21, the New York *Herald* published an extensive description of a Unionist demonstration organized to welcome Major Robert Anderson to New York.

put into my breast pin & Hemphill said if he had known where I meant
to put them he would have been out flower hunting himself.

Went to the parlour; Mrs. Bishop called — & Gov. Moore. They of-
fered him all sorts of seats — & he said any chair so it was by Mrs.
Chesnut. Then Mr. Josselyn the poet called, Jeff Davis' private secre-
tary, then Mr. Haskell & the Wigfalls, the male Wigfall terribly excited
at the behaviour of Anderson. Next time he will not risk his life to save
him — the mean cowardly wretch, not to tell those New York people
how magnanimously he was treated. Then Mr. Haskell & others. I be-
came so exhausted, altho I had been all day in bed. Today breakfasted
again with the Brownes & Memmingers & Wilkinson. Mr. C never speaks;
lets me talk all — & people encourage me so to talk. The ladies want
me in spite of my red eyes to go to the Capitol with them to hear the
President's message read. I have sent for a Doctor for my eyes — how
sad to be so disfigured. My poor eyes. My only decent feature. ⟨⟨"Even
Cupid can not bear inflammation to redden his blind eye."⟩⟩

[April 30, 1861]

Yesterday went with Mrs. Browne & the Memmingers to hear the
President's message — had a pleasant time. Saw many friends. Talked
all the time with Mr. Drayton & Mr. McFarlane[8] tho so many other[s]
came up. Walked home with them — objected to the word *"prudent"* ap-
plied to the enemy's fleet.

Before going to the Capitol, Dr. Jones[9] came to see my eye, sat 2 hours.
Says he is my cousin, his mother was Eliza Crawford that my father was
so fond of. Dined with Wright, Nisbet,[1] the Judge & Mr. Mallory &
Hill — if the glare was not so maddening, might have [had] a glorious
time. Last night Mr. Nixon called — but before that Jessie James took
Mrs. Wigfall & me to see Mrs. Davis. After tea I went with Mrs. Bishop
to see the Memmingers. Mr. Mallory & I were in full chat & the singing
was delightful when Zack Deas[2] called — staid until ten, when my eyes
gave out & I came up. To day breakfasted with the Brownes, &c.

Mrs. Secretary Walker[3] & Mrs. Woods called, the former preposter-
ously fine — & affected. Then went with Mr. C for Mrs. Wigfall to go

8. This is either William H. McFarlane of Richmond, publisher of the *Southern Literary
Messenger,* or William H. McFarland, the Richmond banker and Confederate con-
gressman.
9. Benjamin Rush Jones, a Montgomery physician who was born in Lancaster, S.C.
1. Eugenius Aristides Nisbet, a former U.S. congressman and judge of the Ga. supreme
court, was a member of the Provisional Confederate Congress.
2. JC's first cousin, Zachariah Cantey Deas.
3. Eliza (Pickett) Walker, the daughter of a Montgomery judge, was the wife of Confed-
erate secretary of war Leroy Pope Walker.

to Mrs. Davis' reception. Met Captain Ingraham; he thinks we cannot take Fort Pickens. Was introduced to Col. Chase of the Army. Had a merry chat with George Deas, Mr. Smith, Mr. James Holmes,[4] and a hundred others. Came home & met the Dr. who ordered me to stay in a dark room. Dismal news as to a war.

[*May 3, 1861*]

May. These last three days have been shut up in the dark. Mr. C very kind, staying with me, & I very bad, wrangling & tormenting him. Frank Campbell sent me strawberries which he picked himself. Mr. Mallory a splendid bunch of bananas. Went down last night, saw Mr. Mallory, Hemphill, Mr. Marshall, &c. Saw Tom Boykin in my room. Mother wants me to go there. Mrs. Fitzpatrick came also to my room. Went to Memmingers' & heard her sing. Dr. Boykin came to day; had an hour's chat with him — he wants the surgeon's place in Wade Hampton's troop. Mr. C went to Jeff Davis'. Every thing in confusion. Nothing doing. Our *cabinet* so dull & stupid.

My eyes still very red ——

[*May 4, 1861*]

Yesterday after dinner saw Mrs. Huger's[5] maid come in with strawberries & cream — had eaten dinner, a meal I have abstained from so long it *disagreed* with me. Wrote my little cousin Hattie [*following name added later*] Huger[6] an affectionate note. Then Sally [*following middle name added later*] Bev Elmore[7] called, then Mr. Barnwell — the noble old man, then was introduced to the Clarksons, then went with Mr. C to call on the Wigfalls, Mrs. Secretary Walker, &c. Saw there Captain Ingraham, Major Rhett, & his wife, a daughter of my old friend Mrs. Mason,[8] Mr. Miles & old Morrow. Mrs. Walker took old Morrow for *my husband*. Do I look like a woman to marry *old* Morrow. It is an insult to the Palmetto flag to suppose S C would have made such a man Senator. Gen. Waul & Mr. Josselyn came to look at my red eyes. Came home. Saw nobody but the Watsons. To day breakfasted with the Memmingers & Mr. Wilkinson — the latter *affects* me wonderfully.

4. James H. Holmes, who had recently joined the Fifth Regiment of Ala. Infantry.
5. Probably Elizabeth Celestine (Pinckney) Huger, wife of Benjamin Huger.
6. Hattie Brevard (Withers) Huger, the recent bride of Daniel Elliot Huger, who was born in Camden.
7. Sarah (Brevard) Elmore of Camden, wife of former S.C. treasurer Benjamin F. Elmore.
8. In the 1840s, two brothers, Thomas Grimké Rhett and Charles Hart Rhett, married, respectively, Florence and Matilda Mason, daughters of Eliza (Price) Mason.

Then Tom Boykin called. Then the Duboses.[9] Then a row with Mr. Chesnut. Then Zack Deas — then the little Jones. Zack is a pleasant fellow. Had a note inviting me to a family dinner at the President's. Zack D took it to Mr. Chesnut at the Capitol for me. Wrote to my father in law. Another telegraph from Bonham.

"When the wicked cease from troubling & the weary are at rest."[10]
Montgomery Hall

[*May 6, 1961*]

On Saturday I went to Mrs. Toombs'[1] reception. Talked all the time to Stephens, the vice president, when a stupid Bibb man interrupted. Mrs. Wigfall & I came home together. Mrs. Fitzpatrick came to see me; I am to make her a bonnet. Dined at President Davis'. Taken to dinner by the Pres. — had a jolly time —Mrs. Davis so witty. Had poor Miss Windle's[2] case up. Gen. Anderson, just from Alexandria, gave us doleful news. They are so much better prepared than we are. We are in wild confusion on the Virginia border & wretchedly armed. *What horrors!* Washington[3] came yesterday with the same story but I was not at home. Waited a long time for him to day. Yesterday I went in the drawing room & found the inevitable Watsons. Mr. Withers insulted Mr. Mallory by abusing Jeff Davis. The Judge will find people here will not tolerate such stuff — he will have to answer for his rude speeches. Mr. Mallory spoke to me of it to day. George Deas & his "mess" have come here to live — a pleasant fellow he is.

I am very much disheartened at the state of our affairs. Reading *Friends in Council.*[4] Mrs. Lincoln's mother & sisters[5] are here —I should watch them!

9. Kimbrough Cassels Dubose, a Marengo County planter, and Elizabeth Boykin (Witherspoon) Dubose.
10. Job 3:17.
1. Julia (DuBose) Toombs, wife of Robert Augustus Toombs.
2. Mary Jane Windle, the Delaware-born author of *Life in Sulphur Springs* (1857) and *Life in Washington and Life Here and There* (1859), was a correspondent for the Southern press.
3. Littleton Quinter Washington, a Washington, D.C., journalist who served as chief clerk of the Confederate State Department.
4. Sir Arthur Helps, historian and author, was an adviser to Queen Victoria and clerk of the Privy Council. His *Friends in Council*, earnest dialogues on political questions, first appeared in 1847.
5. Mary (Todd) Lincoln's stepmother, Elizabeth (Humphries) Todd of Ky., was a Confederate sympathizer, and three of Mrs. Lincoln's four half-sisters had husbands in the C.S.A.

[May 7, 1861]

Spent yesterday sadly enough —Miss Waters sent me a bouquet, Mr. Mallory sent me a lovely supply of oranges. Mrs. Mallory[6] has come & a nice woman she seems to be. Spent yesterday evening with Mr. Hemphill, Gov. Moore, Mr. Withers, Mrs. Wigfall & the inevitable Watsons. I left when it came to a tête à tête with those my special aversions.

John Manning spent two hours here & Quinter Washington. What a tale of the country's dangers they tell. To day Lieut. Moffatt & Mr. Heart[7] came — the former fresh from Washington. He says *they* (the enemy) have the finest body of troops he ever *saw*.

Breakfasted with Gen. Cooper & Col. Meyers.[8] Dr. Gibbes is here — he is to go with us to day to Mrs. Davis' reception. Capt. Moffatt says Gen. Scott has a regiment of spies in the South. Guess who has just called. Robert Barnwell Rhett. Quite an animated chat we had. Thinks all this trouble comes of not taking Fort Sumter soon enough. Stephen has sent me Polly. The old lady seems quite satisfied to be with me. What a comfort a maid will be.

Have been to Mrs. Davis' reception. Saw there Dr. Trescot, Dr. Buist[9] — young surgeons, Mr. Russell of the *Times*, Captain Decie[1] who came over in his own yacht, &c. Had a glorious morning if I had been in the humour. Dr. Gibbes lost his head because he was taken for Beauregard. Russell's manner I did not like —he was, I thought, snobbish. Sam Ward was as oily as ever. Decie was the nicest of the lot. Browne was in his glory — & Mrs. B assisting to receive. Russell wonders how we had the heart to go on so when so soon we were to be exterminated. Must write to Stephen.

[May 8–9, 1861]

The evening of May 7th I had a regular reception — Keitt, Cobb, Miles, Dr. Trescot, Dr. Buist, Campbell, Washington, &c. It was all spoiled by the Judge who would sit by me & grumble & insult every body. Yes-

6. Angela (Moreno) Mallory, wife of Confederate Secretary of the Navy Stephen R. Mallory.
7. John Heart, former editor of the Charleston *Mercury*.
8. A native of N.J. married to a Virginian, Samuel Cooper resigned as U.S. adjutant-general in March and became adjutant and inspector-general of the Confederacy. He was a friend and intimate adviser of Jefferson Davis. Abraham Charles Meyers of Georgetown, S.C., colonel in the U.S. Army during the Mexican War, became quartermaster general of the Confederacy.
9. George Buist, principal surgeon at Forts Walker and Beauregard.
1. Henry E. Decie, the Englishman whose racing yacht *America* was rechristened the *Camilla* and used as a blockade runner in 1861–62.

terday a quantity of ladies called & then Mrs. Wigfall, &c, called but it was so hot & I could not stand it.

Dined with Hill, &c. Last night Washington called. Afterwards I met in Mrs. Memminger's room Mr. Edmonston & Mr. Staples—the latter a commissioner of Virginia. Mat Ward,[2] formerly of Texas, came to see me — & Ben McCulloch,[3] the Texan ranger. Mr. Staples said Virginia had no grievance. She came out on a point of honour. She would not see her sister states invaded. Anderson has been offered the Kentucky brigade. Will they raise one.

Gen. Beauregard & John Manning went off to day — no one knows where — Charleston?

I shall have no calls to day, I have dressed myself so nicely. Last night took tea with the Mallorys. Mrs. Mallory so foreign & piquante. We must go as soon as any thing is settled & see Mother. Last night I had an hour's talk with Browne, principally *literary*, &c. He told me how Russell ridiculed Mrs. Trescot[4] — how vulgar she was & how she screamed for the negroes *three* fields off.

[*May 10, 1861*]

Yesterday dined with the mess — but Judge Withers' absence worried me. Mrs. Glack Myer called, whose husband had his pistol coolly taken from him ⟨yesterday⟩ a few days since. Then I sat awhile with Mr. Mallory. Then Mr. Washington called & took tea with us. Then Mrs. Gen. Waul[5] & Col. or Major Beall — who married Fanny Hayne.[6] They came to see a Mrs. McLean who was a Miss *Sumner*[7] — cousin of Charles Sumner — so I did not speak to her, thinking she might resent the unpleasant way Mr. Chesnut spoke to her relative.

To day I breakfasted with the Mallorys — & had a two hours' talk with her afterwards. She is not all *American*.

2. Va. lawyer Waller Redd Staples was a member of the Confederate Congress following ratification of the Va. ordinance of secession on May 23. Matthias Ward was U.S. senator from Texas, 1858–59.
3. A U.S. marshal and colonel of Texas state troops, McCulloch was shortly commissioned a brigadier general in the C.S.A. and given command of Confederate forces in Ark.
4. Mrs. Eliza (Cuthbert) Trescot, wife of William Henry Trescot.
5. Mary (Simmons) Waul, wife of Thomas Neville Waul.
6. Col. Lloyd James Beall, commandant of the Confederate Marine Corps, had married Frances Alston Hayne, daughter of Elizabeth Laura (Alston) Hayne and Arthur Perroneau Hayne.
7. Margaret (Sumner) McLean, daughter of U.S. Army Maj. Gen. Edwin Vose Sumner and the wife of Lt. Eugene McLean of Md. Though his father-in-law was chosen to escort Lincoln to Washington, McLean resigned his commission when the war broke out and joined the C.S.A.

[*May 13, 1861*]

Dallas County, Alabama —Friday night. I heard the boat started at 8 or 10 o'clock & we came down, slept on the boat — where mosquitoes eat me up. Was really ill all night. Next day ill all day & so hot on the boat — got to Portland at dark, found every body drunk. Came 8 miles at night in a buggy in a road we did not know — scared to death — found Mother & Sally well, looking badly. T. B.[8] said there were 15 men in Dallas. Met *four* drunk.

Yesterday Langs, &c, came to see me, I feeling miserably — to day not much better ——

[*May 17, 1861*]

Was two days & nights on the river bank. What a time with the Hailes.[9] Mr. Robert Smith spent one day with us — he is handsome, *nice* & very agreeable — two more wretched days on the *Southern Republic*. Last night got here, Montgomery. Every body glad to see me. Sat up with Mallory & co. until eleven. Saw Mrs. Fitzpatrick. She says Jeff Davis is gloomy! Says we will be unmercifully whipped at *First*.[10]

[*May 18, 1861*]

Paid visits yesterday. Came home & found cards. Dined at table with the Florida *Mess*. What a dinner. I could only manage to eat cold asparagus — & black berries. Drove out with Mrs. Jeff Davis. *She* is very queer. She *preferred* Washington & her friends to being Mrs. President. I don't wonder! Came home at 8. Mr. Browne & Mallory insisted on my going to the reception at Mrs. Toombs' — but I did not. Mr. Hunter[1] called; sat some time. The Judge joined us.

A *nice* man Mr. H is — if he had been made president of the U.S.A., what would it not have saved us. Then Miles & then Judge Frost & then Jamison.[2] I had a pleasanter set than I should have had at the levee. Tho Mrs. Browne said every body asked for me. Mrs. Morast told me Mother & Sally were on the boat. They came to day on their way to

8. "Sally" is MBC's youngest sister, Sarah Amelia (Miller) Boykin. "T.B." is her husband, Thomas Edward Boykin, a first cousin of MBC.
9. Columbus and Ann Louisa (McCaa) Haile, MBC's first cousin, were natives of Camden who had recently moved to Dallas County.
10. Omitted here is a list of "Visits to be paid," nine women, most of whom were wives of Confederate politicians or prominent Montgomery planters and lawyers.
1. Robert Mercer Taliaferro Hunter of Va., Speaker of the U.S. House, 1839–41; U.S. senator, 1847–March 1861; and a member of the Provisional Confederate Congress.
2. Daniel Flavel Jamison, a Barnwell Dist. planter, had resigned his post as secretary of war in the S.C. Executive Council earlier in the month.

Conecuh. Mrs. Fitzpatrick & Miss Howell,[3] Mrs. Taylor, Jessie James, Mrs. Clayton[4] who told Washington news — how Maury[5] came to resign. Mr. Hunter says it would not be safe for even Mary Garnett to go to Hoboken.

How the Dodds must rejoice.

Mother & my maid Polly have gone. I with a horrid pain in the chest sit here so lonely ——

[*May 19, 1861*]

A.M. Sunday I laid in bed with pain in my chest. Saturday evening I had a row with the Floyds about my lock. Then drove out with Mrs. Farley, got caught in the rain & came home. Captain Ingraham came & sat with me. He is so *curious* — so enthusiastic in *our* cause & yet believing so the *old* Navy can whip any thing. Mr. Ward also called who wrote the poem on Mt. Vernon.[6] The Judge engrossed him, abusing every body. Sunday night the Wigfalls came & George Cross — who used to make love to me twenty years ago. Wigfall worse than ever.

[*May 20, 1861*]

Monday. I went after breakfast & spent the morning with Mrs. Davis. She gave me a delicious lunch. Poor famished creature that I was, I had not had a dinner for nearly a fortnight. Then called for Mrs. Wigfall & paid several visit[s]. Adjourned to [*one or two illegible words*] dram shop. Paid my washerwoman to pack for me. Saw Washington, Ingraham, Cruger & no end of men & heard them tell tales & discuss — every man has his own theory. Told [*two illegible words*]. To Brownes', Memmingers', &c — but *not* to Mr. Mallory who is *huffed* evidently.

Next day with *glad* heart left that abode of Misery, Montgomery Hall. Our compagnons de voyage were R. M. T. Hunter, Washington, Mr. Barnwell, Edward Boykin & Tom Lang & his wife. Two days never in my life have passed so rapidly & pleasantly. Every body *well* bred. No body disagreeable — nobody unkind — all clever, some remarkably so. Mr. C was more brilliant than I ever knew him. Mr. Hunter more genial — Mr. Barnwell, chatty, clever, *appreciative!* Came home — were

3. Margaret Graham Howell, Varina Davis's younger sister, was known in Confederate society for her keen conversation and caustic wit. MBC often called her "Maggie."

4. Mrs. Leona (Harper) Clayton was married to Philip Clayton of Ga., who had just resigned as assistant secretary of the U.S. treasury to fill the same post in the Confederacy.

5. Matthew Fontaine Maury of Va., who resigned from the U.S.N. on April 20 to become a commander in the C.S.N.

6. Thomas Ward, *A Month of Freedom, an American Poem* (1837).

joyfully greeted — but overcome with fatigue & the remains of indigestion brought from that den of horrors, Montgomery Hall.

England is on our side —I hope. Congress has been moved to Richmond. Mr. Chesnut considers it unwise. Kate Williams will not go to Buncombe. Here I am as unsettled as ever.

[*May 23, 1861*]

Thursday. Mulberry. Last night old Mr. Chesnut begged my husband never to leave him again — until he died.

> Nay rather steel thine aching heart,
> To act the martyr's sterner part,
> And watch with calm unshirking eye
> The darling visions as they die,
> Till all bright hopes & hues of day
> Have faded into twilight grey.
> Montgomery Hall[7]

I
What will you do Love?

What will you do love, when I am going,
 With white sail flowing,
 The seas beyond?

What will you do love when waves divide us
 And friends may chide us
 For being fond?

'Tho' waves divide us & friends be chiding,
 In faith abiding,
 I'll still be true;

And I'll pray for thee on the stormy ⟨sea⟩ ocean
 In deep devotion
 That's what I'll do!

II
What would you do, love if distant tidings
 Thy fond confidings
 Should undermine;

And I abiding neath sultry skies
 Should think other eyes
 Were bright as thine?

Oh name it not. Tho' guilt & shame
 Were on thy name,
 I'd still be true!

7. This unidentified poem, dubbed in the 1880s version "Byron*ish*," and the long poem that follows (also included by MBC in the manuscript of the 1880s version) may be her own work.

But that heart of thine, should another share it,
 I could not bear it,
 What would I do?

III

What would you do love, when home returning,
 With Hopes high burning,
 With wealth for you, —

If my bark, that bounded o'er foreign foam
 Should be lost near home —
 Oh what would you do!

So thou wert spared I'd bless the morrow
 In want & sorrow
 That left me you!

And I'd welcome thee from the wasting billow
 My heart thy pillow! —
 That's what I'd do —

[*May 25, 1861*]

Yesterday went to Kirkwood. There had a delightful visit; heard my two cousins were about to ⟨make striking matches⟩ marry — M. W. B. to marry Edward Cantey, M. McR. B. to marry Libby Cureton[8] — ⟨two common *vulgar* men⟩. Found Mary Kirkland as lovely as ever.

In the evening our fighting parson came to see us. *Read* Byron's "Siege of Ishmael"[9] & a quantity of poetry. Newspapers with nothing in them at night. Met John Darby[1] on the cars & he told me a wonderful tale of his double escape from hanging at Philadelphia for being a Southern man & *here* at Atlanta for being a *Northerner* — *rope* was ready.

Wrote to Kate, Mother, & Miss Cunningham, & Lena. Today looking over Library.

[*May 26–28, 1861*]

One day here is so like another I forget I have a journal — & at Montgomery & Charleston, *events*, witticisms, &c, are so rapidly following each other's heels I have no time to record them.

The news now is — a fight imminent at Harpers Ferry & at Norfolk. Beauregard is at Norfolk & if I was a man I should be there too! Sixty

8. Mary Whitaker Boykin married Edward Alfred Brevard Cantey of Kershaw Dist.; Mary Boykin, daughter of Burwell Boykin, married Everard B. Cureton, a Kershaw Dist. slaveholder and son of planter James Belton Cureton.
9. "Siege of Ishmael" is in Cantos 7 and 8 of Lord Byron's *Don Juan* (1819–24).
1. Dr. John Thomson Darby, twenty-four, was the son of a noted physician, planter, and member of the S.C. secession convention from Orangeburg Dist.

of our cavalry have been taken by Sherman's Brigade.[2] A man named Jackson shot Ellsworth,[3] the Col. of the Zouave Regiment at Alexandria, for cutting down the Confederate flag. Thirty odd of Tom Boykin's men have come home because they were not given rifles but musket[s] — miserable cowards. Mr. & Mrs. Chesnut are at Mrs. Reynolds'. We are here — if this world has one ray of sunshine, I do not know where to find it. Vanity, vanity & vexation of spirit.

Yesterday was up at Aunt Betsey's; found Mary well — but the baby ill. John was here last night — but left me to day so quietly I suppose he is offended with me. I was told last night that I was a ⟨⟨[*several illegible words*] because I told an impolite fable terrible⟩⟩.

List Silver to be left in Bank —

2 waiters	12 ⟨silver⟩ forks
10 spoons — tea	1 ⟨silver⟩ cake knife
2 Ladles	1 Knife, &c
18 Spoons — large	12 gold spoons
4 spoon[s] salt	1 Pitcher
1 sugar tongs	1 Sugar dish
2 butter knives	1 Milk Jug
2 Shell spoons	1 Coffee pot
3 pickle forks	1 Large Pitcher

Reading *Say & Seal.*[4] New England *piety* & love making — *pie* making. Such baking & brewing — house maid's duties elevated to the highest scale of human refinement. The Christian Hero quoting scripture & making love with equal *unction.* Never takes a kiss without a text to back him — & every *embrace* & every kiss is duly chronicled, *several* a page — & not one *breakfast,* dinner or *tea* spared the reader. The hero who manfully admires the heroine through her butter making, pie making, cooking, & bed making, scrubbing, &c, is finally dreadfully shocked to find she clandestinely makes dresses.

Read Lord Byron & *Guesses at Truth.*[5]

2. Only about half this number were captured by Maj. Thomas West Sherman, U.S.A., during the seizure of Alexandria.

3. On May 24, the day after the secession of Va., U.S. troops seized Alexandria, Va. One of the invaders, Col. Elmer Ephraim Ellsworth, took down a Confederate flag flying from the roof of a hotel. He was killed coming downstairs by the hotelkeeper, James W. Jackson, who was then shot by a Federal private.

4. *Say and Seal* (1860) published under the pseudonyms Elizabeth Wetherell and Amy Lothrop by two sisters from N.Y., Anna Bartlett Warner and Susan Bogert Warner.

5. Julius C. and Augustus W. Hare frequently revised their popular work *Guesses at Truth* (1827). MBC probably had the 1861 edition.

[*May 30–31, 1861*]

Alone at Sandy Hill[6] — where every thing good was first emptied out of me. This is the end of the farce & sentimental talk of Mr. Chesnut's family. "They could never bear him out of sight"; "he must never leave them." "Just recovering [from] the shock of his joining Beauregard," & *now,* three days after his return for so short a rest at home, go to spend a week with Mrs. Reynolds who is always here — & who never since she was made sacrificed one instant or one wish to their pleasure, & leave us *alone* at Sandy Hill. I am happier far without *them* — but for the life of me can not help wondering at such bare face[d] *cant,* &c.

Read Thornbury's *Spain*[7] all day yesterday — feel so miserably about our troops in Virginia. If I was a *man* I would not doze & drink & drivel here until the fight is over in Virginia. John Chesnut came down yesterday, to go to Virginia as a *private* next Saturday. Poor John — that is the end of *all* your consultings. My advice last January was to take all the money (*he has wasted* since) & make a company of his own — he was counselled against it — & here it is *now*. These people make me weary of *humanity*. Never know their own minds ten minutes. Can have no desire — no plan — no enterprise strong enough not to act. Stopped by an obstacle that would not deter a chicken. John has come down to make his will & leave his property to educate his sister's children — the only sensible thing I have heard or *unselfish* one I have heard for many a long day. "As thy day so shall thy strength be" — Mrs. Lowndes quoted [that] when she heard *we* had seceded.

[*June 1–2, 1861*]

Friday I paid two visits, Uncle B & Uncle H's — found Aunt S. B. *miserable*. Negroes ill with typhus fever. Had news from Burwell. John going to the wars[8] — & *Seb* Cureton in the house *calling* on his fiancée. She told me one *miserable* thing. They say the poor white people say why should they fight for the rich people's property. Aunt S. H.[9] wanted to talk of her *Mary* & her unfortunate engagement — but Mrs. Gibbes'[1] presence prevented. Came home & found it still in *solitude*. We are left alone here! After all the row of wanting us to be with them.

6. A plantation three miles east of Mulberry, used as a summer retreat by the Chesnuts.
7. Walter Thornbury, *Life in Spain: Past and Present* (1860).
8. Burwell Boykin, younger brother of MBC's mother, Mary (Boykin) Miller, was a Kershaw Dist. planter. His wife was known as "Aunt Sally B." John was the son of Burwell Boykin.
9. Sarah Jones Boykin, the wife of MBC's uncle, Alexander Hamilton Boykin, and the mother of Mary Whitaker Boykin.
1. Caroline Elizabeth (Guignard) Gibbes, wife of S.C. Surgeon General Robert Wilson Gibbes.

John C came in high spirits; is to take fifteen men. Gave me a memento of pearl buttons — poor John — he has been so affectionate, so kind, so respectful to me, I part with him with a pang — the only one of my *kin in law* for whom I care one particle.

Yesterday I went to Kirkwood; found Kate & her *five* lovely children. David & I went to say good bye to John C. Saw the *cars* go — great crowd there.

Dined at Judge Withers' — he meant to *cut* me several times at dinner, but I take care of myself. Kate is looking so sweetly — & her *manners* are beyond praise. Darling little baby — little Kate. Mr. Chesnut came in the evening. I said as I was coming down some *ugly* things of those Reynoldses — the very name sets my teeth on edge. I was very sorry afterwards. Then I said I detested Dr. R as his Mother should do any man who murdered those sixteen children she is so proud of having given birth to — but I ought not to have said *that*. Mrs. Chesnut would not be so unchristian as to *hate* any one for killing her children. She would find out some good excuse they had for such a performance.

Today, Sunday, I sit here *alone* — too ill to go & spend the day with Kate — besides she is so bright & happy & I am so miserable. Davin[2] has been put in jail for *treason*. Dean & Davis accomplices. What will be done with him I can't say — our town's people are *incapables*.

Beauregard has gone to take command of S C troops.

[*June 3–4, 1861*]

Sunday evening Uncle John[3] & Uncle Burwell came to see us — such nice good old country gentlemen — so simple minded. Poor Uncle B — after a life of such ease & happiness, what a dismal ending this sudden bursting out of the terrible ⟨mad Lang malady⟩ in his family will cause him.

Monday. I went up — met Kate at Mrs. Reynolds'. Mrs. Chesnut in a *gale* of spirits. I told them a great many *home truths* — in the shape of jokes. Kate & I then went to Cool Spring[4] — found things *nicer* but smaller than I expected.

[*June 5–7, 1861*]

Tuesday Kate & I moved to Cool Spring & worked hard all day — lived picnic *style*. Wednesday morning I hurried to Mulberry to bring

2. Contemporary newspaper accounts indicate that JC, William Shannon, and T. J. Withers were all involved in the arrest and trial of a Camden music teacher named "Devine" on charges of treason. No accomplices were mentioned.

3. John Boykin, a Kershaw Dist. planter, was an elder brother of MBC's mother, Mary (Boykin) Miller.

4. Plantation home of MBC's nephew John Chesnut.

Kate some housekeeping materials. Met Mr. C on the way & returned *here*. Wednesday we went up, he to try Davin for treason & I to Cool Spring. Sold my side board & waiters to Aunt B for 85 dollars. Mary K, looking lovely, went with me to C S. The Curetons had been to see Kate. Aunt Betsey *resents* my saying Kate is childish for seventeen. Came back Mrs. Reynolds, who is an intolerable woman to me. Saw Mrs. C who is in a world of sentimental *love* at Mr. C's going away. The old gentleman really dislikes it — says he is so feeble, &c.

Davin banished. I am not satisfied with the verdict. Mr. C says one of the finest meetings he ever attended. Some of the malcontents present. Not settled if I am to go to Virginia.

Mrs. Wigfall answered my telegraph. I sent this message: "Where are you *& where* shrieks the wild sea mew?"[5]

She answers, "Sea mew at Spotswood — will shriek soon. I will remain here — C. M. Wigfall." Also a long letter from dear little Johnny — he is as far as Richmond & in fine spirits.

> The time hath been, when no harsh sound would fall
> From lips that now may seem imbued with gall,
> Nor fools no follies tempt me to despise
> The meanest thing that craw[l]ed beneath my eyes;
> But now so callous grown, so changed since youth
> I've learned to think & sternly speak the truth.
> <div align="right">Sandy Hill, June 7th 1861[6]</div>

"Much may be said on both sides."

> But of all plagues, good Heaven, thy wrath can send,
> Save, *save* oh save me from a *Candid friend!*
> <div align="right">Canning[7]</div>

As for feasts of reason & for flow of soul, is it not a question whether any such flows & feasts are necessary between man & wife? How many men can truly assert that they ever enjoy connubial flows of soul or that feasts of reason are in their nature enjoyable? Trollope

My wife exasperates me in many things; in getting up at insane hours to go to early church — in looking at me in a particular way at dinner, when I am about to eat one of those entrés which Dr. Goodenough declares disagree with me. In nothing more than in that obstinate silence, which she persists in maintaining sometimes when I am abusing people, whom I do not like, whom she does not like & who abuse me — this reticence makes me wild! Thackeray

5. Lord Byron, *Childe Harold*, Canto 1, stanza 13.
6. Probably MBC's own poem.
7. Fifteen lines of "The New Morality," a poem by George Canning (1770–1827), are omitted here. The last two lines quoted by MBC are retained.

All those good things about people & against people! Never my dear young friend say them to any body — not to a stranger, for he will go away & tell — not to the mistress of your affections, for you may quarrel with her & then she will tell — not to your son, for the artless child will return to his school fellows & say, "Papa says Mr. B is a muff." My child, praise every body — smile on every body; & in return every body will smile on you, a sham smile — & hold you out a sham hand — & in a word esteem you as you deserve. *No,* I think you & I will take the ups & the downs, the roughs & the smooths of this daily existence & conversation. We will praise those whom we like tho nobody repeat our kind sayings — & say our say about those we do not like tho we are pretty sure our words will be carried by tale bearers, & increased & multiplied & remembered long after we have forgotten them.

<div align="right">Thackeray</div>

I think the surest sign that a great battle is at hand, of our seeking if not Gen. Scott's, is that Davis has ordered away 2,800 men from Bragg at Pensacola.[8]

Douglas[9] is dead — killed by the times I think.

The lovely Mrs. Douglas is *free* — & *poor* I am afraid.

I think this nation was like Blanch among "il me faut des emotions." We had all led such prosperous quiet uneventful lives — we were ready to rush into any thing for change & excitment — even as the six hundred rushed "into the Jaws of Hell."[1]

These foolish Charleston people showing the same thin skinned sensitiveness to what any stray Englishman says that the English have always so ridiculed in the Yankees. All Britons come here to make a book armed with three things, "pen, paper, & prejudices," & Russell seems to me to be far more free from the latter than any. He has made some unavoidable mistakes to a foreigner — but his letter is far better for us than we had any right to expect from the history of the past of letter writers. One thing he said — our people were so *fine looking,* it contradicted the idea that white men could not live in this country.

What nonsense. The parts where white men grow so happily are not the parts where rice & cotton are made — & he forgets that the manly fellows he saw about the Mills house would be killed by one night between May & December where thousands of Negroes are working the fields. Not to speak of their fate if they braved not only night air & malaria but if they attempted *work* under our tropical sun. I wonder a man who knows India could make such a mistake. Besides, these fine

8. Confederate Brig. Gen. Braxton Bragg of N.C. commanded the coast between Pensacola and Mobile.

9. Stephen Arnold Douglas of Ill. In 1856, Douglas, a widower, married the popular Adèle Cutts.

1. From Tennyson's "The Charge of the Light Brigade," stanza 3.

specimens in this hot climate, hither to it has been Newport, Sarotoga, Europe — & now it must be Flat Rock, Buncombe, White Sulphur,[2] &c, &c.

Mac Brevard is dead.

One very good thing I do not think I have recorded. While the enemy's boats were over the bar, a Negro brought his little sloop in. When asked if he was not afraid, he answered, "if Mass Anderson fire at me *he know* he would hear from Massa *shure.*" Faith for you.

Willie Preston[3] shot down the flag staff, he said, at the first shot from Sumter at Fort Moultrie — it knocked the cotton bales up. Some body said, "cotton is rising." When the next shot hit the kitchen chimney & smashed up that department, they added, *"breadstuff* is falling." Quite cool for raw militia.

John C has telegraphed for his servant. Dear John. Was invited last week to Louisa Ingraham's wedding to Jasper Whiting.[4]

Ben Huger is made a Brigadier General — & says he wants to wash out his disgrace in his blood. He it was advised Anderson to move from Moultrie to Sumter — the doubledeed traitor. Saw a good thing to day about the phrase printing kisses. Their man thought if they were printed & left the print there would be some not taken ——

Major Emory[5] left his resignation in the hands of his brother who sent it in the day after the Baltimore row. His wife, finding Maryland did not mean to secede, went to the President's & asked for his resignation back again — but she was refused. *So* Emory is out of the U.S.A. & Jeff Davis will do something handsome for him. Mrs. Emory is Mrs. Davis' best beloved friend — & the cleverest woman in America — & a *flirt*.

Edward Boykin told me he heard that old beast of a Camden De-Leon brag of his having given me that silver Gondola. I wish he had it back.

My husband's going to the war makes me miserable!

> And yet I hate that he should linger here;
> I cannot love my lord & not his name.
> And liefer had I gird his harness on him,

2. The fashionable western Va. (now West Va.) resort. In 1875 MBC added: " '75 These men camped all summer in the low country unharmed by malaria."
3. William Campbell Preston, Jr., a lieutenant of the First S.C. Artillery at Fort Moultrie, was the son of John Smith Preston and Caroline (Hampton) Preston.
4. Louisa was the daughter of Capt. Duncan Ingraham, and Jasper was the son of Major William H.C. Whiting.
5. After resigning on May 9, Lt. Col. William Hemsley Emory accepted another commission as lieutenant colonel of Union cavalry on May 14. His wife was Matilda (Bache) Emory of Md.

And ride with him to battle & stand by,
And watch his mightful hand striking great blows
At caitiffs & at wrongers of the world.
Far better were I laid in the black earth,
Not hearing any more his noble voice,
Not to be folded more in these dear arms,
And darkened from the high light in his eyes,
Than that my Lord through me should suffer shame.[6]

Enid

So feeling, I used not one word to prevent his going — because I knew
he ought to be there.

[*June 8–10, 1861*]

On Saturday I drove madly to Camden for things for Mr. C. Met his
father who does *not* show love as I would by *doing things* for him. Then
we went to Mulberry, drove home — talked & had had a charming day
tête à tête. Undiminished *peace*. Not a jar.

Sunday staid at home. David & Kate dined with us — Miller & Daby.[7]
Mrs. Williams as lovely & agreeable as ever. *Not* one of my husband's
friends & relations come near. In the afternoon — Uncle H sent for us.
We drove over — found him looking as if he had been in a frolic for a
month. Bragged. I did not hear many things out there I have seen in
the newspapers. Came home — & talked until mid night.

Monday — went up to Camden with my husband. Saw no end of men
& heard their nonsense. Bishop Davis[8] said from my voice I was *dis-
gusted*. I said it is too near home. Strained my eyes — & waved my
handkerchief to *JC, Jr.* Saw him bid his loving, cool blooded family
farewell. No soul came to see him off but Miss Sally C & myself. Came
back & tried every thing but feel too badly. Next I am to go & stay all
night at Uncle B's — *then* I am to go to Richmond with A. H. B.[9]

[*June 11–12, 1861*]

Tuesday — spent at Aunt B's. Kate ill with sore throat — & miserably
despondent. Found Kate Williams there — & Dr. Boykin. The latter
brought Charleston news. All privateering mad there. The *Savannah* has
been captured — & the Charleston *Mercury* will execute a fearful ven-

6. Taken from the first section of Tennyson's *Idylls of the King* (1859).
7. Stephen Miller and David Rogerson, the children of Kate and David Williams. "Daby"
 is MBC's nickname for her nephew David.
8. Thomas Frederick Davis, Sr., had been pastor of the Grace Episcopal Church of Cam-
 den since 1846 and bishop of the diocese of S.C. since 1853.
9. "Uncle B" is Burwell Boykin and "A. H. B." is Alexander Hamilton Boykin.

geance if a hair of their head is hurt![1] Arrangements made for sending Devine to Fort Sumter. Went down in the afternoon & found Kate better. Came back & talked French with the German teacher. Newspapers full of details of army movements.

Today went to Camden to give Wm. E. Johnson[2] some papers for Mr. C — he told me to go & see Mrs. Johnson, his wife. She was a good creature. "Nothing in her! but honest & simple hearted!" he said. Miss McEwen told me Mrs. Kershaw[3] sat alone in the dark with bare arms & low neck covered with bracelets & ear rings & necklaces of Joe's hair.

Uncle H still the hero of Camden. Tom Shannon says when Beauregard's report came out Willie Ancrum[4] said, "Why Tom, I do not see any mention of you & Ham Boykin." Pompum cum swellum. Judge Withers has resigned his seat in Congress. What a man.

Mary ill to day with sore throat. Made a visit to Mary Boykin[5] — found her kind as ever, Charlotte lovely. A pleasant hour. Promised books, &c, drank Alex Matheson's[6] wine. Col. Magruder conquered the enemy at Bethel Church; killed three hundred — but retreated.[7]

[*June 13, 1861*]

Last night an hour's conversation in French with Mr. Bormann[8] — he says I speak correctly but too *slowly*. Not my *fault* in English. To day too languid for church. Wrote two long letters, one to John C, one to Mother. Another investigation of what Mr. Bormann is doing with those children — he is too absurd. Reading Cooper's Naval History.[9] Remembering the dates: moved into Frogvale, 1848; into Kamchatka, 1854;[1] sold, 1859; spent 1859 at Sandy Hill in the summer — the previous winter in Washington; "60" in Washington, Hoboken, White Sul-

1. The *Savannah*, a Charleston privateer, was captured by the USS *Perry* on June 3. Since President Lincoln had already declared his intention to treat such captives not as prisoners of war but as pirates, the fate of the captain and his 13-man crew was highly uncertain.
2. Johnson had been president of the Bank of Camden since 1845.
3. Lucretia (Douglas) Kershaw, wife of Joseph Brevard Kershaw.
4. Thomas English Shannon and William Alexander Ancrum were Camden planters and close friends of the Chesnuts.
5. Mary Chesnut (Lang) Boykin was the wife of Dr. Edward M. Boykin and a first cousin once removed of JC.
6. Alexander Matheson, a Camden merchant and storekeeper.
7. Only 18 Union troops fell June 10 in the first land battle of the war, fought on the peninsula southeast of Richmond. Confederate commander John Bankhead Magruder of Va. claimed a major victory, however, and won promotion to brigadier general a week later.
8. The Williams children's language tutor.
9. James Fenimore Cooper, *The History of the Navy of the United States of America* (1839).
1. The names of Camden homes JC and MBC built.

phur, Sweet Springs, & Sandy Hill, Florida, Charleston, Combahee; 61, Montgomery, Charleston & Sandy Hill & Cool Spring. Read *Passion & Principle*, Edward Musgrave, Theodore Hook.[2]

> Walter Thornbury —
> Slow to grow — long to last
> Quick to grow — quick to pass.

The fable of the Hare & the Tortoise — the flower & the oak. *Republic of America.*

> Naught can make us rue
> If to ourselves we be *bold* & true.[3]

Montgomery — "What a contempt the man who has been in a place a day has for the man who has just arrived."

In every day's journey there are three leagues of heart breaking.
 Spanish proverb.

Frightened partridge, half cooked!

[*June 14–15, 1861*]

Friday. Spent the morning at Aunt B's. She shows every now & then that Mr. Chesnut has been accused of *something* by the Judge. May[4] very ill with sore throat. Came home, was bored to death by the *French* German teacher. In the afternoon the Curetons — he gave amusing memories of Tom Ancrum.[5] I really love to see any thing done *well* — & in that department of life Cureton is perfect. Read all the afternoon. Si jeunesse savait, si vieillesse pourvait.

Jim Villepigue[6] accuses Robert E. Lee of being at heart against us. He says euphuistic Joe Kershaw begged Beauregard to change the name of the place he is stationed — did not think Bull Run would fill pleasantly the trump of future fame. But Beauregard said the South Carolinians are proud of *Cowpens*[7]; why [be] ashamed of Bull Run. I came here to day — Sandy Hill — found Mrs. Chesnut raving of Mt. Vernon & what was due our Northern *sisters. We* ought not to take possession of it but let them have their share. Miss Sally was whimpering about being separated from "her only sister," Mrs. Reynolds. She seemed to

2. Theodore Hook was an English novelist, magazine editor, and satirist.
3. A play on the last lines of Shakespeare's *King John*.
4. Mary (Withers) Kirkland.
5. Thomas James Ancrum, a Camden planter, Willie Ancrum's brother.
6. James Irwin Villepigue, a prosperous Camden merchant.
7. The site of Brig. Gen. Daniel Morgan's decisive victory over British troops in January 1781.

think *I* thought her father was worried at his son's absence & she informed David & I that nothing ever *distressed* her father not connected with her Mother. 〈〈*Interlinear insertion of several illegible words, followed by five exclamation points.*〉〉 I had such a surfeit of them that I came here to be in peace — the *school house.*

I have been reading the account of Magruder's victory at Bethel's Church. One poor young man found dead with a shot through his heart had a Bible in his pocket in which was written: "Given to the defender of his country by the Bible Society."

How *dare* men mix up the Bible so with their own *bad* passions.

Merciful God! forgive me if I *fail.* Can I respect what is not respectable. Can I *honor* what is dishonorable. *Rachel* — & *her brood* — make this place a horrid nightmare to me.[8] I believe in nothing with this before me.

[*June 16–17, 1861*]

My husband's letter yesterday brought little comfort — for he says every thing is in confusion in Richmond. He slept in the bed with Mr. Henry Marshall with a quantity of other men in the room. Mrs. Wigfall will write to me & her letter will determine my plans. Jim Villepique brought the news that Robert E. Lee was suspected! Mr. Kirkland states private letters say he is to be tried. I do not believe it.

James Kirkpatrick[9] writes that a butcher has been taken up for supplying the blockading fleet & for giving the notice which captured the *Savannah!* The papers do not speak of it — if true I suppose *he* will hang. Nancy's baby died to day. I was *ill* yesterday & all night — with nervous headache, &c — how one can suffer. To day feeble in mind & body. Wrote to Chesnut by James Villepigue — gave David the letter to give him, but as he never yet has attended to any thing in person, fear he may forget.

Saw in church many persons. Nobody spoke to me but Mary Hammy & Sam Shannon. Miss Susan Lang[1] came to day — received her in my room. Still an invalid. Latest news says Harpers Ferry evacuated. I dare say Mr. Chesnut slipped through Richmond hiding for fear any one should see him. Spent the day looking over my things — getting ready for a visit to Virginia — 'tho' not very hopeful of one.

8. See prior reference to "Rachel" and "Leah" (p. 42). She seems to be making an indirect reference to the commandment "Honor thy father and mother" It is her father-in-law she has in mind.
9. James L. Kirkpatrick, Presbyterian minister in Charleston.
1. One of two spinsters living together in Camden, nieces of wealthy Kershaw planter Thomas Lang, Sr.

The "union defense committee" in New York rules the country. It is an illegal, irresponsible revolutionary body, who form really the de facto government of the United States.[2]

Have been reading all day Cooper's Naval History — read the repulse of the British at Fort Moultrie.

[*June 18, 1861*]

Yesterday afternoon Kate & Tanny[3] came — then Charlotte & Mary Boykin. I felt so weak when I attempted to dress. The *Mercury* last night was filled by an article complaining of Barnwell Rhett's want of a place — *in fact* if not by name. What an exasperating paper. The fight at Manassas Junction is imminent & by what ever name I may call my disease I shall not feel well again until it is over & JC safe. Not one wink did I sleep last night. Still the report gains ground that Harpers Ferry has been evacuated. Gregory & Lindsay are speaking for us in England.[4] Last night received a telegram from B. Heyward saying he was going at 3 today by Charlotte to Richmond. I had half my clothes at Sandy Hill — & was ill. Still I regret I could not go.

The German teacher asked me to day if I remained in my room & if I was always engaged in la lecture & l'écriture. I said *no.* Today I made a jar of pickles — made a pudding — had the *cows* fed & went out to give Molly's baby physic. My occupations are *decidedly* diversified. Read Emerson all day when Kate was not talking to me. No news — & I dare not think.

Napoleon says two armies always try to frighten each other & the best general is the one who takes advantage of the first *panic.*

I have begun a dozen books but I read nothing long.

[*June 19–20, 1861*]

The evening of the 18th was spent as usual with the papers. Russell's letters filled with *absurdities* — rubbish about our wanting an English prince to reign over us — & *fairly* intimates that the arming, &c, at the North scared us. I wonder if he will describe Mrs. Davis' drawing room.

Yesterday I went to Camden, got Mrs. Wigfall's letter, & commenced to get ready for Virginia. Saw some disbanded troops. Saw Uncle H — he goes on Thursday, takes troops with him & his daughter Mary. I

2. New York City's Union Defense Committee was established at a city-wide mass meeting on April 22 in order to raise funds for the equipment of local regiments.
3. William Randolph Withers, the 15-year-old son of Judge Withers.
4. Sir William Henry Gregory and William Schaw Lindsay were the leaders of the small group in Parliament who urged their government to give full diplomatic recognition to the Confederacy.

have concluded to go with Mr. Meynardie[5] — & [have] so written to Mary Hammy & Mrs. Wigfall. Also had a preposterous letter from a Mrs. Bradford[6] & answered it as *absurdly*. Saw by a letter writer in the *Mercury* that JC was at Manassas with Beauregard.

[*June 21, 1861*]

Was busy with needle work all day yesterday. Mary & Mr. K called in the evening. Nothing new except battle seems to hang over Virginia at every point — & I go on Monday if possible.

Mr. Isaac Hayne has answered Russell himself. I have the Anglo Mania as strong as anyone but Russell's letters are too much for me. Still if Russell thinks them worth the trouble he will ridicule the thin skinned sensitiveness of our people who, instead of laughing at his absurdities, are in solemn fits of indignation — & vociferous protest.

I said every man in ⟨America⟩ S C was willing for a monarchy if *he* (himself) could be King — but not otherwise. Telegram from the North or rather Virginia more *Lowering*.

[*June 21–23, 1861*]

Friday afternoon Dr. Boykin called, but he came early while it was *so hot* I did not dress, & when I got out the newspapers came. *Now* newspapers have precedence of all things, so we had no chat.

Saturday morning I heard from Mr. Chesnut — dated 16th June. Rather gloomy. They need a general in chief. Wants his gun, &c. We may not go with Mr. Meynardie until Wednesday. What a bore vacillation is.

Mrs. Chesnut seems distressed at not being able to hear from Mrs. Binney — but the only way I care to hear of the Binneys is to hear Mr. B & Horace[7] have been made to repent *that* letter in the *Intelligencer*. They care very little at Sandy Hill but for *themselves*.

I woke in the night, heard such a commotion, such loud talking of a crowd — I rushed out, thinking what could they have heard from Virginia, but found only Mrs. Chesnut had smelled a *Smell* — & roused the whole *yard*. One of Col. Chesnut's negroes was taken yesterday with a pistol.

5. E. J. Meynardie of Camden was going to Richmond as the chaplain in Kershaw's Regiment.
6. Louisiana (Taul) Bradford was the wife of Jacob Tipton Bradford, the Confederate commissioner of public lands for Ala.
7. Old Mrs. Chesnut's youngest sister, Elizabeth (Cox) Binney, was the wife of Horace Binney, noted Philadelphia jurist. His support for Lincoln's suspension of the writ of habeas corpus helped give the measure the legitimacy it so badly needed. Horace Binney, Jr., was his son and legal associate.

They do not send for the *papers* down there at *night* — & do not care for them. Say if any thing happens they will hear it soon enough. Saw Mrs. Lee to day — & Mrs. John DeSaussure[8] bade God bless me. I felt quite pleased; generally Camden people are so cold. Took Miller to Sandy Hill with me.

[*June 27, 1861*]

Richmond.

Monday the 24th I left Camden *hot* & dusty, under Mr. Meynardie's care — with Mary Boykin & two Yankee school mistresses. Mr. Meynardie I found very attentive — & a good kind man, slightly *show off* — evidently pleased at the grandees I introduced him to. At Kingsville Tom Waties took charge & at Florence I met Keitt & his family. Mrs. Keitt spanked her *baby well* several times — evidently a bad tempered woman. Keitt had long talks with me, evidently thinks Jeff Davis a failure. Thinks they are playing *Cabinet* to a ridiculous degree. Soldiers all the time. Wrote a note on the cars to Major Jones & himself not to *talk* against the administration for there were Yankees on board. Ashmore[9] was *then* humbled & *miserable*. I felt sorry for him. Keitt says Mr. Chesnut made Jeff Davis *president* — that his vote turned the South Carolina delegation. At the depot here I met Mr. Mallory & Eddie Felder got a carriage for us & we came up. Garnett & Wigfall rushed to me at the carriage door. Mrs. Wigfall had rooms for us. We stayed the first night in Mrs. Preston's room. Wednesday my husband came. We dined with the President. Mrs. Davis & himself are ⟨coarse⟩ talking people. Mr. Marshall came to see me, Mrs. Waul, the Brownes, &c, &c.

Mrs. Wigfall gave me an account of her quarrel with Mrs. Davis — & the amende & her present.[1] Mr. Chesnut sent by Beauregard for more ammunition & Davis says they have enough there. Last night Garnett & Lamar[2] called — the latter, saying he only *meant* to stay five minutes, stayed until *12*. He gave the same account of the Davis' as Mrs. Wigfall — ditto Garnett.

The President ridiculed Beauregard's staff — & both Mr. C & I answered. The president said who ever they did not know how to fit out,

8. Mrs. Catharine (Clark) Lee, widow of Camden dentist Dr. Joseph Lee; Eliza Hester (Champion) DeSaussure, wife of wealthy Camden planter John McPherson De-Saussure.

9. John Durant Ashmore of Anderson Dist., S.C., a former U.S. congressman.

1. *Amende* and *present* are French dueling terms.

2. Former U.S. congressman Lucius Quintus Cincinnatus Lamar was the author of the Miss. Ordinance of Secession and lieutenant colonel of the Nineteenth Miss. Regiment.

they sent to Beauregard's staff. Mr. C told him they had not enough red tape in his *shop* to measure Beauregard's staff.

Wigfall has lost caste here by being a ⟨*one illegible word underscored*⟩ of the President's. Poor Mrs. *W.* She feels her position. Mr. Chesnut eats at his *own* table. Lamar seemed so glad to see me. Mrs. Davis says she is so attentive to Mrs. P because she adores rich people. [*Following sentence added later:*] Mrs. Wigfall says all this. What a woman; her crony now is a Mrs. McLean who is a fast woman who is here making interest for a Captain *Blake,* a man who has made her much scandalized already, & her husband on Johnston's staff. Johnston has not attacked Cadwalader & McClellan[3] because he has not ammunition *enough!* What a *War* department.

Captain Ingraham was so glad to see me. They are so busy playing *court* here they forget the war *altogether* — these women! Mr. Chesnut goes back to morrow. I have had a long talk with Mrs. McLean. She is very clever. Mrs. Davis sent to Mrs. Montgomery Blair[4] a dress for her baby, & Mrs. Blair sent her in return a letter of thanks in which she said if their husbands killed each other they would love each other to their graves.

[*Following phrase added later:*] Richmond scandal.

[*June 28, 1861*]

Yesterday, for fear of giving offence, had to take tea a second time with Mrs. Davis. She was not civil enough, kept me bandied about for a seat — but I would not tell Mr. C. He was annoyed enough before. Captain Hartstene called. They say he is crazy but I can see nothing of it. Then Mr. Henry Marshall, who is frantic about Gregg's regiment, offers himself as security for the guns, tents, &c, if Pickens will let them keep them. Louis Wigfall kept Mr. C to day. The president & I had a long talk — he is despondent, does not see the end of this thing! Gives the north credit for *courage* — says they will fight like devils. Still harping on the *staff* business — says Mr. C ought to have gotten up a regiment. (So he ought!)

Mrs. Bradley Johnson[5] says she knew me in Washington. I carried

3. Brig. Gen. Joseph Eggleston Johnston of Va. was commander of the Army of the Shenandoah. Maj. Gen. George Brinton McClellan commanded the Union forces which had moved into western Va. from Ohio. George Cadwalader, Maj. Gen. of Penn. Volunteers, was second in command of the Union troops in the lower Shenandoah Valley.

4. Mary Elizabeth (Woodbury) Blair, the wife of Lincoln's postmaster general. The Davises and the Blairs had been close friends in Washington.

5. Jane Claudia (Saunders) Johnson was the wife of Bradley Tyler Johnson, organizer and major of the First Md. Regiment.

her to Miss Lane's levee. She is a heroine now with her husband's regiment which she procured rifles for — & new clothes. Mr. Mallory & Mrs. McLean were having queer jokes because Mrs. McLean's key was found in Mr. M's pocket. What people. To day was introduced to Mrs. Bartow[6] by Capt. Hartstene — & then drove with Mrs. Preston & made purchases.

Yesterday found a book I ⟨bought⟩ borrowed was an old one by a new name. *Basil* it was — now it is *The Crossed Path*. Today I bought *Westward Ho* — & I find it is *Sir Amyas Leigh* of Kingsley,[7] an old friend with a new face. Have been reading all day *Soulouque* — the Emperor of Haiti.[8]

Mr C goes tomorrow with Mr. Marshall.

Mrs. Preston reiterates the cry for ammunition from the camps.

[*July 3, 1861*]

My husband left me — & from that time until today, July 3rd, I have had no keys to open my lock & so could not write in my journal. I continue to dine at Mrs. ⟨Preston's⟩ Davis' table but it is not pleasant. Saturday we drove to the camps — Mrs. Preston, Mrs. Wigfall & I [and] Mary Boykin. It was really beautiful. The president on his grey horse, Wigfall & Col. Davis[9] — & *Gen. Lee,* who is the picture of a soldier.

That night Geo. Deas — as pleasant as ever, Smith Lee, &c, came — no end of people. I was told poor Lamar had an apoplexy or paralysis. Sunday I called at his door opposite Mrs. Preston's & he insisted on my coming in — seemed so glad & so grateful. Florence Nightingale would not do with *our* men. They are too excitable — he could scarcely speak, did not know that he would live the night through, & yet he said such things. I asked if he felt better — & he answered, *"already* your being in here would *cure* anyone," & then apologized for being *ill* & not bringing me those letters, poor fellow, & murmured how he had always respected & admired & loved me. Mrs. Johnson who was with me &

6. Louisa (Berrien) Bartow, wife of Francis S. Bartow. Her father, John MacPherson Berrien of Ga., was U.S. attorney general, 1829–31.

7. Wilkie Collins, *Basil: A Story of Modern Life* (London, 1852; New York, 1853) was reprinted under the title *The Crossed Path; or Basil: A Story of Modern Life* (Philadelphia, 1860). No available evidence indicates that Charles Kingsley's *Westward Ho!* (1855) ever had a different title; nor did Sir Amyas Leigh appear as a character in other books written by him.

8. Faustin Élie Soulouque took part as a slave in the Haitian revolt against the French in 1803. He became president of Haiti in 1847 and crowned himself emperor two years later, but was deposed in 1859. Several biographies of Soulouque were published in the 1850s.

9. Joseph Robert Davis, nephew of the Confederate president.

several gentlemen seemed touched by his emotion 'tho' they could not hear what he said.

Yesterday he was better & sent for me. Mrs. Davis & all the ladies go, so how could I refuse without being conspicuous. He was so grateful — & begged me so hard to stay, wanted me to bring a book & read to him, & said such *earnest* feeling things about his wife & sister that I could hardly get away. I carried him a peach. His brain must be affected — he told Mrs. Johnson that my presence made the room feel delicious & that the aroma remained there still. So that I am glad I am going away for I think his *brain* is affected — he was desperately ill again last night.

I think it provokes Mrs. ⟨Davis⟩ that such men praise me so. What a place this is; how every one hates each other. Mrs. McLean — to the very *diable* with her reputation & her husband's, flirting with Captain Blake — Mrs. Davis & Jeff Davis proving themselves any thing but ⟨well bred by their talk⟩. I am so sorry Mr. Chesnut told those men of the fling Jeff Davis made at them — I mean Beauregard's staff.

I see a great deal of Uncle H. Bob Ellnar is as queer as ever & as devoted to me. I have never had a pleasanter time.

Such pleasant men & women are here — such *brilliant* ones, I might say. Saw Mrs. Myers. She says Adèle Auzé[1] wishes men had mistresses now instead of wives. What a little miscreant. Read [*illegible word*] all day. Drove to see Hampton's Legion. Col. Johnson so glad to see us, Captain Butler, Willie Alston, Wat Taylor, poor little Dick Singleton[2] so feeble, & Lamar Starke. Came home, took tea with the President & then saw the old set, Captain Ingraham, George Deas, Mr. Mallory, Clingman, &c. Yesterday Mr. Lyons[3] called & Miss Ritchie — & a Mrs. Gibson. Mrs. Joe Johnston[4] is here.

Miss McLean, that was. Mr. Mallory told his tale of ill usage, &c, since he lived here. Miss Howell is the rudest, most ill bred girl I ever saw. I think the Brownes behave queerly. Saw a comet[5] yesterday — & paid five dollars for my drive.

1. Marion (Twiggs) Myers was the wife of Abraham Myers; Adèle Auzé later married JC's cousin John Chesnut Deas.
2. Lt. Col. Benjamin Jenkins Johnson of Hampton's Legion was a prominent Christ Church Parish, S.C., planter and a state legislator. Matthew Calbraith Butler of Edgefield Dist., son-in-law of Gov. Francis Pickens, was captain of the Edgefield Hussars of Hampton's Legion. Benjamin Walter ("Wat") Taylor was a surgeon in the Legion. Richard Singleton was the son of planter John Coles Singleton and Mary Lewis (Carter) Singleton of Richland Dist., S.C.
3. James Lyons, a prominent Richmond attorney.
4. Lydia (McLane) Johnston, wife of Gen. Joseph E. Johnston. Her father was Louis McLane, secretary of the treasury in the Jackson administration.
5. Probably Thatcher's Comet, first sighted early in April and visible to the naked eye in early July.

As we drove off in a nice landau, Mrs. Wigfall was telling us that Mrs. Davis thought Mrs. Waul a *Jealous* disposition — we have been nursing her for several days — when out popped Gen. Waul's head from a window & kissed his hands wildly to us. What shouts of laughter *greeted* him. I dare say he was amazed, but he did not know our previous conversation. These men call Mrs. Davis the Empress — Eugénie,[6] &c, & do not like her.

The notorious A. D. Banks abuses her worst of all. Says she is so killingly patronizing. They say John Rutherfoord[7] is here & is coming to see me.

Mr. Brewster has kindly offered to go with us to Orange Court House & stay until we are settled or agree to come back here. There seems to be a vague notion that a fight will take place on the 4th of July. Quien Sabe? Keitt & Boyce take me in tomorrow. They go musket on shoulder. To day Col. Moore[8] breakfasted with us. Old Sid Moore now a Col. of an Alabama regiment, as kind to me as ever — one of my devoted Washington friends — with a crooked mouth. A man was taken up yesterday in Richmond with passports both from Butler[9] & Lincoln & they say they will hang him. Mr. Lyons told me. An expedition which has been eminently successful was undertaken by Thomas & Hollins.[1] I shall cut an account of it out of the paper & also Russell's last letter. Wigfall is acting a silly part here.

[*July 4, 1861*]

4th of July. Yesterday Browne took me to dinner. Said Russell has written a letter from New Orleans abusing us. We all abused Russell. Prince Polignac[2] dined with us; is stupid. Had a pleasant dinner. Saw a moment Mr. Lamar — as kind as ever — & so sad. He was furious that I kept out & Mrs. Davis ⟨got⟩ went in. I did not like the expression of his eyes. After, we drove to the fair grounds — saw five thousand soldiers & ⟨Gen.⟩ President Davis presented a flag to the Marylanders; quite a beautiful & exciting scene. Music. A Baltimore man so handsome & so excited stood by me, & Mrs. Preston gave a seat to another

6. An allusion to Eugénie de Montijo, wife of Napoleon III.
7. Va. lawyer John Coles Rutherfoord.
8. Sydenham Moore, a former U.S. congressman, was colonel of the Eleventh Ala. Regiment.
9. Benjamin Franklin Butler, a former senator from Mass., was currently brigadier general of the Mass. militia.
1. On June 28 a group of Confederates led by C.S.N. Capt. George N. Hollins seized the steamer *St. Nicholas* on the Potomac River.
2. Camille Armand Jules Marie, prince de Polignac, a French veteran of the Crimean War, volunteered his services to the Confederacy and was commissioned a lieutenant colonel two weeks later.

Marylander who has been acting as a spy — & is an aide to Joe John-
ston. Met Mrs. Joe in the passage — in high spirits. Afterwards had a
scene. Geo. Deas with her & he told her of the battle likely to be to day.
Herself & Mrs. McLean we supposed to be submerged in tears, but found
Blake in Mrs. McLean's room & they drinking brandy & water. What
disgust Mrs. Wigfall showed.

Mrs. Davis was rude to me & I got Mrs. Preston to ask her what she
meant. Ample apology made. Captain Ingraham as usual — but by sit-
ting in Mrs. Waul's room I missed Arnoldus VanderHorst & Ben Alls-
ton.[3]

Today Mallory sent me books & candy. I carried some of the candy
to Mr. Lamar — he as grateful as ever. Says the reason Mrs. Davis don't
like me that I take up with the Wigfalls — & besides that, wherever I
sit I am some *how in the way!* ["I am . . . way" *written over unrecoverable
erasure.*] The president was excessively complimentary. Mrs. Davis & I
had a touching reconciliation. [*Following sentence added later:*] She was so
kind!

Robert Barnwell called, Dr. LaBorde,[4] Wat Taylor, Wade Hampton,
Theo Barker,[5] & Col. Johnson. Then went calling, saw Agnes Lee,[6] the
daughter of the Gen. Mrs. Toombs excused herself.

A fight anticipated between Joe Johnston & Cadwalader & Patter-
son.[7] Military parading all day. I feel so sad at the sound of a drum.
Uncle Hamilton came — praised Mary to him. How pleasant all this is —
if it lasts. Drive this afternoon with Mrs. Wigfall to Hampton's Legion.

A young Carolinian rode his horse in to the *bar* here — scattered the
men right & left. Quite a scene. We breakfasted with Captain Ingra-
ham. He told us he was sorry to see a Carolinian intoxicated, but it was
splendid riding. John Chestnut is here & Gregg's regiment. The people
are so aroused at their leaving in the face of the enemy that they spoke
of hissing them ——

[*July 5, 1861*]

What a day I have passed. Not one moment's peace. After breakfast,
⟨John⟩ went into Mr. Lamar's room, found Mrs. Davis there & she talked

3. Arnoldus VanderHorst, a Christ Church Parish planter who became a C.S.A. major,
 was the grandson and namesake of the eighteenth-century S.C. governor. Benjamin
 Allston, a colonel in the C.S.A. and son of former governor Robert Allston.
4. Maximilian LaBorde, physician, author, journalist, and professor at S.C. College.
5. Theodore Gaillard Barker, a Charleston lawyer, was lieutenant and adjutant of
 Hampton's Legion.
6. Eleanor Agnes Lee was Robert E. Lee's third daughter.
7. Maj. Gen. Robert Patterson, commander of Union forces in the lower Shenandoah
 Valley.

two hours ⟨at him. I dare say it was two minutes — bragged & was in worse taste⟩ than ever. He begged me to stay when she left. I sat down — & he began to tell me what she had said of me. Until that day had confined herself to praising my beauty! Heaven save the mark. As if I had any, even when I was young — & Mr. Lamar seemed to think there was something better about me than that. However, dans le royaume des aveugles un borgne est roi — & an uglier set I never saw. He said what she disliked about me was that wherever I sat was the centre of a S C group ["the . . . group" *written over unrecoverable erasure*]. He told me of his mother Mrs. Troutman having heard that Mr. Chesnut & I praised him & how it gratified him. Then *men* came in. Then John Rutherfoord & his wife[8] called & we talked — he is as kind & as handsome as ever. I am very willing to be like that woman.

Then Mrs. Singleton — then Mrs. Stanard.[9] The latter asked us to drive. We declined, to be together. Then Mrs. Singleton went to my room & stayed until dinner. Then I dressed & went to dinner — Mrs. Joe Johnston saying she should die if Joe was defeated, Mr. Davis reproving her for ambition. I am afraid they do not want him to be victorious.

Mrs. McLean still in fits. We do not think about McLean, but Blake's absence — brandy & water going to her room all the time. At dinner Browne & Mallory talked to me — Mrs. Davis trying to listen from the foot of the table. Two Virginia women incensed me speaking of Gregg's company as cowards. I answered *bravely* & fled.

Then drove to see Gregg's regiment. Saw a musket twisted by a cannon ball — then to Hampton's Legion. Saw a beautiful drill, had a crowd around the carriage. Toady Barker, James Lowndes,[1] &c, that nicest set. Came home exhausted. Went to tell Mr. Lamar good b'ye. Saw his wife[2] — so grateful to me & I had done nothing. Sat by him a moment — queer man — held my hand to his heart for a moment & then covered his eyes. Made them light the gas for two Professors to see me — poor old me. Saw the old set in the drawing room, Captain Ingraham, Mallory, H. Marshall, Waul, &c, &c — had a brief interview with Mrs. Davis. Carried Mrs. Singleton in & Dr. Gibbes. The former in state. A little upset at the tone of Mrs. Davis' anecdotes about cows, &c. The president seemed so averse to our coming it has frightened me.

8. Anne Seddon (Roy) Rutherfoord.
9. Mary Lewis (Carter) Singleton of Richland Dist., S.C., was the widow of planter John Coles Singleton and the mother-in-law of the Rev. Robert Woodward Barnwell. Martha (Pierce) Stanard was a Richmond widow whose home became a center of Confederate high society.
1. A Charleston lawyer in Hampton's Legion.
2. Virginia (Longstreet) Lamar, a daughter of the writer Augustus Baldwin Longstreet.

Got Arnoldus VanderHorst to take a letter for Mrs. Bartow & me for Mrs. Joe Johnston. Mrs. Wigfall at twelve o clock packed my *trunks*. What a good woman.

[*July 6, 1861*]

Got on the cars with Brewster, Keitt, Clingman, Robert Barnwell, Brown[3] from Camden, & Dunlap[4] — was so *crowded*. Virginia troops crammed the cars — so *polite*. All the aisles crowded — every body talking to me — & I felt *ill* from the heat & *close* car. Found Mr. C & Mr. P at Warrenton — not a nice place. Saw the Campbells at a distance; did not want to speak to them or they to me. On the cars a woman said we were *starving* in Charleston. Told May to tell her while we had the whole rice crop unsold we would not starve. Came to this place, the Fauquier White — beautiful place it is, very comfortable, nice fare, &c.

[*July 7, 1861*]

Mr. Chesnut stayed with me — he was ill but this water cured him. Said he had a glorious bath. Says Beauregard can whip sixty thousand. Met a quantity of pleasant people — among others, Mrs. Ould[5] [and] a woman covered with curls, suspected of being a spy. Mr. Brewster wonders how an old woman can waste so much time curling her hair, instead of preparing for eternity — as a spy. I talked to her. Asked Brewster how he liked my discourse. Said very much, especially the last *brick bat*.

Mr. C gave an enthusiastic girl a palmetto which she wears in her breast knot. A Mr. Gailliard here. Mrs. Ould harrowed me up with stories of my old friends in Washington.

[*July 8, 1861*]

Took Mr. Chesnut & Preston to Warrenton, heard there that Joe Johnston, &c, *retreated* — & felt ill. Also that a column was advancing on *Beauregard*. Mr. C & P went off in fine spirits. They *must* not be taken prisoner. We came *back* forlorn — oh this *retreating*. Mrs. Ould had a letter from Richmond; this retreat horrified them there. Read *Rutledge*.[6]

Went down at night — & we unfortunate women *talked*. A nice, *very* nice assembly of ladies here. Lincoln has called for four hundred

3. Either John Brown or his brother Henry, both wealthy Camden planters.
4. Probably Joseph D. Dunlap of Camden, a lieutenant of the Second Regiment of S.C. Volunteers.
5. Sarah (Turpin) Ould, the wife of Confederate bureaucrat Robert Ould.
6. Mrs. S.S. Harris (Miriam Coles Harris), *Rutledge* (1860).

[thousand] more troops & four hundred millions of dollars! Will he get it? I see no end now to the war — & our men retreating. If Joe Johnston retreats for want of ammunition, what a burst there will be about their ears in Richmond. Read *Rutledge* until midnight. Feel more gloomy than I have ever felt since this war began.

Brewster has gone to get the news from Manassas for us. Mrs. Joe Johnston whispered to me in Richmond that Henry May was all right.

> A month ago, & I was happy! No, not happy — yet
> encircled by deep joy, which tho 't was all around
> I could not touch. But it was ever thus with Happiness;
> It is the gay tomorrow of the mind that never comes.
> <div align="right">Barry Cornwall[7]</div>

Fauquier White Sulphur

[*July 9, 1861*]

Battle Summer. The devoted Brewster came back to us — had ever forlorn women such a friend — & he is so *clever* too. Brought a Richmond paper. Terrific threats. Every thing to be confiscated, *our* cotton sold, by our task masters, to England, through our ports! I would fire it myself first — if I hung afterwards for it.

Written home for them to work for our sick soldiers. Wrote to Mr. C to let him know Brewster is with us & so satisfy him as to our safety. Thirty miles from Washinton is too near. I will be glad when we leave this, calm & peaceful as it is.

One of our women we call Miss Albina McLush.[8] She is so soft & vapid. They are all so soft & slow & affected — & *wonder* to find us so *fair*. Thought before that *below* N.C. we were as brown as berries.

Miss Hetty Cary[9] had her hands tied behind her in Baltimore & *insults* offered to her person, pretending, the monsters, that they were searching for ⟨flags⟩ arms. Read a stupid book, *Will He Find Her.*[1] We are all so miserable at Joe Johnston's retreat.

Brewster says *bitter* are the *curses* heaped upon the War department for his want of *men,* arms & ammunition. Oh this fearful red tape.

Brewster says they will not have *Van Dorn*[2] because *he would* fight.

7. Barry Cornwall was the pseudonym of British poet Bryan Waller Procter (1790–1874).
8. From "Miss Albina McLush," a sketch by Nathaniel Parker Willis in *Fun-jottings; or, Laughs I Have Taken a Pen To* (1853).
9. Hetty Cary, of Baltimore, cousin of Richmond wartime belle Constance Cary, had been forced to flee to Richmond after waving the Confederate flag at Union troops.
1. Winter Summerton (pseud.), *Will He Find Her? A Romance of New York and New Orleans* (1860).
2. Brig. Gen. Earl Van Dorn of Miss. was in Texas, not Richmond.

[*July 10, 1861*]

White Sulphur. Yesterday was one of my gloomy days. I felt they *might* over run us. I do not feel so to day. Thank God for a stout heart. It is the darkest hour before day light. I see the Texians have offered their command to Wigfall. I think he will take it. Not a word from my Mother since I saw her in May. Gave Mrs. Ould Mr. Chesnut's carte de visite. Mrs. Preston, Brewster, & Mary Boykin have gone to Warrenton for the *news*. I found Mary transcribing some frantically love sick *farewell* to a lover — so I suppose she still thinks of Edward Cantey. She is so obedient — so kind — so attentive & *withal* so much more sense than I expected that I begin to love her dearly. Oh my country — if I could forget you one moment. What is to become of us all.[3]

> The good die Young.
> But those whose hearts are dry as summer's dust
> Burn to the socket.
> Wordsworth[4]

Mrs. Preston says a negro nurse told her once the way to keep young was never to take any more into her heart than she could kick off at the end of her toes.

May, Mrs. P, & Brewster returned. No news — not even a rumour or a report.

Read to day *The Rectory of Moreland* — *goody* book.[5] Thinks keeping a journal *bad,* morbid, selfish. I do not feel it hurts me. Wrote a long letter to Murray Lang[6] — & must write at once to the Convent in Georgetown.

[*July 11, 1861*]

Yesterday we had no mail — but heard cannon. I read *Rectory of Moreland,* slowly & sadly. Last night a ̂horrible old woman with a wig & *tiara* & red fricked fat arms & black bracelets began telling me how badly Mrs. Davis' ladies dressed in Richmond, in *flats* & gaudy colours. Mrs. Preston got into a *girlish* giggle. There were a bride & groom — the latter a widower, the first sixteen — who played *flute* & piano. The red headed spy rushed in excited & happy that seven hundred were ill in the hospital at Culpepper, that two were dead & thus already speechless, & that Beauregard had sent a flag of *truce* to Washington. Not a word of *truth* — the *fiend.* All night I fancied I heard cannon.

3. Omitted here are six lines of a poem by Nathaniel Parker Willis, and four lines of "The World" from *Melaia, and Other Poems* (1844) by Eliza Cook.
4. From Wordsworth's "The Excursion."
5. Mrs. Clara Louise Thompson, *The Rectory of Moreland; or, My Duty* (1860).
6. Murray Lang, a spinster niece of Thomas Lang, Sr., a Kershaw planter.

All of us, Mrs. Preston, Mary, myself & Maria, passed a sleepless night. Maria had seen suspicious persons. Mary saw lights. I remembered a ladder by my window. Mrs. Ould & Mrs. Preston relieved themselves abusing Edward Carrington. Today I remained in bed. I am so anxious & so nervous.

Mr. Chesnut writes we must be off to Richmond. They may, by a flank movement, cut us off — but if they can make a flank movement, will Richmond be safe. He says they are advancing in great force. They won't give us our clothes but we are so terrified we will go. I am trying to read *Dr. Oldham at Greystones*[7] but I can't.

Mrs. Stewart read me a letter from her husband more desponding than mine written to Lena. God have mercy on us.

Have been reading one clever thing in *Dr. Oldham.* He praises his wife — says she has all the recommendations for which Lemuel's mother praised a woman but *one,* which would have been disagreeable: keeping a light burning all night in her room & getting up before day. Ends by saying, "Look then upon your work basket as a badge of dignity, upon scissors & needles as holy implements. Shirt making is sacred — stocking mending divine." Recommends her highly for not neglecting buttons for Borrioboola-Gha[8] & then shorts for the flannel skirts of the benighted dwellers in Timbuktu.

Mr. Brewster is vestry man of the First Episcopal Church in Texas. Before they were annexed the city of Philadelphia sent them a silver communion service which they were too poor to pay the import duty on. They played cards all night with some lawyers & a Judge & won enough to get the service — but afterwards the church was knocked into flinters by Lightning ——

Wigfall told us one of our first generals spelt *fire, fiar* — like *liar,* & *drumb* for drum — like *crumb.* Our curly headed spy was routed by me again to day but I am glad to get away. When her brother Dr. ⟨⟨Richards⟩⟩ was apprehended by Beauregard she said it was to get *his horse* — Beauregard having a right to *ten* horses & taking two only. Mrs. Ould says they sent him to Richmond as they always do — & then they acquitted him there as they *always do* — & sent [him] down to Norfolk that he might see every thing there & then by a flag of truce to Fortress Monroe — the invariable rule with all suspected persons ——

[*July 13, 1861*]

Richmond. Mr. Chesnut's alarm letter brought us on Friday from the Springs. We met Mr. Preston at Warrenton. Long & tedious was the way.

7. Caleb Sprague Henry, *Doctor Oldham at Greystones, and His Talk There* (1860).
8. A fictional poverty-stricken country in Dickens' *Bleak House.*

I relieved the *tedium* by taking Laudanum. Came & thanked god when we got into the Spotswood that we were here safely once more. Found the drawing room full. The Notts, Auzés[9] — Miss Adèle was made to speak to me & call me cousin — Wade Hampton, Toady Barker, Waul, George Deas. Went to my room. John Chesnut came & Uncle Hamilton.

Then I dressed & went below. Saw Lamar very feeble on *crutches*. Judge Longstreet[1] carried him off today. Captain Ingraham, Mallory, Mr. Marshall, Brewster — no end of people. Mrs. Davis meets us so cordially. Dr. Gibbes, &c. Saw a vivandière today who played the *piano,* dressed in the uniform of the regiment — men devoted to her. Saw a bride of sixty & her husband *thirty five.* Saw *hundred & fifteen* sick soldiers yesterday — the saddest sight these poor eyes have ever encountered. Mr. Barnwell was on the cars. I am to do all I can to help them.

[*July 14, 1861*]

Richmond 1861. Yesterday after breakfast, which I took with the Prestons, went into Mrs. Wigfall's room. There met Mrs. Davis, had a very bad Washington gossip, then came to my room. Sent excuses to several young men who called — thinking myself ill. Mr. Ould called & they said Hugh Rose,[2] so I went down. While I was talking to Mr. O & Waul, I saw Mr. C standing in the door staring at me. I rushed up to him much to the amazement of my party. Before we got to our room, Mrs. Davis came for him & then he dined with us. Closeted with Gen. Lee & Gen. Cooper & Davis all the afternoon. To day he is here — goes tomorrow. Most observed scene last night with Gov. Allston. I gave Baldwin a *sockdolager.* Said he had only changed his coat.[3] I was sorry, I said, he covered a heart not *with* us by such a coat. To day Wm. Haskell & Brewster & the Rutherfoords. The war news still not pleasant. Mr. C dining with John C & Captain Boykin! Wrote to Col. C & Kate — feel miserably.

9. Josiah Clark Nott of Mobile was a prominent surgeon and ethnologist whose wife, Sarah Cantey (Deas) Nott, was a first cousin of JC. The Auzés were probably Charles and Margaret Auzé, a first cousin of JC, from Mobile.

1. Augustus Baldwin Longstreet, author of *Georgia Scenes* (1835), was also a judge, a Methodist minister, and president successively of Georgia's Emory College, Louisiana's Centenary College, the University of Miss., and S.C. College.

2. The son of James Rose, a planter of Christ Church Parish, S.C., and Julia (Rutledge) Rose.

3. John Brown Baldwin of Va. voted against secession in his state's convention but became inspector general of state volunteers and later a representative in the Confederate Congress. In her 1880s version MBC reveals that he had declared to her a year earlier that he was "a 'Union man' to the last point." When she saw him in Confederate uniform, she asked him what he had changed besides his coat.

[*July 16, 1861*]

Dined yesterday with Eugénie the Empress — had a merry time. Mr. Tom Drayton was there — an old class mate of the president's. Mrs. Davis cited me all the time. Joe Davis asked me if I would take wine with him & sent me what he called white port. I found on taking a mouthful that it was *whiskey*. I said quickly, "I have not endured a practical joke for *fifty* years." He saw his blunder — such jokes are so stupid & vulgar. Discussed Shakespeare & the musical glasses — *Idylls of the King.* Mrs. McLean said Juliet was so free of her *love* at sixteen because she was a Southerner. I said, "*No, free love* is a *Yankee* predilection — we have never introduced it at the South."

Saw old Letcher[4] but would not speak to him. Maxcy Gregg came & Mr. Marshall, Major Smith, no end of men. Drove out with Eugénie, had *rather* a pleasant time. Saw several camps. Mr. Chesnut left to day at day light, disheartened. Beauregard sent him to get permission for Johnston & himself to join & *rush* the enemy over the Potomac — refused. [*Following sentence added later:*] At Manassas, President proved right & Beauregard wrong! What is to become of us! They grow stronger every day. *We* grow *weaker* — or rather we have no more arms, so can arm no more men.

Tom Emory[5] had a letter from his mother urging him to go home. He showed it to Mrs. Wigfall & seemed to want to go. Mrs. Davis induced him to stay. I heard her say *Emory* père was a miserably mean puppy. Mrs. Waters & Mrs. Cabell[6] called. Mrs. Preston heard Mrs. Davis ask Tom Emory if he had *prayed* over his determination to stay.

Went to see Mrs. Singleton, found her not at home, went shopping. Saw John Chesnut & Uncle H. Willie Bull[7] came to see Mary B. I feel more depressed to day than I have ever done; less hope for my country. I cried well when James Chesnut, Jr., left me. Mr. Mallory wants us to go tomorrow to see his new ship, the *Yorktown,* to be called the *Patrick Henry.* Had a letter from Garnett telling me he had a son. Poor little Mary. *6* of Mrs. Davis' ladies are *childless.* Jasper Whiting, Captain Ingraham's son in law, says Joe Johnston is as anxious for the union of forces as Beauregard. The president is so nervous — & irritable & weak in health.

4. John Letcher was currently governor of Va.
5. Thomas Emory, a son of Matilda and William Hemsley Emory, was visiting the Davises when the war began. The Confederate president urged him to return to his parents in the North, but he joined the Confederate navy instead.
6. Jane (Alston) Cabell of S.C. was married to Richmond lawyer Henry Coalten Cabell, but retained a plantation in her native state.
7. William Izard Bull, the son of a rich Beaufort planter, served as a surgeon with the First S.C. Regiment.

[*July 17–18, 1861*]

Yesterday was in bed all day. Mrs. Wigfall came & lodged her complaints against the Davises. I said nothing because when I was angry I could not get her sympathy. In the evening every body came to see me. McLean read my poetry book.[8]

Mrs. Davis sat with me ever so long — abused Mrs. Wigfall. Mrs. Auzé got me to take 25 drops of laudanum. I cheated her & took *bitters* from a laudanum vial. A sick man next door sent to ask me for books. Wrote some things for Mrs. Johnston which I could not remember — poor thing, she is ill today. Now must I tell the *worst*.

The fight goes on at Manassas Junction. Poor me — I could not get my husband away soon enough.

A row in the Hampton Legion. They ought to be in the fight — instead of fighting each other.

Mallory has just sent me the nicest peach.

[*July 19, 1861*]

Yesterday we little knew the truth. Beauregard telegraphed Joe Johnston "for god sake to come down & help," he was overwhelmed by numbers — & Davis telegraphed Johnston to come.

Our forces fell back to Bull Run. Bonham's Brigade & Ewell's — & Longstreet's fought from twelve until five & repulsed the enemy three times.[9] Our loss small, theirs great. We took six hundred prisoners. Last night I felt I was deceived, &c, by being shut up, & dressed & went down. There this *news* awaited me at the foot of the stairs by Mrs. Davis. Then Gen. Cooper, who has never spoken to me before, came rushing up & looked so bright & told me this news. Then Clingman.

At tea we had a Col. Smith who was with McClellan & Garnett in Europe.[1] Garnett is dead[2] — killed — & his troops dispersed. *1,000* of our men taken — the cowardice or *treachery* of *Scott* causing Garnett's death. Scott is one of the appointments of that horrid old Letcher. Last night

8. If this means a book of her own poetry, it has not survived.

9. The battle of Blackburn's Ford, a few miles northeast of Manassas Junction on the 18th, was a minor victory. Milledge Luke Bonham commanded the First Brigade of Beauregard's army, Brig. Gen. Richard Stoddert Ewell the Second Brigade, and Brig. Gen. James "Pete" Longstreet of S.C., nephew of Augustus Baldwin Longstreet, led the Fourth.

1. In her 1880s version "Col. Smith" is identified as Paul Thomas Delage Sumter, former U.S. congressman. He, George Brinton McClellan, and Confederate Brig. Gen. Robert Selden Garnett of Va. had separately visited Europe as U.S. Army officers before the war.

2. The first general of either side to die in the war, Garnett was killed on July 13 in western Va. by Union troops rather than by the treachery of any of Va. Gov. John Letcher's appointees.

Mrs. Davis sat with us until twelve & was *fascinating*. Old Waul is a fool with his nonsense.

Mrs. Waul I shall treat differently. She has lost two children, both when she was away from home — the last burnt to death. Poor thing —— Two Carolina regiments went by to day. The two *Carolinas* furnish men every day. So far no news today. Will Chesnut come up to the Congress — that is the question now to me. Mallory has sent to ask Mrs. Preston & me to go & see the *Patrick Henry*. We declined. He sent me *two* lovely peaches.

Sat the morning with Mrs. McLean & Mrs. Johnston. Mrs. *Mc* is against us — seemed to enjoy the way I snapped up old Waul. Can't read. Too miserable. Mr. C dispatched me all was *well*.

Great disaffection in the legion. Wade Hampton in trouble. Told John C good b'ye. Mary H lent him twenty dollars. She gave me two hundred & eighty to keep for her.

[*July 20, 1861*]

Stirring news. Still the cry is that a battle rages at Manassas. Keitt has come in. Says our great battle was a *skirmish,* to the disgust of every one. Last night Joe Davis wished some one with the genius of Napoleon would spring up. I said, "That would do no good. I did not think Walker would give him a commission."

Last night I went down. Mrs. Carrington told me of a *fresh* fight & 140 killed. I was about to rush back in despair when Mr. Mallory came with Mr. Davis' contradiction. Went to tea with the President — then talked with Lieut. Col. Sumter who is a bridegroom, Mr. Mallory, Capt. Ingraham. Went for a sho[r]t time to Mrs. Davis' room. She came to Mrs. Preston's room. Stayed until 11.

Today had calls from Dr. LaBorde & Dr. Gibbes, Waul, &c. Read Jeff Davis' message. Keitt has come & Boyce. Dr. Gibbes at the opening of Congress sat in Mr. Chesnut's chair. Now try & sleep until dinner. Mrs. Davis' *own* niece of those Philadelphia Howells.

[*July 21, 1861*]

Troops pour in — every day several regiments pass. Tom Taylor & John Rhett[3] bowed & laughed to us from their horses. Dined at Mrs. Davis' table — had a pass with Mrs. McLean. She said every body ought

3. A Richland Dist. planter serving in Hampton's Legion, Thomas Taylor was the husband of a cousin of JC. John Taylor, a soldier in Hampton's Legion, was a nephew of Robert Barnwell Rhett, Sr., and the grandson of JC's aunt Sarah Cantey (Chesnut) Taylor.

to be for their own section. I said yes, so much do I agree with you that I never see a northerner now that I do not doubt her.

Last night had a gay time with the two Tuckers — *Ran* & Beverley.[4] I like *Ran*. *Bev* told us how he passed himself for [*illegible name*] — & so cheated old Giddings. Saw Mrs. Wigfall & Mrs. Bradley Johnson. We took six hundred stands of arms & three rifled cannon at Bull Run.

President Davis has gone to Manassas — *left* Wigfall designedly. Poor Mrs. Wigfall. Mrs. Davis passed the morning with us. I feel really ill — no news — battle expected every day. Mrs. McLean[5] came into my room with her sister's baby — quite humanized.

[*July 22, 1861*]

Yesterday after writing I laid so ill. Mrs. Davis came in, sat by me. Kissed me, said a great battle had been fought at Manassas — Jeff Davis led the centre — Beauregard the right wing — Johnston the left. Beauregard's staff safe. What a load from my heart. Wade Hampton wounded — Lieut. Col. Johnson killed — Gen. Bee killed — Kirby Smith killed[6] [*following word added later:*] wounded. Poor Col. Bartow — killed gallantly leading his men into action. President telegraphs we have had a great victory — a thorough *rout* — dead & dying strewing the fields. Several batteries taken — Sherman's[7] among others — by the Lynchburg regiment which was cut to pieces in doing it. Three hundred of the Legion killed — one U.S.A. flag. Then I lay upon Mrs. Preston's bed — one set of women & men coming in after another. Such miserable wretches, so glad of the victory, so sad for the dead. Those miserable beasts sent a flag of truce to bury their dead. Instead of burying them as they pretended, were throwing up entrenchments.

We are so frantic at this victory. Met Mr. Hunter to day; too busy crying over Mrs. Bartow to say much. Spent the morning with Mrs. Wigfall. She is nearly *mad* to see Louis Wigfall — he has not been here since Tuesday. *Drunk* somewhere — his troop ordered off tomorrow. Miserable woman.

The horrible accident maker, Mrs. Montmolin, is really mad with ag-

4. John Randolph Tucker and Nathaniel Beverley Tucker of Va. were the sons of Henry St. George Tucker, the half-brother of John Randolph of Roanoke. John Tucker was attorney general of Va.; Nathaniel had resigned as American consul at Liverpool to return home and join the Confederate army.

5. Mary Heron Sumner, daughter of U.S. Gen. Edwin Vose Sumner and sister of Mrs. McLean, married Armistead Lindsay Long in 1860.

6. Brig. Gen. Barnard Elliot Bee of Texas, commander of the Third Brigade of Joseph E. Johnston's Army of the Shenandoah. Brig. Gen. Edmund Kirby Smith of Fla. was only wounded.

7. Probably U.S. Capt. James Brewerton Ricketts's company of artillery, which was not, however, a part of the brigade commanded by Col. William Tecumseh Sherman.

itation at the report of her son wounded. She was so angry that she was not allowed to tell the bad news to Mrs. Bartow. Have not dared to face Mrs. Bartow. Met Trescot. Wonder what brings him here. Col. Meyers is so kind. George Deas will not know any thing.

Rain — rain — what is before us. Mrs. Davis has been so devoted to me since my trouble. Mrs. Preston's maid, when I read the papers, said no body talks in them of *S C* — but the number of our *dead* shows we were not backward. Telegraphed Col. Chesnut. Mrs. Johnston told me President Davis said he liked best to have me sit opposite *him;* he liked my style of *chat.* Mrs. McLean introduced her handsome brother in law & her sister[8] — he is to take command somewhere in Western Virginia. Sydney Johnston[9] is expected every day.

We want to go & nurse the soldiers.

[*July 23, 1861*]

Yesterday dined at Mrs. Davis' table next to Mrs. Joe Johnston — had a merry time. So many witty things said. Came to my room & slept until nearly nine. Went down, had a long talk of poor Bartow with Judge Nisbet, Mrs. & Mr. Hill, &c. They told me he was an only son — devoted, good, clever, every thing. Was trying to rally his men. Said, "I wish to god as you disgrace me that a shot would go through my heart" & *it did.* His wife lies quiet. To day as a solemn touching military funeral went by, the first sound she heard of the dead march, she fainted!

Mrs. Sad Accident's[1] son came — he was only hit by the butt end of a musket in the stomach. I found Mrs. Seddon[2] in Mrs. Davis' room, a most agreeable room — had a long & most agreeable conversation — introduced the Hills, &c, then talked with Banks. Left him because he ridiculed Mr. Hunter. There met Dr. Nott fresh from Manassas — he said they ran like dogs — lost three batteries of artillery, horses, men, ammunition, &c. John Cochrane & Ely[3] came down to witness the fun & were taken prisoner — a *perfect* rout. He said he slept under a *tree* with General Johnston & Adèle said to Mrs. Johnston, "don't you wish it was you?" Every body giggled. *He* is very disagreeable. Met Trescot, went with him into Mrs. Davis' room. She treated him to a quantity of

8. Mary (Sumner) Long and her husband, Armistead Lindsay Long. Although Long was aide-de-camp to his father-in-law, Gen. Sumner, he resigned his commission on June 10, 1861, and was appointed a major of artillery in the C.S.A.
9. Confederate Gen. Albert Sydney Johnston of Texas.
1. The otherwise unidentified Mrs. Montmolin.
2. Sarah (Bruce) Seddon, wife of Richmond lawyer and Confederate congressman James A. Seddon.
3. Col. John Cochrane of N.Y. avoided the fate of his Republican colleague Alfred Ely, who was captured.

indirect abuse — & when we left the room he said she was the *vulgarest* woman he ever knew.

Came to Mrs. Preston's room, where all the Davises, Deas, & Dr. Nott met. He made him self agreeable by saying that the President got there too late. Bledsoe[4] wanted to turn a man out of office for saying so in the papers, but it is *true*. Then praised Beauregard & *not* Johnston which is the mode here — & then ridiculed John Preston & Mr. Chesnut, but he said Mr. Chesnut & the aides were in all the danger — & that Mr. C went with the foremost in the retreat. I mean pursuing the flying foe. Miles refused to recognize his *quondam foes* of the Congress — horrified the Mississippian by saying they ran. Said the Legion ran but Mrs. Preston made him take it back. She made a Mrs. Wynne write an apology for saying the same. Was introduced to a Mrs. Slocum who came to hear whether her husband was dead or alive — covered with diamonds. Saw *Chin* again. Mrs. McLean denouncing Mrs. Wigfall for saying she wished all the Yankee generals *dead*.

To day breakfasted with Mrs. Davis. Read a Baltimore *Sun* claiming the victory of last *Thursday*, but [in] a telegraph today they acknowledge more of a defeat than we claim. Why do not our Generals rush on to Washington? Davis still at Manassas — great jealousy of Beauregard. Mrs. Preston has just had a telegraph from her husband saying the enemy are flying through Washington. Mrs. Singleton came to day & mingled her tears with ours. We hear poor Toady Barker & James Lowndes are killed. Darby shot down with the flag in his hand — Beauregard seized it & led on the men — not [a] handful of the men.

[*July 24, 1861*]

Lying down last night in a most dreary state at the loss of so many of my friends. Suddenly my husband came in the room. *Was* I not glad to see him! — safe & well. He was in all the fight — brought up regiments all day — heard shot whizzing round him — cannon & shell — carrying orders. Calls Beauregard "Eugene" and Johnston "Marlboro." Rode at the head of Lay's cavalry in the charge upon the retreating army — what a rout it was. I told him what Dr. Nott said & he wanted to cut his ears of[f]. So I talked something else. *None* of the young men we mourn so sincerely are even hurt.

We went to supper. A Carolina man, [*following name added later:*] Duncan, seemed so pleased that I bowed & [he] rushed up. Mr. C was the belle, a crowd round him all the time — Mr. Hunter, the Cobbs.

4. Albert Taylor Bledsoe retired from his chair in mathematics at the University of Va. to become a colonel in the C.S.A. and assistant secretary of war in Davis' cabinet.

Went to the drawing room, saw Wilmot DeSaussure[5] & reassured him as to our loss. What a splendid victory.

All their cannon — ammunition — clothes — came near taking Wilson of Massachusetts.[6] All had come here prepared for a ball in Richmond. The *Tribune*[7] says they must have Charleston, Memphis, New Orleans & Richmond — perhaps Montgomery.

Brought me a portfolio from the field of battle — filled with letters from *hard* Yankee women — *but women,* wives & mothers & I *cried.* One from a man to his sweetheart "thrilling with her last embrace." A bund[l]e of envelopes franked by *Harlan,*[8] the villain. Such spelling.

I have never seen a more brilliant drawing [room] than Mrs. Davis'. I went in with Mr. Robert Barnwell & Mr. Henry Marshall & Captain Ingraham. Sat between them while the president addressed the crowd — thousands. The President took all the credit to himself for the victory. Said the wounded roused & shouted for Jeff Davis — & the men rallied at the sight of him & rushed on & routed the enemy. The truth is Jeff Davis was not two miles from the battle field — but he is greedy for military fame. Mr. Chesnut was then called for & gave a capital speech. He gave the glory of the victory to Beauregard — & said if the President had not said so much for him self he would have praised him. Mrs. McLean left in disgust — & went off to write a note to one of the Prisoners.

To day she has had a row with Joe Davis who wishes all the Yankees *dead* — & Mrs. Davis has not taken it up, but consults with Mrs. Preston what she will do. Every body gives Mrs. McLean a fling.

I felt so proud of my husband last night — & so happy. To day we breakfasted with the president. They tell me my husband made another beautiful eulogy of Bartow. I sat with that poor woman hours last night & again to day. She seems so grateful for Mr. Chesnut's praise of her husband. She has neither father nor mother nor children — alone in the world. I wrote a long letter to my father in law today — & enclosed scraps from the papers. Then Mrs. Singleton came. Judge Nisbet & I had a long talk. How kind every body is to me. Then Waul. Then Mrs. Preston told me all the Cabinet quarrels.

Thousands of anecdotes of the war float round. Only 13 men killed in the Legion. Cut out the handsomest notice of Wade Hampton & gave it to Mrs. Preston. She loves him. Was so provoked when I found the

5. Wilmot Gibbes DeSaussure, nephew of John McPherson DeSaussure, was a Charleston lawyer and state legislator who commanded artillery at Fort Sumter.
6. Anti-slavery leader Henry Wilson.
7. The New York *Tribune.*
8. James Harlan, Republican senator from Iowa.

Dispatch did not notice Mr. C's speech. Cut extracts from all the rest for the old gentleman.

Wigfall has come here to stay now — & his wife is jubilant, making a flag. The Davises go to their own house tomorrow. At least Mrs. Joe Davis[9] begins it. What a reaction in Richmond when last week they were packing up for flight. Saw Mr. Seddon last night again — he's so pleasant. Then Mr. Rives.[1]

Men come in to Mrs. Davis' drawing room with their hats. The President swears vengeance against Dr. Nott for saying the Mississippians ran.

Adèle Auzé worse than ever — running out in a ragged old dressing gown to speak to a young officer. A beautiful Mrs. Slocum read aloud my Yankee letters. Must return some calls now — never read any thing.

[*July 25, 1861*]

Went down last night, found Brewster & Clingman. Mrs. Dubose, Mr. Toombs' daughter,[2] wished she could scalp a man who went off for a tête à tête with Mrs. McLean, a surgeon U.S.A. on his parole. Went to supper with Mr. Trescot — he was as *insolent* as ever. Mrs. Reagan[3] was as absurd with her damp mouth. Arnoldus VanderHorst came — says we were whipped last Sunday until two o'clock.

Wigfall had been to see Arnold Harris,[4] who says telegraphs came in until two in Washington announcing a great victory for *them*. Then there was no news until about nine or ten when the bulletins came in on foot — wounded, weary & terrified, spreading dismay & horror. Why did not our men push on. We wait until they prepare & fight us again.

They say a battle is raging now at Bethel.[5] Wise has defeated them at Kanawha[6] but we think of nothing but Manassas. Mrs. McLean says

9. Frances (Peyton) Davis, wife of Jefferson Davis' nephew Joseph Robert Davis.

1. William Cabell Rives of Va., a former U.S. senator and minister to France, had been elected in April to the Confederate Congress by a margin of one vote over James Alexander Seddon, a former U.S. congressman, who then won a congressional appointment in June. Seddon became secretary of war the following year.

2. The wife of Confederate Lieut. Dudley McIver Dubose was a daughter of Confederate general and congressman Robert Toombs.

3. Edwina (Nelms) Reagan was the second wife of John H. Reagan, postmaster of the Confederacy.

4. Sent from Washington to recover the body of a New York colonel killed at Bull Run, Arnold Harris, former commission merchant and U.S. Army officer, had been taken prisoner by Confederate troops.

5. A false rumor, probably arising from Gen. Magruder's attempts to keep slaves from fleeing toward Federal garrisons at Fort Monroe, Hampton Roads, and Newport News.

6. Brig. Gen. and former Va. Gov. Henry A. Wise, in command of the Kanawha Valley in western Va., had actually retreated in response to a Northern attack on July 24.

this is no victory. It will not hurt the North. What a villain that woman is.

In Mrs. Davis' room saw some stupid women, Mrs. Allison among them. Then talked to John *Waties*[7] — who described all the danger of the combat. Then *Mr. Shand.*[8] Then Trescot & Mrs. Joe Johnston. Then a serenade & speech from the President & *then* — a call from the *mob* for *Chesnut* — South Carolina Chesnut. Today making visits all day — such stupid work. Venable says a Columbia Negro rushed in the midst of the fight & carried his Master a tin pan filled with rice & ham, screaming, "Make haste & *eat*. You must be *tired* & hungry, Massa."

We still find *cannon*, ammunition & rifles, every thing in the woods. The congressmen were having a *picnic* & had their luggage *ticketed* to Richmond. Saw a Mrs. Cole yesterday, cousin of Milledge Bonham, who was his confidante when he made love to me. Wadsie Ramsey was found killed, fighting against us. I said I was sorry — & Mr. Chesnut said, "What, sorry for your enemy?" I said, "*No*, sorry he fought against us." Mrs. Davis said I let Mr. C *bully* me. Cameron[9] has issued a proclamation saying they are busier than ever getting ready to fight us ——

The Lord help us. Oh that England & France would help open a port.

[*July 26, 1861*]

All day I was in bed — the night before sat up too late hearing Mrs. Davis abuse & *disabuse* Mrs. McLean. Mrs. Joe Johnston & McLean have gone to Orange C. H. I am truly glad they did not get to Manassas. Mrs. Davis, Wigfall, &c, &c, sat with me & told me unutterable stories of the War — but I forget after so *much* opium. Mr. Chesnut would not go to bed but sat up & gave me such a scolding.

Last night the Bank committee called & a crowd came to serenade Gen. Jackson,[1] Gov. of Missouri. Mrs. Pryor[2] & Mrs. Faulkner called but I was out. Night before last Mr. Mason[3] called & would march me in on his arm to see Mrs. Davis. Miles went in meekly behind. Mr. Calhoun[4] called & Maxcy Gregg & Judge Nisbet, Mr. Seddon, &c, &c, &c. Mr. Mason told me his son's clothes were *riddled*. I had a charming

7. A Charleston lawyer and clerk of the court of appeals serving in Hampton's Legion.
8. Peter J. Shand, Episcopal minister in Columbia.
9. Simon Cameron of Pa., the U.S. secretary of war. The rumors of a proclamation were false, but perhaps arose from Lincoln's approval on July 22 of a bill authorizing the acceptance of 500,000 volunteers.
1. Clairborne Fox Jackson, pro-secession governor of Missouri.
2. Sarah (Rice) Pryor, wife of Roger Atkinson Pryor.
3. James Murray Mason of Va., brother-in-law of Confederate Adj. Gen. Samuel Cooper, was a U.S. senator from 1847 until March 1861 and a member of the Provisional Confederate Congress.
4. William Ransom Calhoun, captain of the First S.C. Artillery.

evening — heard a man they called Dick Snowden[5] give his account. It is Douglas Ramsey & not Wadsie who was killed.[6]

A Mississippian told me today one of the enemy's prisoners said, "What sort of a place is Richmond for trade? I am tired of the old concern — I believe I will take the oath of allegiance & set up there." He was told if he sat up there it would be in a penitentiary.

The[y] brough[t] 30 thousand *handcuffs*. I saw some to day. I am to have others. Had a cage for Jeff Davis & one for Beauregard. Why did our men not pursue them to Alexandria. Russell the *Times* man was there. Their prisoners, they say, are very insolent. Dr. Gibbes promises me a pair of handcuffs. I shall send them to my respected father in law — an old Union man. Dr. Gibbes said a man of the runaway enemy came to a lady's house & asked for a drink. She gave it to him & then gave him some brandy. He refused the brandy for fear it should be *poisoned*. She said, "Do you know I am a *Virginia* lady? Here, Tom & Bill, disarm this man." The Negroes did it. Then another came. She had them disarmed also. Then at the well another asked for water. A Negro girl said, "Go in & ask Missis." She followed, screaming, "Look, Missis, I took a prisoner too." Preston went on Beauregard's part to thank the lady.

Jeff Davis offers Mr. Chesnut any thing he wants — & is going to give Mr. Preston a commission.

Dr. Gibbes says the faces of the dead are black & shining like charcoal.

Poor old Gibbes; how he was delighted at the attention we paid him. He promised me a hand cuff. To day I have had a long talk with Banks. Hammond[7] is here. Hugh Rose has let his father take part of his *room* — must be improving — he would never stay in the house with them.

Dr. Nott & Dr. Gibbes both want to be Surgeon General. DeLeon is always drunk. Dr. Gibbes read a beautiful letter from a *fallen* soldier — so pious — & so true.

We begged him not to publish it. In one of the letters there is a picture of Jeff Davis trying to stuff wool, *cotton* wool, into John Bull's ears. I hear *DePass*[8] is wounded — not Joe Kershaw.

The most absurd women come here. We sent to day one hundred

5. Probably Richard Snowden Andrews, a Baltimore architect who was organizing the First Md. Artillery in Richmond.

6. U.S. Major George Douglas Ramsey of Va. was not killed at Bull Run.

7. James Henry Hammond of Edgefield Dist., S.C., a former U.S. congressman, governor, and U.S. senator, was in Richmond to argue for the establishment of cotton as a basis of Confederate credit.

8. William Lambert DePass, a Camden attorney and captain of Company C, Palmetto Battery of Light Artillery.

dollars to Mrs. Randolph[9] — for the sick soldiers. I[n] some of the portfolios Mr. C picked up are commissions. The *Herald* acknowledges twenty thousand killed & wounded. Mary B had another box of pretty clothes sent her. Clingman said wounded "soldiers asked him for water but it was too far to bring it," but when *he* found it — a pool or puddle, he "drank with avidity."

[*July 28, 1861*]
Sunday. Too unwell for church.

Last night Dr. Gibbes came but did not bring me the manacles — he is disappointed his promotion did not come. A Dr. Moore[1] was made Surgeon General.

Smith Lee & Captain Ingraham came. What a pleasant hour we had. After all manner of teasing, Captain I told Captain Lee, "Any how, Mrs. Chesnut thinks your brother [*following name added later:*] R. E. Lee handsomer than you" — it was so true I had nothing to say. Also a nice talk with Mr. Seddon, reading Yankee papers & seeing the excuses they make for their defeat.

Saw Toombs — called him *General* & told him he was born under a lucky star — that no Yankee could kill him. Mr. Chesnut came down after 5 hours sleep — rather cross. We then went into Mrs. Davis' room. She insists we shall dine with her still. Wigfall ordered off. Mrs. Davis teasing Mrs. W about a beautiful vivandiere in his regiment! Mrs. Montmolin heard me call her "Bad Accident." How Mr. C laughed at me & how I fibbed out of it. Judge Nisbet stopped me to ask if it be true that Ewell[2] was court martialled [because] he did not obey orders — it seems he did not receive them.

Zack Deas brings word another regiment taken yesterday at Falls Church. Bledsoe confirms it — 12 thousand stands of arms. Venable speaks in the highest terms of the conduct of Kershaw's regiment — especially Hugh Garden,[3] whose fiancée is dying in Columbia.

Saw Lord King in the Confederate States uniform — & absurd enough it is. Jeff Davis took my two hands to day & said, "Have you breakfasted?" I said, "Yes" — he said, "Miserable — que je suis!" & I ran on.

9. Mary Elizabeth (Adams) Pope Randolph maintained a fashionable Richmond salon with her second husband, attorney George Wythe Randolph.
1. Samuel Preston Moore, a native of Charleston, had served as a surgeon in the U.S. Army and practiced medicine in Little Rock, Ark., before the war.
2. Gen. Richard Stoddert Ewell was not court-martialed.
3. Hugh Richardson Garden of Sumter, a private and color bearer in Joseph Kershaw's Second S.C. Regiment, graduated in 1860 from S.C. College, where Charles Venable was professor of mathematics.

Quantities for the hospitals, white sugar, tea, &c, were taken from the enemy.

Mrs. Preston has gone to see her husband. Davis has offered him a commission. Miles carried Mr. C off to see what could be done for the coast defenses of So. Ca. at the War depa[r]tment.

Mary Boykin is a great favourite here.

Absurd hash of Mr. C's speech in the *Mercury*.

[*July 29, 1861*]

Yesterday we dined with the President — had rather a good time. After dinner Mrs. Slocum sat with me until nearly dark. Then came *that nap* which my overdone nature requires — then a long talk with Judge Nisbet. He deplored Judge Withers' retiring from *work*. Then Banks, Gibbes, &c, & my friend McCall,[4] née Huggins. Then a long walk with Mrs. Davis. Then the Whitings. I gave part of my trophies to Mrs. W — & sent some to Susan Rutledge. Then Wm. C. Rives, who was as gallant & gay & as agreeable as ever. Today we breakfasted late, Mrs. Davis coming to ask Mr. Chesnut at the public table to go for Wigfall — but I ran up & found she expected him — so I was truly glad to get away from the unpleasant duty. Mrs. Slocum gave a *lunch* — made Claret cup — bought melons. Mrs. Singleton called, wants Mrs. Preston to go with her to Charlottesville. Do not know if she will do it.

The Yankees confess their *defeats* — but are making preparations for *us*. What next oh my heart. Banks told of Arnold Harris having a dinner party. They say we cut up a Zouave into four parts — & that we have their prisoners tied to a tree & throw bayonets at them. The liars. We are treating their men as well as we do ours.

Dr. Gibbes still after the Surgeon General's place. Old Waul still doing the "gay *Lutherian*."[5]

Today dined with the Davises — very pleasant. Mrs. Wigfall out does me — & he is too bad — but all are so polite to me. Adèle worse than ever but so very funny.

Mrs. Wigfall expects her children tomorrow.[6] Had a long letter from my octogenarian father in law, very kind & flattering. Calls our president the Great Frederick — & says we have splendid crops. I told them of the letter at dinner. Col. & Mrs. Deas have come — he frantic for news. The old lady looks so feeble — my friend *Zack* as foolish as ever —

4. Louisa Caroline (Huggins) McCall, the wife of planter George Jay Washington McCall of Darlington Dist., S.C.
5. In the 1880s version, *Mary Chesnut's Civil War,* MBC makes an obscure analogy using Martin Luther and the quarreling secessionists.
6. Louis Wigfall's teenaged daughters, Louise Sophie "Louly" Wigfall and Frances "Fanny" Wigfall.

& old Gibbes hanging on for the Surgeon Generalcy. No end of people *call*. I wish they would not. There is the expense of hack hire returning them.

The McLeans[7] came back — Mrs. Joe Johnston to be there a fortnight. I dare say it was to get rid of her Mrs. Johnston stayed. Lord King furious at the way they *treated* his sister on the cars. Sent Dr. Gibbes' letter to publish.

[*July 30, 1861*]

Yesterday dined at the President's, then talked with Mrs. Auzé until time to rest. I mean all the Deas family — old Colonel, Aunt Deas, &c, Zack & Dr. Nott. Dr. Gibbes, &c.

Last night met Mr. Mallory on the steps. [He] joined me & we were about to have a nice chat. Mr. Hill & Mrs. Long joined. Mrs. Deas came & we went to tea taking Mrs. *Long*. Mr. Chesnut was so civil to *her* — to undo his bad reputation to the *Sumners. Then* Major McLean joined us. Brewster went to tea with us. Professor Bledsoe joined me while I was talking to Mr. James Holmes — said he told Mr. Alexander[8] he knew me very well & would introduce him. When he bowed, I did not return it — so he thought himself cut. Brought up Mr. Alexander, grandson of [*one illegible word*] blind preacher & we talked Hoboken & Princeton. Those people all *against us — Potters,* even, who hold Savannah plantations we should *confiscate*.

Then came *Sprate* — & such a talk — red hot. Then Trescot — raving of Mrs. Stanard — & saying when Mr. Chesnut is reelected Senator I must make tea every night. Told me he heard Mr. Chesnut bragging of some of my *smart* speeches. I doubt that. Sat up until twelve — he abusing Davis & Mrs. Davis — & saying Keitt & Boyce & Hammond are *violent* against the President. Did not see Mrs. Davis, I had so many visitors. [*Added later:*] disintegration begun already.

Today breakfasted with Miles. Then Allen Green called — *merit* over looked again — had a two hours' talk. *Somebody* hurt — poor Allen.

Taken rooms at the Arlington. Willing *to go* — paid two dollars more for putting a lock on that old trunk that originally cost three. Why did we not *pursue* the flying rout to Washington. Our papers are *now* for pushing the war beyond the Potomac. Dr. Green says he helped to *take* Sherman's battery & he turned their guns against them.

7. Husband of Margaret (Sumner) McLean and son-in-law of U.S. Maj. Gen. Edwin Vose Sumner, Eugene McLean had resigned his commission in the U.S. Army and joined the C.S.A.
8. Peter Wellington Alexander, a war correspondent for the Savannah *Republican* who had covered the battle of First Manassas.

Mr. Chesnut met his old flame, Miss Lizzie Dallas — now Mrs. Tucker,[9] & found her he *said old* but very agreeable — did not mention it to me for several days.

[*July 31, 1861*]

Dined with the President for the last time. Had a pleasant time with Joe Davis — talked as I ought not of the McWillies. At night went down — was talking with Brewster & Mallory when Mr. Chesnut came & said I must go & drink tea with Mr. Mason.

Mrs. Davis stopped me to introduce me to Mrs. Tom Anderson, a widow, a niece of Jeff Davis, who says her grandfather was a grandson of Gen. Cantey[1] of the Revolution. Consequently she is a cousin of Mr. C. We had a nice time at supper.

Mr. Mason, Mr. Miles & Mr. Eustis[2] — we abused the Yankees — & Mr. Chesnut talked to Mrs. Long to prevent her hearing. After tea I went to talk to Mrs. Anderson but Beverley Tucker came & I found it impossible so I led her to Mrs. Deas, who is [a] S C Cantey.

Then had a *really* nice talk with Miles & Captain Ingraham. The latter brought me *two* palmetto cockades. Then came Trescot — he had been as usual to Mrs. Stanard's. So had Mr. Chesnut. Mrs. Stanard called him fascinating — & me sprightly! Then I went to call Mr. C for Trescot but he would not let me go back to tell him that he was in bed. To day Trescot asked why I treated him *so*. Kept him an hour waiting on the stairs — in vain. Breakfasted with the Wauls & the man Waul was more absurd than ever — told *all* the *Times,* or *Tribune* rather, to those *men.* What *lies* — pretend to believe our 15,000 were 100,000 or 90,000 — say we are ill treating prisoners. Such *stupid* lies — & pretend they are coming against us worse than ever. God grant they may not be able! Lord Lyons said, "Now I suppose we may be allowed to call them *Belligerents.*"[3]

Russell's letter to the *Times* will be *rich* — if they let it go. They are abusing each other — criminations & recriminations.

Here we are at the Arlington House — every body leaving the Spotswood — the Davises one & all, Mrs. Wigfall & the Nott & Deas party,

9. Elizabeth Nicklin (Dallas) Tucker, daughter of U.S. senator and Vice-President George M. Dallas of Pa., was the wife of Dr. David Hunter Tucker, a Richmond physician.
1. John Cantey of Camden.
2. Former U.S. congressman George Eustis, Jr., of La.
3. Rumored remark of the British minister at Washington, Richard Bickerton Lyons, second baron Lyons, to U.S. Secretary of State Seward as they watched Union troops returning in disarray from Bull Run. Lyons was alluding to the outrage of the North at the British recognition of the Confederacy as "belligerents" (but not a nation) in May.

Mrs. Slocum, Mr. and Mrs. McLean. Letter from Uncle H saying he has made John Chesnut first Lieut., Thurston second, Guerard 3. Letter from Kate Williams — Uncle B dying.

[*August 1, 1861*]

Arlington House — Richmond. After a scribble with a pencil in my journal & a long sleep — waking half dead with heat, I found a message from Mrs. Wigfall. We drove with her to the fair grounds. Mr. Chesnut rode with the President & one of his aides. The grounds are more covered with tents & soldiers than I have ever seen them — immense *crowd* — number of carriages. We drove immediately behind Mrs. Davis. Wigfall charging about like mad — making those poor fellows rush about & maneuvre in a way perfectly distracting [on] such a *hot* day. The President presented the lone star flag which we had in our carriage. Mr. C came for it & handed it to the president. We did not hear the speech — nor Wigfall's, but could *see*. Wigfall wore his *hat* — the president *uncovered*. Mr. C said neither speech much.

It was a grand gala show, music, *mustering*, &c — one sees so many now. Mrs. Wigfall had a message that her children were at Gordonsville. I sent twenty dollars by Dr. Gibbes to Mrs. Singleton — from Mr. Lyles.[4] *Toombs* — Brigadier General Toombs was rushing a fine horse about, shaking his whip at coach man trying to make us *back,* when his horse *threw* him & he lay just by our carriage with his foot in the *stirrup* & the horse prancing over him; his face I could see purple. People seemed so slow in going to his assistance — however he was extricated with out hurt — & he immediately got on his horse again. After coming home, Capt. Ingraham, who drove with us, took me to supper. Rather dismal. We found Mr. Mason & Mr. MacFarland[5] after tea calling. Mr. Barnwell boards here & he sat with us — also *Wilmot* DeSaussure.

Mr. Henry Marshall spent the evening. We talked altogether of the news from Manassas. *Beauregard* wrote to Mr. Chesnut & Miles that his army was *starving* thirty six hours *without* food — all through the stupidity of a man named *Northrop*.[6] Wilmot DeSaussure brings the same news. How *violent* we were, ready to hang any body who starved the Army of *Heroes* of the 21st. Want of *food* & want of *wagons* has kept Beauregard & Johnston where they are. *Shame.*

Sent a letter praising Mr. Chesnut to Wm. Shannon. Wonder if he

4. Probably James V. Lyles, a Camden businessman and a lieutenant in the Kershaw Guards.
5. Richmond banker and member of the Provisional Confederate Congress William Hamilton MacFarland.
6. Col. Lucius Bellinger Northrop of S.C., Confederate commisary general.

will *print* it in the *Journal*. To day was introduced to Commodore Barron's[7] family & two Carolinians, Lipscomb[8] & *Simson*. Said I always shook hands with *S C's* — hardy, bronzed figures they were.

Russell's letter from the Mississippi — intolerable, *horribly* abusive — but I must *own* just the impression that region made upon me in *'40*. It cannot have improved. The Congress U.S.A. has 42 votes for a peace *proposition.*[9] They have *hung* 4 Carolinians.[1] I came in my room by *ten* & Mr. C sat in the window & talked until *midnight*. I do not believe he will join the army again. They want him in Congress.

[*August 2, 1861*]

Yesterday was spent writing letters & reading & knitting, sleeping, eating water melon, &c. Dined with the Barrons, Ingraham & Smith Lee, &c. Captain I said the want of food in the army had been *remedied,* they *said*. A month's mismanagement, he added, could not be remedied in a day. After dinner I did not leave my room for hours. Went to tea & then talked with Wilmot DeSaussure & Dr. Gibbes & then a Mrs. Allen — who thought the President *crazy* to threaten to hang *4* Northern men for *two* Carolinians. She received a hint as to who I was & changed her manner of speaking. She was from Baltimore.

To day two Sumter men — Frasier, who stayed in Bonney's shop, & a Mr. Barrett came to get passes to go to Manassas for the body of Barrett's brother. I did not know Frasier had left Camden — where he has not been for a year — but I said truly I had not been there either. The Carolinians are beginning to brag as usual — claiming the credit of routing *the* enemy. Dr. Gibbes told a touching story.

Yesterday he met a Mrs. Wood from Columbia who came on, she said, because she could hear nothing of her husband. She was standing in the entry at the Spotswood, could not get a room. He went on & met a man who was from Columbia & he asked his business & he replied, "I came to bring down poor Wood's body from Manassas!" So Dr. Gibbes had to go & hasten the poor woman to a room & break the news to her — poor soul. Dr. Gibbes has been appointed Inspector of the Hos-

7. Samuel Barron of Virginia had been a captain in the U.S. Navy when he resigned in April 1861 to become a captain of the C.S.N.
8. Thomas Jefferson Lipscomb, a second lieutenant in the Third Regiment of S.C. Volunteers.
9. On July 29 the House voted 41–85 not to take up Ohio Democrat Samuel S. Cox's resolution proposing a committee of Northerners and Southerners to draw up a constitutional amendment as the basis for a sectional reconciliation.
1. A false rumor, which prompted President Davis to declare that Union prisoners would receive "the same treatment and the same fate."

pitals in Virginia — wants to get his commission & his pay. Mr. Horace Binney has written a complimentary letter to Gen. Scott.

[*August 3, 1861*]

Yesterday after writing I took a hack & with Mr. Brewster went to the capitol Library. There met Boyce who talked gallantry & said Mr. Chesnut being at Manassas on the 21st insured his reelection to the Senate! Funny if *that* could do it. Saw Hemphill & Mr. Hunter — got *12* books. The man said *two* was the usual *quantity* — but I offered to get six Senators — so he let me have them.

Went to Mrs. Wigfall's who was not very civil. Little Fanny,[2] who had not been allowed to speak on the way, when she got into Virginia said, "Now I may be permitted to express my political sentiments."

Mr. Brewster told me a man named Christ Suber[3] said, "Mr. C might be defeated because the North West of the State *had had* nothing." It would be mortifying to be beaten. I wrote a letter for Mr. C to Jordan[4] — of which I have kept a copy.

At dinner was with Capt. Ingraham, DeSaussure, &c. Clayton came in & said old Ben McCulloch, &c, won a great victory over Lyon in Missouri — another complete rout.[5] He said the reason old George Mason[6] opposed slavery in the North West, he was an aristocrat & did not wish the Yankees to have so good a thing. Miles called on me — as pleasant as ever. I begin to like him *truly*. Then Mr. Barnwell & Capt. Ingraham — Wilmot DeSaussure — two Masons,[7] very nice both — then Dr. Carter[8] & his wife said to look like *me* — but too handsome — real *Virginians*, bragged on the black House of Tarquin.

Then Lieut. Powell[9] of the *Patrick Henry* sat & whispered to Mary Boykin. What a lucky girl she is.

[*Following written on the end paper of notebook:*]

2. Frances Wigfall.
3. Christian Henry Suber, member of the S.C. house from Newberry Dist. and a quartermaster in the C.S.A.
4. Lt. Col. Thomas Jordan of Va. was Beauregard's adjutant-general.
5. A false report. In the early days of Aug. only minor skirmishes occurred between McCulloch's troops and Union forces led by U.S. Brig. Gen. Nathaniel Lyon.
6. Grandfather of James Murray Mason; author of the Va. Declaration of Rights of 1776; and one of three delegates to the Constitutional Convention of 1787.
7. Apparently Confederate ambassador James Murray Mason and his wife Elizabeth (Chew) Mason.
8. Charles Shirley Carter, assistant surgeon at Richmond military hospital.
9. Lieut. William Llewellyn Powell, commander of the *Patrick Henry*.

The end — of what was begun February 25th 1861.

McClellan virtually supersedes Gen'l Scott.[1]

Mrs. Davis in a very nice house[2] — formerly Mrs. Brockenbrough's, really a handsome establishment.

The papers call Mrs. D portly & middle aged[3] — Helas ——

[*Following added sometime later:*] The man with too winning ways — not so dangerous to women as at the card table — *apropos* of the hidden husband.

[*Entries dated August 3 through September 9, 1861, are recorded in a daybook bound in black leather with ruled pages. Chesnut had apparently begun keeping the daybook in October 1860. The first nine pages contain quotations and notations made well before Chesnut began to use the book as a continuation of her diary. Before the first entry, she wrote,* "Continuation of my Journal of the Summer of 1861."]

[*August 3, 1861*]

"Died of typhoid fever on the 24th July 1861 Burwell Boykin — the purest, the best, the noblest man I have ever known." So writes Kate Williams to me. I feel so much for poor Aunt Sally. So strange the thousands on the battle field, apparently in the very jaws of death, spared; this peaceful one at home taken. Harriet,[4] too, they think will die.

Sally Boykin, my sister, has a daughter which she calls *Kate* for our sweetest sister. How my mother will feel her brother's death — every body loved him best.

[*August 4, 1861*]

Richmond. Remained in our room. Adèle Auzé came, behaved so kindly — I am sorry she has been so abused by me. Deas Nott & Henry Deas[5] came. Ransom Calhoun & Willie Preston have come & nearly had a fight for the ground with a Maryland Regiment to picket their horses.

1. After Bull Run, Lincoln called McClellan from western Va. to head the defeated Federal army at Washington. Winfield Scott remained general-in-chief but the man known as "Little Mac" had emerged as Lincoln's foremost commander.
2. The mansion, built in 1818 by Dr. John Brockenbrough and his wife Gabriella, was bought by the city of Richmond and rented to the Confederate government. It became known as the "White House of the Confederacy."
3. Mrs. Davis, then thirty-five, was three years younger than MBC.
4. Harriet Grant, the orphaned daughter of Camden attorney William Joshua Grant and Harriet Serena (Chesnut) Grant, JC's sister.
5. James Deas Nott of the Twenty-second Ala. and Henry Deas of Camden, a member of Gen. Kershaw's staff.

Oh my country men, why will you be so overbearing & quarrelsome. When Mr. Chesnut came home from Mr. Lyon's at twelve, Mr. Barnwell sent for him. I wanted to know what he wanted but Mr. C sent word he was asleep. Today we find it is a trouble between Toombs & Maxcy Gregg about surrendering the men who attacked Davis who killed Axson.[6] He goes now to try & do what he can.

Also a letter from Jordan complaining of the treatment of Beauregard & his army. Also one from Edward Boykin, first Lieut. of Kirkwood Rangers[7] — wanted service & wanting a cavalry regiment formed with Mr. C *colonel.*

He says so little I do not know what he means to do. Mr. Mason, Mr. Barnwell & Wilmot DeSaussure & Capt. Ingraham made my morning reception. My head feels heavy — & I feel miserably. Poor Uncle Burwell. One company of Hampton's legion ran — & Sloan's regiment[8] — oh my *heart.* Carolinians, who would *begin* this thing, you must every man *do* or *die* — if you run *I shall* die of shame. A young Lieut. Thomas of Maryland read a letter saying Captain Boggs of company *1*, Virginia Volunteers, *ran* — but his lieut. rallied the Greys & they fought like Hermes.

Have written two letters, one to Kate Williams, one to Miss Mary Stark,[9] having ascertained the whereabouts of John Means Thompson.[1]

Mr. Chesnut did not go as I wished to Maxcy Gregg, but to see those ⟨*one illegible word*⟩ people who are my aversion. 'Tho' thanks be to the Lord I have managed to treat them decently.

Mrs. Deas has returned Kate's touching letters. Mr. C said no one seemed to care — Dr. Nott not at all. I remember Uncle B once challenged Dr. Nott — perhaps he remembered that. Only Mrs. Deas & the Colonel — how hard this world goes. I feel too sadly for the heat & trouble of dinner — a mid day dinner in August I can't stand. Read yesterday *Hermsprong; or, Man As He Is Not*[2] — a good book — & Thackeray's *Georges*[3] — picked some ideas.

6. Arthur B. Davis, a Georgia soldier, who killed Charles H. Axson, a South Carolinian, in a quarrel over watermelons according to MBC.
7. A company of the Seventh S.C. Cavalry organized by William M. Shannon of Camden.
8. The Fourth Regiment of S.C. Volunteers, commanded by Col. Joseph B.E. Sloan.
9. Mary Sophia Stark, sister-in-law of former S.C. governor John Hugh Means.
1. Nephew of Gen. Waddy Thompson and supposedly a member of the Washington Light Infantry.
2. A novel by English free-thinker Robert Bage, published in 1796, about a "natural man" raised by North American savages.
3. *The Four Georges. Sketches of Manners, Morals, Court, and Town Life* (1860).

What *does* Prince Jerome[4] mean by going to Washington at such a time. What is before us if we have to fight French trained troops besides the Yankees. The good Lord have mercy upon us!

Sunday. 4th Aug., Arlington House, Virginia — with a heavy heart.

Another telegram from Jordan — I mean Col. Jordan & not the *stream* in Canaan. Oh how hot!

> They that govern make least noise. You see, when they row in a barge, they that do the drudgery work, slash, & puff & sweat; but he that governs, sits quietly at the stern, & is scarce seen to stir. Selden

> 'Tho' we have peace, yet twill be a great while e'er things be settled. Tho the wind lie, yet after a storm the sea will work a great while.
>
> Selden[5]

[*August 5, 1861*]

Yesterday afternoon, Dr. & Mrs. Nott called to say good bye — then Clayton, Mr. Wilmot DeSaussure & Capt. Ingraham, Mr. Chesnut & myself, Mary B & Willie Bull sat in the drawing room. Mrs. Auzé & Zack Deas called. The former expressed great commiseration for Aunt Sally B. Then Dick Snowden — the author of "Corcorani"[6] — the absurd opera written about poor Miss Corcoran's escapade with the Spaniard.

The *Herald* calls for 600,000 men to invade us & says England has concluded a treaty with them — & Louis *Jerome* Napoleon is in Washington. Oh if England & France are against us! My breath is stopped. Mr. Chesnut is for a second Moscow[7] — burning the *cotton* — or not making it. Maxcy Gregg here. Toombs is the man. Two soldiers called — Spenser & Blodget. Dan Murray Lee[8] says they had U.S.A. buttons.

Mrs. Preston not yet come. Mrs. Reagan ill — & Mrs. Cole's child — so Dr. Garnett[9] tells. I am truly glad we are out of that house. Dr. Gibbes

4. Not Jerome Bonaparte, but his half-brother, Napoleon Joseph Charles Paul Bonaparte, Prince Napoleon, who was the nephew of Napoleon Bonaparte. The Prince had landed in New York several days earlier for an American pleasure trip.
5. From *The Table Talk of John Selden* (1689), a posthumous collection of the opinions of this English legal scholar. Two other quotations from this book have been omitted.
6. A comic operetta written by the Baltimore architect Richard Snowden Andrews.
7. When Napoleon occupied Moscow in 1812, much of the city was destroyed by fires apparently set accidentally by French looters but fanned intentionally by Russians to deprive the invaders of their prize. In Nov. and Dec. 1861 many planters on the coasts of Ga. and S.C. would take up Chesnut's idea.
8. Daniel Murray Lee, 18-year-old son of Sydney Smith Lee, soon became a midshipman in the C.S.N.
9. Dr. Alexander Yelverton Peyton Garnett left private practice in Washington, D.C., to become director of two Richmond military hospitals and personal physician to Jefferson Davis and his family.

says 1,100 are ill & wounded at Charlottesville & 8 died day before yesterday of virulent typhus fever — want nurses, money & clothes. Written a long letter to my dear Mother.

Sent two books & a note to Mrs. Davis — delicious breeze. Uncle Burwell's death in the paper.

Dr. Berrien[1] has called on Mary B — what nice *beaux* that girl has. Qui se ressemble s'assemble.

[*August 6, 1861*]

Yesterday I kept my room — Mary B went to drive with Major Smith & J. B. Hood.[2] I gave her no advice — left her conduct to her own feelings. I sat with Captain I, Mr. Barnwell, Wilmot DeSaussure. Had a row with Mrs. Lee about Miles & his saying he hated the Star Spangled Banner — as the symbol of oppression — [*one inch at bottom of MS page and another at top of next page cut out*] except Mrs. Browne.

Mr. Chesnut rode with the president but has not yet told me what was said. Read Mrs. Gore's sketches.[3] Saw to day Alex Haskell[4] & he told me the true story of Axson & Davis. Gregg is doing all he can. Mr. McLamklin called for a note but there was none. I saw a note of thanks from that old Whitaker[5] saying his wife & himself would call.

Sent Laurence out shopping for me — stockings & shoes. Mrs. Lee & I reconciled [*see above note; portion of page cut out*].

I see in Shaftesbury's *Characteristicks*[6] that *panic* — comes from the God Pan who, when he went to India with Bacchus, made such a noise in a wooded rill that the imagination & frantic fears were excited & the[y] fancied ten thousand where there were none.

[*August 7, 1861*]

Yesterday I did not go to dinner but read *Hajji Baba*.[7] At night went down to see Mrs. & Gen. Cooper. [*Portion of page cut away*] picked at to their movements — the armies. Went into Mrs. Lee's room & eat wa-

1. James H. Berrien, a Ga. surgeon in the C.S.A., was the son of former U.S. Attorney General John McPherson Berrien and the brother of Mrs. Francis Bartow.
2. John Bell Hood of Ky. had resigned his U.S. Army commission in April and been swiftly promoted by the Confederacy from lieutenant to colonel of the Fourth Texas Regiment.
3. Catherine Grace Frances (Moody) Gore, *Sketches of English Character* (1848).
4. Alexander Cheves Haskell was the nephew of Langdon Cheves, Jr., and the grandson of former Speaker of the House Langdon Cheves, Sr.
5. L. L. Whitaker, a Camden planter.
6. Paraphrase from Anthony Ashley Cooper, third earl of Shaftesbury, *Characteristics of Men, Manners, Opinions, Times* (1711), I, Treatise I, sect. 2.
7. Either James Justinian Morier, *The Adventures of Hajji Baba of Ispahan* (1824) or *The Adventures of Hajji Baba of Ispahan in England* (1828).

termelons. Lieut. Cooper[8] was on the Island with Mary Withers & me —
remembered Silvey's[9] ravings — & old Vogdes[1] — & the stir Mary's
beauty raised — & the embarkation. Says he was the man who tied that
wretch to a tree that howled so.

Talked with Miss Sally Tompkins.[2] Asked if any Carolinians were at
her Hospital & she answered, "I never inquire which state my patients
are from."

Today breakfasted with Captain Ingraham. Then went to see Mrs.
Preston. That poor Mrs. Cole has lost her child! born after 16 years
without one — poor thing. Mrs. Reagan very ill.

Wade Hampton says nobody was more exposed than Mr. Chesnut —
& that Mr. C led his legion up to the last charge.

Mary McDuffie Hampton & Mary Fisher[3] have come to make a hos-
pital of their own down there — poor Mary Mc, can she do it. P. P. C.'s[4]
last night from the Spann Hammonds. Dr. Gibbes ill with fever — would
shake hands with me. Then we went to look at Knitting Machines.

John Chesnut first Lieut. Boykin's rangers.[5] I am glad he was *elected*
by the company & not *chosen* by A. H. B.

No ice — & the thermometer at 96. Mrs. Johnston says the generals
speak of Mr. C in the highest terms. She says John Manning ask[ed]
her — does Mrs. C really speak well of me? The deceitful wretch! he
suspects everybody!

I really wonder what Mr. C means to do.

John Manning knows I never believed in him or trusted him. Snake
in the grass — *beautiful* as he is.

[August 8, 1861]

Yesterday was too hot to dress & go to dinner. Went down late in the
evening — sat on the front porch first with Wilmot DeSaussure who

8. Samuel Cooper's son, Samuel Mason Cooper, had been a U.S. Army second lieutenant
 at Fort Moultrie on Sullivan's Island before the war. The Mrs. Cooper is Sarah Maria
 (Mason) Cooper, his mother.
9. William Silvey of Ohio, then a first lieutenant at Fort Moultrie.
1. Israel Vogdes of Pa., an artillery officer stationed at Fort Moultrie.
2. After Bull Run, Sally Louisa Tompkins had outfitted an old Richmond house as a hos-
 pital at her own expense. When the government took over private hospitals, she was
 allowed to maintain hers and Jefferson Davis commissioned her a captain, the only
 woman to hold military rank in the Confederacy.
3. Mary (McDuffie) Hampton was the second wife of Wade Hampton, III. Mary Fisher
 was probably the wife of a Columbia physician, Dr. John Fisher.
4. "P. P. C's" was MBC's shorthand for "hometown news."
5. Company A of the Second S.C. Cavalry, a unit of Kershaw County troops organized
 and led by MBC's uncle, Capt. Alexander Hamilton Boykin.

showed me a sword taken from the Yankees by a Mr. Prentiss[6] — who was taken prisoner by them. They took every thing he had, his sleeve buttons, & were just going to take off his boots when the rout began — & he took the initiative as revenge. Wade Hampton says those men who were not seen during the engagement pretending to be prisoners are liars & cowards. Wilmot DeSaussure is a Brigadier General! Miles came. I found him affected & a *bore.* Then Commodore Barron who is charming. Says they have just taken three prizes — one with molasses, one with fruit & one with salt. The *Gordon*[7] took two. He wants Cape Hatteras fortified — says it is as important as Fortress Monroe or Charleston.

Only ate a few tomatoes for dinner & sat with Miles instead of tea. So about ten last night felt *ill* with emptiness. Came up & Mr. C & myself had a dissipation of crackers & cheese & ale.

Pickens publishes some stuff to day. The public have lost sight of Pickens quite as long as he cares to be forgotten. Waiting for Mrs. Preston. Miss Barron[8] has a letter from Mrs. Porter — who says Tilly Emory reads them the most amusing [*one page torn out*] her Mother is ill.

[*August 9, 1861*]

Yesterday Mr. Chesnut dined at Mr. MacFarland's. Mrs. Preston & I drove to Mr. Lyons' — found a beautiful country place — & a large party seated on the grass plot. Heard there that Lord Dundas has said the blockade was not complete — which seems to be taken as good news.[9] Commodore Barron said it might only make them stricter. Ingraham said they could not be; they are doing now their best.

Called on Mrs. Stanard; found she had gone to the Salt Sulphur. Came home — talked to Wilmot DeSaussure, Clayton, who said that Jeff Davis could not *now* get the vote of Congress for President. Then Mr. James Holmes & Mrs. Wm. Roper & poor Ashby's boy came. Willie Laurens. Mr. Chesnut came home, said he has given his horse to Toombs who told him the President complimented Mr. C to his Cabinet when he came home from Manassas — told of Mr. Chesnut's coolness on the field, &c. Said Mr. C ought to be a Brigadier General. [*Following sentence added later:*] *Toombs so paid for the horse.*

6. Charles B. Prentiss or his brother Otis, both of whom had enlisted as privates in S.C.'s Palmetto Guard, which DeSaussure had commanded in Charleston.
7. Confederate privateer.
8. Imogene Barron, daughter of Samuel Barron.
9. Lyons was repeating a false rumor that the commander of a British fleet off Charleston believed the Union blockade of the harbor ineffective and intended to sail into port. Dundas was not even in command of ships outside the harbor.

Today John Green[1] came. Says Kershaw met Wade Hampton's Legion running from the battle & said, "Damn you Cowards, turn back, &c, &c." I said, "But Joe is so *pious.*" "Not so very," says John Green. What would Wade Hampton have said to that. What would Wade say indeed?

Called at Mrs. Davis' with Mrs. Preston. Mrs. Jones[2] has told Mrs. Davis that Mrs. Wigfall said in Charleston that she, Mrs. Davis, "was a coarse western belle." Poor Wigfall. Mrs. Joe Johnston was then on her way to see Mrs. *Ricketts,*[3] the Yankee *prisoner.*

Called to see Dr. Gibbes; found him ill at Dr. Gibson's.[4] He rails at Walker. Says Walker's slowness will cost hundreds of lives. Called at Reagans' — Mrs. R very ill — but delicious ices.

Prince Napoleon [*one page torn out*] he is very stout & as he reviewed our troops — it was so hot. John Manning says "en avant," "Allons," is all he heard him say.

Sent a message to Mrs. Davis by Capt. I, but she did not appear last night. Mrs. Joe Johnston & Mrs. Ricketts cried all the time. Mrs. Smith Lee says the prisoners ought to be ironed & Mrs. Ricketts chained with a light chain to a bed post. She was offered a private room, but preferred being with her friends. So has nine or ten men in the room with her. The town seems more filled with soldiers than I have ever seen it — but by John Manning & Preston coming away, I suppose no battle can be expected soon.

Mrs. Preston sends me word Isaac is dead of typhus fever — & Mr. P expected every day. Wm. Shannon now writes his corps will not arm themselves & [he is] in a great accession of military fervor.

Russell wrote a burlesque account of the battle to Bunch,[5] the consul at Charleston, of Wilson's terror, &c, & Sister Bernard of the Georgetown convent writes me word that for a week we could have walked into Washington at any moment. That they acknowledged 25,000 lost & missing, but that troops are pouring in there — that they have *acres*

1. Probably John Sitgraves Green, a Columbia attorney who was the brother of Allen Jones Green, Jr.
2. Sarah Rebecca (Taylor) Jones, niece of Zachary Taylor, was the wife of Brig. Gen. David Rumph Jones of S.C.
3. When Fanny (Lawrence) Ricketts learned of the wounding and capture of her husband, U.S. Army Capt. James Brewerton Ricketts, at Bull Run, she crossed the Confederate lines and gained permission from Joseph E. Johnston to tend Capt. Ricketts on the battlefield and then in Richmond. Mrs. Ricketts's devotion captured the fancy of Confederate leaders, who sent her gifts of food until Ricketts's exchange in Dec.
4. Charles Bell Gibson, a Richmond surgeon and professor of surgery at Hampden-Sidney College, had served briefly as surgeon general of Va. in 1861 before becoming the head of the Officer's Hospital.
5. The British consul at Charleston, S.C.

of horses. Nelson says they have also taken prisoner Elder Nelson[6] who rated Pryor so in Congress.

Hot — Hot — Hot. I can't go to church. Mrs. Wigfall came. I sat awhile with her. She says Toombs & Cobb are at the Head of the opposition to Davis & Stephens — also Hammond, Keitt, Boyce & Banks, &c. She says unless it be Clay of Ala., that Davis has not a personal friend. Clayton talked the same to Mr. C. I dressed & went with her to see Mrs. Preston. In the passage, John Manning & Wigfall rushed out — the former "bearded like the pard." Then Zack Deas & then George Deas.

In Mrs. Preston's room, Mrs. Wigfall & I found again Gov. Manning — he described the Prince's reception at Manassas — & Col. Lay received him *drunk*. Sat on the table with his back to the Frenchman — was a disgrace to us. Beauregard & Joe Johnston did the best they could — but it was soldiers' fare at last — & hard sleeping. The battle field made Prince Napoleon ill — & he drank whiskey gratefully. *One* named Arago[7] took great interest & praised our victory. Beauregard speaks French like a *native* so could tell every thing. The prince said one more battle would settle every thing!

Came home & gave Mary Boykin's seat to Captain Ingraham. Brewster dined with us. Wigfall said any man who behaved as Lay did should be arrested. I said I did not believe I ever should be glad to hear a man was a drunkard — but — I was glad McClellan is said so to be! Had a jolly time at dinner. Brewster says Banks looks like a man who is hunting always for something he ought not to have. Manning says the needs of the army are as great as ever. Wigfall goes tomorrow to Manassas with his Texians. A man named Grey said (the same one Walker asked his business) *the* battle was one succession of blunders — remedied by the indomitable pluck of the two thirds that did *not* run away. Dr. Mason[8] said those of the fugitives he talked to said a million of men with the Devil to back them could not have whipped [us] at Bull Run. Rebecca Singleton[9] is engaged to that nice Alex Haskell. So Mrs. Preston tells me. Good match for *her* — I am glad of it!

[*August 12, 1861*]

Last night talked all the evening to Wilmot DeSaussure & John Green. The former discussed with me the prospect of opposition to Mr. C as Senator — puts Hammond at the bottom of it all. The candidates will

6. U.S. congressman Thomas Amos Rogers Nelson, a Tennessean who opposed his state's secession, had been arrested by Confederate scouts on his way to Washington. On August 13, Jefferson Davis ordered his release.
7. A French naval officer accompanying Prince Napoleon.
8. Probably C.S.A. assistant surgeon Alexander S. Mason, son of James Murray Mason.
9. Rebecca Coles "Decca" Singleton was the daughter of Mary Lewis (Carter) Singleton.

be Manning, Preston or Hampton, McQueen, Orr, Gist,[1] Allston, Hammond, Bonham. A round dozen, but I forget the others. I wish Mr. Davis would send *me* to Paris — & so I should not *need* a South Carolina Legislature for anything else.

DeSaussure says there is entered on the Magistrate's books in Charleston of Jews there — J. Christ assaulted by J. Iscariot & bailed [out] by Barabbas! To day Mrs. Preston & [I] went to tell the Wigfalls good bye — then to Mrs. Davis. She is beginning to find the troubles about Davis — pitched into Cobb at once — & Mrs. Constitution Browne. Stood up for Mrs. McLean. Had rather a more satisfactory visit than usual — left Mary Boykin to stay all night.

After a week's bla[ck]guarding from our papers, it turns out *we* burned Hampton & not the enemy.[2] Mrs. Reagan said to be very ill. Dr. Gibbes better & abusing Walker. So do *I*. I wish I could have told Mrs. Davis all my Prince Napoleon news. Right or wrong — we must stand by our President & our generals — & stop fault finding.

Before I was up, the McKains & John McCaa[3] called — mad for the wars. Camden *shut* up like Sunday. What geese. James Cantey[4] coming here as Col. of a regiment. The *Tribune* quotes an Augusta paper saying *Cobb* is the man & not Davis, that Davis is a reconstructionist.

Mrs. Ricketts told Mrs. Johnston that she was forced to sleep in the room with five men, had no curtain, *no [illegible word]*! &c, &c. Every individual word a falsehood. What liars those Yankees are.

[*August 13, 1861*]

This opposition begins before he has time to offend. I am depressed today. Last night Mr. Barnwell sat with me all the evening & the feeling against Davis is stronger than I expected in S C. Orr, Marshall, McGowan,[5] Hammond, Keitt & Boyce & the Rhetts & *Mercury* influence. What if the same combination, with John Manning thrown in, which is against Davis likewise oppose JC — he must be left out of the next Senate! What shall I do in those long dreary years in Camden — with out outside friendship, with people who have treated me badly & no inter-

1. Brig. Gen. States Rights (so christened) Gist, a lawyer from Union Dist., S.C.
2. On Aug. 7, Confederate troops under Gen. John Bankhead Magruder had burned the village of Hampton, Va., after hearing that U.S. Gen. Benjamin Franklin Butler intended to use it as a depot for runaway slaves.
3. John J. McKain, who was a lieutenant in the Second Regiment of S.C. Volunteers, and his brother, William, both of Camden. John McCaa was a Camden physician and a first cousin of MBC.
4. James Cantey, formerly of Camden, was a colonel of the Fifteenth Ala. Infantry.
5. Samuel McGowan, a member of the S.C. general assembly from Union Dist.

course with those who have always been my friends. God's will be done. I will bear all the best I can. So many are more miserable.

Johnston Pettigrew[6] called to thank Mr. C for his attempt to get him a regiment. Gonzales[7] was there, so like Beauregard. I sat a while with Gen. Robert Lee's daughters who came on a visit to Mrs. Stanard & she is not here. Gen. Lee is fencing with Rosecrans[8] in the West.

Then paid a visit to our Sister of Charity, Miss Sally Tompkins. Found Mrs. Carter there — & Mrs. Alfred Jones[9] who told me Mrs. Zack Deas[1] had come. Zack going home for a regiment.

The cool change has come. I hope we may go home & not to the Mountains. Nine funerals passed here on Sunday. Jordan writes that the mortality in the camp is fearful.

Berig, Mrs. McLean's friend, has written an article for the *Tribune*. Reading Motley'[s] *Netherlands*. Too much of it. Must stop journalizing & write home. Miss Captain Ingraham! Yet I have been & spent the morning with Mrs. Preston — he has been offered the place he wants. Mrs. P abuses J. Manning. We talked the Canteys over, Dickinson,[2] &c. Told her of the Wigfalls spending last night with the Davises & the children spending to day there. *Hypocrisy.* I can no longer respect Mrs. Wigfall.

An atrociously false letter said to be from Gen. Lee in to day's paper — & a lying report of the battle from McDowell.[3] We shall have another hard fought.

John Manning said Preston ought not to resign his aideship — because the *trophies* were to be brought by them.

Seward is fêting the correspondent of the London *Times,* Russell —& Prince Napoleon. Johnston Pettigrew repeated somebody's *mot* that Bonham had as much to learn as a General could have & he *had* learned a good deal.

6. After fighting in the Italian wars of unification in 1858–59, Charleston lawyer James Johnston Pettigrew had trained S.C. militia. Chesnut had helped secure his election as colonel of the Twelfth N.C. Regiment.
7. Fleeing Cuba after an abortive uprising against Spain in 1848, Ambrosio José Gonzales settled in Beaufort, S.C., and married Harriet Rutledge Elliott. He was in Richmond overseeing the manufacture of cannon at the Tredegar Iron Works as colonel and chief of artillery for S.C.
8. Lee had been sent from Richmond at the end of July to coordinate (but not command) the Confederate forces confronting the Union army in western Va. now led by McClellan's replacement, Brig. Gen. William Starke Rosecrans of Ohio.
9. Martha Milledge (Flournoy) Carter, widow of Dr. John Carter of Augusta, Ga., and Mary (Henry) Jones, wife of a Richmond attorney.
1. Wife of Zachariah Cantey Deas, JC's first cousin.
2. Probably Mary F. Dickinson, wife of James Shelton Dickinson, colonel of his own company of Ala. infantry.
3. Brig. Gen. Irvin McDowell, the Union commander at Bull Run.

I am trying to look *defeat* of my personal ambition in the face. So if it does come I can better bear it! & if it does not come the rebound will be so much more delightful.[4]

Clayton told me Stephens says this revolution was only begun — we should soon have Washington & the Northern states! Mrs. Reagan worse because she is so passionate! Spanks children, &c, &c.

[*August 14, 1861*]

Yesterday dined at the table for a wonder. Afterwards letters came, one a very sneering cynical one from old Mr. Chesnut — filled with inquiries for friends north & south & particularly Deas & Hugers. If he only wants letters from me "about Deas & Hugers," I shan't waste my time writing. One from Kate saying Mary Kirkland has been only once to see her since we left — *oh gratitude!* & the Judge says or intimates that Mr. Chesnut has been abusing him. What nonsense & folly! Joe Kershaw won the battle — he says himself. Says Boykin's rangers got there too late. & Mr. C, who don't write puff of himself (Joe writes or sees [to] his own praise), bore the brunt of it, not noticed at all — except a tribute to his speaking "while all the rest were fighting."

After tea talked with Capt. Hartstene, Mr. Barnwell — Willie Preston called & Mr. Snowden & Mr. Seddon & Mason. Let me see if I can remember any thing they said. Old Mr. Mason told a story of a thing he saw in the cars — one man getting in the car & announcing he was from the seat of war, another taking out pencil & paper asking if Fairfax C. H. was burnt. The fresh arrival from the war said, "Yes." The Court House, somebody said, he had seen still standing! "Then," said the man, "it was the tavern — but I must do them the justice to say they were only meaning to tear up & burn the rail road when the tavern caught." "But," said some one, "there is no rail road through Fairfax C. H." "Oh, no rail road? I did not know that," & immediately began talking of something else.

Mr. Barnwell told me Ripley[5] was a general. Willie Preston says he is a good General but not a gentleman. Mr. Seddon was very agreeable & the cleverest man I saw last night but I do not remember any thing he said. Mr. Cooper, Gen. Cooper's son, was very amusing about Cash &

4. Anticipating more than one "defeat," MBC is worried about JC's approaching contest in the S.C. legislature for election to the Confederate Senate, as well as her hopes for the Paris or London diplomatic appointments.
5. Brig. Gen. Roswell Sabine Ripley, an Ohioan who married a South Carolinian and moved to Charleston in the 1850s, was a commander of the Department of S.C., Ga., and Fla.

Ely[6] — Cash told them to take him back & shoot him through the head —
Snowden told how Ely begged & cried.

He said one parson sat on a box in the stable & cried & howled like
a dog at intervals all night. Ely, a negro & the parson were put in one
wagon — & someone called out, "Do not shoot the negro; give him a
good master & a good whipping — but hang the congressman & the
parson," & poor Ely nearly died of terror.

Mr. Snowden says he can find no mortal who heard any thing but
"God damn" & "En avant" from Prince Napoleon — & he repeats the
story of Lay's drunkenness. Ate water melon with Miss Sally Tompkins
& Mrs. Carter. Read Motley. See he is made a consul somewhere.[7]

Our people seem lashing themselves in a fury as to the prisoners. I
hope common decency will not be forgotten & prisoner[s] be treated as
they ought.

Mrs. Reagan[8] was so ill, Mrs. Davis did not think it right to go to the
capitol. I went to see the DeLeons[9] — & then picked up Mary, Maggie
Howell having gone — & we went to a Book Shop — bought for Mary
Boykin several capital books. She is improving. Met some of the college
cadets — Harry DeSaussure among them. Went to the Reagans', picked
up Mrs. Preston & carried that dear old lady home — feel more san-
guine of life in general — do not take such gloomy views of things.

Put 10¢ in my purse.

Kershaw — & A. H. Boykin — & those who are so frantic to be in the
fight & *newspapered* may have many more opportunities & so need not
quarrel about Manassas.

[*August 15, 1861*]

Yesterday afternoon Mrs. Randolph came to see me & the Freelands[1]
to see Mary Boykin. Mrs. R says Harriet Grant has sent her a box marked

6. Col. Ellerbe Bogan Crawford Cash of Chesterfield Dist., commanding the Eighth Reg-
iment of S.C. Volunteers, threatened captive N.Y. congressman Alfred Ely. Ely wrote
in his diary that Cash put a pistol "directly to my head" and said, "G-d d--n your white-
livered soul! I'll blow your brains out on the spot." After two Confederates kept their
colonel from fulfilling his threat, one explained to the frightened congressman that
Cash was drunk.
7. John Lothrop Motley had been appointed minister to Austria.
8. Edwina (Nelms) Reagan, wife of John Henninger Reagan.
9. Agnes DeLeon and her brother Edwin DeLeon, former U.S. consul general in Egypt.
When the war began, DeLeon returned to the South and volunteered for service as a
Confederate diplomat.
1. Rosalie and Maria, popular belles of Confederate society, were the daughters of Rich-
mond tobacco-factory owner Jonathan Freeland.

from Harriet Chesnut Grant — so she came to thank me. Said quantities of things were pouring in from Carolina. I was to go with Mrs. Preston & herself to day to the Hospitals but they do not come. Mr. Marshall came & Gen. Waul. Mr. Chesnut thought Mrs. Randolph lovely. Went to tea with Mr. Barnwell — they discussed orators. Clayton said Prentiss of Miss. was the best he ever heard. Mr. Marshall & Mr. B said Preston — Mr. Chesnut said Colquitt was the best *stump* orator.[2]

We then went to see Mrs. P & the Col. at the Spotswood. Saw there the Wauls, &c, & Henry Deas Nott[3] just from Paris & New York. Says Paris during the Crimean War was never the camp New York is. They claim the 21st battle as a victory for them — the liars — but the returned volunteers go home rejoicing.

Mr. Preston is pleased with his own mission.[4] Says he is no longer an errand boy. Came back & found Captain Buchanan[5] of Maryland — whose stories were the opposite of Henry Nott's. He says a disbanded Massachusetts regiment cheered Jeff Davis. His account of Maryland is [*one illegible word*]. One of those men sent off to New York is Howard who married Miss *Key*, daughter of the Star Spangled Banner.[6] They say she raves. Mr. Buchanan said Evans was likely to have a fight near Leesburg & Gen. Lee & Loring with Rosecrans.[7] Heaven Help us.

Joe Kershaw has published the most impudent & braggart report of the battle too, in advance of all others.[8] ⟨⟨His [*one illegible word*] of Mr. Chesnut⟩⟩ make me so angry — I felt ill. Beauregard calls him an idiot, the miserable little puff of vanity. Hereafter I pray I may be enabled to take life as I find it & not fret my self to death — evidently, from this report, Hampton alone with 500 kept the whole army at bay & was

2. Seargent Smith Prentiss of Miss. won his reputation as an orator with a three-day speech before the House in 1837. Alfred Holt Colquitt was a former congressman, a member of the Ga. secession convention, and an officer in the C.S.A.

3. Henry Junius Nott, surgeon's assistant of the Second S.C. Volunteers, son of Sarah Cantey (Deas) Nott.

4. Preston had been named assistant adjutant-general with the rank of lieutenant colonel on Beauregard's staff.

5. Franklin Buchanan, organizer and first superintendent of the U.S. Naval Academy from 1845 to 1857, was commissioned a captain of the C.S.N. in Sept.

6. On July 1, 1861, Charles Howard, president of the Baltimore board of police, was arrested. Howard was a member of one of Md.'s most prominent families; his father, Col. John Eager Howard, was a Revolutionary War hero, a member of Washington's cabinet, and a U.S. senator; his wife was a daughter of Francis Scott Key.

7. At Leesburg in northern Va., Confederates under Brig. Gen. Nathan George "Shanks" Evans of S.C. were watching for a Federal advance across the Potomac. Brig. Gen. William Wing Loring of N.C. was the titular commander of the Confederate army in western Va.

8. Kershaw had written several pieces for the Charleston *Mercury* glorifying the role of his troops at Bull Run.

just routed & repulsed & beaten when Joe Kershaw came up with Cash & Gen. Kirby Smith & Olliver under his command, returned the fight, routed the Yankees — & would have followed into Washington but Beauregard forced him back. Oh my country men, where is your *modesty*, not to say decency. Above all, where were the 20,000 Virginians, N.C.'s, Ala.'s, Georgians — &c, &c.

Beauregard called Joe Kershaw "a militia idiot" for his frantic hurry to get his deeds in the *Mercury*. Mr. Barnwell says our men are gamecocks — they do fight but then they *crow* so too.[9]

[*August 16, 1861*]

Reported yesterday that Evans had taken a column of Banks' army — at Lovettesville — & that the Federals had taken Aquia Creek[1] — the latter contradicted.

Went to tea with Mr. Barnwell & Clayton — every body laughing at Joe Kershaw. Mr. B says, "fame is an article of home manufacture." Had a delightful long talk with Wilmot DeSaussure, then Dr. Murray[2] — then came Mr. & Mrs. Preston — & Mr. Chesnut made the visit detestable by grumbling & complaining & talking *at me* all the time & abusing every body. He has even got me in a scrape by repeating what Allen Green said to me. I feel miserably to day. Old Crittenden is the traitor.[3] Says we began the war & it must be vigorously *ended* — so much for Kentucky!

Read "Abednego the Money Lender" yesterday & one of Russell's abominable letters today.

Mr. Coffin came to see us from Charlottesville — dreadful accounts of illness among our troops. Mary B had a letter from her father in which he said "generally he had not a strong affection for his friends — but he dearly loved his brother B." He said J. Chesnut had the respect & confidence of all the men. As she was with me, he might have left out his uncalled for account of the coldness of his heart to friends & relations, but I was grateful for praise of JC.

9. Omitted here are three stanzas of a poem which MBC identifies as "Abednego the Money Lender."
1. False rumors. Maj. Gen. Nathaniel Prentiss Banks, former Speaker of the U.S. House of Representatives from Mass., was commander of Union forces in the Shenandoah Valley.
2. Dr. James H. Murray, a surgeon in the Forty-ninth Va. Infantry.
3. On July 22, the U.S. House of Representatives had adopted resolutions introduced by John Jordan Crittenden of Ky. which blamed the outbreak of the war on the South. But the resolutions, accepted by the Senate three days later, were less hostile than MBC allowed: they declared that the North sought to preserve the Union and not to interfere with the "established institutions" of the South.

[*August 17, 1861*]

Richmond. Yesterday remained in bed all day. Wilmot DeSaussure sent me an extra with an account of the battle in Missouri[4] which we take with sufficient allowance for their lies & count it a victory. No confirmation of the yesterday stories of Evans & Aquia Creek — but Johnston Pettigrew & [*illegible name*] & several crack regiments will be there.

I could gain nothing from Mary B but that Gen. Walker[5] had a very handsome aide de camp & that Gonzales looked well in blue uniform — instead of grey — important items. Wm. Shannon, Mr. Mac-Farland & Mr. James M. Mason called last night. Wm. S again today — proud of his company — prouder of the fact that several Charleston men are in it — laughed at my knitting socks. Said all the military men said JC ought to be general, behaved so calmly & bravely on the field. Wants him to be a general or at least a Colonel of Cavalry.

Read *Oliver Twist;* had forgotten how good it is.

[*August 18, 1861*]

Yesterday Mr. C borrowed my ten — & I paid 4½ besides to my washerwoman & 50¢ for cakes. Dined at the table & read *Oliver Twist* until afternoon. Went to tea with Mr. Barnwell — & Clayton told an anecdote of the pluck of a young Carolinian. Mr. Chesnut was talking with a spy to be sent to Washington, Donellen.[6] The spy came afterwards & took his tea with the Douglases with whom he seemed very intimate. I did not like his countenance.

After tea Gonzales asked to be introduced to me. We had a long & very pleasant talk. He told me all about his Lopez expedition to Cuba[7] — in which he was shot — & gave me a most satisfactory account of our coast defenses. Then Mr. Thurston came. He gave us the latest news from Uncle H's company — in which his brother is. Says the sickness there not as bad as represented. Gen. Beauregard still at Manassas, soon to move. Jordan writes to Mr. Chesnut in the most complimentary way.

Went into Miss Tompkins' room & ate watermelon. One of the men in the hospital very *complimentary* to Mrs. Carter — & she very indignant. Mr. Barnwell & Mr. Chesnut returned from the congressional re-

4. At Wilson's Creek, Mo., on Aug. 10, Confederate troops led by Ben McCulloch and Sterling Price stopped a Union advance with over 1,000 casualties on each side.
5. Brig. Gen. William Henry Talbot Walker of Ga.
6. George Donellen, a former employee of the U.S. Land Office in Washington, was a member of the Confederate spy ring that sent information on Union troop movements to Beauregard before Bull Run.
7. In 1850 Gonzales served as adjutant general in the filibustering expedition of Cuban revolutionaries and American annexationists led by Narciso Lopez which set out from New Orleans in a vain attempt to free Cuba from Spain.

ception at the President's; found it very dull. Mr. C told Mrs. Davis entertaining was unnecessary. Breakfasted to day with Captain Hartstene & the handsome aide de camp.

Received a pile of letters. They will not buy the knitting machine in Camden. Miss S.C. is too penny wise for that. Murray Lang writes me an absurd little letter — & old Mr. Chesnut one filled as usual with the *Lewises*,[8] *Deas & Hugers*, [*following phrase added later:*] too liberal to confine his interest to his son. They only find us when they want office.

A letter from Harvey[9] is quite squally for *Magrath* — in the Fort Sumter business. Nothing new from the seat of war. Gen. Means writes [in] a letter he wants to be a *Brigadier*. I have a notion John Manning has gone home for something of that sort.

Mary B is keeping a journal. Mrs. Lee says she is the nicest girl she ever saw — so lady like in every way, does credit to her bringing up — or rather her Mother. Mrs. Davis said also that she never saw a better *behaved* young person. So Mary Boykin pleases those whose praise[s] are worth something.

[*August 19, 1861*]

Went down stairs yesterday afternoon. Sat with the Douglases. Found the spy Donellen, who has the great scheme for taking Washington from the inside, is a friend of theirs. They say he is a Tennessean by birth, now hails from Louisiana & was in Jaque Thompson's bureau. Went to tea with Mr. Barnwell — Clayton telling me Hardee[1] had cut Russell to pieces — hope it is true.

All the papers North and South corroborate McCulloch victory. Boteler[2] has been taken prisoner. He was preaching Union & distracting us last year — when if we had been united all, this civil war might have been avoided. Gen. Waul made a foolish speech & has been sent South somewhere. We have repulsed them at Aquia Creek. If Gen. Lee only whips them in North West Virginia!

Went to see Mrs. Preston — *he* begged Cooper not to make out his

8. The family of John Williams Lewis, a Colleton Dist. planter.
9. A native South Carolinian, James E. Harvey was a correspondent for the Philadelphia *North American* and a moderate Republican anxious to avert war during the spring of 1861. Working with William Seward, Harvey sent a series of telegrams about Lincoln's plans for reinforcing Fort Sumter to a boyhood friend, S.C. Secretary of State Andrew Gordon Magrath.
1. The characters involved were probably Gen. William Joseph Hardee and London *Times* correspondent William Howard Russell, whose letters to his paper were often uncomplimentary to the South.
2. Alexander Robinson Boteler, American party congressman from 1859 to 1861 and a member of the Provisional Confederate Congress, had been taken from his home in Jefferson County, Va., by Union troops on Aug. 13 but was released the same day.

commission for a while! but is quite pleased with his office. They go home today — to be back in October. What a lovely old lady. Saw Eustis & his wife.[3] Mrs. P says she speaks broken English! — having been abroad one year. Saw Mrs. Wynne. She said England & France recognized us *Yesterday!* Spirit wrappers must have brought the news. Did not see the Hamptons. Saw Wilmot DeSaussure. Wm. Shannon will not leave until tomorrow.

Mr. Chesnut has decided against the Military. Hope it may be for the best — but I do not *feel* that to be the case — far from it!

Altho England & France have not heard of our great victory, still all their papers seem to be for us. They had heard of McClellan's defeat & destruction of Garnett!

Their prisoners here are publishing letters in the *Herald* denying all stories of their ill treatment. *Peace,* Peace — if we could have it once more. My head aches & I feel so depressed. I laugh aloud at the idea of Mrs. Lee trusting her son so fondly to the pious influences of his god-father — ⟨⟨*three illegible initials*⟩⟩.

I feel so deeply mortified that Mr. C will not accept a commission in the army — every body says he could get whatever he wanted. Poor Johnston Pettigrew after all ordered to Yorktown — he was so frantic to get to Lee or Beauregard. Wigfall gone — she to Charlottesville, he to Manassas. So Cruger told us last night — the direst bore of all, *Cruger.*

Monday — 4 weeks after the battle of Manassas.

Mr. C has let Mr. Barnwell persuade him that he can be most use to the country in the Senate — & I dare not say, "Go in the Army," because if anything happened, what would I feel then. Why was I born so frightfully ambitious.

[*August 20, 1861*]

Yesterday Mrs. Preston came to say good bye — pressed me to write to her & to go to see her in Columbia — urged me to make Mr. C a Colonel of Dragoons. I wish it was in my power. Wm. Shannon called & told me of the Judge's queerness & Kirklands' taking up all his *vagaries* — against us — too true I dare say. What extraordinary conduct. Wm. Shannon still most complimentary to Mr. C — told me of Keitt's bitterness & opposition to the administration.

Beauregard has written to Miles asking if he delivered the message to Joe Kershaw — & Miles says he told Joe *nothing* — question of veracity. Joe too *smart* — as usual. Mr. C saw James Cantey yesterday, now

3. Louisiana congressman and diplomat George Eustis was married to Louise Corcoran, daughter of Washington banker and philanthropist William Wilson Corcoran.

Col. of Georgians. Mr. C spoke yesterday against the confiscation bill as against the laws of nations. He is for sequestration. Confiscation is against states rights.

Had fever all the evening — ill today. Last night at tea Mr. Barnwell & Captain Walker had *words.* Walker was violent — & repeated so often I thought he must be intoxicated. There are two officers who were at the battle of Manassas who since then have deserted & come here. Walker said if he had a brother killed at Manassas he would shoot down in the street these men if he met them. Mr. Barnwell said, "Then you would be hanged!" Then Walker said, "*No,* 20 thousand Georgians would make a counter revolution first" — & continued to say the same thing until I left the table in disgust.

After tea Mr. Barnwell came by me. Gen. Gonzales, Wilmot De-Saussure, Wm. Shannon & John Lewis — son or grandson of Nelly Custis, Mrs. Washington's daughter.[4] I hope Col. Chesnut will be satisfied now that we have seen some of his northern kin. Dick Snowden too was with us & very funny — he says John Manning's man was all in tears at being left at Manassas. He said he did not like a way the president had of asking him if there were no doubled barrelled guns in Maryland — & Maggie Howell always said, "I don't like Maryland." He answers, "*Poor* Maryland, it must be very flat to you after the bowie knife amusements you are accustomed to at home in Miss." Mr. C says Dick Snowden is a humbug but I find him very funny. Clayton bragged as usual. Donellen the spy came to see Mr. C but the war department will not trust him, so Bledsoe says.

The *Tribune* says to stir up its people that if they "do not subjugate us we will subjugate them." What folly. They report now that Hardee has finished *Lyons'* army.[5] So mote it be.

Frightful illness at Manassas so Gonzales says.

Mr. Chesnut sent Clyburn[6] 25 dollars because Armsted once told him Clyburn took up a chair to a man who abused Mr. C. Anything is better than giving Toombs that horse.

Wm. Shannon says Toombs threatens fearfully — & Clayton says if he does only half what he says we will soon have no enemy to frighten. John Lewis did not seem to care very much for his Philadelphia kin. They have passed a bill for direct taxation. Mary Boykin unwell in her

4. Eleanor "Nelly" Parke Custis, Martha Washington's granddaughter, had married George Washington's nephew, Lawrence Lewis. Their son, Lorenzo Lewis, married Esther Coxe; John Redman Coxe Lewis was their son.

5. At the battle of Wilson's Creek. The Confederate general was Benjamin McCulloch, not William Joseph Hardee, who was stationed in Arkansas.

6. William Craig Clyburn, a planter of Kershaw Dist.

room & JC in mine. Read Motley all day. I find it dull & spun out. I dare say I know he is such a horrid black republican.

Gen. Wool[7] says this war on our part is to extend the area of slavery. They are beginning to find out they cannot trust the *black man* — not, as they expected, every one an enemy of their master's — but nearly all spies.

Saw States Rights Gist last night — he behaved gallantly on the 21st, led the fighting Alabama 4th when all their officers were killed or wounded. My friend Charlie Scott was wounded like a soldier every inch of him — he was member of Congress from California but a native of Virginia & his wife from Ala. Left home as a private & was made major. I wonder where all of those gunboats have gone. Our coast, I am afraid. The *Mercury* tells them of Port Royal, constantly fearing they may forget it.

Letters came, one from A. H. B. to his daughter, sending a hundred dollars. I fancy he thought she would want it for mourning. One from John C sending for an india rubber overcoat which I have bought & have ready now to send. Another from Johnston Pettigrew at Aquia Creek wanting to be sent to Manassas. Mr. C still feverish & neuralgic — he ought to have been able to continue the debate today.

Gave six dollars for the mackintosh. Dined at table with Wilmot DeSaussure & we whispered so *politically* we forgot *to eat*. He says S. R. Gist told him Davis is growing daily more unpopular. I think it is the old cry — from Georgia. Keitt, Hammond, &c.

Gonzales sent me wine. Cleland Huger, Charles Alston & Robert Pringle[8] are here on their way to Manassas.

> Yes! other tones may soften love
> When to thine ear addrest,
> As breezes lulled the barque allure
> O'er ocean's treacherous breast,
> Oh! did I love thee less, be sure,
> My words would smoother be;
> Content thee, then, with praise from them;
> And bear with truth from me!
>
> Yes! other arms may bear them Love,
> Mine, with unwearied, fervent faith,
> Abide the darker day.
> Oh did I love thee less, be sure

7. U.S. Brig. Gen. John Ellis Wool, a veteran of the War of 1812, in a speech in New York on Aug. 15.

8. Lieut. Cleland Kinloch Huger, Jr., of Charleston; Charles Alston Pringle, captain of Lucas' Batallion, and his brother Robert Pringle, a lieutenant of the First Regiment of S.C. Infantry, sons of Charleston planter William Bull Pringle.

My aid would prompter be!
Content thee then with pleasing them!
And keep thy love for me![9]

Mr. DeSaussure said Mr. Barnwell is likely to be Mr. Chesnut's colleague in the Senate. I wish I was certain JC would be *there*. That is my ambition now. No news from the war except they are telegraphing frantically for men from Washington north. Also a letter from Edward Boykin enthusiastic about his cavalry corps. Spent the day *knitting*.

[*August 21, 1861*]

Arlington House. The telegraph says my friend Dan Porter[1] is in Irons. What next. Their best naval officer — for uttering secession arguments — or sentiments.

McCulloch has made a clean platter in Missouri.[2] One half of our army ill at Manassas — can't move on account of illness. Oh that *commissary* Northrop. They are telegraphing from New York for all *sorts of regiments* — any thing & any body. They must have a second panic. Banks — the notorious irrepressible A. D. had a fight yesterday. Mr. Clayton says he picked up an old pamphlet once without covers which said the Georgia colony was only cared for by the British as a barrier between S C & the savages, so they will protect us now.

Last night I found Mr. Tom Drayton down stairs. Says he was at Mrs. Lee's wedding. I said some nonsense & he said, "No woman in America could have said that but you — it is so clever." He stayed to tea with us. So did Dick Snowden who was so absurd that I laughed until the tears streamed. That beast Nat Willis[3] has an account of Lincoln changing his shirt at the open window — & adonizing — says he took 22 minutes to dress.

After tea we had an animated war talk. Mr. Drayton, Mr. Barnwell, Clayton, Mr. C, Dick Snowden. Mr. D wanted to know how many *scalps* Mr. C took — & he said he took forty prisoners at once at Falls Church.

Then came Mr. Seddon — who was only personally complimentary. I came to bed early not to disturb Mr. C. Still very unwell. The excitement against Northrop is *terrible* — for his deficiency in the commissariat. Lee's army can't move on account of sickness too.

Went to drive with Mary Boykin. Met Anthony Kennedy from home on his way to Manassas. Found Mrs. Davis not disposed to see com-

9. Perhaps MBC's own poem.
1. A false report about Commodore William David Porter of the U.S. Navy.
2. A reference to a Confederate victory at Wilson's Creek, Mo.
3. Popular journalist Nathaniel Parker Willis, then Washington correspondent of the New York *Home Journal*.

pany. Went to see Mrs. Roper. Saw there Mrs. Gregg[4] & Mrs. Wm. Preston[5] knitting socks. Mrs. Ingraham not heard from. Then brought peaches & grapes for the hospital. My poor Carolinian looked so *grateful* — he spoke so eagerly & looked so wistfully — his name is Corley & a Georgian eyed my fruit so I carried him some too. Could not find Mrs. Walker's. How I wish I could do more for the soldiers. Anthony Kennedy[6] seized my *dear* bought peaches & eat them as if I had bushels. He will be a good opportunity to send John Chesnut his over coat — dear little Johnnie. I must write to Mrs. P. I wrote an ill natured long letter to Col. Chesnut — but he wearied me so with his Deas, Hugers & Lewises. I wrote a note to day for Mr. C to the President for poor Dick Snowden. Going to try tomorrow night a new *cheveux* experiment.

[*August 22, 1861*]

Arlington House. Went down last night. Sat on the front steps with Clayton & Capt. Hartstene — & Miss Douglas.

Went to tea with Mr. Barnwell. Met Wilmot D who told us a horrid case of drowning on Sullivan's Island. A Mr. Porcher & his child — trying to save his sister — death every where — not confined to camps. Mr. Chesnut rode out with Mr. Davis & came home exhausted & ill looking — in a bad humour. I do not know yet if it be because Mr. Barnwell defeated Edward Stockton[7] or that the President offended him. To day before breakfast came Anthony Kennedy. Still for a passport — I have given him JC's overcoat.

Mary B took Lees & Barrons, &c, to drive. I went at eleven to day to a meeting of the Aid Society. Mrs. R is beautiful & willful and disliked I hear. She certainly has an illfavored crowd — & so contradictory. All in ill temper. I an, to go tomorrow with her to see them.

Mr. C still unwell. I hear terrible accounts of the illness. Wilmot D says in Whiting's Brigade of 4,000, 1,700 are unfit for service. Talked at breakfast with Gen. Walker & W. D. The former thought McClellan might take advantage of our weakness. All the Commissary's fault —we ought to have moved sooner.

Hardee has made a clean sweep in Missouri. I saw an account of Lyon's death most pathetically told to stir up the north.[8] The fight was to day at the Ladies' Meeting over giving things to Yankee wounded.

4. Probably Cornelia (Maxcy) Gregg, wife of Maxcy Gregg.
5. Lucinda (Redd) Preston, wife of Va. congressman William Ballard Preston.
6. John Doby Kennedy's father, a wealthy Scots merchant in Camden.
7. Edward Cantey Stockton of Camden, a second lieutenant in the Confederate marines, was a cousin of both JC and MBC.
8. Nathaniel Lyon, general of Union forces in Mo., was killed during the battle of Wilson's Creek.

The news from England is not as decided as I hoped — after our victory. Russell scores it into them for cowardice, &c, &c. How must they feel after their vaunting — & how will we feel if beaten *once* even. (Helas!)

[*August 23, 1861*]

Arlington House. Mr. Chesnut *ill* & *restless*. I think annoyed at something. Went down last night. Saw Clayton who told me he had just seen a brother of Dr. Garnett returned from Cambridge, Boston — who said he came by Cincinnati, Pittsburgh, &c — & he found recruiting dead — & the cities looking like Sunday. I hope it is true. Mean time our sickness continues — & so does abuse of the Confederate Government officers. W. D. tells me the dissatisfaction is immense. Says the magazine of discontent is ready if any one applies the torch. Says Mr. Memminger[9] is as bad as any.

I had a long talk with Gonzales yesterday & last night. He likes so much to hear of his likeness to Beauregard — lit my candle & gave me quinine pills for Mr. Chesnut.

To day have been all day at the Hospitals. Such a day. At Gilland's factory — saw sick men with measles, typhus fever & dinner tables & all horrors all in one room — dreadful — but at the alms house where the federals are, every comfort. Saw Dr. Grason there — fine looking & agreeable. Would not see Mrs. Ricketts. Saw a Vermont Yankee with his arm off — & a quantity of others. Took biscuits to our Carolinians & they seemed so pleased. Then went to the St. Charles. What horrors I saw there, dirt & discomfort & bad smells enough [for] the stoutest man. At the first I saw a poor dying Carolinian — in all his misery dying. I saw another dying at the St. Charles — & heard one had died in that room early yesterday. God help us.

At the alms house where the Sisters are, every thing was so nice & clean — & comfortable, my Carolinians are as merry as grigs — & seemed so glad to see me. Told me to come often.

We had a Dr. Barney in the carriage, very pleasant, & I had a funny time with a Dr. Page — who said they had sent away the only pretty sister for he was so fond of *sky larking* her. Dr. Gibson said Sister Valentina said she must speak to him. He said, "Very well, tomorrow we will lay our heads together about that business." She said, "No, doctor, it must be to night & the others round." She said, "Mal a aux qui mal y pense." So they joke. The[y] are angels of mercy. Night before last

9. Christopher Gustavus Memminger, a Charleston lawyer, who was secretary of the Confederate navy.

we had here a Dr. Carter that we used to call bumble bee & old hare trunk, a little moth eaten.

Read Russell's letter written the day after the battle of Manassas. He is *against* us — but tries to make our success owing to the northern cowardice entirely. Gives our courage no credit. I will not believe the army is on the move until I hear Mrs. Joe Johnston has come.

Today a Georgia regiment of cavalry passed us sitting at the door of one of the Hospitals or shops in the carriage — & Dr. Barney said he counted with it 15,000 dollars of negro property. I saw a wounded negro among the Yankee soldiers. Wrote three letters for Mr. C, one to Dr. Moorman,[1] one to J. Walter Hill. Gen. Walker paid for putting them in. I must remember to pay him for it if I can.

[*August 24, 1861*]

Yesterday afternoon Dr. Barney & his wife called. I suppose I made a pleasant *impression* — & several other people to all of whom I excused my self. Mr. Miles came when I was ready to go to Mrs. Davis — he is going when Congress adjourns to spend some time with Mr. Mason. I wonder he does not fear they will take him as they did Mr. Boteler. Winchester is very near Banks' command — he must have incensed them by his treatment of Ely.

Mr. Miles & Wilmot DeSaussure went with us to Mrs. Davis. She was affability itself. Asks me next Monday to take lunch with her. The president was kinder than ever & says I must make Mr. C ride with him every afternoon.

Saw comical people there — one lady in a gold belt & green silk with huge bunches of green grapes & gold wheat sheaves in her hair. Mr. & Mrs. Daniels[2] were there — the Editor of the *Examiner*. Miles said he thought he would feel odd in going to see people he abused as the administration is abused in the *Examiner*. Saw De Bow — of the *Review*.[3] Bob Wood engaged himself to Mary VanBurtheyson & then courted Maggie, so they were in a row. Came home after finding the driver gone & the carriage at the door — & had to send all over the neighbourhood to find him.

Came home & found James Lowndes. Had a charming chat. He says Beauregard asked Joe Kershaw what he meant by such a report; it was worded as if he had been a Major General instead of a Colonel — &

1. Dr. John J. Moorman, resident physician at White Sulphur Springs.
2. John Moncure Daniel, editor of the Richmond *Examiner*.
3. James Dunwoody Brownson De Bow, the South Carolinian political economist who edited *De Bow's Review* in New Orleans before the war, became chief Confederate agent for the purchase and sale of cotton.

Joe excused himself saying he was not *accustomed* to military *etiquette*. Mr. Lowndes [says] he knows two things to be untrue, that he took Ricketts' battery & that he led the Legion & saved it.

Mr. L said some old man said the great injury the war would do us, that it would take forty years to get rid of the *heroes* it made. He said the war had proved one thing the pest of civil life: the *heroes* who tormented every body with their *courage* were the first to leave the battle field.

A Carolinian knocked down four Baltimore men last night & was himself knocked in the head with a club. Soon recovered & went away singing.

Saw Ransom Spann[4] to day; he has come on to join Hampton's legion with his company.

Saw Mr. Perry — B. F.[5] Saw Mrs. Toombs & Mrs. Sandaidge[6]; she had left a card here. Am paying away my substance in hack hire — must reform. Read Bright's speech *against us*.[7] No news — *a lull* in the rush of events.

[*August 25, 1861*]

Arlington House. Yesterday dined at the table, stupid & head-achey — & sleepy — in the afternoon was hurried down to see Mr. Ould who had been twice to see me in two days. Mrs. Bright[8] writes to Mrs. O that Lina is perfectly safe & the nuns wish to keep her. I am relieved. We had a merry time, Mr. Barnwell, Mr. Clayton, Mr. C, Mr. O & myself. Mr. O told me much of the dissatisfaction of the people with Walker & Northrop. I find I made shocking blunders with James Lowndes. They have made the second Lieut. Captain of Washington Light Infantry[9] over his head — & I spoke to him of his being captain & wanting nothing — how stupid I was.

Mr. B says democracies make people as *we*, & the Yankees are a nation of liars — every body is always *electioneering* & dare not speak truth. He says our Low country speak truth more, as they *own* their constituents. The English individually the most *truthful* nation. I forgot to tell him what Thackeray says of the English. Lies in the French War. It is as bad as what Russell says of us now.

4. A planter from Sumter Dist.
5. Benjamin Franklin Perry, lawyer and former state legislator from Pendleton Dist, S.C.
6. A native of Richmond and an assistant at Sally Tompkins' hospital.
7. At an election meeting on Aug. 1, English Liberal M.P. John Bright had linked British prosperity with the success of the Union.
8. Mrs. Jesse David Bright, wife of the U.S. senator from Indiana.
9. A Charleston militia unit formed in 1807 which served as Company A of Hampton's Legion during 1861.

Agnes DeLeon & her brother came in. I tried to make her talk of *Egypt* & the Nile, &c, the crocodiles & turks, &c, but she would make Washington & the times her theme. It was a mean trick in Mr. C to tell Mr. B how dissipated I was in Washington just as he begins to like me so well. But the shabbiest of all things was Garnett coming here & going away without coming to see me. Oh human gratitude! Clayton, assistant Secretary of State, says we are spending 2 Million a week — awful prospect!

Mary B has bought an emerald & diamond ring for Mattie Howell & received letters from her Mother that she is getting mourning for her. Six new Carolinians at Miss Sally Tompkins' hospital. We are plebeian as to names. Think of it — "Pig Point," "Bull Run," "Dug Springs"[1] & our Florence Nightingale is named Sally Tompkins.

Mr. Barnwell told a story at which he laughed to tears — of a man who in the Court House heard another fined five dollars for "Contempt of Court," his own case coming on. The Judge talked pat nonsense & showed a partial spirit — so the man said, "May it please your honor, fine me 5 dollars too." "Why?" "Because I feel coming on me a secret contempt for the court." I over heard Miles say to Mr. Barnwell that he thought the five thousand dollars for the President's house in Montgomery caused Judge Withers to resign. They were in full blast last night when my head ache caused me to come up. Wrote to JC at Fairfax C. H. Boykin's rangers, Bonham's Brigade.

> The Assyrian came down like a wolf on the fold
> And his cohorts were gleaming with purple & gold;
> & the Sheen of their spears was like stars on the Sea,
> Where the blue wave rolls nightly on deep Galilee.
> Manassas Plains[2]

Was seated in my rocking chair in petticoat & sack — hair plaited & screwed up & dishevelled like a crazy Jane, when in walked Captain Page[3] — stared wildly — stood still — & rushed out. I am such an object I do not think he will recognize me in decent attire.

[*August 26, 1861*]

Richmond. Arlington House. Yesterday went to tea with JC — felt ill — feverish, the old ruinous fever symptoms. After tea Mr. Clayton & Mr. Barnwell & a young Stuart from Beaufort. The latter brought the pris-

1. Early in June 1861 the *Harriet Lane* bombarded the Confederate Pig Point battery on the James River in Va. Skirmishes near Dug Springs, Mo., on July 25 and Aug. 2, 1861, opened the fighting between Union and Confederate forces in that state.
2. Five more stanzas of this unidentified poem are omitted.
3. Probably Richard Lucien Page, a captain in the C.S.N., stationed at Norfolk.

oners from the *Thompson*,[4] a merchant vessel. One, a rapid *concessionist*, says he has lost all his property & will *prosecute* us for life. Yet they turned him loose. The rest foreigners. Afterwards Gonzales & Wilmot De-Saussure. W. D. tells Joe Kershaw has had to rewrite his report & modify.

That handsome Anderson[5] talked with us two hours after dinner. Says his wife & child were at Fort Hamilton when Doubleday[6] got there after Fort Sumter. The child not more than 10 months old had been taught to hurra for Davis & Beauregard — which the poor baby called Dadis & *Bogar* — & Doubleday said such a child must be the product of rebels. Stormed at the little thing & said her father should be arrested — his wife wrote him this & he came home immediately by Cincinnati, not going to New York. He says a meek little Gibbes said, "How do you do, Mrs. Foster," & was answered in a voice of thunder, "How dare you speak to me, you rebel," & Gibbes collapsed.

These young men from Beaufort say in the cars in N.C. a woman came in who thought these merchantmen were enemies caught in battle & shamed them — & said, "If you kill all our men — we women will murder you with broom *sticks*." So much for *belligerent* women. Had to come up last night & take opium.

Mr. B tells me Etta Aiken's[7] engagement to Burnet Rhett has been announced & they are to be married in the autumn.

Clayton said he witnessed a scene between *Cobb*, Governor Cobb & his man Laurens. He said, "Let us come to an understanding. Am I to wait on you or you on me." I asked Laurens' answer & was told Laurens did not say much but looked as if he preferred the Governor waiting on him. I see an account of the letters in [*illegible name*] possession in the northern papers — I fancy true, as Captain Hartstene brought the news from Charleston that Russell had burlesqued the battle to Bunch & repeated what Lord Lyons said about *belligerents*. Another story of Beligny & Bunch sending Trescot here. All the papers favourable to us have been stopped at the *north* — *Journal of Commerce, Day Book* news[8] —

4. The *Mary E. Thompson* had been captured by the Confederate brig *Jefferson Davis* on July 9. Stewart was a lieutenant on the ship.
5. Aide-de-camp to Gen. William Walker.
6. The reputed inventor of baseball, Abner Doubleday was a U.S. Army captain stationed in Charleston Harbor in 1860–61.
7. Henrietta Aiken, the only child of former governor and Colleton Dist. planter William Aiken of Charleston, was engaged to Andrew Burnet Rhett, a son of Robert Barnwell Rhett, Sr., currently serving as an artillary major in the C.S.A.
8. On Aug. 21, the U.S. government ordered that several pro-Southern New York newspapers, among them the *Journal of Commerce* and the *Day Book,* be suppressed and prohibited from the mails, since they were allegedly aiding the rebellion.

Baltimore also — & a quantity of new arrests made. *Terror* is there no doubt.

That report of Clayton is not true as to our expenses — for the money issued was to pay the troops, therefore cannot be *weekly*.

I saw an immense Brigade go by today. Gonzales made himself very agreeable last night. Mrs. Carter & Miss Barron joined us. Mr. Chesnut went to see Jeff Davis about the colonelcy of *cavalry* — but he was ill in bed. I am afraid Mr. C will decide too late as usual. From what I see in the *Journal*, Wm. Shannon, Edward Boykin mean to have a superb company. Wilmot D had been to inspect a cooking stove cut out of earth in the side of a hill — which has succeeded wonderfully. If Mr. C takes a Colonelcy I will go as *cook* — the men fare so badly.

Went to day to see Mrs. Davis. Mr. Davis too ill for Mrs. D to see any one. Mary went in & gave her ring to Maggie who thanked her but did not look at it. Then we went to Pizzini's for fruit & carried it to Miss Sally Tompkins. Found Mrs. Sandaidge nursing there. Gave my Carolinians the fruit; had a pleasant chat. One man said he saw Mr. Chesnut with shot & shell raining over him in the battle quite cool as a May morning. Had all bright, pleasant faces. One who looked more forlorn than the rest, in a corner, kept saying, "We have had a hard time since we left home."

Went to Mrs. Toombs'. She ridiculed Mrs. D. Would not allow Mr. D was ill. Said the entertainment given by the President to Congress was *execrable*. Even Mrs. Reagan said she could do better. Says Mrs. Reagan is the lowest woman she ever saw — little negroes & her children sleep together. Then went to see Mrs. Walker — find her pretty, silly & I really believe half crazy.

Then Mrs. Dr. Barney — not at home — had such "a hunt." These preposterous people put no number on their card & the hack drivers know nothing. I find Jessie James' card when I came home. Does not say where she is staying. Must go this afternoon to see her to repay or at least show gratitude for her kindness in Montgomery. I hear Mrs. Winston Hunter is also here. Met in the st. to day Walker Adams & Taff Wallace. Say they are coming to see Mr. Chesnut to get passports to Manassas. Must remember to return W. D.'s books. Mrs. Lee is too funny about Mrs. Eustis. Says she was Linda Corcoran, brought up rough & tumble in Washington, her grand mother coarse & strong & hearty. Says she has been one winter in New Orleans with the Eustises & she comes soft & sweet & languid & low voiced like a Southern woman. Felt disposed to shake the affectation out of her.

Left Mary H down stairs with Willy Bull & a man whose name I did not hear. Sent Laurence to change a fifty dollar bill — which he brought

in, & I sent him to find where Jessie James is — how useful he is. Must remember to call on Mrs. Semmes,[9] Miss Meredith.

Wilmot DeSaussure told me to day at dinner that Theodore Barker is here. A. VanderHorst & Barker told him that Beauregard's expression of face was wonderful when Joe Kershaw told him that he sent off his account first because Burnet Rhett was so anxious to get it into the *Mercury*. Mr. Miles' prophecy proved correct. It was a Rhett business at last.

Mr. D says Tom Drayton was with him, swearing at the departments to day. Mrs. Toombs says it is no use to talk to her. "If one of them Yankees kill Mr. Toombs — *she* will kill one sure." All the time ridiculing Mrs. Reagan's want of polish — & education.

The thing which pleases me best today is that the London *Post*, the government organ, says, "The Southern States have *achieved* their independence," & a Scottish paper has the best notice of us printed over the waters yet.

[*August 27, 1861*]

Richmond. Yesterday as I finished writing Mr. Chesnut came in & was in a bad humour — spoke of not going in to the service except as a congressman. Then Toady Barker called — had a pleasant chat with him. He has not been promoted any how. He is very bitter against Kershaw's braggadocio report. Says however it was not himself but Arnoldus VanderHorst who heard Beauregard reprove him. Toady thinks James Lowndes wretchedly treated. At six I went to see Jessie James — & took her to drive. She said Frank Campbell was a Captain of Zouaves in New Orleans. Still engaged to Miss King but has never been to Charleston since the engagement. Writes to her constantly & begged to go to Point Clear to meet *him*. She wrote she would set him up with it. She was coming here to meet Alfred James! I think she must have *felt* that Mrs. Davis has improved her condition. When I showed her the President's house, I inquired there & found Mr. Davis better — have just sent a note to Mrs. Davis to ask after him today.

She told me the Harrisons sold their house for 20 thousand dollars. The President brought luck to the Harrisons. What *Yankee screws* they are. Came home & had a chat with W. D. & Clayton. Told them Mrs. Toombs' speech. Then Mr. Barnwell came to me & his nephew Mr. Barnwell Fuller[1] — & then James Lowndes. We had a delightful talk —

9. Anne Elizabeth (Spencer) Semmes, wife of C.S.N. Capt. Raphael Semmes.

1. The son of Robert Woodward Barnwell's sister Elizabeth and her husband Dr. Thomas Fuller.

but he did not ask me any thing. Mr. C joined us & said to my amaze-
ment that "all he wanted in this world was to be in peace on his plan-
tation." Mr. Lowndes said "he wished he had a plantation to be on —
but *now* nothing could induce him to leave the Army." So proper a re-
ply stopped the talk.

Mr. C went off & was called down to Captain Archer[2] just from Cal-
ifornia — he was an old classmate of Mr. Chesnut at Princeton & so pretty
they called him *Sally* Archer. He is handsome now. I had no opportu-
nity to speak to him, so many called — my old frantic *Lover,* Gen. Fair[3] —
he has been Consul at *Brussels.* &c, has a *rascally* wife, poor fellow. I
remember when he made such desperate love to me, I thought him
hideous. Now he is handsome — & imposing. He spoke to me only as
an acquaintance of yesterday — but I saw he constantly drew *nearer,* I
fancy to see the ravages made in me by the battle of life. I have been
pretty severely damaged by its wounds & fevers.

Sim Fair[4] came with him & Boyce. The latter said Faulkner's son
begged him not to go to Washington; he would be arrested. Boyce ought
to know, through his double flirtation with Mother & daughter, the af-
fairs of that family. Then came Mr. Mason — & I told him what I
thought of Garnett's shabby conduct. Then Miles — he was in one of
his moods which I find pleasant. Sometimes I like him — sometimes I
hate his affectation & folly. These men discussed duelling — no new ideas
thrown out.

James Lowndes asked me if Mr. C got up a regiment of cavalry to
give him a *place* & he shall have it — if I have any *influence.* Mr. C says,
"Why do not those young men come to *me?* why all to you?" I said, "Poor
things, they think I have more influence with you than I really have —
they think you think more highly of me than you do." So that ended
that chapter.

Captain Hartstene rushed after me to beg me to come back & say
good bye to Gen. Walker & Handsome Anderson but I was too tired —
& sent good bye to them. Hartstene is an odd genius. My note to Mrs.
Davis is answered by Maggie Howell. That Mr. D has escaped fever but
is very weak.

I read a letter from Mary Lang Boykin in which she says she is very
"misserable" & Harriet a "mean rech," so I conclude Sebby Cureton is
a good match for such a *speller.*

2. James Jay Archer of Md. resigned his captain's commission in the U.S. Army to be-
 come a colonel and eventually a brigadier general in the C.S.A.
3. Elisha Young Fair, born in S.C., was a minister to Belgium under Buchanan.
4. Simeon Fair, a brother of Elisha Fair, had been a delegate from Newberry to the S.C.
 secession convention.

Feel *misserable* myself today.

The only thing worthy of note in the morning's papers was the evident consolidation going on at the North. *All* newspapers suppressed which express a feeling against them — & all state divisions removed as to states — the Army broken up & *reorganized* as a national one. *Russell* still visiting the Camps — cursed by the *U.S.A.* Soldiers for his letter — & a quantity more of arrests. I cannot find out what Mrs. George Parker is doing *here*. I am as bad as the man who screamed for an hour in the French convention for "l'arrestation de tous les scélérats et coquins." I am always wanting some one taken up.[5]

James Lowndes was very particular in his inquiries after Mrs. Kirkland.

> Friend after Friend departs
> Who has not lost a friend.
> There is no union here of hearts
> That has not here an end.[6]

Custis Lee[7] called last night — he told us he heard nothing of his father, Gen. Lee. There was a rumour told Mr. Chesnut by Gov. Letcher that, by treachery of the guides, a plan of Gen. Lee's for taking Rosecrans had been frustrated. I said immediately, "I hope they hung the guides." Every body laughed — my blood thirsty sentiments being so well known. James Lowndes told me Rose Freeland is engaged to a Mr. Harrison.[8] Those Freeland girls have devoted themselves to *S C* soldiers.

The knitting mania *rages*. You never see a woman without her needles are going.

Just had a call from Walker Adams — son of my poor friend Gov. Adams. He is dissipated — had a brandy & water odour today. Said Mr. C ought not to give up Congress for the Army. Said he was the best fitted man in S C for his office. Wanted to abuse B. Rhett but I did not encourage. Maggie Howell & those two spooky girls called on M. B. Mr. Davis no fever but so weak that even talking in the room with him makes

5. Carlyle describes the invasion of the convention in *The French Revolution* (1837), book 7, chap. 5. A single episode symbolizes the degeneration of republicanism into mob rule: "One man we discern bawling 'for the space of an hour at all intervals' . . . 'I also demand the arrest of the knaves and dastards.' " Carlyle has it in French somewhat different from MBC's version.
6. From "Friends," published in *The Poetical Works of James Montgomery, Collected by Himself* (1841).
7. George Washington Custis Lee, eldest son of Robert E. Lee, had been a career officer in the U.S. Army and then a Confederate major of engineers before becoming a colonel and aide to Jefferson Davis.
8. Rosalie Freeland of Richmond was engaged to Dr. Randolph Harrison.

him flushed & feverish. She admires excessively M. B.'s ring. "So does Sister."

I have a firmly fixed conviction if I undress some one will call immediately — & I will have the agony of dressing in a hurry — & if I punish myself by sitting *thus* — pinked, I shall have the consciousness of rectitude for my misery but there will be no visitors. Have returned Motley to Wilmot DeSaussure *unread*. The vile Yankee.

[*August 28, 1861*]

Was in bed all day yesterday — ill still. Nobody knows when congress will adjourn now. Want M. H. B. to go home with W. D. See by today's papers that Mrs. Greenhow, Mrs. Phillips & Mrs. Gwin are arrested [9] — & Jesse D. Bright [1] threatened. Despotism complete. Mr. C sent for a Doctor. David Porter of the Navy cleared himself from Yankee suspicion. I am sorry for it.

Nelson [2] has really come out for us in East Tennessee. Davis managed that business beautifully. Wm. B. Reed, Wharton, &c, have been arrested in Philadelphia — & Miss *Windle* [3] in Alexandria — she boldly proclaiming herself a secessionist & saying she is in correspondence with Confederate leaders. Poor Miss Windle.

Does not she enjoy the delicious notoriety of being *persecuted*. I see the *Tribune* acknowledges they have a *hard* nut to *crack* in the Southern army. He speaks of the superior intelligence & education of the men — from the letters I have seen, there is no evidence that the school master has been abroad in Yankee Land. No confirmation of the news from Gen. Lee — a fleet of steamers gone South — Dr. Gibson ill — & Dr. Garnett out.

Mr. Mason is nominated for the Minister to *England*. [4] There goes my bread & butter on the *buttered* side. JC would have suited that place better than any man in the Confederate States says MBC.

9. Rose O'Neal Greenhow led the Washington spy ring that passed Union secrets to the Confederates before Bull Run. On Aug. 23, Pinkerton agents searched Mrs. Greenhow's home, placed her under house arrest, and detained several of her associates, including Eugenia (Levy) Phillips, the wife of a former Ala. congressman. The news of Mary (Bell) Gwin's arrest was false.
1. Jesse David Bright, U.S. senator from Ind., was accused of treason after Federal authorities intercepted a letter of introduction he addressed "To His Excellency Jefferson Davis, President of the Confederation of States." On Feb. 5, 1862, he was expelled from the Senate.
2. Thomas Amos Rogers Nelson was less enthusiastic than MBC suggests.
3. William Bradford Reed, a Philadelphia-born pro-Southern Democrat, and George M. Wharton, a former U.S. district attorney. Reports of their arrests were subsequently retracted. Mary Jane Windle was arrested leaving Alexandria, Va., on Aug 22.
4. Davis designated James Murray Mason as Confederate commissioner to Great Britain on Aug. 24.

I saw JC walk by my window with Sam Ferguson,[5] Arnoldus VanderHorst rushing after. Mr. C has been to physic Mr. Barnwell who is also ill with my disease — all from his infamous cooking. Today they have given me milk & rice & I know now the probabilities are that I shall get well. Can't see Clayton to hear the news — if ——

Telegram from J. S. Preston as to Gen. Means' regiment. Mr. C has treated Means shabbily, I think. M. H. B. has the blues. I am getting well — & bear losing the English Mission nobly. Old Team & his wife are on their way here — so Captain Ingraham says. Maggie Howell sends me word that the President is better. See Henry M. Rutledge[6] has been appointed 2 Lieut. They will think we did not try hard for Robert but we did.

Wish I was well enough to go down & hear Charleston news from Capt. I. Can't be too glad the Doctors were out — shall get well so much sooner. The papers, those licensed liars, say the sickness abates in the Army — so mote it be.

[*August 29, 1861*]

I have just read a letter of Russell's which enrages me — the second after the battle of Manassas. In which he tries to make it believed that the battle of the 21st was fought at long ranges — 500 yards apart — we steadily retreating until they were frightened at something among *themselves* & they fled & we were too frightened to pursue. Occasional *gleams* appear — in which in spite of himself he shows the truth for us. Their miserable *cowardice* & want of honesty & truth.

We are Americans as well as the Yankees — & Russell cannot do us justice — he even repeats those hateful & *hideous* falsehoods as to our treatment of wounded & prisoners, when their own officers write such different stories — & one of the head surgeons writes to thank our surgeons. It is really amusing to see the accounts of the way Mrs. Gwin & Phillips & Greenhow are treated — houses guarded. Our women are now in a nice condition — traveling, your false hair is developed & taken off to see if papers are rolled in it — & you are turned up instantly to see if you have pistols concealed — not to speak of their having women to examine if you are a *man* — in disguise. I think *these* times make all women feel their humiliation in the affairs of the world. With *men* it is on to the field — "glory, honour, praise, &c, power." Women can only stay at home — & every paper reminds us that women are to be *violated* — ravished & all manner of humiliation. How are the daughters of Eve punished.

5. Samuel Wragg Ferguson of Charleston was a captain on the staff of P. G. T. Beauregard.
6. Henry Middleton Rutledge, a cousin of John Rutledge.

Mary H. Boykin at this time last year had every reason to believe Wm. Matthews desperately in love with her. Since then he has courted, married, & had a daughter — rapid changes, this truth of time brings. Captain Ingraham says he wants to see me so much. Mr. Barnwell so ill the Doctor has been sent for — & I am confined to my room.

Mrs. Lee is killing herself laughing at those old ladies — being *confined.*

Mrs. Gwin — Mrs. Greenhow — & Mrs. Phillips. I think Mrs. Greenhow's incarceration a ruse de guerre. She has all her life been for *sale* — & we will trust her better & she can do us more injury if they pretend to distrust her. Capt. I has a handsome son. M. H. B. says just the right size for her.

Capital article in the *Albion*[7] to day — on the lettre de cachet system, passport system & suppression of the press at the north. Freedoms gone there in the hope to subjugate us. Russell [says] the tramp of the man, who ever he may be (McClellan?) is already heard who is to be their *despot. Then* our trouble comes. We can easily fight the "many headed monster thing" now pretending to govern.

Had a row with Mr. C for not wanting to answer John S. Preston's telegram. Accused him of the prevailing *insolence* of office here. Shall tell him what I have heard my father say of Calhoun's attention to Carolinians. I see every state is organizing to take care of its own sick. Mr. Chesnut came home today to say Slidell will be Minister to France[8] — so "all my pretty chickens at one fell swoop."[9]

Now if we are not reelected to the Senate! My experience reverses all others — private life is wrangles & rows — & strife & ill blood & neighbourhood & family snarls. *Public* life has been peace & happiness, *quiet* & comfort. Now as JC's genius does not lie in the military I suppose Camden is my dark fate if he is defeated in November — but I will harbour so dark a thought against my own peace of mind. Pride must have a fall — perhaps I have not borne my honours meekly.

Congress will adjourn Saturday. Mr. Barnwell, Laurence says, eat my rice & milk eagerly.

[*August 30, 1861*]

Went down last night. Found Clayton who professed not to have known I was sick. Told me we had gained another victory in Missouri[1] —

7. The New York *Albion.*
8. He had been named commissioner to France on the twenty-fourth.
9. *Macbeth,* act 4, scene 3. The response of Macduff to the murder of his wife and children.
1. The report was exaggerated; in the final days of Aug. only minor skirmishing took place in Mo.

also amusing particulars of Mrs. Phillips, Gwin, &c. I see today they say Mrs. Phillips has nine children as a reason she could not mean mischief. *They* have never been in her way yet in that particular. Capt. I agreed with [me] Mrs. Greenhow would always be knocked down to the highest bidder.

It seems pitiful in McClellan to take Russell with him after such atrocious letters. I think the northern mind utterly demonized.

I see Gen. Robert Anderson's staff is organized — & *he* is ready for action. Three days ago, handsome Anderson said he would not fight the South. He told me he was in the North West with that unlucky Garnett who was killed at Cheat Mountain. He says Garnett was always cold & proud — loved nothing but his wife & child.[2] Went on an expedition for six weeks. Came back & found them, *both* wife & child, under ground. Said nothing! but seemed more frozen & stern & isolated than ever. The night before he left Richmond he said they have sent him to *die,* "For they give me no adequate force to do anything." A dreary, sad man — it is acknowledged he threw away his life.

It seems confirmed that a large fleet — with Butler & 4,000 men have sailed South. Spoken last off Cape Hatteras.[3] Capt. Ingraham says Ripley is ready for them in Charleston. I think Orr is keeping his troops at home for the autumn.

JC seemed unusually depressed last night. I see that [they] have voted thanks to Cobb — in whose seat & whose work JC has done since we have been here. Gonzales seemed charmed to see me last night. Says he has telegraphed Pickens & *Port Royal* of the advent of Butler & his Myrmidons. When they invade N.C. will not the old lady *shake* herself — & rouse — how she pours out men — so quietly & swiftly.

I think in spite of Russell the English journals lean towards us. An aide of Beauregard's came last night — Alexander.[4] Says he wants cannon. Johnston took *all* but two captured in the battle — also 4,000 cavalry. Now there is a chance for *JC — but* he may not think so.

Mr. Barnwell still ill in bed — he had a Doctor so did not escape as easily as I hope to do — 'tho' I am not *cured,* only better. I wish something could be done for *our* hospitals but every one seems so inert.

Captain Ingraham & I had a long talk last night. Commodore Barron says he has hoisted his flag in the *Manassas*[5] — not so grand a ves-

2. Mrs. Robert Selden Garnett, wife of C.S.A. general killed at Cheat Mountain, Va.
3. U.S. Maj. Gen. Benjamin F. Butler commanded the expedition that captured two Confederate forts at Hatteras Inlet, N.C., on Aug. 28. Only 880 Federal troops were involved.
4. Edward Porter Alexander of Ga., a signal officer of Gen. Beauregard's and a future brigadier general.
5. Ironclad Confederate ram.

sel as the *Wabash* but he is proud of it — has two launches, *Mosquito* & *Firefly*. What a splendid set of fellows our naval officers are.

A man named Tom Jones came from Washington yesterday. I do not like his face — his brother Roger Jones burnt our *navy* yard — & is still in the U.S.A. army. Two brothers, Walter & Catesby, are on our side. What if he be a spy of brother Roger![6] He gave a pitiful account of Washington & says the recruiting goes of[f] *slowly*. A great many leaving the city in fear.

Corcoran is taken *prisoner*[7] — as I expected. Elisha Riggs[8] just returned from Europe a hot union man & Lincolnite. Said he left because he had as soon be in South Carolina as in his brother George Riggs' house, so much treason was taught there. & *spoken*. George Riggs the banker will be the next — a lively time they are having.

Clayton tells me *our* state department pays *30* dollars a month for the *Herald* & gets it two days after it is published — 360 dollars a year. Capt. I says it was rumoured in Charleston that Mason was to be our Minister to England — how things slip out. M. H. B. spent the evening with Jenny Cooper[1] — & now has ordered her carriage for a drive. Had a large meeting of ladies last night — all *knitting*, no scandal. Our leviathan of Loveliness, Mrs. Carter, looks lovelier than ever.

I sat knitting. In rushed M. H. B. — all in tears. Capt. Barron & his Lieuts. taken prisoners! I felt faint & ill — those poor girls. Mary cried, "How soon may our turn come," her father in the *advanced* post — scouting — & my poor child John Chesnut. When Mrs. Lee told Imogene, she *fainted!* I sent Mary down to them — to say the enemy dare not hurt a hair of his head. I wish I felt that. They are in terrible distress.

Mrs. Lee met Mrs. Eustis (Loulie Corcoran) & said, "Have you seen the *arrests?*" meaning those Washington belles. She simpered, "Yes, I suppose you mean my father's — I see by the papers he is taken prisoner." Mrs. Lee had not seen it or she would not have spoken of it in a casual encounter — however Mrs. Eustis is not likely to break her heart. If that fleet lands at either N.C. or goes on to Port Royal — won't we have work. Oh my heart — how silly are my disappointments to these heavy *troubles* of these orphan girls.

6. Catesby Jones, a former U.S. Navy officer, was later second officer on the *Merrimack,* and Walter resigned a lieutenant's commission to join the C.S.A. Lt. Roger Jones, commander of the Federal arsenal at Harpers Ferry, destroyed the armory before the Confederates could capture it in April and remained in the U.S. Army.
7. A false rumor.
8. George Riggs, a former partner of William Corcoran's, and his younger half-brother Elisha, owned the prominent Washington banking firm Riggs and Co.
1. The daughter of Adj. Gen. Samuel Cooper.

I see that Anderson is to replace Bragg at *Pensacola*. They will not fear this Tom Todd Anderson.[2] Besides, it is an unlucky name. I hope Bragg will not come. M. H. B. has been to Mrs. Davis — both better — inquired particularly after me. Were told I was ill still. Oh my heart! These poor Barron *children*.

Fort Hatteras is taken! & it will take 30,000 men to retake it. Oh my country! What folly — Capt. B came here three weeks ago to tell them this very thing & they neglected him — he said that point required as much guarding as Fortress Monroe, Pickens or Charleston. Ho for Port Royal!

[*August 31, 1861*]

Saturday. Woke to day so miserably bit by some unknown bug or reptile that I feel as if I had the measles.

Yesterday afternoon Mrs. Waul came to see me. Said all out of doors was furious at the negligence which had occasioned the fall of Fort Hatteras.

I really *feel* this war is fought by private & individual zeal — the men who will bring companies & regiments, who will be surgeons & navy officers, who *will* fight & win glory — & the good of officers is to hold them back & only let those do any thing that they can't prevent by any snubbing.

Last night Capt. I would not remember all Capt. Barron said — as he was one who did not heed him. When poor Miss Barron came down with her red eyes & pale face, I had to cough & drink & eat & look every where. I was near bursting out crying. I was so sorry for her. The youngest is too engrossed with her *lover*, John Lee.[3] Capt. I went to Mrs. Davis & Washington came to see me. What a dreary time it was — he told such unpleasant tales of the camp. Says J. Chesnut in his Scout's place is not more exposed than other people. Abuses Bonham most heartily — & laughs at Kershaw. He knew Mrs. Carter & Miss Cooper & Maria Tompkins[4] & finally Mary Boykin — slowly blundering on all.

I hope they will stop abusing Gov. Letcher now. This Hatteras business is quite as bad.

Got a note from Mr. Ould asking me to help him get his office. Must do what I can. What Mr. C will say to my answering it. Must ask before I do it — hope he will help. We are told to pack to day. Think we ought

2. James Patton Anderson, a colonel of the First Fla. Infantry stationed at Pensacola. MBC apparently had little regard for him, nicknaming him "tom todd," after the English ditty, "Little Tom Toddy, All head and no body."
3. Probably John Mason Lee, Robert E. Lee's nephew.
4. Maria (Patterson) Tompkins, the wife of the Richmond philanthropist Col. Christopher Tompkins and the mother of Sally Tompkins.

to go home. We repulsed two regiments they say at Manassas — but nobody thinks except of Hatteras.

The congress adjourns tonight & I am packed up. Monday we go. Jeff Davis still too ill to see JC — so he cannot get his commission — he seems puzzled. Mr. Barnwell still in bed. If I had any fever I should say I had measles.

Mary B has gone to drive with Maggie Howell in Major Smith's buggy. She seemed quite proud of his call & this second drive. Won't she find the change great when she gets in the Sandhills. I can already feel the awful effect of that stillness & *torpor* piercing to the marrow of my bones. Mother still there but neighbourly *strife — festers* in provincial sloth.

No further news to day or I hear none shut up here. After my experience last night I shall not venture again. Mr. C has drawn $450 dollars for his pay — much is it needed. I fancy Mr. Mason will take Miles as his Secretary of Legation.

The youngest Barron was in my room all the morning — he bought me some wool for knitting — & seemed so pleased at his being thought able to purchase any thing. I sent him, poor child, to get me some candy for Kate's children that he might have some too. Jenny Barron was here also with Mary B & Jenny Cooper's likeness. All taken together & *knitting* — the *tricoteuses.* I am enjoying the noise & bustle of a city — that I so dearly love before the change takes me to my beloved country. The streets are as crammed as ever with uniforms & gay soldiers — but I *feel* the theatrical Joe Kershaw war is over — practical earnest bitter fighting begins.

These inroads upon the Coasts have been my terror & despair from the first — but our government has such a knack of hoping — it looked for peace by every mail from Europe. So Micawber like — something would turn up — & no getting ready. Now the wolf is not at the door but *in* N.C.

[*September 1, 1861*]

September — in the eventful year 1861.

Yesterday I felt too unwell to go down. Mr. Mallory called & I was too sorry to have *missed* him — he would have told me *so* much — & I wanted a good laugh with him over these female conspirators in Washington. Mrs. Smith Lee sat with me & told comical tales of Mrs. Mason, adventures with the Rhetts[5] — & their impertinence, funny tales of a

5. In the 1840s, two brothers, Thomas Grimké Rhett and Charles Hart Rhett, married respectively, Florence and Matilda Mason, daughters of Eliza (Price) Mason. The men, later officers in the C.S.A., were nephews of Robert Barnwell Rhett, Sr.; their wives were nieces of James Murray Mason.

platonic marriage of a Captain Gardiner who dared not go in his wife's room.

Mary B came in saying she had been at the President's. He is better. Mrs. D sends much love to me. They drove to see Cobb's Legion.[6]

Reports say the enemy have taken twelve hundred of our men. Saw a battery go by just now — & cavalry earlier. There are to be stirring times in N.C. We may not get back here next winter. Now that Congress has adjourned, JC does not seem in such a hurry to go home — proposes tomorrow evening. We shall go as usual — in a row — with the N.C. Soldiers.

N.C. has written here for arms — & they say we have none to give. Jeff Davis ill & shut up — & none but *noodles* have the world in charge — Cooper, Meyers, &c. Gen. Lee in Western Virginia — all the good generals gone. Brewster was here too last night — how much I missed that funny Dick Snowden. Today when I gain strength & courage to go down, nobody will be there. M. B. is to go with Maggie Howell to church & then dine at the President's & then to night go to church with Sam Cooper. It was Ransom Calhoun's Artillery which went by just now.

Read the correspondence between Toombs & Gregg on that Axson murder & Davis assault business. I did not think Toombs could be such a goose. How [I] wish I had gone down last night. Brewster takes the most *sensible* views & so practical always. I wish I could have seen him. I hope Mr. Ould will get my letter.

Letter from Aunt S. H. B. saying she is in Kirkwood — the terrible typhus raging in the Sandhills. Eugene desperately ill with it. She does not say where she is — but says Mary must go to Aunt Betsey's. I shall advise her to go to Kate Williams. *No.* My meddling & advising days are over. The Barrons have a letter from a young officer giving substantially the newspaper account of their father's capture.[7]

Sept. 1. Arlington House, 1861. Sunday — *beautiful,* bright & clear.

[*September 2, 1861*]

Arlington House. Read a letter yesterday from Garlington threatening the administration if a man named James was not attended to. Went down, saw Clayton & Capt. I & Dick Snowden. Clayton told Dick S that a Georgia negro was freer than a Maryland white man — which produced angry words & looks. Mr. Mallory called — talked over the Phillips, &c, business. An ungrammatical note of Mrs. Gwin's to day settles the question of her arrest. She is quietly at West Point.

6. The company of Thomas Reade Rootes Cobb of Ga.
7. Omitted here is the Third Psalm.

Another letter of Russell's. Says we can't survive the death of the Hamptons, Prestons, Mannings, &c. I think we can. Also a list of his aides by Beauregard — in his account of the battles of the 18th. Mr. C mentioned third. One thing is certain. I will Jeremy Taylor fashion use these ideas to keep up my spirits.[8] I am better off than the Prisoners or their families — than the sick & wounded & even than the poor soldiers in Camp.

Mr. Mallory says Mrs. Davis don't like me. I wish he had not told me. Miles came — & said he was on the special committee & had to stay here for a while if not until Congress meets — a committee to look into camps, Hospitals & commissariats. He was in one of his best moods. Then poor Imogene Barron came to get all the comfort from Mr. Mallory she could — asked if he had any body to exchange, for her father. Mr. M answered he would give *all* Richmond for him. Then Gonzales & a Dr. Waring, the last utterly a bore — *Cha[rle]ston,* & then Capt. I, Mr. C, & Dick Snowden, making the animated & interesting group.

JC showed me his watch as an invalid & to travel today; it was a hint to retire — which I did & in "good order" as the Yankees say — except I dropt my handkerchief & Gonzales rushed after me & gave to me at the foot of the stairs — & said he had a present for me. His foreign [way] is so earnest & pathetic I was alarmed — thinking he was going to ask me to accept something I could not — but it only proved a bottle of cherry bounce he wanted me to take travelling.

I dread the effect of taking these forts at the North — it will strengthen their *recruiting* — & give them fresh hope of conquering us. The English papers are both *ways,* for & against the blockade's being respected. The President out & has been as I supposed seeing company every day. Asked why JC had not been. Mr. Barnwell, still ill, was to go to day. I sent good bye to Mary B.

Dick Snowden *cursed* this administration from first to last with his whole might — but they say he does not tell the truth.

Mrs. Lee said when Sickles got out of prison for killing Barton Key, Mrs. Phillips said to him — patting him on the back, "Now try & be a good boy since we got you off this time."[9] I had no idea she was as bad as that.

Had the most affectionate messages from Mrs. President — but Mr. Davis' illness & the *want* of her carriage kept her from coming to see

8. Jeremy Taylor, *The Rule and Exercises of Holy Living* (1650), chap. 2, sect. 6, "Of contentedness in all estates and accidents."

9. Mrs. Eugenia Phillips, whose husband Philip was briefly involved in the case. Maj. Gen. Daniel Edgar Sickles had been prosecuted in 1859 for the murder of Francis Scott Key's son, Philip Barton Key, but won acquittal by pleading temporary insanity.

me. If we had not been so interrupted I should like to have had more particulars from Mr. Mallory of what Mrs. Davis says about me — he seemed quite inclined to tell every thing. "Incompatibility of temper & manners" could not be the reason — he told the same tale as Mr. Lamar. When I was spoken of she only said, "Yes, she *is* pretty," but would allow nothing else. Now my friends think & so do I that the *pretty* is all humbug — to be able to say something which will do me no good.

It seems JC saw Jeff Davis last night. As he rushed out of the room frantically when I asked him about it, I suppose it was not a pleasant recollection — he certainly asked him for no commission of any kind whatever. Our forts in N.C. were lost because the long range guns were not mounted!

I asked JC what Mr. Davis said to him — & find it most flattering. He wanted to offer Tom Drayton & himself the command of two of the new Regiments but that fool Walker has ordered an *election* — without consulting the President. He begs him to continue in the Congress. Says if all good men go into the Army the country will be ruined for the want of good men or sensible men in the conduct of affairs. He tells JC to go home & look around at the State defenses & he will give him any office or position he desires. This would be as good as could be wished if any body had it but *JC* — who will rate himself so low — & modestly & if he asks for any thing, which I think most improbable, will not demand what his position calls for. Sufficient for the day is the evil thereof — & so I ought to be satisfied today for bad feelings with my own miserable *physical* condition.

I hope I may be well enough to get home safely without fever.

Gave Mrs. Carter & Miss Imogene JC's carte de visite. Mr. Washington has sent JC Shenck's military book. I have written a letter to the President with my own hand for Mr. Ould.

[*September 9, 1861*]

South Carolina — Sandy Hill. The 2 September left Richmond. Capt. I — & Gonzales, Waring & Dick Snowden saw me off. Staid all night at Petersburg — eaten up by Mosquitoes. Eat a watermelon which was a great risk after my illness in Richmond.

3. Were detained on the cars too late to make the connection at Wilmington. Did not see a soldier in N.C. but some Georgians (rough savages) going to Virginia, after all accounts of the stir in N.C.

But George Davis[1] was in a fume in Wilmington. There slept but must

1. George Davis, Confederate congressman from N.C.

have taken cold. Came on the 4th with the Moseses, mother & son,[2] & a young Hainsworth & Westcott — & another ill man. They left all wounded in the battle of the 21st — each averred we had 15,000 sick & wounded in Virg. & had lost *dead* 8,000. JC says 5,000. Saw that Mrs. McCall who wandered about the Spotswood. Met Mr. & Mrs. Savage Heyward — & Mr. Kirkland. Sam Shannon on his way to defend Stono. Came home *ill*. Went to bed.

The 5th woke ill — remember nothing except that I did not see Kate.

6th *ill* — fever — did see Kate & made myself worse talking to her.

7 — Kate came again. I had less fever. JC as devoted & as good a nurse as ever. Team came home with his son dead ——

8th, Kate came again in the evening — & Mary Kirkland — had a long talk. Edward Boykin came before them & prescribed. I was ill & exhausted at night. Spent a wretched night.

9th, to day better. H. C. G. been to see me. Sandy Hill not altogether the abode of innocence & peace it looks.[3]

[*The following segment of the diary, containing entries dated September 14 through October 1, 1861, is recorded in a small address book bound in tan leather, with indexed tabs. On the first page of the volume, MBC recorded her name, the date, her location, Sandy Hill, South Carolina, and the sentence, "God be thanked for all his mercies!"*]

[*September 14, 1861*]

> My God! I feel the mournful scene;
> My bowels yearn o'er dying men;
> And fain my pity would reclaim;
> And snatch the fire brands from the flame!
>
> ———————————
>
> But feeble my compassion proves,
> And can but weep where most it loves;
> Thine own all saving arm employ
> And turn these drops of grief to joy.

[*September 15, 1861*]

Sunday. Mourning over our thousands of dying soldiers in Virginia.

2. Jane (McClelland) Moses was the wife of Franklin J. Moses, Sr., a prosperous lawyer who had represented Sumter Dist. in the S.C. senate for twenty years. Their son was Franklin, Jr., Gov. Pickens' private secretary.

3. The last three pages of this volume as well as the fly leaf and endpaper contain accounts MBC kept of expenses in Richmond and on the trip back to S.C., a record of money kept for her niece, Mary Boykin, who accompanied her to Richmond, and a brief list of books which, presumably, she intended to read.

Wherewithal shall a young man cleanse his way?
By taking heed thereto according to thy word.
119 Psalm.

[*September 16, 1861*]

Two weeks have I been shut up here with illness. Time has passed unnoticed. All have been kind. My dear old maid Betsey best of all.

Kate Williams came constantly — Mary Kirkland once — Mary Boykin once. Mattie Shannon[4] I did not ask in. Minnie Frierson was very attentive & had sweet children. I did not see James Frierson nor a Doctor Coldwell. H. Grant presented the Rangers with a flag — & a Mr. Johnson[5] made a speech. They had a concert & a tableau.

John Lee[6] came to ask JC to get him an office — the foolish boy.

Wm. Shannon persisted in giving up his seat in the Legislature & going with his Rangers to Virginia. Now the *wolf* is at the door of his own house. That we will be invaded with an overwhelming force at once, no mortal can question or hope *against*. It is so certain.

The *Mercury*, I see, explains that *now* the tides are high enough to bring in *any* vessel. Joe Kershaw's glory seems to overshadow the Land. Meynardie preached a sermon saying Joe prayed, shut his bible, got off his knees, took his sword & went into battle — & John Green said swore like a trooper & not a Christian when he got there. Oh for a [*one illegible word*] parson power to shout thy praise. Hypocrisy.

Poor old Mr. Murray stayed here last night. Miss Sally Chesnut offers to do his plain sewing. That man Turner that I saw die in convulsions in Richmond is the son of Mrs. Turner that I used to help at the factory & I expect the very boy I sent to keep Henrietta's school.[7] Now they are raising money to send his body home. They are *too late* — he died in filth & squalid want — his clothes unchanged — in an atmosphere of horror that made me faint. Oh the mockery & folly of this world ——

Mr. Chesnut has written to ask Pickens to give him an office in this state.

Mr. Murray says Floyd has defeated Rosecrans — & that we have had another victory at Missouri.[8]

4. Sam Shannon's twin sister, Martha Allison English Shannon.
5. The Reverend John Johnson, an Episcopal minister from Camden.
6. John Boykin Lee, a 19-year-old from Camden serving in the Kirkwood Rangers.
7. Henrietta DeLeon, who ran a private school in Camden, was the aunt of Agnes and David Camden DeLeon.
8. Actually, the reverse was true: U.S. Gen. William Starke Rosecrans had defeated Brig. Gen. John Buchanan Floyd in a minor battle at Carnifix Ferry, W.Va. on Sept. 10. Probably a reference to the ultimately successful Confederate siege of Lexington, Mo.

John Chesnut writes capital letters home; if his life is spared he will return vastly improved. I told old Mr. C so — & he answered, "When your husband goes — my family ends." I wonder what he meant.

Suppose his Grandsons are grown now — & he sees what stuff they are made of.

He is no saint — my in law aged P[9] — but after a while he gives you a hint that he is not fooled.

[*September 17, 1861*]

Yesterday read one of Balzac's, *César Birotteau.*[1] Remember no new ideas gained. The "impertinent solemnity of men of the world hiding incipient epigrams" was cleverly put. In the evening went to the House. Read newspapers but felt too miserable to read aloud. The victories in western Virginia & in Missouri confirmed.

Ben McCulloch found a Dutch parson had just sworn some men to allegiance to the U.S.A. So told him to take his book & *unswear* them at once. Things I hope are *mixing* up a little North. I hope if Kentucky does not come out & help us she at least will prevent them freeing all negroes & so displease that formidable crusader of the abolitionists.

I see McClellan is giving offense by imprisoning the *fugitives* — slaves.

I never forget our present danger on the coast. I see McQueen nominated for the next Congress — in a paper from Cheraw proposing to keep the old set. I see a *bad* example in N.C., putting J. Davis & [*illegible name*] in — in place of Clingman & Bragg.[2]

I sometimes fear I am so vain, so conceited — think myself so *clever* & my neighbours such geese that pride comes before a fall. I pray I may be spared.

Last night *ill* with my heart — it felt like a Western high pressure steam boat — raging, snorting, bursting, thumping — & again like a loaded ammunition wagon over a stone pavement. Took ether. To day stupid with swollen face & feet & hands — a reminder how frail this poor body is.

Russell writes that Prince Nap did not like Beauregard. Russell evidently don't like *us*. Had a visit as usual today from Col. C. I in petticoat & sack.

9. Wemmick's term of endearment for his father in Charles Dickens' *Great Expectations* (1861).
1. *Histoire de la grandeur et de la décadence de César Birotteau* (1837), a volume of Balzac's *Comédie humaine,* is an account of the rise and fall of a socially ambitious perfume merchant.
2. Former Congressman Thomas L. Clingman and ex-Gov. Thomas Bragg were N.C.'s U.S. senators in 1860, but both failed to secure election to the Confederate senate in 1861.

Wrote Mother a long letter yesterday.

Read today *Our Farm of Four Acres.*[3]

> For God doth know how many now in health,
> Shall drop their blood in approbation
> Of what your reverence shall incite us to:
> Therefore take heed how you impawn our person
> How you wake the sleeping sword of war;
> We charge you in the name of God — take heed:
> For never two such Kingdoms did contend
> Without much fall of blood; whose, guiltless drops
> Are every one a woe, a sore complaint
> 'Gainst him whose wrongs give edge unto the swords
> That makes such waste in brief mortality.
>
> Henry 5th[4]

Russell writes that Napoleon did not like the looks of our troops. What are looks. Bull Run told who did the best fighting. Listen to Henry 5 the night before Agincourt as to the appearance of his gallant English.

> Why should they mock poor fellows thus!
> The man that once did sell the Lion's skin
> While the beast lived, was killed with hunting him.
> And many of our bodies shall, no doubt,
> Find native graves; upon the which, I trust,
> Shall witness life in Brass of this day's work.
> Tell the constable
> We are but warriors for the working day;
> Our gayness and our gilt are all besmirched
> With rainy marching in the painful field;
> There is not a piece of feather in our host,
> (Good argument I hope, we shall not fly,)
> And time has worn us into slovenry;
> But by the mass, our hearts are in the trim;
> And my poor soldiers tell me yet ere night
> They'll be in fresher robes.
>
> Henry 5th[5]

> We are the sons of men
> Who conquered on Cressy's plain
> And what our fathers did
> Their sons can do again
>
> Fracy Horn

The men of Manassas.

3. Miss Coulton, *Our Farm of Four Acres, and the Money We Made by It* (1859), 6th edition.
4. *Henry V,* act 1, scene 2.
5. *Henry V,* act 4, scene 3.

[*September 18, 1861*]

Yesterday *read* all day. We had a reception — 6 men & a boy. Two men came for overseer's places. One Jackson Revel, a stupid country lout, & his friend came at 12 & stayed until *five* — boring JC to madness. Is there no remedy for such an evil! One named Love came to get a pass to return to the wars. He was with JC at Manassas. All came [at] dinner time. The boy came to beg for food for his Mother & her children at the gate. In the afternoon the two Workmans.[6] I had never known them & JC made me dress & go over. I fancy he was not so proud of me as he contradicted my statements & tales very often.

Papers last night show the Northerners claim *all* our victories as much as we do.

JC wrote to Tobin, Moses, & Benjamin[7] & Walker. The Secretary of War Walker resigned.[8] Cooper, Polk,[9] &c, spoken of for his place. Letter from Wilmot D — busy preparing the coast. We have 10,000 men ready for an invasion. So far so good. No letter from Pickens — letter from John Chesnut. He is as bad as Kershaw — he sinks his Captain as much as Joe does the General.

The *Examiner* has a furious article against Provisional Vice President Stephens — & says Cobb, Toombs, Slidell, Lamar, Chesnut, Boyce, &c, &c, would do better. I was glad to see JC's name in print once more. The world seems forgetting him.

Miss Mitford tells a strange story.

"A governess at Wilton House — happening to read the *Arcadia,* had discovered between two of the leaves folded in paper, as yellow from age as the printed pages between which it reposed, a lock of hair, and on the envelope, enclosing the lock, was written in Sir Philip Sidney's well known autograph an inscription purporting that the Hair was that of her Gracious Majesty Queen Elizabeth. None of the family had ever heard of the Treasure. So this identical volume, not only dedicated to his beloved Sister but entitled by himself 'The Countess of Pembroke's *Arcadia,*' had remained for two centuries in the library of her descendants, without any one of them ever taking the trouble to open the book! The governess only. No Sidney — no Herbert — had taste enough or curiosity enough to take down the prose poem." Miss Mitford[1]

6. John and William C. Workman, brothers who were Camden merchants. John's son William was the law partner of JC after the war.
7. Judah P. Benjamin of La.
8. Plagued by ill health and complaints about administrative inefficiency, Secretary of War Leroy Pope Walker resigned Sept. 16 and became a brigadier general in command of unarmed Ala. troops. Davis replaced him with Atty. Gen. Judah P. Benjamin.
9. Maj. Gen. Leonidas Polk of N.C.
1. Mary Russell Mitford (1787–1855), British poet, playwright, and novelist, related this anecdote in her *Recollections of a Literary Life* (1852). Wilton House, where Sir Philip

Ben Jonson:

> Underneath this sable hearse
> Lies the subject of all verse,
> Sidney's Sister — Pembroke's Mother;
> Death, ere thou hast slain another
> Learned & fair, & good as she,
> Time shall throw a dart at thee.[2]

[*September 19, 1861*]

Ill all night. Consequently stupid & full of head ache today. Harriet came back still President of the association & Sue Bonney[3] Vice President. I can see from her own account that the society will die — there is but *one* set or clique who go now. When I first came she said every body went but the Witherses & Perkinses but I find now out of 80 or 90 so called members, 10 or twenty go — besides, they are forgetting the Hospitals, the only place they can do any good.

Uncle John came last night. He seems quite reconciled to Uncle B's death — talks of him as if he were alive & well. Says laughingly that "old man Stephen used to prophecy that Uncle J would outlive all of the name" & he wrinkled with pleasure at the idea. How precious life must be & how dreadful death to the very best of mortals. Mrs. Chesnut, deaf and blind, says she does not mind her privations. She is "only thankful to be here."

Heard yesterday of the death of Cousin Betsey Witherspoon[4] — found dead in her bed. Went to bed quite well — had been dead several hours — her family troubles, I fear, killed her. If so, it is the third of that family the same has been said of — her husband, Mr. Williams & herself. Uncle J said it of Uncle B.

Read yesterday those beautiful lines of Montrose, then Professor Aytoun's ballad[5] & finally the plain Montrose *prose* — & find the last most touching of the whole. I have never read his death scene without tears.

Sidney composed his pastoral romance *Arcadia* (1590), was the home of his sister Mary Herbert, Countess of Pembroke.

2. From Jonson's "Epitaph on the Countess of Pembroke" as quoted in Miss Mitford's *Recollections of a Literary Life.*
3. Susan Bonney, the daughter of Camden merchant Eli W. Bonney. The association was the Ladies Aid Society.
4. Elizabeth (Boykin) Witherspoon was the widow of John Dick Witherspoon, a wealthy planter, lawyer, and state legislator of Darlington Dist. She was a first cousin of MBC's mother and the mother-in-law of JC's niece Mary Serena Chesnut (Williams) Witherspoon. John Nicholas Williams of Darlington Dist., a planter and cotton mill owner, died in April 1861. His first wife was JC's sister Esther Serena Chesnut; his second was Elizabeth Witherspoon's daughter Sarah Cantey Witherspoon. David Rogerson Williams, Jr., the husband of MBC's sister Kate, was a child of his first marriage.
5. William Edmonstoune Aytoun, "The Execution of Montrose," as recommended in Miss Mitford's *Recollections.*

James Grahame, Marquis of Montrose:

> But if thou wilt be constant then,
> And faithful of thy word,
> I'll make thee glorious by my pen,
> And famous by my sword.
> I'll serve thee in such noble ways
> Was never heard before.
> I'll crown & deck thee all with bays
> & Love thee ever more.[6]

"Can it be in woman to resist such promises from such a man?"
Miss Mitford[7]

Lovelace:

> Tell me not sweet I am unkind,
> That from the memory
> Of thy chaste breast & quiet mind
> To war & arms I fly.
> True a new mistress now I choose,
> The first foe in the field;
> And with a stronger faith embrace
> A sword, a horse, a shield,
> Yet this inconstancy is such
> As you too shall adore;
> I could not love thee, dear, so much
> Loved I not honour more.[8]

I wonder who in the eyes of the proud & gentle & loving, forgiving, meek and forbearing were worst — the laughing, swearing, godless ("so called" cavalier), drinking, fighting, praying after the fashion of King & Church — or the bitter, sour, hard & cruel, persecuting, unforgiving, sighing, canting covenanters, like the Israelites, not Christians, glad to smite "hip & thigh," crowding like buzzards round Montrose to enjoy his agony & to tease him to being reconciled to God & *his Kirk*. He praying alone, forgetful even of their presence. I see no resemblance in either party to what men would be if they followed Jesus & his example & precept solely.

I hate puritanism by temperament & instinct — but I can not shut my eyes to the faults & sins of high church party. Jeremy Taylor encourages cheerfulness & innocent amusement & mirth — & mankind

6. From "Montrose to His Mistress" by James Grahame, Marquis of Montrose, as cited in Miss Mitford's *Recollections*.
7. Miss Mitford's judgment on James Grahame and his poetry.
8. Richard Lovelace, "To Lucasta, On Going to the Wars," also from Mitford's *Recollections*.

will not fail to be amused if they seek their "distraction" in love feasts & religious groaning & Methodist shouting. Froissart says of the English, "they take their pleasures *sadly* after their *fashion.*"[9]

I find today a note from Mr. Ould showing he had received mine — it was covered by a memorandum from Mr. C, but he had not mentioned it to me. I am afraid The President did not attend to Mr. Ould's petition or JC's letter that I wrote, for I see no mention of Ould in any nomination for any thing.

Found also in sorting JC's papers a note from John West[1] thanking me his office. Hemphill had written that I solicited it for him — so much for gratitude, &c.

Burke on Newspapers:

> Because a half a dozen grasshoppers under a fern make the field ring with their importunate chirp, while thousands of great cattle reposing beneath their shadow of the British oak, chew the cud & are silent, pray do not imagine that those who make the noise are the only inhabitants of the field, that, of course, they are many in number or that after all, they are other than the little shrivelled, meager, hopping, 'tho' loud and troublesome, insects of an hour.

Lady Sale's entry in her journal, "Earthquakes as usual," may soon be possible here — terrible as the idea shakes one. We have had two in a month. We hear of death & mortality on every side. Men murdering each other wholesale in these great battles — & *sickness* & disease Godsent, laughing their puny efforts to scorn. Ten men dying in hospitals where one dies on the battle field — & our friends who never leave home & are thought *safe* dying in their beds & found dead — cause unknown. God shows he can *make troubles* & disregards our puny efforts to make it for ourselves. But this thing of feeling the ground struck from under our feet — a wonderful thing to shake one's nerves.

[*September 20, 1861*]

Kate came Yesterday & stopped the flow of my eloquence in a journal way. Sweet as ever, "So proud & happy" in her children.

Queer tales of the Witherses. She says her Mary[2] declared, "Aunt B likes every body & wants to be at peace with every body & wants her children to go every where & enjoy themselves. The Judge dislikes every

9. From Jean Froissart, *Chronicles of England, France, Spain, and the Adjoining Countries.*
1. John Camden West, the son of a former Camden mayor, had been appointed district attorney for the western district of Texas.
2. Mary Williams, whom MBC sometimes calls "Mamie," was the daughter of her sister Kate.

body & does not want any body to go any where & to be miserable all the time — & all the children are just like him." Kate sent Dr. Boykin a salmon pie to the camp. Said Thompson waited to get some, it smelt so nice, but he said it came from the table as clean as if it had been through the kitchen.

Violent abuse of "Aleck Stephens" in the *Examiner*. & yet he, Swallow Bill, still puts JC in the list of people preferable to Stephens — but as Clingman's is there too!!! However, I am glad to see that JC's name, as they say of rare books, has not entirely gotten out of *print*. I was truly sorry to see the call for more men on our side in Western Virginia & that wise. Floyd & Lee can not yet cope with Cox & Rosecrans.[3] I see Reynolds & his aides are *captured* — & they say an *Iron* Steamer has run the blockade of Savannah. How eagerly we cling to hope & *good news*. Kate thinks Cally Perkins in a dying way — poor young thing.

[September 21, 1861]

Last night Mary Witherspoon[4] wrote to JC that her mother [in] law, dear old cousin Betsey, had been murdered by her negroes. Mr. C concluded to go at once. She was smothered — arms & legs bruised & face scratched. William, a man of hers, & several others suspected of her own negroes, people she has pampered & spoiled & done every thing for. Next day I came here, that is, to day. Told David & JC good bye at Bonney's.[5] Came to Aunt B's; had a pleasant visit but drank port wine. Judge very kind. Then I went to the Perkinses' but did not see Cally. As I expected, her Mother is tormenting her to death.

Came here, found Mr. Borman and the children as I left them — & was *ill*. Aunt Sally H & Mary came. I had to rush in & was really ill.

[September 22, 1861]

Sunday did not leave my bed — in the evening Aunt B came — in the most wretched state about this most foul murder.

[September 23, 1861]

Sat in the piazza — & kind Mary Boykin — Mary Edward — sent me some lemons. Nothing pleasant in the northern or rather Richmond papers. Pickens wrote to JC to offer him a rifle regiment but in Confederate Service.

3. Gen. Jacob Dolson Cox, in command of Federal troops in the Kanawha Valley, W.Va. The combined Confederate forces under Lee met defeat in mid-September at the battles of Carnifix Ferry and Cheat Mountain, thereby ensuring Union control of W.Va.
4. Mary Serena Chesnut (Williams) Witherspoon, David Williams' sister.
5. The store of Eli W. Bonney, a Camden merchant.

Retire now to the Caxtons'. Mrs. Cureton[6] sends scuppernongs. Col. & Mrs. Deas at Sandy Hill.

[*September 24, 1861*]

Tuesday. Mrs. Cureton sat the morning — & I knit a sock. At night David & JC returned — nothing definite. William & Rhody & several others in jail.

George Williams[7] has not been [to see] his sister since the murder. Society Hill in a ferment. John Wallace & Kirby there & Sam Evans, wanting all the Negroes burnt.

[*September 25, 1861*]

Wednesday. Spent at Kate's & came down in the evening & came by. *Saw* the Rangers but did not drive near enough to say good bye. Came home & Col. C & Miss Sally came to hear the news.

[*September 26, 1861*]

Thursday. Rainy day — knit — & arranged my things.

[*September 27, 1861*]

Friday, Sandy Hill. Mr. Chesnut wrote 4 pages of foolscap for his mother with the details of that fiendish murder at Society Hill. The papers are dreary — if our army retires into winter quarters woe be unto us.

Read a frantic article in the *Mercury* — arranging a party for Barnwell Rhett. I do not see what Mr. C means — he writes to no one — knows nothing that is going on. If he has *one* active friend in the state I do not know it unless it be Wilmot DeSaussure & Bob McCaw. In the mean time at these fiery times he is as peaceful here & as *secure!* Making arrangements to spend the winter in Richmond. John C writes capital letters — pitches into Capt. B, Bonham, Douglas, DeSaussure, &c, &c, as boldly.

Davis has given Tom Drayton a *generalcy*. If JC made Jeff Davis *President* has he not been *rewarded* as usual. Wm. T. Martin[8] [is] Gen. of Cavalry — the post JC could have gotten by lifting a finger.

I went to see the Perkinses — but only saw Miss Ossear[9] while I was in Kirkwood. She says it is the same as if Cally was twice widowed —

6. Mary (Cunningham) Cureton, wife of Kershaw Dist. planter James Belton Cureton.
7. George Frederick Williams, Elizabeth Witherspoon's grandson.
8. William Thompson Martin, colonel of the Jefferson Davis Legion.
9. A maid of Priscilla Perkins.

poor thing. Such comforters. Mr. Chesnut treated Mrs. Lee shamefully. I do not know how she will feel towards us.

Poor old cousin Betsey — Murdered! I always felt that I had never injured any one black especially & therefore feared nothing from them — but *now*. She was so good — so kind — the ground is knocked up from under me. I sleep & wake with the horrid vision before my eyes of those vile black hands — smothering her.

Mr. C says David ought at least to threaten to break Mr. W's *will* — & so bring Cousin Sally to her senses — or drive her mad outright.[1] I find Cousin Sally has been writing to David & Kate to set her against her own Mother. *My* Mother — who never did evil to any one much less one of her own children. Miss Sally told me yesterday that poor Romeo of Dr. McCaa's,[2] so frightfully treated in his youth, was for once happy at John McKain's & fell from the neck & shoulders of another boy as they were sky larking & broke his *neck* — instantly.

[September 28, 1861]

Spent the day at Kirkwood — paid a long visit to Mary Boykin[3] who looked ill & miserable. Kate Heyward *jolly* & amusing — said it was a hard case that one with my *gifts* could only *knit* for my country. Dined at Aunt Betsey's & found every thing very pleasant & kind. The Judge thought as Uncle H had given ten thousand dollars to the Rangers & twenty to the Confederacy he ought not to be so readily unseated by Wm. E. Johnson. Now we understand what all this whispering of Uncle H's unpopularity *means*.

Aunt S. H. as absurd as ever — left her child with his broken arm to be nursed by the DeSaussures. Mrs. Henry DeSaussure was *great* on the subject. Saw her in at Bonney's. Bought at Bonney's a dressing gown & buttons, needles, tapes, &c, &c.

Nothing new in the papers. Came down with H. Grant — the *society* dead. She killed it — & the Reynoldses & Mattie Shannon ad *nauseam*. Miller, who has been down with me, dodged his grandfather & stayed at home. Saw John Williams[4]; asked very kindly after his brother's family — but did not stop to see him. H. Grant asked him *here*.

Nothing last night. A letter from Trescot yesterday, impudent mes-

1. "Mr. W" was David Williams Jr's. father; "Cousin Sally" was his second wife; David's stepmother was Sarah Cantey Witherspoon, a daughter of Elizabeth (Boykin) Witherspoon. The father's will was highly unfavorable to David, Jr.
2. Dr. John McCaa, III, of Camden.
3. Mary Chesnut (Lang) Boykin was the wife of Dr. Edward M. Boykin and a first cousin once removed of JC.
4. John Witherspoon Williams, a half-brother of David Rogerson Williams, Jr., the son of John Nicholas Williams and the grandson of Elizabeth (Boykin) Witherspoon.

sage to me, & says as so many new members are to be elected the future [of] Senatorships puzzles *conjecture* — & JC dashing aside letters & not answering them as if he was *heir* apparent to the throne of *the world* & his election certain!

[September 29, 1861]

Sunday. Too wretched a cold to go to church. I feel so depressed for my country & for *myself* & for my future political hopes. God grant I may not be left destitute in my old age. Letter from Mattie — Sally & her children have had fever. Also Dick & Hetty.[5] Nine of Gladden's men deserted to the enemy at Pensacola.[6] JC thinks the Florida men ought to bring all their Negroes here.

I am so selfish I do not want an inroad of the *Florida* folks — but I must stifle such meanness.

[September 30, 1861]

After writing yesterday went over & sat with Mrs. Chesnut. My virtue was rewarded by having a long discourse on the subject of Charlotte Villepigue.[7] I was asked if she had any more children. Said, *"One* more." Was she married? "No." Was she [a] *bad* girl? I said, "Yes," & was *answered,* "poor thing," may be she was not, &c, &c. Now I really feel like a fool. When I was young I was taught that an unchaste woman was a bad one. I believe from what I see & hear daily that is an old & vulgar prejudice rapidly dying out. Mrs. Chesnut, the best & purest of women, talks as if Harriet had committed a sin in turning off her maid for being somebody's kept mistress — her harshness & folly cannot be too much censured. The maid is only a poor delicate creature that Mrs. C will protect from harm & Harriet would show more true delicacy by not seeming to notice her situation, &c, &c, &c.

Mrs. Reynolds & her daughters came down. Harriet calls them refined, &c, &c. I see nothing but shy, awkward, inoffensive, silent — but lady like girls.

Dr. Young[8] says John is reaping Laurels in Virginia, so trusted by officers & men — so bold, so courageous, so prompt. Such a splendid rider.

I told at dinner the Bad Accident story — & at night Mrs. Chesnut's

5. Dick and Hetty had been MBC's mother's servants since her childhood.
6. Adley Hogan Gladden, a colonel of the First La. Regulars stationed at Pensacola.
7. A daughter of the prominent Camden merchant James Irwin Villepigue. MBC changes her first name to "Charlotte" in allusion to the heroine, a woman of uncertain virtue, in Susanna Rowson's popular novel *Charlotte Temple: A Tale of Truth* (1794).
8. Dr. James Andrew Young, a Camden physician and silversmith.

bad smell. That night every woman laughed themselves down — but Mr. Chesnut thought his father did not like to be laughed at.

Wrote a letter to Tobin for Mr. C — begged him to write to Frank Elmore[9] but could not get it done. Read life of Wycliffe. Freshet in the river — destroying corn. I have wondered they did not do something after Friday night's rain. Ill with a bad cold. Mr. Chesnut seigneur paid me a call as usual. Cut out sack & gave Maria the dress to make. Will give Laurence the nice sack.

[*October 1, 1861*]

Went up to the Society with Emma Reynolds. Last night Emma, Ellen & Lila Davis[1] invaded my room. Nothing was said worth remembering. The Society I feel to be a failure. Murray Lang & Miss Susan, whom I consider my bosom friends, only nodded to me. Ditto the Brevards.[2] Miss Lee was quite dolorous. Louisa Salmond really active & efficient. I gave 5 dollars donation & one admittance fee.

Sat by & stood up & talked to Milly Trimlin & the likes of her who came for work. Every body knitting. They are forty dollars in debt, &c, when giving out drawers for Tom Warren's company.[3]

Came home used up at half past three. Kate Williams walked into the Hall so graceful & gracious & elegant looking. There was nothing like my sister there — those wooden pegs looked stiffer than ever.

Saw Dr. Young — he gives a terrible account of Richmond, the Army & Jeff Davis. Says the causes are at work to depose Jeff Davis. The newspapers say he has taken a farm & retired there with his Doctor. *Sad* enough. The country is in a distracted condition. What is ahead of us. He gave a famous account of John Chesnut.

Went with Kate Williams to see Miss Glennie, Miss Mary Starke's sister. All hospital talk. Saw my dear old home & beloved flowers. Knew my roses in the Trapiers' hands.[4]

Aunt Betsey in ecstasies over the abuse heaped over Jeff Davis. We will quarrel if I answer, so I am obliged to swallow in quantity. They say Stephens procured Gregg's being sent to Norfolk. Keitt has written a defence of Stephens. I wanted to tell Aunt B if we could not wait to venge our private spites until we were once more a nation it was a

9. Probably Franklin H. Elmore, husband of JC's cousin Harriet (Chesnut) Elmore.
1. Emma and Ellen, daughters of Dr. George Reynolds and JC's sister Mary, and Ann Eliza Davis, daughter of Episcopal bishop of S.C., Thomas Frederick Davis, Sr.
2. The Brevards were probably the daughters of physician Alfred Brevard; Louisa Salmond was the daughter of Thomas Durham Salmond, all of Camden.
3. The Kershaw Guards of the Fifteenth S.C. Regiment.
4. Probably the family of Rev. Richard S. Trapier, Episcopal minister from St. John's Parish, then living in a house that once belonged to MBC.

hopeless business. Republics won't do. I am a strong government woman.

Mr. Chesnut has had an offer of a company from Georgia. & he writes in the letter *no* answer. I have answered several. He has answered Elmore & Gist. I have written to W. D., L. Q. W., Mrs. Joe Johnston, Stephen — & now am going to try Mrs. Wigfall. Fleet still threaten[s] us — & anarchy seems to prevail in high quarters. I can never say otherwise than that it was wretched work to keep our army there until the others were ready. I do not believe we ever had any plan.

Letter from old Edward Hanrick.

Mercury doing its worst.

Oh my country.

Sam Shannon says he met John Manning at Kingsville — he burst into tears & said, "Ah Sam — I am put away on the shelf. I never see my name in the papers now."

I laughed over this folly — & told the thing once & again. I seem to have been quite as idiotic in exactly the same way.

Borrowing means sorrowing — & *pluck, luck.*

"Ode to Duty," Wordsworth
Southey's life of Cowper
Sir Thomas More's life of Edward 5th.
Izaak Walton's lives.[5]

[*The following segment of the diary, containing entries dated October 3 through December 8, 1861, is recorded in a school copy book, bound in a marbled paper cover with a black cloth spine.*]

Books Wanted.
Lord Mahon's history of England.
Life of Oberlin
Sir William Temple.
Fuller's Worthies of England.[6]

[*October 3, 1861*]

Sandy Hill, S.C. Last night the *Mercury* correspondent was saucier than ever. Said he hoped when they won another battle, they would not "have

5. Robert Southey, *The Life of William Cowper* (1835); Sir Thomas More, *The Life and Reign of Edward V and Richard III, Kings of England* (1706 edition); Izaak Walton, *The Lives of Dr. John Donne, Sir Henry Wotton, Mr. Richard Hooker, Mr. George Herbert and Dr. Robert Sanderson* (1678).
6. Philip Henry Stanhope, fifth earl, *History of England from the Peace of Utrecht to the Peace of Versailles*, 7 vols. (1836–54); Temple was a seventeenth-century British statesman who wrote history, political theory, and literature; Thomas Fuller, *The History of the Worthies of England* (1662).

to wait half a year for wagons — or for President Davis to get well — or for Beauregard to write his report of the Battle." Dr. Gibbes returned me my letter & two newspaper[s] — tries to entice me into a correspondence by pretending to know a joke I will be crazy to hear.

Nothing new from the Seat of War. To day I am left in charge of Mrs. Chesnut. JC detained from over the river by illness on his plantation. This side — rain — rain.

> I have no repugnances. Shaftesbury is not too genteel for me, nor Jonathan Wilde too low. I can read anything which I call a book.
>
> Lamb[7]

<div style="text-align:center">

Why should I seek to call forth tears?
 The source from whence we weep
Too near the surface lies in youth,
 In age it lies too deep.

Enough of foresight sad, too much
 Of retrospect have I:
And well for me that I sometimes
 Can put those feelings by;

From public ills, & thoughts that else
 Might weigh me down to earth,
That I can gain some intervals
 For healthful, hopeful Mirth.
 Southey[8]

War is passion's basest game
 Madly played to win a name.
 ————————

War is mercy, glory, fame,
 Waged in freedom's holy cause,
Freedom such as man may claim
 Under God's restraining laws.
 Wordsworth — Installation of
 Prince Albert as Chancellor
 of Cambridge[9]

Lightly is life laid down amongst us now,
And lightly is deathbed mourned —
 We have not time to mourn;
 ————————

</div>

7. From Charles Lamb, "Detached Thoughts on Works and Reading," as quoted in Henry Reed's *Lectures on English Literature* (1855).
8. From Robert Southey's "Epilogue to the Young Dragoon," as quoted in Reed's *Lectures*.
9. From Wordsworth's "Ode on the Installation of His Royal Highness Prince Albert as Chancellor of the University of Cambridge." Omitted after this is a passage of Spencer's *The Faerie Queene* from Reed's *Lectures*.

The worse for us!
He that lacks time to mourn, lacks time to mend.
Eternity mourns that. Tis an ill cure
For life's worst ills, to have no time to feel for them.
Where sorrow is held intrusive & turned out,
There wisdom will not enter nor true power,
Nor aught that dignifies humanity.
Yet such the barrenness of busy life.
 Taylor — in *Philip van Artevelde*[1]

Confirmation last night of the taking of Lexington by Price of the Confederate Army.[2] Various accounts of the loss of the Enemy — but all say a brilliant victory. I am afraid they will try & revenge themselves by a descent on the coast. The *Mercury* as usual calls attention to Wilmington. Undefended — & quantities of stores there. Lila Davis said here Monday night that her uncle wrote they would hardly be ready in a fortnight.

Will the enemy wait on them. We always wait for the U.S.A. to get ready! Dr. Deas came. Said no news. On account of Joe Kershaw's intimacy with Burnet Rhett I ought not to [have said] as I did that if Davis had made Barnwell Rhett Secretary of State as he expected & *asked* to be, there would have been no war on Davis in the *Mercury*. Woe be unto my long tongue.

Breckinridge, Clay & Preston have escaped from the Lincolnites[3] — into the part of Kentucky which is true to the South. Breckinridge is too late — how much might he have done by an earlier & bolder stand.

Have written a letter to Mary Garnett. The scribbling mania is strong upon me — have an insane idea in my brain to write a *tale* for Dr. Gibbes's weekly literary paper. Am afraid I have grown too scheming & cunning — & all my darling plans will be upset.[4]

'T was partly love, & partly fear,
And partly 'twas a bashful art,
That I might rather feel than see
The swelling of her heart.

1. Henry Taylor, *Philip van Artevelde*, act 1, scene 5 (1834).
2. The capture of Lexington, Mo., on September 20 by Sterling Price, commander of the state's Confederate militia.
3. John C. Breckinridge, William Preston, and James Brown Clay were forced to flee after the Unionist Ky. legislature threatened to arrest them for treason. The former vice president accepted a brigadier general's commission in the C.S.A.; Preston, a former Ky. congressman, U.S. minister to Spain, and brother-in-law to A.S. Johnston, became a colonel on the general's staff. Clay, who was also a former Ky. congressman and the son of Henry Clay, was arrested and later deported to Canada.
4. Omitted here is the last stanza of "First Love's Recollections" by John Clare (1793–1864).

The last time I heard this it was Edward Pringle whispering to Marian Ramsey — in those happy Washington days while we were driving to Georgetown.

[October 4, 1861]

Friday. Went up to Camden. Stopped at Aunt Betsey's, had a pleasant time, but evidently insulted them by saying if Old Barney Rhett had his Secretary of Stateship given him he would not abuse the President so. Dined with Kate & drove down again to Aunt B's in the afternoon. At night examined the children's French & drawing. Mr. Dallas made a strong speech against us[5] — the ungrateful wretch — pledging their last man & their last dollar. John R. Thompson, too, & Moffat[6] in Princeton — the latter JC's bosom friend — *educated* by Mr. Douglas,[7] too, of Camden!

[October 5, 1861]

Drove over the river — first stopping at Aunt B's. Mary Kirkland had on a Mull Mull morning dress with puffs & flounces & black & purple silk Zouave.

First to the Laurence Whitakers'. The most uninteresting people in the world. Then to old Mrs. Haile's & Mrs. Kennedy's where we spoiled all by not asking for Mrs. John Whitaker.[8]

Then to Aunt S. B. — where I was too tired & miserable to be sorry for her. Then home, making *21* miles that hot day. Was really *ill* — & undressed. Then went to bed in the schoolhouse, then put on a wrapper & went to the House. Slept there an hour. JC came home & I put on the wrapper & came here again.

Edward Haile seemed so grateful that Kate takes Nellie.[9] I hope David will go with Edward Haile & so see after his property in Florida. E. H. says the government in Richmond says the States must take care of *themselves* — how can we when we have given all our money & men to

5. Former Vice President George Mifflin Dallas of Pa. was equally opposed to abolitionism and secession.
6. John Renshaw Thompson, U.S. senator from N.J. since 1853, had been among the Chesnuts' social circle in Washington. James Clement Moffat, a classmate of JC at Princeton, became professor of ecclesiastical history at Princeton Theological Seminary in 1861.
7. A Camden merchant, James Kennedy Douglas was active in the Presbyterian Church.
8. Probably Mrs. Benjamin Haile, who was the mother of Mary (Haile) Kennedy. Mary Kennedy was married to Camden merchant William Kennedy, and their daughter, Kate, was Mrs. John Whitaker.
9. This planter of Alachua County, Fla., was Louisa (McCaa) Haile's brother-in-law. His wife, Mary (Chesnut) Haile, was a niece of JC. Presumably Nellie was his daughter.

the Confederate Government. Poor Florida. The fleet's destination is not known yet.

The *Herald* says if we defeat them the country north will be too hot for Greeley, Beecher[1] & company — but it augers well for their cause that we are so divided among our selves. The *Inquirer* begs our people to *win* the spoils before we begin to divide them.

[*October 6, 1861*]

Sunday. Too wearied for church. JC wrote to Trescot. I read my prayers — Wycliffe & *Guesses at Truth*.

The list of foreign generals appalls me in the Northern Army. No end of Hungarians, Prussians, Russians, English, Duc de Chartres, de Joinville,[2] &c. Those men will not run like the Yankees. *I hope still.* Mr. C was saying his father's 16 thousand acres cut up into 8 hundred farms would make such a *prosperous* country — & *now* it is one profitless plantation. Where the black man must be kept as dark & unenlightened as his skin.

[*October 7, 1861*]

Monday. Went over to Aunt S. H.'s — to get Mary H. B. to write a letter to Maggie Howell to enquire what really is the state of things with Mrs. Davis & Mrs. Joe Johnston. I wrote to Mrs. Johnston on Thursday, anxious for the President & Joe Johnston — never dreaming the *females* were in any danger. The very next day I see in the papers that Mrs. Davis & Mrs. J are upset, badly bruising Mrs. D who is in no situation to be knocked about, & breaking Mrs. J's arm. Saw no necessity of sky larking on their part or any danger whatever.

Mary Barnwell[3] was there with diamond ring. Tom Boykin [*one illegible word*] S. B. up at his house but I did not stop — it was too sad. Uncle H writes that he is tired to death of this marching & countermarching. So objectless. Take a place, then retire. Then let the enemy take it & then take it back from them. Davis' visit to the camp & review of the troops seems to have created great enthusiasm.

> Gather ye rosebuds, while ye may,
> Old time is still a flying;

1. Horace Greeley, editor of the New York *Tribune;* Henry Ward Beecher of N.Y., Congregationalist minister, abolitionist, and brother of Harriet Beecher Stowe.
2. Prince de Joinville and his nephews the comte de Paris and the duc de Chartres were exiled members of the French royal family. Traveling in America at the start of the war, the three men became aides on George B. McClellan's staff.
3. Mary (Singleton) Barnwell was the wife of the Rev. Robert Woodward Barnwell.

And this same flower that smiles to day,
 Tomorrow will be dying.

The glorious lamp of Heaven, the Sun,
 The higher he is getting
The sooner will his race be run,
 The nearer he's to setting.

The age is best which is the first,
 When youth & blood are warmer;
But being spent, the worse & worse
 Times still succeed the former.
 Withers[4]

JC came in with a letter from Wilmot DeSaussure which I don't half like. No news. South Carolina prepared for the invasion. Gonzales still in Richmond where W. D. goes in a week. No mention of the Senators, he says, what ever. Miles not to be opposed for congress. Barnwell Rhett will be beaten.[5]

> To remould a government & frame a constitution anew, are works of the greatest difficulty & hazard. The attempt is likely to fail altogether, & cannot succeed thoroughly under very many years. It is the last desperate resource of a desperate people, a staking double or quits with evil, & almost giving it the first game. But still it is a resource. We make use of cataplasm to restore suspended animation — & Burke himself might have tried Medea's kettle on a Carcass.
>
> To those whose god is honour — disgrace alone is sin.
>
> Nobody has ever been able to change to day into tomorrow, or into yesterday; & yet every body, who has much energy or character, is trying to do one or the other.
>
> *Guesses at Truth*

[*October 7, 1861*]

Yesterday Edward Haile & David Williams dined here. The former still thinks with guerilla warfare they will be able to hold Florida against the Yankees. I said, "Stop talking & fight." JC said the Yankees could keep Florida from Fernandina to Cedar Keys with 1,000 men. In the afternoon Mr. Haile sent I must come there. Col. Chesnut wanted to hear me talk — but I did not go. So the old gentleman brought his chair

4. The first three stanzas of Robert Herrick's "To the Virgins, To Make Much of Time" from his *Hesperides* (1648). MBC apparently views this poem as apropos of Judge Withers. Omitted here are four stanzas of a poem MBC identifies as "Cleveland's Serenade in The Pirate."
5. Omitted here a brief passage on the Second Punic War from Charles and Julius Hare, *Guesses at Truth* (1861 edition). The following quotations are from the same book, pp. 17, 19.

& jammed it by me — to hear *me* — quite a compliment & I think it astonished E. H.

David has heard from M. W. that a bloody cloth has been found in Rhody's room — & a washed out night gown, & they have sent for a Detective to try & see better into matters. No news last night — but that R. R. Jackson has repulsed Reynolds[6] & Captain Lynch taken a federal Steamer with thousands of overcoats, &c, &c.[7] It is just as I said it would be; the rush of Europe here when the cry was raised that a war was going on for the extirpation of slavery.

> Half the failures in life arise from pulling in one's horse as he is leaping.[8]

> The great cry with every body is "get on! get on" just as if the world were travelling past. How astonished people will be, when they arrive in Heaven to find the Angels, who are so much wiser, laying no schemes to be made archangels.
>
> *Guesses at Truth*

Drove to day with Betsey to Mulberry. Took a rout among my goods & chattels — did not find as much as I expected for the soldiers — found a good deal for myself & for Kate. David says she wants to go to Buncombe for the winter — too *cold*. Found some capital old books — library in sad disorder but what a mine of pleasure it will be to me if debarred Society.

> Novels. The interest of which mostly arises from entangling & disentangling a love story. Indeed this is all that the bulk of novel readers care about: Who loves whom? by what difficulties their loves are crossed? how those difficulties are surmounted? & how the love knot after the tying & untying of sundry other knots, twists about at length into a Marriage Knot.
>
> *Guesses*[9]

Dugald Stewart[1] says "our first & our third thoughts will be found to coincide." Burke was a fine specimen of a third thoughted man. Wrote to Sally.[2]

6. Actually, only skirmishes occurred in early Oct. between Confederate Gen. Henry Rootes Jackson and Union Gen. Joseph Jones Reynolds in western Virginia.

7. Captain William Francis Lynch, famous before the war as an explorer of the Jordan River and the Dead Sea, commanded the Confederate naval defenses of N.C. MBC is probably referring to the Oct. 1 capture of the Federal supply ship *Fanny* in Pamlico Sound.

8. Omitted here is a brief aphorism about indulging children from Hare, *Guesses at Truth*.

9. Three brief quotations from the same book on barbarism, the rewards of noble thought, and sneering are omitted here.

1. A reference to the Scottish philosopher Dugald Stewart (1753–1825).

2. Omitted here are fourteen lines about a beautiful woman from the Scottish ballad "Sir Patrick Spens."

[*October 8, 1861*]

Reynoldses dined here & H. Grant — the latter brought an atmosphere of contention with her. JC & herself wrangled so unpleasantly last night there was no pleasure for any one. He wanted her to print what her Society did but she was so modest.

So we had an unpleasant evening. Besides, she wanted to give a dinner, that she might have *Johnson,* to Fannie Hay.[3] This time last year she said she preferred touching the tongs to Fannie or a rattlesnake. Nothing new in the papers.

[*October 9, 1861*]

To day attended the association — found it more meagre than ever. No body could give any account of any thing. Lin Davis[4] scouted the idea of putting on any box where it came from. "Father says we must not publish ourselves." Of course Emma Reynolds joined. Kate & I drove about — bade farewell at the depot to David & Edward Haile. Kate told David she would not be mortified if he *ran;* he must come home safe & sound. She persists in going to Buncombe. I feel she is right.

Nothing here to keep any one a day.

John Witherspoon writes that Rhody & Romeo have confessed that they & William & Silvy murdered Mrs. W — William holding the counterpane over her face & the others her arms & feet — & then they changed her clothes. Hicks the detective says it was one of the best managed plots he has ever had any thing to do with.

The Philadelphia Smiths have come. Mrs. Edward Stockton[5] another baby. Mrs. John Williams[6] did not come but sent a piece of worsted work & a letter. None of them have taken any concern about Mrs. Witherspoon's death — in any way, shape or form. JC had a letter from F. J. Moses offering a company for *his* regiment!

[*October 10, 1861*]

Went up to Cool Spring. Stopped at Aunt B's, had a very pleasant morning. *No Joe.* Got to Kate's to dinner. Found as I feared that Negroes & over seer & all had tried to make it unpleasant to her & she wishes to go to Buncombe. Thompson is the worst.

Circumstantial details of Mrs. Witherspoon's death. Wm. came home & Rhody told him John had threatened them with punishment next day. Wm. said, "Do as I bid you & there will be no whipping here tomor-

3. Frances Snowden Hay was the teenaged daughter of the Rev. Samuel Hutson Hay.
4. Probably MBC meant Lila Davis.
5. Emma Stockton, wife of Edward Cantey Stockton of Camden.
6. Augusta Rebecca (Howell) Williams was the wife of John Witherspoon Williams.

row." John had found out about them having a party & using Mrs. W's silver & house linen. They went to sleep & William woke them up in time. They went in one by one. Wm. stood at her head with the counterpane & Rhody at her feet & Romeo & Silvy at each arm. She struggled very hard & a long time. After they thought her dead she revived — & they commenced their hellish work again. Next day while Molly was so scared, Rhody saw her cap was bloodied & changed it — & she saw that the counterpane on the crib was bloodied & showed it herself that she might not be suspected.

Mr. Chesnut found a superb crop on John's place — but sulky & dissatisfied negroes.

[*October 11, 1861*]

Aunt B came to Kate's & spent the morning. Kate making dresses for Kate Withers — a very pleasant time we had. Aunt B wants to take a house in town.

Terrible row between the Heywards[7] & Caperses. Each abusing the other & accusing the other of running the firm into debt. There is something amiss in this wrong world of ours. Poor Kate Boykin.

Came home to dinner with three children — Mary Williams, Millie Haile & Becky Cureton.[8] Nothing new in the papers. Read at the top of my voice — & when I had finished a letter from Robert J. Walker,[9] old Mr. C showed he thought it was Mr. Secretary of War Walker! How my breath was wasted.

Had a kind letter from Mary Cantey Preston.[1] One from Betty Boykin — enclosing one from Sally directed to me in Aunt Charlotte's hand — & to show how Sally urged her to come & see her. James Boykin[2] says if the Yankees defer their attack a month we will be ready for them at Mobile. Will they? But James Boykin is such a humbug. However, Col. Deas writes the same. The Generals Beauregard, Johnston & Smith[3] deny that the President is keeping them back.

7. A prominent Colleton Dist. family with extensive land and slaveholding interests.
8. Millie was probably a daughter of Edward Haile. Becky was the child of James Belton and Mary Cureton.
9. Robert James Walker, a former senator from Miss., secretary of the treasury, and territorial governor of Kansas who sided with the Union during the war.
1. A daughter of John S. Preston, nicknamed "Mamie."
2. A planter who valued his holdings at $285,000 in 1860, James William Boykin of Dallas County, Ala., was MBC's second cousin once removed.
3. Maj. Gen. Gustavus Woodson Smith, who commanded a wing of the Army of Northern Va.

[*October 12, 1861*]

Went to Mulberry & spent the day alone arranging library & assorting boxes of letters & papers. Got about half through — a melancholy pleasure reading my French cook Therese's bills for the delicious dinners Mary Stevens & I eat so ravenously in Washington — with the appetite our frantic exercise & fatigue in the pursuit of pleasure gave us. Found numerous receipts for the Reynoldses & Grants. Came home & met Miss Sally & the children on their way up.

[*October 13, 1861*]

Sunday. Went to church. Heard Tom Davis[4] — think he is more uninteresting from his illness — & his manner if possible more atrocious — awkward — & grotesque. He is *earnest*. Gave us a poli[ti]cal sermon. Said a celebrated person from Washington had refused to go to church because politics were tiresome in the week — but Sunday the Gospel only could be endured. Was afraid he meant *me* — I have said that so often — but found it was *only* Henry Clay. He cited Lord Nelson as a case where a bad man's prayers were answered — for Lord Nelson was very devout — & prayed before the battle of Trafalgar, & after his wound, said, "Thank God I die doing my duty." His prayers for Lady Hamilton were not answered — he left her a legacy to his Country[5] but his country ungratefully did not accept.

Came home, read the papers. Nothing new. Went to church again & heard Manning Brown[6] preach to the Negroes — a full congregation — well dressed & well behaved. He preached *hell fire*. I found myself thinking any of our Sins here could not merit the weary eternity in torment. Then I remembered all this evil sin & misery in this world came fro[m] Eve's disobedience in the small matter of eating the apple & so I got rid of that heresy of the Universal Salvationists at once.

I do not think I spent Sunday as well yesterday with my twenty miles driving, &c, as I do at home — but I told Harriet Grant when she pitied me for hearing Tom Davis that I only went "to assemble myself together & not neglect it as the habit of some is," not that I enjoyed it as I do private devotion. Still I think it right & best, if it were not commanded even, to praise God & thank him publicly for his great mercies.

4. Lila Davis' half-brother, Thomas Frederick Davis, Jr., was associate pastor of the Grace Episcopal Church in Camden. His wife was MBC's first cousin.
5. The night before his death at the battle of Trafalgar, Horatio Nelson added a codicil to his will, leaving his mistress Lady Emma Hamilton and her daughter Horatia "a legacy to my king and country" and asking that they be given a pension. The will was not made public, and no such grant was ever made.
6. A nephew of Old Colonal Chesnut who lived in Sumter Dist.

Jim Nelson, a coloured preacher, prayed. Such a wild exciting prayer. The words were nothing — but the voice & manner so madly exciting — so touching in its wild melody & passion that I wept outright. The Negroes groaned & wept & swayed backwards & forwards — shouting Methodist fashion. A most exciting scene — purely, I believe, of the senses & does no permanent good. When he got off his knees he trembled & shook so from the finest ecstasy he could hardly stand. The singing I always find touching. The[y] have sweet splendid voices — & sing with their whole souls.

At night I made Col. Chesnut laugh until he was nearly choked — telling stories on JC & Miss Sally — & their vain attempts to influence him in the management of his affairs.

Chaucer

> The wrestling of the world asketh a fall;
> Here is no home: here is but wildernesse.
> Forth pilgrim! forth, o beast, out of thy stall!
> Look up on high, & thank thy God of all![7]

[*October 14, 1861*]

Monday got up early & wrote a letter to Mary Cantey Preston. JC hoped it was a good one. I said, "No. I could never rise above the dead level of my every day smartness." Sent M. W.'s letter to Sally Boykin. JC wrote to John Manning, John Chesnut, Kirkpatrick & Robinson. To day I have already picked to pieces some Moreen curtains — enough to make six shirts for the soldiers — 4 counterpanes & some white stuff for bandages. Waiting now for Kate Williams.

[*October 15, 1861*]

Kate came & we sat & knit & gossipped. She brought several items of news — first the little butting ram of steam that JC would have the congress patent has been eminently successful on the New Orleans coast. Then, Hatteras is evacuated. & that Mason & Slidell have left Charleston in the *Gordon* for Bermuda — Nassau or some nearest point. S. R. Gist wrote that to JC also. A letter from Mary Witherspoon with more unpleasant details. Says Boykin Witherspoon vows vengeance against the murderers of his Mother. Mrs. John N. Williams writes a long business letter to Dr. Mark Reynolds[8] & puts as a postscript, "My poor old Mother has been murdered. *They say* her negroes did it." The mad woman —

7. Goeffrey Chaucer's "Balade de Bon Conseyl" (also known as "Truth"). Following this quotation, MBC wrote: "November 10th. The battle raging at Beaufort," apparently a false start on a later entry.

8. The brother-in-law of Mary Cox (Chesnut) Reynolds.

the bad woman she is. I say let her have the money. She sold her body to Mr. Williams for it in her youth — & her soul to the devil in her age — so let the bargain stand. The Reynoldses [are] here — more distasteful to me every day.

Read yesterday Ponsard's *Homère*[9] & was very much amused. At night JC gave Scip a rowing up for not being respectful to Miss Sally. She was pleased. I do not know how it was with his Master.

I had an absurd letter from Quinter Washington, Editor of the *Examiner.* JC says he is writing down to my weak feminine *intellect.*

To day I am at home that Miss Sally may call on Aunts S. B. & H. Poor thing, nobody seems to think they ought ever to give her an opportunity to go any where. Her nieces, the Reynoldses that she thinks so much of & H. Grant, *never* do they for a moment feel it their duty to relieve her for one moment's pleasure from this dreary mill horse round of duty. Kate Williams has undertaken to right up my wardrobe a little. I gave Miller one of JC's old cavalry coats. I wish I could see him in it.

[*October 16, 1861*]

Went over yesterday after noon to see Aunt S. B. — too painful to write about. Saw Lem who is evidently crazed — but harmless — also Uncle John who says Mother has written him a long letter.

Came home. Knit & read "Quitts," a thing I have a passion [for] I think. I read it in Richmond where Mr. Mallory gave it to me. News confirmed of the successful attack upon the blockading squadron at New Orleans. The ship sunk is the *Vincennes,* not the *Preble.*[1] Spent the morning with Mrs. Chesnut — who as usual discussed the virtues of her servants — chastity not one expected from negroes.

[*October 17, 1861.*]

Thursday.

Went yesterday to the Society. H. G. flew about like a mad woman in a wonderfully fine fitting Gabrielle dress. Flew off to Statesburg & left her business at sixes & sevens. Kate did not come until so late that I had asked Charlotte Boykin to take my butter & burdens & had taken a seat with Mary DeSaussure for a trip to Kirkwood — having heard that Mary Kirkland was ill & that Kate Withers goes on Monday to Charleston with Mr. John DeSaussure & Ida.[2] Met Kate; changed car-

9. François Ponsard, *Homère* (1853).
1. On Oct. 12 the Confederate ironclad ram *Manassas* grounded the U.S.S. *Richmond* and *Vincennes* at the mouth of the Mississippi.
2. Ida DeSaussure, a daughter of John McPherson and Eliza (Champion) DeSaussure.

riages. I fear Kate is going to be ill. She turned white & then wept when I told her of Quinter Washington's letter — saying Jordan had written to him that the Army weakened on the Potomac — & I noticed at Aunt B's when she attempted to repeat some vile slander of Mrs. Williams upon Mrs. Serena Williams[3] she became so agitated & confused she could not go on. All this is so unlike my quiet & philosophic sister. God forbid any thing should happen to her. I wrote to Mother yesterday offering her back her money she gave me last winter. Kate says Tom Lang has lost his senses. Mr. C thought so the last time he spoke to him.

The news yesterday was that we had driven back the invading squadron on the Potomac, at what loss, none know of it.[4] Fifteen steamers at Annapolis armed & filled with men against us. Oh my heart. Where will they land.

Every where our men seem satisfied to drive the enemy back — that seems our settled policy. I hear from Miss Denie McEwen — good authority equal to the reliable gentleman who brings all the news — that Capt. Ingraham & some other sea captain got out with Mason & Slidell & are to take command of iron clad steamers some where. I read a silly piece in the *Courier*[5] showing how easily taken Fort Sumter would have been last summer & really showing a very thin defence *now*. It must be a ruse to entrap the enemy — but I fear it is only stupidity.

Had a very pleasant time yesterday with my old cronies — Susan Lang & Brevards. The[y] would not take work because they had to make winter clothes. I said they ought to be like the *Isabel* who wore the same chemise until the siege was over[6] but these people have felt nothing yet of the horrors of war & so will not make any sacrifice. The time may come oh my country women.

Reread to day Reed's lectures on Literature, particularly wit & humor — he quotes Sydney Smith saying a man [was] "splashing in the froth of his own rhetoric."[7]

[*One page torn out.*] to attend to it. *Now*, when if ever man was stirred to the highest for his country & for his own future — he seems as utterly absorbed by Negro squabble, hay stealing, cotton saving, neglecting the corn which may be caught by a freshet & we starve next year. The only part of it that is not utterly horrible to me is the devotion to sick Negroes. If I had been a man in this great revolution — I should

3. Esther Serena (Chesnut) Williams, first wife of John N. Williams of Society Hill.
4. A false rumor.
5. The Charleston *Daily Courier*.
6. According to a popular but inaccurate legend, Princess Isabella of Austria refused to change her linen during her father's three-year siege of the town of Ostend.
7. From Reed's *Lectures,* p. 375. Omitted here are seventeen lines on the ideal woman from Tennyson's *The Princess,* vii (1847).

have either been killed at once or made a name & done some good for my country. Lord Nelson's motto would be mine — Victory or Westminster Abbey.

> Win
> The women and make them draw in
> The men, as Indians with a female
> Elephant inveigle the male.
> *Hudibras*[8]

> But Oh! Ye Lords of ladies intellectual
> Inform us truly, haven't they hen-peck'd-you-all.
> Byron[9]

> He that hangs or beats out's brains
> The devil is in him if he feigns.
> *Hudibras*[1]

> Weep no more lady, weep no more,
> Thy sorrow is in vain;
> For violets plucked! the sweetest showers
> Will ne'er make grow again.
> Friar of Orders Gray[2]

> But he my lion, & my noble Lord,
> How does he find in cruel heart to hate
> Her that him loved, & ever most adored
> As the God of my life? Why hath he me abhorred?
> *Faerie Queene.*[3]

Sandy Hill. Rain — & dreariness!

[*October 18, 1861*]

Today spent at Aunt B's.

Mary Kirkland has a sweet little daughter after a desperate illness. They were all busy arranging Kate's affairs for Charleston. Kate Williams was there & sent down with me Mary, Ellen, & Miller — who tormented me sufficiently in that small Carriage. Nelly is utterly spoiled & selfish, but these children in their rough play will cure all that. Hermes

8. From Samuel Butler, *Hudibras* (1663–78), Part 1, Canto 2, which refer to ministers' use of women as bait to attract male churchgoers.
9. From Lord Byron's *Don Juan*, Canto 1, stanza 22 (1819–24). Omitted are six lines from an unidentified poem.
1. From Butler, *Hudibras,* Part 2, Canto 1, in which a widow maintains that a man can prove his love only by suicide.
2. Stanza 12 of "The Friar of Orders Gray," a ballad composed by Bishop Percy from fragments of ancient songs in Shakespeare's plays. It was published in *Reliques of Ancient English Poetry* (1775 edition).
3. Edmund Spenser, *The Faerie Queene*, Book 1, Canto 3, stanza 7 (1590).

in the *Mercury* writes that *our officers* are resigning twenty a day — & that the army is thoroughly disorganized. Russell writes to the *Times* that we can be subjugated. But at the end he acknowledges their loan is not taken up. Some hope in that.

[*October 19, 1861*]

Went off with the children to a sort of picnic at Mulberry. Kate came & brought Daby & Becky Cureton. I had two hours of work in the library before they came — assorting letters. Found some quite interesting — two from Lovell,[4] now Brigadier General of the Louisiana department, to Mr. C asking him to procure him a furlough, from Albert Pike,[5] from Jeff Davis, & from Beauregard, &c.

Kate & I had a delightful long talk in the library. She found a quantity of books for the children. Daby spoilt every thing playing with red peppers. Got them in his eyes & mouth — & roared with pain. JC dined with us — opened two bottles of champagne for the fête. Read *Don Quixote* & laughed aloud at Teresa Panza's[6] letter.

What queer times we live in & how hardened we are to danger. Kate says Betsey brought her bed in to sleep in her room when she was left alone — & she thought, "Is this to protect me or to murder me?" She decided, however, she could manage Betsey, who was so "fat & scant of breath" (like Hamlet)[7] & she so noisy. The same day at dinner Mrs. C rushed in urging the family not to taste the soup, it was so bitter. *Some thing* was in it! She meant *poison*. The family quietly eat on to keep the negroes from supposing it possible they should suspect such a thing.

Kate told a wonderful tale which I must set down. Laurence M. Keitt's brother — a Dr. K[8] that I knew full well was poisoned by his negroes — he was very indulgent. Spoiled them utterly — but was passionate & impulsive. Mr. Taylor, who married an acquaintance of ours, Miss Baker of Sumter, said to him, "Keitt, these negroes are poisoning you. Do not let them know you suspect them unless you take them up instantly, but I advise you to go away at once, say to day — & see if this extraordinary disease will not stop." He promised. Just after Mr. Taylor left the house a woman brought him a cup of coffee & as he stirred

4. A civil servant in New York City before the war, Mansfield Lovell was commissioned a major general in the C.S.A. and assigned to command New Orleans in 1861.
5. Brig. Gen. Albert Pike was commissioned to negotiate treaties with the Indians and to win their support for the Confederacy.
6. Chapter 50, part 2 of Cervantes' *Don Quixote* recounts the letters of Teresa Panza to her husband, Sancho, and The Duchess.
7. *Hamlet*, act 5, scene 2.
8. Dr. William J. Keitt had his throat cut by his slaves while he lay sick in bed on his Fla. plantation in Feb. 1860.

it — it was so evident some white powder was at the bottom of the cup — that in a passion he dashed the cup in her face without drinking it. That night his throat was cut. Afterwards, by their confession it [was] proved they had been giving him calomel for months every morning in his coffee. Thre[e] were hung — but two suspected men escaped because a brother of his believed them honest & guiltless.

Laurence Keitt refused to touch a cent of the money left by his murdered brother — saying there was blood on it.

A few weeks after, Mr. Taylor, who is [a] plain, honest farmer — matter of fact — not romantic or sentimental but simple & truthful, was riding to his plantation. At a place where Dr. Keitt always stopped & sat on a log & waited for him — he saw him sitting so naturally — he felt no alarm — but rode & said, "I am glad to see you, old fellow. Some how I though[t] you were dead." They had a *pleasant,* neighbourly chat & then Keitt said, "You let off the rascals who cut my throat," & then vanished. For the first time Mr. Taylor felt the awe & horror any feeling of the supernatural brings — & rode home so violently. Restless & miserable, he told his wife — who laughed at his story — & urged him to go to bed & sleep away such a night mare. While they were talking, Mr. Keitt's brother, who inherited the murdered man's plantation, came in — pale & restless. After an attempt at casual conversation, without an idea what had happened to Mr. Taylor, Mr. K said, "My brother came to me last night. We had a long talk — he told me I had screened the two rascals who cut his throat." Mrs. Taylor was astounded. Keitt repeated, "I did not say I had a dream. I was awake — awake as I am now. He came to me. I saw him & talked to him." The Negroes had been sold out of the country, nobody knew where.

I wish Robert Dale Owen with his *Footprints of Another World*[9] had this *true* story.

Fairies have gone — goblins & ghosts have gone — devils also. We will have to give up our souls, too. Now there are no devils, we won't mind that so much. No body to contend with to save them.

[*October 20, 1861*]

Sunday. Staid at home. Read good books, *Life of Wycliffe* — & *Guesses at Truth.* Had a pleasant day with JC. He wrote letters as usual. In the afternoon — the Reynoldses came down — brought the lamentable tale that poor Mrs. John Whitaker, Cally Kennedy,[1] was buried. John, poor wretch, was married in June or July & now!

9. *Footfalls on the Boundary of Another World* (1860) reflects the interest of this Northern social reformer in the cult of spiritualism.
1. Kate (Kennedy) Whitaker was the daughter of Kershaw County planter William Kennedy and the wife of John Whitaker.

The *Mercury* was more than usually *atrocious*. Accuses our government of every thing horrible — & ends by saying the Carolinians feel *sold* & would not reenlist — & will leave as soon as their year is out. He ought to be burned, this *traitor* — who publishes such.

[*October 21, 1861*]

Monday — after a night of rain, rain, rain.

I hope I may not be too conceited & spoil J. Chesnut's affairs by writing in such a hurry letters for him. To day I have written to the President, Jeff Davis — 1; to Benjamin, Secretary of War, 2; to Mallory, Secretary of the Navy, 1; to Warren Nelson,[2] 1; to Mr. Henry Gourdin, 1; all with the best intentions possible. I hope it may prove *so* — in the end. Would like to cut out the foolish letter of Phillips in the mail.

I am sure Boyce is frightened when he sees the enemy have Mrs. Phillips' *correspondence*. Mallory & *Holt* may *tremble* from what I know of the scandals.

They are making a rave row over Wilson's regiment. He disclaims all hatred & vengeance against us — & also disdains long ranges & distant firing. Wants to give us the Bayonet. Cold *steel* is the best word in his mouth — all in pure brotherly love. For our good, wants to punch our heads with his sharp shooters — if I understand the stuff. A Mr. Pierpont[3] throws off disguise. It is abject slavery, such as God has allowed only here — & evidently Mr. P thinks he ought to be very much ashamed of himself for allowing it only here — that Mr. P is after putting down! at the point of his ecclesiastic bayonet. & he sings praises, of course, to his *sisterin,* old women in Massachusetts — the Deborah Beecher Stowes.[4]

I felt ashamed for Mr. Brady, for he must have understood what a wonderful humbug this Napoleon *Crispin* was, all the time he was lauding him. I hope we may catch him here & make him make shoes for our Negroes, he has cheated them so often with his paper soles. He wants to get so close he must needs want to use his awl.[5]

Reading Lamartine's *Geneviève*.[6] He quotes [*illegible word*] old Roman for the fidelity of servants in the time of Octavius Caesar — Augustus, I mean — & says in the French revolution, nine out of ten were faithful.

2. Samuel Warren Nelson, member of the S.C. house from Clarendon Dist. Henry Gourdin was the brother and business partner of Robert Gourdin.
3. John Pierpont, Unitarian minister and abolitionist in Mass.
4. MBC surely means Harriet Beecher Stowes.
5. The "Mr. Brady" was James Topham Brady, a New York lawyer, states' rights advocate, and Southern sympathizer. MBC identifies "this Napoleon *Crispin*" in her 1880s version as Sen. Henry Wilson of Mass., who made much of his origins as a journeyman shoemaker.
6. Alphonse de Lamartine, *Geneviève, histoire d'une servante* (1850), part 3.

Arnold says, "If an historian be an unbeliever in all heroism, if he be a man who brings every thing down to the level of a common mediocrity, depend upon it, the truth is not found in such a writer."[7] The best truth of history, let me add, is lost to that censorious, sneering, sarcastic temper, which is its own curse — for it can see only what is selfish & mean & vicious. There will be evil passion & guilt enough found upon the pages of history, but when sentence is pronounced, let it be with the tone of solemn judgment & not of satire.

Hume, at the end of a splendid era of English History, makes this reflection: "The study of the early institutions of the country is instructive as showing that a mighty fabric of government is built up by a great deal of *accident* with a very little human foresight & wisdom."[8] For "accident," Mr. deistical Hume, read "Christian Providence." Lamartine says, "Dieu est Dieu! et ce que les hommes appellent rencontre, les anges l'appellent Providence!"[9]

They say we are to have no more gas or candles while this war lasts. It will be worse than the old Norman *curfew* bell. Shutting out light.

Lamb says in his "Popular Fallacies" in which he eulogises candle light as more kindly than the light of Sun: "What savage unsocial nights must our ancestors have spent, wintering in caves & unilluminated fastnesses! they must have lain about & grumbled at one another in the dark.

"What repartees could have passed when you must have felt about for a smile, & had to handle your neighbour's cheek to be sure he understood it."[1] Oh blessed pine of my country. We can have torches. Link boys will come in fashion again in Richmond.

> Ah gentle dames! it gars me greet,
> To think how many counsels sweet,
> How many lengthened sage advices,
> The husband from the wife despises![2]

Poor me ——

Respect for high places seems so ingrained in some people's nature. It reminds one of Shakespeare's

> Respect to your great place! and let the Devil
> Be sometimes honoured for his burning throne![3]

7. Matthew Arnold, as quoted in Reed's *Lectures on English History* (1855), p. 39.
8. David Hume, *History of England* (1754–62), II, chap. 23.
9. A paraphrase from *Geneviève*, part 116.
1. Paraphrase and quotations from Charles Lamb, "Popular Fallacies, XV. — That We Should Lie Down with the Lamb" in the *Last Essays of Elia* (1833).
2. Robert Burns, "Tam o'Shanter" (1791).
3. *Measure for Measure*, act 5, scene 1.

> And he, that stands upon a slippery place,
> Makes nice of no vile hold to stay him up.[4]
>
> Shakespeare

[*October 22, 1861*]

Tuesday, Sandy Hill. I read Lamartine's *Geneviève* yesterday & finished it about nine last night. H. Grant coming home in a pouring rain & [as] I found it too wet & was too interested in my book to go there, she came here.

Such a mass of stuff she told — accusing Mrs. L. Cantey of lying, stealing — accusing Hatch & Glover of making money out of their commissary duties — & absurdest of all accusing the *Hampton* girls[5] of keeping the soldiers' money. Such low venom & slander makes me ill.

I wrote a critique for the papers yesterday of Brady's & Wilson's speeches — but I did not find myself very *clever*. It read very flat. My sentences were too long & too intricate — & the ideas spun out. I could not compress & condense & intensify as I can do talking.

Harriet was very impudent to me to day. Served me right. I shall never be familiar with her again — but give her no opportunity to fly out.[6]

> Retribution walks with a foot of velvet & strikes with a hand of steel.
>
>> Send danger from the East unto the West,
>> So honour cross it from the North to South
>> And let them grapple. Oh the blood more stirs
>> To rouse a lion than to start a hare.
>>
>>
>>
>> Would it were bed time Hal! & all were well![7]

Lincoln will find it.

>> Better be with the dead —
>> Whom we to gain our place have sent to peace,
>> Than on the torture of the mind to lie
>> In restless ecstasy —— [8]

Reed on friendship:

It is with a true knowledge of human nature, & not with any morbid, & therefore unjust, estimate of it, that Shakespeare considered, I sup-

4. *King John*, act 3, scene 4.
5. The sisters of Wade Hampton, III: Caroline, Catharine Ann, and Mary Fisher Hampton, no longer "girls."
6. Omitted is a passage on Simon de Montfort from Henry Reed, *Lectures on English History*, p. 148.
7. Of the last two quotations, the first is from Hotspur in *Henry IV, Part I*, act 1, scene 3; the second is Falstaff in the same play, act 5, scene 1.
8. *Macbeth*, act 3, scene 2.

pose, friendship between men as a relation that is rarely of long dura-
tion, & more rarely of very deep feeling. The course of the world hardly
admits of it, save under peculiar circumstances.

Reed, vide Damon & Pythias[9]

Gloster tis true we are in great danger;
The greater therefore should our courage be!

Henry 5th[1]

Let Wilson remember this & Russell, who buys our cotton now from
the Yankees.

The man that once did sell the lion's skin
While the beast lived, was killed with hunting him![2]

Apt quotation for the times.

Harriet & Miss Sally have gone to Camden — & I see James Frier-
son's bugg[y] drive to the stable. Miller tells me he is in the house. Miller
& I boiled a pot of candy yesterday. Quite a youthful feeling it gave
me.[3]

[*October 23, 1861*]

Wednesday. Mr. Frierson's errand was too painful to write or even
think of — "of our pleasant vices are made the whips to scourge us,"[4]
may these Southern *men* say.

I cut out nine shirts of moreen out of my old curtains. I have had
them twenty years & never before found any use for them. JC wrote to
John Witherspoon. I see those four Negroes — William, Rhody, Ro-
meo & Silvy — are hung — & commenced an abusive & denunciating
letter of the *Mercury* which I stopped. The papers had nothing new ex-
cept a fight going on at Yorktown — Magruder's command. Lady Sale's
"Earthquakes as usual."

The *Mercury* worse than ever — & one of the most amusing, rollick-
ing, funny articles by Washington — against Wilson. I could imagine him
saying it all. Lieut. Warley of S C & T. B. Huger were among the lead-
ers of the New Orleans brush.[5] I knew Tom Huger would do some-

9. Reed, *Lectures on English History*, p. 228.
1. *Henry V*, act 4, scene 1.
2. *Henry V*, act 4, scene 3.
3. Omitted are lines 103–8 from John Milton's "Il Penseroso" and lines 935–38 from
 Geoffrey Chaucer's *The Canterbury Tales*, "The Clerkes Tale."
4. *King Lear*, act 5, scene 3.
5. The Federal blockade at the mouth of the Mississippi had been briefly disrupted after
 an engagement on Oct. 12 in which South Carolinian Alexander F. Warley com-
 manded the Confederate ironclad *Manassas* and Lt. Thomas B. Huger served aboard
 the C.S.S. *McRae*.

thing as soon as he got a chance. I have never seen a man who seemed more the beau ideal of a dashing devil may care sailor. To day I have written to Mrs. Smith Lee to engage rooms for me at the Arlington. Raining — still — I am alarmed for the corn.

[*October 24, 1861*]

Thursday. Yesterday I drove first to Mulberry, then to Camden. Stopped at Bonney's — heard there that Evans had defeated the Lincolnites at Leesburg — & taken 300 prisoners — killed 500 — & *drowned* a quanti[t]y. We lost 300.[6] All exaggerated I expect — however last night's papers confirm it — & also the death of Baker, the Oregon Senator[7] — & the capture of 10 commissioned officers. Bonney also told me Mrs. Ben Lee[8] had brought the news from Charleston that the ship that ran the Blockade two days ago pretended to the Blockaders that she was bound for Bath, Maine, & was entrusted by the fleet with letters for New York. Which being brought into Charleston of course were opened — & they told that our coast was to be attacked at 4 places at once — Bulls Bay, Stono, Port Royal, &c, to prevent our concentrating.

Went to Mary Kirkland's — found her better — Kate gone — & Mary's heart & soul still in clothes. Such senseless extravagance. I carried Kate Williams a calico dress. She does so much for me & a fur collar. I found her on bare floors, no beds, no furniture. The day before, Team came with a letter & took all the furniture saying it was James Chesnut's of Florida,[9] who chose this auspicious time — while Kate was alone, to send an overseer to turn her out. He never knew what one gentlemanly impulse or action meant. Kate would never have used the furniture if she had known it was theirs.

I mentioned these things last night & was insulted both by H. Grant & Miss Sally. The former asked me *insolently* if Kate was quarrelling with the McCaa Chesnuts[1] too. I went off to bed enraged but trying to keep my temper & not *sin* as I did before. I felt last winter that all the mortification & misery I endured were a fit punishment for my sinful hatred of these people.

Just as I got to bed Minnie & her children & Converse Frierson[2] drove

6. The battle of Ball's Bluff, Va., on Oct. 21.
7. Edward Dickinson Baker, U.S. senator from Oregon, died on Oct. 22 while commanding his own brigade at Ball's Bluff.
8. Eliza (Lee) Lee, sister-in-law of Ann (Cooper) Lee and the wife of Charleston banker Benjamin Lee.
9. Another of JC's nephews, the brother of John Chesnut.
1. Johnny Chesnut's brother James was married to MBC's first cousin, Amelia (McCaa) Chesnut.
2. Converse Frierson was the son of John Napoleon Frierson, a wealthy planter and former state legislator from Sumter Dist. Minnie Frierson was his aunt.

up. Of course I heard a carriage but did not inquire whose it was. After a *half* an hour — a message came to JC in these words, "If you want to see Miss Minnie come over. She goes at daylight tomorrow morning." I suppose by the ill bred wording of it, it was Harriet's. It was to borrow money they wanted him — he lent them twenty dollars which will be the last of it. If I had only got it to give to the soldiers.

God have mercy on me & keep me with Christian feelings to these people. They remind me of dogs with eager eyes watching a man eating, with mouths open watching to catch every bone — & snapping and snarling at every other dog who comes near for fear he should get any thing. The miserable degraded money loving grasping spirit these poor people have from dogging this poor old man for forty years for his *money*.

Minnie went to day. Sent her love — but no message to me offering to do anything for me in New Orleans — as she ought. How she could go to New Orleans with that wretched negro is more than I know. Mrs. Chesnut wondered at it too. She is a philosopher, that old lady. So she is warm & comfortable & has a plenty of *very, very* nice things to eat & pleasant books. God help — me — how bitter I am.

Joan of Arc:

> Look on thy country — look on fertile France,
> And see the cities & the towns defaced
> By wasting ruin of the cruel foe!
> As looks the Mother on her lowly babe
> When death doth close his tender dying eyes,
> See, See, the pining malady of France;
> Behold the wounds, the most unnatural wounds!
> Which thou thyself hast given her woeful breast!
> Oh turn thy edged sword another way;
> Strike those that hurt, & hurt not those that help!
> One drop of blood drawn from thy country's bosom
> Should grieve thee more than streams of foreign gore.
> Return then therefore with a flood of tears,
> And wash away thy country's stained spots.

The village of Domremy was not taxed — at the request of Joan of Arc — her only *reward*. Until the French Revolution, the tax book was marked, "Néant à cause de la Pucelle!"

> Oh thou eternal Mover of the Heavens!
> Look with a gentle eye upon this wretch!
> Oh beat away the busy meddling fiend
> That lays strong siege unto this wretch's soul,
> & from his bosom purge this black despair!
> · · · · · ·

Lord Cardinal, if thou thinkest on heaven's bliss,
Hold up thy hand — make a signal of thy hope —
He dies & makes no sign!

.

In the Wars of the Roses at Towton — more men fell than at Vimiero, Talavera, Albuera, Salamanca, Vittorio & at Waterloo. 28,000 Lancastrians. Number of Yorkists not specified.

The Molochs of human nature who are endebted for the larger part of their meteoric success to their total want of principle, & who surpass the generality of their fellow-creatures in one act of courage only — that of daring to say with their whole heart, "Evil, be thou my good!"[3]

[*October 25, 1861*]

Sandy Hill. Went up to Camden. Spent the morning at Aunt B's. Met the Judge — he never once met my eye! Talked politely but would not look at me. *That* means mischief! Saw Mary & her baby. Kate came & brought me my dresses. Said she would never have so much work for any body in the world, not even her own children — *only* for Mary Chesnut. I think she did it on purpose for those people to see how much she thought of me — for I have devoted myself to them more than to her, more than to mother, sister, anybody in the world ——

Came home. Haddie's guests did not come. I had treated her shabbily about Callie Perkins' candy. Read *Knight of St. Johns* — find the siege of Malta quite interesting — that noble old LaValette.[4] The red cross knights have always had a fascination for me.

The reports of our victories corroborated. Found JC reading a speech of Mr. Petigru's[5] sneering at us & Isaac Hayne in his answer acknowledging our weakness. Oh that I was a man! Did not go to the house!

[*October 26, 1861*]

Mary & John Witherspoon expected to night. Enie Williams[6] is with me. Have been reading Reed's criticisms of Lear, Macbeth. Am sligh[t]ly upset. I am sure if I go through Hamlet, [it] will finish me.

3. A paraphrase from Henry Reed's *Lectures on English History*, p. 295.
4. Presumably a history of the Knights of Malta, the Order of St. John of Jerusalem, a religious and military order located on the island of Malta, which, under Grandmaster John de la Valette, withstood continuous attacks from the Ottoman Empire during the sixteenth century.
5. James Louis Petigru, a noted Charleston lawyer and Unionist. JC read law in his office after graduating from Princeton, and MBC was a childhood friend of his daughter Susan.
6. Serena Williams, the 13-year-old daughter of Kate and David Williams.

> Tho his bark cannot be lost,
> Yet it shall be tempest tost.
> > Macbeth
>
> Your face, my thane, is as a book, where men
> May read strange matters. To beguile the time,
> Look like the time, bear welcome in your eye,
> Your hand, your tongue. Look like the innocent flower,
> But be the serpent under it.
> > Lady Macbeth[7]

[*October 27, 1861*]

Sunday. Spent the day discussing poor cousin Betsey's murder — & hearing from Mary W all its hideous details. Miss Sally also staid at home.

She said her negroes said let us go to the hanging — "It will be good warning to us all" — showing they know we are afraid of them. The Reynoldses came down in the evening. I had a pain in my eyes & did not go back to the house.

Mary Witherspoon told me Cousin Sally had been telling ever since Enie's birth that her bad opinion of Kate came from our Mother. Poor Mother — how it would mortify her to know this.

[*October 28, 1861*]

Mary Williams came down with John W[8] last night. Says the negroes go to Buncombe to day — & the family on Thursday. Kate comes down to day.

David came without Kate.

Seems to think the Florida people are under no apprehension. I see every boat, every ship, every available thing is in requisition to invade our coasts, plunder our shores — spoil plantations & steal negroes. 100,000 men are to be engaged in this expedition.

[*October 29, 1861*]

Yesterday I came in my room. John W came here & knocked at the door. I would have excused my self to him if I had any possible excuse — for I do not like him, now, particularly, & I knew I had the same story to hear from him I had from Mary. He told me all manner of horrors — among others, one thing I can never forget. He says Mr. Williams said Mother had insulted them & as they could not get at Mother, she was out of their reach — they must make *Kate feel* it. Kate, a poor young thing just married to his son. John hates Mr. Williams as much as he does his sister.

7. *Macbeth*, act 1, scene 3, and act 1, scene 5.
8. John Witherspoon Williams.

Mrs. Henry DeSaussure came. She told Mr. Chesnut she came to see Mary Witherspoon. I said something she did not like. She was so affected & conceited & ugly it was really funny. I did not go in until dinner time — & came away directly after.

To day I am an invalid.

Yesterday came a letter from Trescot. He says, "Many a slip, &c," about JC's Senatorship — & to me he says Mrs. Joe Johnston's arm will not permit her to answer what she calls a "delicious letter" from me — but she can write to Trescot! He does not believe I can write a "delicious letter."

[*October 30, 1861*]

Today so ill — & took so much laudanum — I mean paregoric, &c, &c, can not write.

Sat awhile with Mrs. Chesnut as all the family were away.

Old Mrs. Haile came — & sat awhile with Ches & Nellie. I can say I interfered with Mrs. C & her Florida messages by staying there. She goes on Saturday.

I offended Mrs. Chesnut by not wanting JC to write a letter to Gen. Huger sending a letter to the Philadelphia Binneys. I feel I was wrong. JC went to talk it all over — & apply soothing syrup.

[*October 31, 1861*]

Still playing interesting invalid. The Witherspoons returned from Cool Spring with Miller & Mary. H. Grant came yesterday to tell me of a grand flare up she had at the Society — her dearly beloved Shannons offended her. I dare say, from her own account, very bad. Today from Miss Sally's I *know* it is horrid.

Wigfall is a Brigadier & Joe Kershaw. JC's election for Senator does not come off until December. I hope he is *right*. I hope he will be Senator — if he had gone in the army it would have made matters certain. I could not have devoted myself heart & soul to my private interest at such a time — not taking even so much interest in public affairs as to write a decent answer to letters.

I must not let my self think of all this. Read yesterday Balzac & *Road to Ruin*.[9] Have been dress making all day. Laurence made me a nice Zouave — which he is putting buttons on today. This immense armament has sailed at last. *Where*, oh my heart! Where will it land. Their spite is to us — but they fear us also. 15 war steamers & a transport — warm work wherever they go. An attack front & rear is threatened by McClellan at the army of the Potomac.

9. At least three books with this title were published between 1792 and 1851.

[*November 1, 1861*]

Rain. Kate expected — but I fear the rain will stop her. My eyes hurt. JC has written to Trescot, to DeSaussure & to Gist. I do not exactly like either letter — but did not say so. That *blab* Trescot may repeat to Mr. Chesnut's disadvantage what he says of Stephens. No news last night. H. Grant in raging *tantrums*.

Col. Chesnut evidently offended because I do not scream loud enough for him to hear. Read Scott.

[*November 2, 1861*]

Went to Camden, Kirkwood & Cool Spring. Found the Judge — who would not look at me. Mary very sweet & queer in some things. Kate Williams sad also. Took out a letter from Jeff Davis to JC — asking the particulars of the interview between them on the 13th July.[1] Beauregard it seems has said in his report of the battle that he had offered Jeff Davis a plan of campaign which he would not accept — so JC must remember & write that memorable interview — which I could give pretty well from my journal. He was the aide de camp who carried up the plan — & John Preston, Gen. Cooper & Gen. Lee were present.

[*November 3, 1861*]

Ill all day — & wrote copies of JC's letter to Davis — his report to Beauregard, written while the guns were firing on the 18th. B must have thought he would be shot & wanted himself justified to poster[it]y. Lee & Jeff Davis did not agree to the plan, saying "it was too soon & the enemy too near his cover." ⟨⟨How the Davises will [*one illegible word*] when they get that letter. That dream is shot⟩⟩ — & now if the Legislature turns us out. Woe is me — for I dare not look plantation & *Camden* life in the face. I am *ruined* for that — by Washington & Richmond.

[*November 4, 1861*]

Last night JC went to see Uncle H. The *Mercury* reporter turned out of the Brigade. Toombs & Miles told A. H. B. that the country would never do JC justice until the Secret Session documents were published. I hope they will do him the justice to make him Senator.

Had a letter from Mother. She wants to get rid of her negroes — scared by the Witherspoon tragedy.

1. Davis and Beauregard, increasingly at odds after Bull Run over questions of rank, command, and strategy, were disputing Beauregard's rejected plan for an attack on Washington, which JC had presented orally from notes to the president on July 14 (not July 13). Amid press charges that Davis sought the destruction of his popular general, the president insisted privately that Beauregard had offered only a general, presumably unofficial proposal. Beauregard maintained that his was a specific, formal plan and suggested that the president consult Chesnut's report of the July 14 meeting.

[*November 5, 1861*]

To day — went to Cool Spring — broke down on the way — dined at Aunt B's — broke down again coming home with H. Grant & Mary Frierson. H. G. does not want to resign — after all the row. Louisa Salmond does.

Tuesday 5th — expected to see the Yankee prisoners but did not — fortunately they did not come. Sebby Cureton has come — brags of Boykin's brigade. Says the army has provisions & to spare — but the extravagance & waste is fearful.

The Mississippians who fought so bravely were those who got into trouble on the 21st July — & [are] determined to redeem themselves. I see the northern papers have found out their government are deceiving them — especially in the Leesburg business.

[*November 6, 1861*]

Last night's telegram said McClellan & several of the Cabinet have *resigned*. Wonderful if true. & there is such a rumour of Beauregard. To day Kate left for Columbia — & JC for Charleston. I intended going to Columbia — got snubbed last night & concluded to stay at home. Today he wanted me to go to either Charleston or Columbia but it was too late. I did not feel well — & so could not get ready. It would have been very agreeable to my feelings to have escaped the bustle & confusion of packing & moving — but we can't have what we like always in this world. JC likes staying at home & he goes. It would have been perfectly delightful to me — a trip either to Charleston or Columbia & I stay at home.

Had my imagination fired to fever heat by Mrs. Shelley's *Last Man.*[2] Lord Raymond is Bryon & Adrian, Shelley, &c, &c. Altho it left me so fevered, it is evidently a strained out story to *sell*.

The gleam,
The light that never was on sea or land —
The consecration, & the poet's dream.[3]

[*November 7, 1861*]

Moved to Mulberry. Had a very busy day — but felt comfortably settled — & my room is so luxurious after Sandy Hill [I] really enjoyed it. Nancy was here & worked like a horse. I arranged the Library somewhat & also look[ed] over a large batch of old letters — an interesting

2. Mary (Wollstonecraft) Shelley, *The Last Man* (1826).
3. Lines from stanza 4 of Wordsworth, "Elegiac Stanzas, Suggested by a Picture of Peele Castle, in a Storm, Painted by Sir George Beaumont" (1805).

business to me. Read *Charlotte Temple*[4] — found the formal, euphuistic language stiff & tiresome — "the pellucid drop" for a tear, &c, but there is enough of nature in it to make it very readable.

At night came the papers. The fleet beaten back from Hilton Head — Commodore Tattnall doing valiantly[5] — Legislature adjourned. Trescot, as he wished, one of the Electors. I wonder if JC's letter did him any good. I see Gonzales is affronted by the President not giving him a fitting office, & goes as aide to Gen. Ripley. I hope JC has written to Benjamin.

The *Mercury* has a very weak defence of its correspondent "Kiawah" who was turned out of the Palmetto Guards. It insults the whole Army in Virginia as well as the President Davis. I read to *JC's father*. I should do it for no other man living. Pickens' message — it is a bid for the Senatorship, & as the *Mercury* praises it most abundantly, I suppose they have coalesced. Miles is reelected. The correspondent of the *Courier* says Hon. R. Barnwell & Hon. James Chesnut are the prominent candidates for Senator — also Boyce very popular on account of his free trade articles — & Orr & R. B. Rhett. I see A. H. B. took his seat in the State Senate.

Read another letter from Russell describing slave holding in Maryland & it applies here also — 'tho' he says they are so much worse off in the South. Gen. Scott resigned & some rumour also of McClellan's.[6] Lincoln throws the blame, or responsibility rather, on him.

[*November 8, 1861*]

Did not sleep last night — feel the effects today in stupifaction. About one, Mrs. Reynolds came with the horrible news that the enemy was getting in at Port Royal.[7] I immediately went to Camden to hear more — felt overwhelmed. There we saw John DeSaussure who gave us no comfort — but seemed to take great pleasure himself in telling what a crop Henry was making — as if that mattered now. Saw Aunt S. H. at McEwen's — busy matching ribbons & buying, &c. Said Uncle H would go to day to Charleston, so I wrote a letter to JC — but I do not know where he is even. I ought to have gone with him.

Heard the Judge was miserable, so went up. I felt uneasy about Mary

4. The heroine, a woman of uncertain virtue, in Susanna Rowson's popular novel, *Charlotte Temple: A Tale of Truth* (1794).

5. Actually Confederate forces, outgunned by the U.S. fleet, fled their forts on Hilton Head, S.C., and Federal troops occupied the island. Josiah Tattnall commanded the Confederate troops.

6. In Oct., Lincoln accepted Winfield Scott's request to retire and named George B. McClellan as his successor.

7. On Nov. 7, the U.S. Navy captured Port Royal, S.C.

as Mr. Kirkland is in the fight. Aunt Betsey said when Mr. Chesnut was at Fort Sumter that she had no body there she cared for — but I could not be as hard to them — imagining them in distress. I went there at once — found the Judge, Tanny & Aunt B in high glee at dinner. He told me Baxter Springs told him that Pickens & five others had written to him that they were candidates for the Senatorship. Aunt B said she did not inquire who the others were as she felt no interest in the matter. Speaks of unutterable corruption among our people. Says Orr & Pickens have made a bargain to assist each other.

I found Mary composed & cheerful, making a very handsome dress for her baby — & very anxious to send to Camden for more trimming — but I heard no anxiety to hear from Beaufort. So I did not feel any necessity for my sympathy. She has stopped calling *JC* "Cousin James" & says "Mr. Chesnut."

Stopped at the office — heard worse news. Our people telegraphing for more men & cavalry & artillery or they will be cut off from all. Nobody here has the sense to feel our awful situation.

[*November 9, 1861*]

I go to Camden after a sleepless night — to see our fate. Where is JC?

> Will no one tell me what she sings?
> Perhaps the plaintive numbers flow
> For old, unhappy, far off things,
> And battles long ago.
> Or is it some more humble lay,
> Familiar matter of today,
> Some natural sorrow, loss, or pain,
> That has been, & may be again.[8]

> Hie upon Hielands,
> And low upon Tay,
> Bonnie George Campbell
> Rade out on a day.
> Saddled & bridled
> And gallant rade he;
> Hame cam his gude horse
> But never cam he!
>
> Out cam his auld mither,
> Greeting fu' sair,
> And out cam his bonnie bride
> Rivin' her hair.

8. The third stanza of Wordsworth's "The Solitary Reaper" (1807).

Saddled & bridled
 And booted rade he,
Toom home cam the saddle,
 But never cam he!

My meadow lies green
 And my corn is unshorn;
My barn is too big,
 And my babies unborn.
Saddled & briddled
 And booted rade he;
Toom hame the saddle
 But never cam he![9]

I drove to Camden — read our defeat at Port Royal & Beaufort. DeSaussure's & Dunovant's regiments cut to pieces & 100 men killed.[1] Telegraphing for help.

Oh my heart ——

Gen. Robert Lee has come to help — he is not a *lucky* man. Wm. Kirkland telegraphs he is well — an aide to Ripley. I went to Aunt B's, did not get out. She said Mary bore up before me but was in a dreadful way. James Davis[2] is adjutant to DeSaussure. I saw Mr. Hanckel walking the poor old blind Bishop up & down before his door. Gen. Drayton wounded! One of his aides shot from his horse. Then ammunition gave out — *shame* some where.

Oh my country —— No word from JC.

Saw Sam Shannon, who two weeks ago threw up his commission! He goes down Monday. Pickens is to blame for all this.

Come the eleventh plague rather this should be;
 Come sink us rather in the Sea;
Come rather pestilence & reap us down;
 Come God's sword rather than our own.
Let rather Roman come again,
 or Saxon, Norman, or the Dane.
In all the Bonds we ever bore,
 We groaned, we sighed, we wept — we never *blushed* before.

Yankee invaders have succeeded in establishing themselves on our soil ——

9. A traditional Scots ballad appearing in varying forms in several collections. Omitted here is sonnet 61 of Michael Drayton's *Idea* (1619).
1. Col. William D. DeSaussure, commander of the Fifteenth S.C. Regiment, was the brother of Mrs. Alexander Hamilton Boykin and the nephew of John McPherson DeSaussure. Col. Richard M. G. Dunovant led the Twelfth S.C. Regiment in the unsuccessful defense of Port Royal that cost the Confederates 66 men.
2. James Moore Davis of Camden was a lieutenant in the C.S.A. under William DeSaussure.

Our indiscretion sometimes serves us well,
When our deep plots do pall; & that should teach us,
There's a divinity that shapes our ends
Rough hew them how we will.[3]

Oh God help us!

> In the hour of my distresse,
> When temptations me oppresse,
> And when I my sins confesse,
> Sweet Spirit comfort me!
>
> When I lie within my bed,
> Sick in heart & sick in head,
> And with doubts discomforted,
> Sweet Spirit, comfort me!
>
> When the house doth sigh & weep,
> And the world is drowned in sleep,
> Yet mine eyes the watch do keep,
> Sweet Spirit comfort me!
>
> When the passing bell doth toll,
> And the furies, in a shoal,
> Come to fright a parting soul,
> Sweet Spirit comfort me!
> Herrick[4]

To day I read a note from Beauregard to the newspapers I really think very *silly*. As the *Examiner* says, soldiers ought to beware of the pen.

> The friends we've tried
> are by our side,
> And the foe we hate before us!

[*November 10, 1861*]

A rainy Sunday morning. Oh my sad heart. The Yankees are in Columbia as prisoners — how soon will their friends at Beaufort release them.

Bluffton has got what it has been begging on for forty years — a fight at last. No news from JC. The papers last night included the story of defeat & retreat & disgrace. I woke to day heavy hearted — oh, that I

3. *Hamlet,* act 5, scene 2.
4. From Robert Herrick, "His Letanie, to the Holy Spirit," in *Noble Numbers; or His Pious Pieces* (1647). Two stanzas included by MBC are omitted here.

had gone with my husband. I do not think these people appreciate the danger.

————————

Pillow has had a victory — lost & won — was beaten & then reinforced — & beat the enemy.[5] What are our men about. I pity the Carolinians now in Virginia.

Hymn sung to day:

> Dread Jehovah, God of Nations,
> From thy temple in the skies,
> Hear thy people's supplications,
> Now for their deliverance rise.[6]

[*November 11, 1861*]

Yesterday dined at Judge Withers'. He spent the time he was with us telling that old story of the Davises taking five thousand dollars for the house in Montgomery. I heard that tale a thousand & one times in Montgomery & every time I have seen him since. I am beginning to fear he is a monomaniac.

Tom Davis preached a dull sermon at this exacting time. What eloquence might have stirred us. I spoke to poor Lou DeSaussure.[7] Davis, her husband, is William DeSaussure's adjutant. John DeS came to Judge Withers' like some one crazy — he is so frightened. They say at Kirkwood that the Negroes are in a state of exultation at our defeat.

Last night after we had gone to bed Rochelle Blair came here. I did not dress & go down as I ought — so do not understand his errand exactly. This much I know. An important dispatch had come from Pickens to JC which the operator would only give to him & he is in Charleston. Beaufort is shelled & two millions of property destroyed — troops hurrying to the scene of action. What next. Judge Wardlaw[8] in Camden joining Judge Withers in abusing Jeff Davis.

> The lovely maid whose form & face
> Nature has decked with every grace,
> But in whose heart no virtues glow,

5. Brig. Gen. Gideon Johnson Pillow's Confederate garrison at Belmont, Mo., aided by reinforcements under Maj. Gen. Leonidas Polk, forced the Federals under Grant to return upriver.
6. Three more stanzas, here omitted, of this hymn by Catharine Foster, first published in 1804, which appears in hymnals under the heading "In Time of Trouble — National."
7. Louisa (DeSaussure) Davis, the daughter of Camden's Major John McPherson DeSaussure and the wife of C.S.A. Lieut. James M. Davis.
8. David Lewis Wardlaw of Abbeville Dist., a circuit court judge who had been a member of the S.C. secession convention.

Whose heart ne'er felt another's woe.
Whose hands ne'er smoothed the bed of pain
Or eased the captive's galling chain;
But like the tulip caught the eye,
Born just to be admired & die;
When gone no one regrets its loss
Or scarce remembers that it was.

Blair said JC would be here by to day's cars — had been at Beaufort but returned to Charleston for more troops. Is it ammunition we want?

[*November 12, 1861*]

Yesterday I went to Camden; heard the telegraph to JC was a great *secret* — which had been told to a man who cannot keep a secret to save his life, Judge Withers, so I heard it. I will not even write it *yet*. Received a letter from Mary Stevens Garnett. The baby's name is James Mercer. She has apparently my horror of "Jim," so calls it Mercer. I went to the road for JC but met Minnie Frierson. Her news is bad — hanging negroes for fear of insurrection in Louisiana & Mississippi like black birds. East Tennessee with fifteen thousand against us — ready to resist — who have already torn up rail roads & burnt bridges.[9] Five hundred negroes on James Island refused to be moved out of the reach of the enemy & they sent for a troop of Cavalry to force them!

Pickens sent JC an order to raise a regiment *now*. When he asked for the permission the first of September, he was *refused*. Pickens said he had soldiers enough for the coast & advised JC to go into the Confederate Army! They were telegraphing him all day yesterday from Columbia & from Richmond — Pickens & Beauregard. The telegrams are sent to Charleston but we do not know where he is.

I go always to the road — as I must think by his not writing he expects to be here every day. Aunt Betsey & Mrs. Reynolds both are horror stricken by the evident exultation they perceive in their servants at the approach of the Yankees. Two people who have been so kind to their servants. Paid a visit to Mrs. Hanckel[1] — found her as charming as ever. Mentioned that Col. Chesnut had said he would lend his Sandy Hill house to any burnt out refugees. & I offered my furniture. I was too *officious* — for I had no right to speak of any thing but my *own*. However, Col. Chesnut behaved handsomely as he always does to me & said they should have it, 'tho' he was sorry we had been in such a hurry, for Mr. Hanckel applied for the house at once.

9. On Nov. 8, in the mountains of east Tenn., pro-Unionist citizens, unassisted by U.S. forces, began to burn railroad bridges and harass Confederate outposts.
1. Fanny Hanckel, the wife of the Rev. James Stewart Hanckel.

If my mind had been at ease might have had a pleasant day at Mary Boykin's. She has a very interesting family. Was a few minutes at Aunt B's. The Judge engrossed by "Tiny Tommy."

A man named Parker has returned from the fight at Port Royal — reports two Camden men killed — Somers, a Jew, & a man named Wilson. He says it was a most horribly botched affair. Gen. Drayton ordered DeSaussure's regiment to an Island to draw off attention from the troops he was trying to throw into the forts. DeSaussure, finding his men decimated, called out "Save yourselves," & the men are consequently scattered from Richmond to Montgomery. So says Parker.

Such unsoldierly conduct I do not believe — and as the official report is only fifteen missing — Parker cannot speak truth. The *Examiner* has an able defence of Jeff Davis in the Walker controversy.[2] After all said & done he was only transferred from a Louisiana to a Georgia Regiment. When I hear every body complaining of their Negroes I feel we are blessed. Ours are so well behaved & affectionate — a little lazy but that is no crime & we do no[t] require more of them.

Came home ill from anxiety. Had such a nervous head ache at Mary Boykin's she gave me some of the doctor's powders for nerves with morphine. She presented me with a few of the powders.

We have had great success in Western Virginia & in Memphis, Tennessee,[3] but our hearts are at home & heavy. I see they are fortifying Charleston on the land side.

Spiritless, stupid & weary today. I see no mention of where JC is in the papers yet. Minnie, Mrs. Reynolds, &c, sat an hour or so with me. Poor Minnie. She has suffered. Ammon told Mrs. Reynolds that at Beaufort our people were burning their cotton & *killing their* negroes to keep the Yankees from getting them! If they think *that* — alas for us.

[*November 13, 1861*]

Mr. Chesnut came yesterday evening. I met him at the depot. He left Charleston for Richmond. Beauregard telegraphed for him but the Governor's telegraph was handed him & he came home to organize a regiment *now*. His description of the state of Charleston gives me no hope. Millions of property destroyed. The women & children were [not] willing to leave home[4] but the men *all* went to the fleet. What idiots our men are — to wait & be caught in that way.

2. Richard Taylor of La., son of former President Zachary Taylor and brother of Davis' first wife, received a promotion to brigadier general and replaced William Henry Talbot Walker of Ga. as commander of a brigade on Oct. 21. Eight days later Walker resigned temporarily.
3. Probably a reference to skirmishes near Cotton Hill, W.Va., and Bristol, Tenn.
4. MBC in *Mary Chesnut's Civil War* (p. 236) makes it plain that she meant to say the slave women and children were *un*willing to leave home.

JC wrote a quantity of letters & [a] call for volunteers to be put in all the papers. I do not think he will get any men. They are all gone already. His father advises him to send to Toombs for his horse! or dun him for the money.

The Hanckels did not take the house & I am very glad. The Inglesbys & Mrs. Grant have written to H. Grant to secure them a house here. Miss Tompkins writes she cannot get me rooms in Richmond — all very well as we are not going. Since the rise in East Tennessee, Kate Williams is in as much danger as we are. John DeSaussure going about making an old granny of himself.

They have picked out the men to hang as soon as our men taken on the *Savannah* are hung. How delightful the consternation among us must be to the Yankees — & we have talked so & *bragged* so. Blair in all probability can not go with JC — he had written to Lucas — & also to Nelson.[5] Warren Nelson went *last* week to Richmond for a commission.

Thou art my redeemer, beat down & drive out the spirit of pride, & impart to me, in much mercy, the treasure of thy own unexampled humility, & wonderful condescension.

Thou art my Saviour. Take from me the rage of anger, & arm me, I beseech thee, with the shield of patience.

Thou art my creator, root out from me all that rancour & malice whereby my nature is corrupted; & implant in me all that sweetness & gentleness of temper, which may render me a man made in thine own Image, and after the likeness of thine own divine goodness.

St. Augustine

[*November 14, 1861*]

Men very slow in recruiting — the fighting material all gone already. JC is so unlucky & yet it is his duty to try & get who he can. Preston has telegraphed him to go to Charleston & meet Miles. No news from the Coast.

Read *King John* after I was weary working. Mattie Shannon came down with Hattie.[6] She is not very entertaining & stuff is too tiresome now. The papers said JC would not have Sumner now in the Senate to rouse him from his close & quiet attention to business. So today I re-read Sumner & JC.[7] I must confess JC was very bitter & Sumner de-

5. Probably Benjamin S. Lucas, captain of Camden's Lucas' Guards and Patrick Henry Nelson, a Sumter Dist. planter and a colonel in the S.C. militia.
6. Mattie's niece, Harriet Shannon, the daughter of William M. Shannon.
7. Sumner's long speech "The Barbarism of Slavery" was his first since returning to the U.S. Senate, four years after Preston Brooks' physical assault. Chesnut replied immediately, very briefly, but with uncharacteristic violence, that "We are not inclined again to send forth the recipient of punishment howling through the world, yelping fresh cries of slander and malice." Chesnut said he had "quietly listened," but added that the senator from Mass. was "the incarnation of malice, mendacity, and cowardice." *Congressional Globe*, 36th Congr., 1st sess., June 4, 1860, pp. 2590–2603.

served it. Read the bible [story] of Eli's sons — & the Ark taken by Philistines.[8]

[*One page torn out, presumably entry for November 15, 1861.*]

[*November 16, 1861*]

Fasted yesterday all day. Not one morsel I tasted all day & was too excited to feel miserable or hungry. A ship has got into Savannah with *arms* in plenty for five brigades. God be thanked.

Went to Aunt Betsey's — had sent there for my books in bags. Saw she was *offended*. Never mean to lend furniture again. Whenever you take it away gives offense.

Drayton abused for the Forts being put where they were said to be for his own advantage — & for putting DeSaussure's regiment w[h]ere they were. Called at the Brevards' to see Sally Elmore. Alfred B[9] came home.

[*November 17, 1861*]

Stayed at home. Ought to have gone to church. Read Bishop Hall.

Anthem

Lord, what am I? A worm — dust — vapour — nothing:
What is my life? A dream, a daily dying:
What is my flesh? My soul's uneasy clothing:
What is my time? A minute ever flying.
My time, my flesh — my life, & I
What are we Lord but vanity?[1]

JC says he will accept Gov. Means' offer — & leave Manning Brown to raise the regiments & go to Virginia. I hope he may so arrange & take me to Virginia.

———————

Thus do I come to thee! "My light & my salvation," imploring the blessings of which I stand in need, & declaring the miseries of which I am afraid.

But in the midst of this address I feel a check from within; my conscience stings, & my heart misgives me; love bids me hope but sense of Sin bids me fear: & dread of thy displeasure damps the zeal with which my heart approaches thee; when I reflect on my own doings I can't but despond — but when I look up to thy goodness I am full of hope.

St. Augustine

8. Samuel I, i–iv, recounts how the sins of Eli's sons were punished by their own deaths, the defeat of Israel, and the capture of God's ark by the Philistines.
9. Lt. Alfred Brevard, Jr., the son of a Camden physician and cousin of JC.
1. Stanza from "Anthem I" in Joseph Hall, "Anthems for the Cathedral Exeter," *The Shaking of the Olive Tree* (1660). Eighteen lines following these are omitted.

[*November 18, 1861*]

Stayed at home. At seven in the morning was in the Library. Have it in nice order — how pleasant all this would be but for the Yankees. Afterwards cut 18 soldier's shirts.

Mary Brevard[2] & Sally Elmore came. The former said while at their grand review at Manassas, one of the soldiers, while Jeff Davis was speaking, screamed, "Hoorah for Beauregard." Jeff Davis clapped his hat on & rode off. It was done because it was reported that Jeff Davis was jealous of Beauregard. I did not believe it. Afterwards opened & arranged 25 bags of books. It was dreadful hard work — but I was in fine spirits until dinner — when JC received three letters, one from Frank Hampton[3] offering men, one from Kate Williams — who seems delightfully situated at Flat Rock, & one from John Preston who says Charleston could be taken in six hours — & that terror reigns there. Lee unhappy. Not hopeful — every thing wrong — every body *miserable*. I did not rouse after *that* — & here it is exactly as it was at Port Royal. We will be caught napping. They will take our cotton & our Negroes. They say John DeSaussure says he will take protection under the Federal flag — he may be taken up yet as a traitor.

I copied JC's letter last night in a book. I mean to Jeff Davis. I wrote sixteen pages.

How I wish they had the Negroes — we the cotton. They may have all the credit of their philanthropy if we had peace & this black incubus removed.

[*November 19, 1861*]

At home again & at work — knitting, &c. The report is that Mason & Slidell are in Fortress Monroe — taken from under the British flag.[4] Oh that we could hear a growl from the British Lion. We have McClellan's report of the Crimean war — & 88 of Mordecai's & one other Military book among the bags[5] — the Military committee's visit to West Point. Humphrey Marshall has whipped the federals in Kentucky, 3 hundred to 15 hundred.[6] A. H. B. & family have gone to Columbia.

2. Probably the daughter of Camden physician Alfred Brevard and the sister of Sally Elmore.
3. A Richland Dist. planter who was the husband of Sally (Baxter) Hampton and a dear friend of MBC.
4. Taken from the British ship *Trent* by the U.S.S. *San Jacinto* near Cuba on Nov. 8, Mason and Slidell arrived at Fortress Monroe, Va., on Nov. 15. Many Northerners and Southerners believed the incident would bring British recognition of the Confederacy and perhaps war between England and the Union.
5. George B. McClellan gathered his report while serving on a board of officers to study European military systems. Alfred Mordecai published numerous military accounts while a member of the U.S. ordnance department.
6. Troops in the command of this brigadier general from Ky. had been in skirmishes at Ivy Mountain and Piketon on Nov. 8 and 9.

I do not understand JC's plans. I wonder if he does himself. He has written to Gov. Means joining his brigade — to Frank Hampton to join him with cavalry — & to John Preston at Charleston.

> When Orpheus went down to the regions below,
> Which men are forbidden to see,
> He turned up his Lyre as old histories show,
> To set his Eurydice free.
>
> All Hell was astonished, a person so wise
> Should rashly endanger his life,
> And venture so far — but how vast their surprise,
> When they found that he came for his wife!
>
> To find out a punishment due for his fault
> Old Pluto long puzzled his brain;
> But Hell had no torments sufficient he thought,
> So he gave him his wife back again!
>
> But pity succeeding soon vanquished his heart,
> And pleased with his playing so well,
> He took her again in reward of his Art:
> Such power had music in Hell.
> from Sir Thomas Browne's works[7]

I see JC writes to these men he will go to Richmond on Monday or Saturday. That means Monday. John Preston says, "Yankees permitting." I am "puzzling my brain" if I shall go!

[*November 20, 1861*]

Drove to Camden. Went to Aunt B's — fireworks & not a pleasant visit. John DeS attacked Cureton[8] for saying he meant to take protection under Lincoln's flag & Cureton merely answered, "I said so because I heard you say so." Two brave old grannies. I suppose Coosawhatchie is safe as I hear Pickens is there.

Mr. Kirkland is obstructing the rivers — but thinks it too late. It makes my cheek mantle with shame when I hear & see the comments of the Northern press. I do hope England will resent the indignity to her flag in taking off Mason & Slidell.

The *Mercury* thinks it is not cause for War. The Richmond papers do. The most important idea is what does England think. Poor Confeder-

7. The passage is not by this seventeenth-century English physician and author but is a poem by eighteenth-century Anglican bishop Samuel Lisle that was inserted as a footnote in several editions of Browne's *Pseudodoxica Epidemica; or, Enquiries into . . . Common Errors* (1846).
8. Probably James Belton Cureton, a Kershaw Dist. planter who was the father of Everard B. Cureton.

ate States — if that booby Mallory had only given us a Navy — had he even taken old *Morrow's* offer of the Iron Steamers for the coast.

Bought more shirts for the soldiers — & answered letters. Massy of Lancaster offers a company & Baskins. JC has now 6 — but his heart is in Richmond. He is going to offer his land to the low country men. The *Herald* calls Beaufort the Land of "Rhetts, Keitts, Orrs & Chesnuts." Par nobile fratrum.

Read yesterday *Eoline* by Mrs. Lee Hunt. Sad stuff — but a relief from the pressure on my brain.

The Enemy acknowledge Kentucky is with us. Say it will take 200,000 men to keep it for them. All the young men are for us. So a General Thomas[9] reports to Cameron & Lincoln, & the northern papers abuse them for publishing such a melancholy tale for themselves.

[*One page torn out.*]

I see my old school mate Lafayette Seabrook, now Mrs. Hopkinson,[1] has burnt her cotton, gins & all. We will make a Moscow of it. I have written to Kate Williams & Susan Rutledge. I find I had to rewrite the former. I am growing crazy with thinking of this never to be forgotten or forgiven Port Royal.

JC had a letter from a Captain McIlwain — offering another troop of Cavalry.

[*November 23, 1861*]

After dinner Mrs. Henry DeSaussure called & asked for me. She tried to frighten her child by telling him I was the lady who laughed at him in church. She seemed DeSaussure mad — "Uncle William" Chancellor, Dr. Henry, Dan,[2] John McPherson, who is undergrown & not in good health — who she wishes she had given the rifle to instead of John Chesnut who insulted her by sending her a message as "Henry DeSaussure's wife." She had a name she hoped. Told her child to ask Grandpa DeSaussure for a *horse* & not Grandpa Chesnut; his were for Willie Frierson. William DeSaussure, the Col., was a *lion.* Such undaunted bravery never seen.

Then Captain McIlwain to see if his Cavalry could be accepted. Then Captain A. H. Boykin in regimentals. Told Manassas stories — hundreds

9. Brig. Gen. Lorenzo Thomas, adjutant general of the U.S. Army.
1. Caroline Lafayette (Seabrook) Hopkinson, wife of wealthy Colleton Dist. planter James Hopkinson.
2. "Uncle William Chancellor" was Henry William DeSaussure, former chancellor of the S.C. supreme court. Dr. Henry DeSaussure and Daniel Louis DeSaussure were his sons.

of Yankees huddled in wells & found afterwards. Jackson's[3] mother taken (over 80 years old) & made to walk to Washington. The brother of Jackson in his troop & said, "Captain, excuse me. I must go. I have another account to settle with those devils," & he went off with his rifle. Tom Warren[4] advertising his men as *deserters* — & the *Confederate* praises JC & [is] saying he ought to have a Regiment. Letter from Dr. William Reynolds[5] asking to be Surgeon to JC's regiment.

Had a nightmare in the night from eating macaroons & all this horrid war talk & waked JC screaming.

I tried to entertain Captain McIlwain but JC compared my bluster to Barnwell Rhett's so rudely — I concluded if the inanity below, without me, suited better, I would not go down to day. I feel we are in a tight place. They seem to have no end of men. Ours seem *exhausted*. No new supply — to fill the places of the old ones. What will England do. JC says accept an *apology* from the Yankees, let them keep Slidell & Mason — & try & get cotton from India & Egypt. Captain B says England has never been governed by a noise from below. The[y] will not care if five million manufacturers starve.

What next! I feel more hopeful of Charleston. I shall order the *Confederate* sent to Mother. Captain McIlwain says my father's country, old Waxhaws, has scarcely three men in it — but some part of Lancaster behaving very badly ——

Ellen Reynolds[6] & Fanny Hay were here.

Read Dickens' *Pictures from Italy*.[7] Trapiers called with a Miss Johnson — who was thought a perfect beauty by Mrs. Chesnut. I did not think so. Said she had good eyes & talk. Col. Chesnut asked if she had "a pug nose" — a sneer at me.

[*November 24, 1861*]

Sunday. Mrs. Trapier says they ran away from the Yankees so *precipitately,* they left even their silver.

Hymn at Church:

> When through the torn sail the wild tempest is steaming,
> When o'er the dark wave the red lightening is gleaming,

3. James W. Jackson.
4. Editor of the Camden *Journal*, who organized the Kershaw Guards of the Fifteenth S.C. Regiment.
5. The brother of Dr. George and Dr. Mark Reynolds of Camden.
6. The daughter of George and Mary Cox (Chesnut) Reynolds.
7. Published in 1846.

No hope lends a ray the poor Seaman to cherish,
We fly to our maker: Save Lord or we perish.[8]

[*November 25, 1861*]

Monday. JC went off to Columbia to day. I drove up alone — & went to the depôt. Said good bye there. I could not trust my nerves or *temper* in the carriage with other people. There is so much *frivole frival.* When one is miserable & in earnest — this deep & abiding interest *only in trifles* is maddening. JC had a letter from John Preston — a queer one. Says he expected to be Senator — but will not be. Others are spoken of. Says JC ought to be a Brigadier. I hope he may be made Senator. Says he is there to muster in troops — *not one* yet offered. "The deep mouthed vengeance, the oath, the cry, the rush to arms when the sacred soil of Carolina is invaded ain't there."

[*November 26, 1861*]

Ill. Stayed at home — arranged boxes of old letters & destroyed quantities. What a stirring up of ghosts those old letters are. I read letters from people who called themselves my dearest friends whose existence I had forgotten. I read my old letters — twenty & fifteen years old — & find I must have been quite an interesting creature. Read *Two Years Ago,* Kingsley. Tom Thurnall[9] is deeply stirring — but *frank!* Cordifiamma. These beastly negroes — if Kingsley had ever lived among them! How different is the truth. I know one wretched Mulatto woman who is a kept mistress — & her son a negro boy — with a black father — beats her white lover for giving her brandy to drink — & white people say well done! to the boy! I wonder if there are more impure women, Negroes & all, North or South. [*Following sentence added later:*] Martha Adamson, a Slave, is the woman.

Harriet Grant came home & told me poor Tom Boykin is dead. I must go to the funeral. Says they met Aunt Betsey coming from there.

[*November 27, 1861*]

Went to the funeral with Col. Chesnut — very sudden death. Aunt S. B. was there in terrible grief. Rode as far as the grave yard with Aunt B. Stood before my grandmother & grandfather's tombs — a miserable place it is. They say another victory for us at Cumberland Gap. H. Grant had 2 Trapiers, Miss Johnson & the two Davises to dine & stay all night.

8. Stanza from a hymn by Reginald Heber appearing in *Hymns Written and Adapted to the Weekly Service of the Year* (1827). Two more stanzas are omitted.
9. Published in 1857. Tom Thurnall is a character in the novel.

I dined in my own room & cut out six shirts. Mrs. Reynolds came to sit with me.

Heard from JC — he is still sanguine as to his being Senator. So mote it be. Says that irrepressible idiot Pickens will not take his mounted men, that he has too many of that sort already. The low country gentlemen miserable but *Pickens* in fine spirits. Says Lee says they can't & shan't have Charleston.

Mr. R. Barnwell remains on his place; he will be taken. Mr. Cuthbert & Rev. Mr. Elliott[1] taken already. Mrs. Preston writes did I "ever believe Carolinians would run leaving swords & flags," & a most kindly invitation to visit her. Susan Rutledge writes that Lee wants the forts manned by *naval* men — but the Rhetts have different ideas.

[*November 28, 1861*]

Today I go to Camden if I can. I begin to find my little maid a little *troublesome.*

Went to Camden & to see Mr. Kirkland at Judge Withers' — he gives such an account of the low country, makes me ill. Says only 5,000 troops there — & no one going. Abuses Lee & Drayton. The Judge & Aunt B abuse every body. I saw the Judge & Mr. Kirkland look at each other & laugh when I told something Mr. Chesnut said. Mr. Hay[2] called. The Judge rattled on so madly Mr. Hay was bewildered. The subject being abuse of Jack Cunningham. But when he began abusing Mr. Barnwell, I openly *defied* him there & I saw Mr. Hay joined me. My visits there are very bitter now. I feel they have no further use for me & I am thrown aside like an old worn out shoe — *one* that has been very serviceable to them, however, in past days.

Came home disheartened & miserable. Found Sally Elmore & Mary Brevard — was so ill I had to take morphine to go down. I know I talked sad nonsense all the evening. I felt mad with suspense & anxiety & morphine! Aunt Sally H has a boy & Uncle H came over on Wednesday.

The newspapers make no mention of Senator's election but I hear of so many of JC's friends either not going or making excuses & leaving.

[*November 29, 1861*]

Ill in bed all day. Letter from a Mr. Muldrow[3] — raising a company. Sent it to Manning Brown. Mattie Shannon here & Miss Wynn but I did not see her.

1. George Barnwell Cuthbert, a St. Helena's Parish planter and a first cousin of Joseph and Edward Barnwell Heyward; Stephen Elliott, Sr., Episcopal bishop of Ga. and a founder of the University of the South at Sewanee, Tenn.
2. Samuel Hutson Hay, pastor of the Presbyterian church in Camden.
3. Probably William James Wilson Muldrow, a Sumter Dist. planter.

The Reynoldses here. They saw Carrie McIver married. She went to Charleston with her husband for three days — & is now at home a mourning bride. The Williamses doing mountains of work. The traitor Smith still there.

[*November 30, 1861*]

Up & cutting out shirts — tho ill.

> Westward the course of Empire takes its way;
> The four first acts already past,
> A fifth shall close the drama with the day:
> Time's noblest offspring is the last.[4]

H. Grant came into my room & made me a bonnet. Nothing in the newspaper. Not one word of mention of the Legislature or the Senatorship. I cannot help thinking all logrolling & chicanery will tell against JC — but I must not repine or be an ill foreboder.

John Manning has gone back into the Senate & *Tobin* changed the name of his company to Hammond *Huzzars*.

[*December 1, 1861*]

Last night slept like a top so am not so miserably ill today.

Went to church & made this resolution which only with God's help I can keep — not to be so bitter — not to abuse people & not to hate them so. At dinner I found myself afoul of Tom Davis & stopped instantly —— Knelt at the communion with Mrs. Kershaw. I do not know who wept most, she or *I*. I have been so reckless a sinner — & God's mercy has been so manifest. I made of Mary Withers my God — & like poor old *Wolsey*, I have had my reward.[5] I must now look beyond this world for reward. I find it hard to believe in the possibility of human friendship.

A Mr. Muldrow offers a company.

Molly comes; as I expected, Mr. Team takes a pound of my butter & does not *pay*. The chicken business goes on finely. If I can only raise eggs & chickens & butter — a great falling off for a *cotton* planter. Says the negroes say nobody shall touch my poultry. *"Missis' things"* nobody shall meddle with. Mr. Team Senior said, "Molly, if any body takes one of your Missis' chickens, rush out & seize the best chicken you can find & put in its place." Queer ideas of justice these *tyrants* have.

Mrs. Henry DeSaussure is, I find, too a member of the church. Mrs. Lee offered me her carriage before the service began — but when she heard I could not pay until after the *war* — she did not seem so anxious.

4. George Berkeley, "On the Prospect of Planting Art and Learning in America," stanza 6 (1752).
5. A play on words in *Henry VIII*, act 3, scene 2.

Mr. John Raven Matthewes[6] has burnt his cotton & negro houses. The idea is spreading. Aunt B told Col. Chesnut in church that Tom Kirkland had been ill — but as I have already made my arrangements, I will go to the Sandhills. Dine with Mary Brevard on Tuesday.

> No sooner is Israel's thirst slaked, than God hath an Amalekite ready to assult them.
> The Almighty hath choice of rods to whip us & will not be content with one trial. They must needs be quarrelling with Moses without a cause, & now God sends the Amalekites to quarrel with them. It is just with God, that they which would be contending with their best friends, should have work enough contending with their Enemies.
>
> Bishop Hall

How well it becomes the just to be thankful! Even very nature teacheth us men to abhor ingratitude in small favours. How much less can that fountain of goodness abide to be laded at with unthankful hands? Of God we cannot but confess our deliverances! Where are our altars? Where are our sacrifices? Where is our Jehovah Missi? I do not more wonder at thy power in preserving us, than at thy mercy, which is not weary of casting away favours on the ungrateful.

M. B. Chesnut from Bishop Hall.[7]

[*December 2, 1861*]

Got up & assorted letters. Miserable work — most affectionate ones from Cally Perkins & Mary Kirkland who now barely know me — & some of Mary Witherspoon's, cold & formal & fantastic — frantic with an attempt at fine writing even in her religious ravings. Some of my father's letters.

Then got ready to go to the Hermitage & to Aunt Sally Hamilton's but met Louisa Salmond at the gate & went with her to spend the day at Aunt Mary Lem's.[8] I *fell* from my high position taken on my knees on Sunday — abused by insinuation Mrs. McCaa & Tom Davis. She talked very pleasantly — had her mother's old maid Renny in the carriage. Said ever since Tom Salmond[9] left them, Renny had left her comfortable bed & slept on the floor in their room to protect her & the children. Said little Margaret called her "Beauregard."

Aunt Mary Lem said she never saw a coffin go out of her house but

6. Owner of a large plantation in Colleton Dist.
7. Two quotations and a paraphrase from Joseph Hall, "The Foil of Amalek; or the Hand of Moses Lift Up," *Contemplations upon the Principal Passages in the Holy Story* (1612–15).
8. Mary (Hopkins) Boykin, the widow of MBC's uncle Lemuel, was a planter with holdings in Kershaw Dist. Her eldest son, Lemuel, Jr., had just died.
9. Thomas Whitaker Salmond, a second cousin of JC and the brother of Louisa Salmond, was a surgeon with the rank of captain in Kershaw's regiment.

she wished she was in it. If I do *not,* it is because I dread to give an account of the deeds done in the flesh. I have been an unprofitable servant. Sam Boykin was at home. She wanted Frank to take his place. Burwell is getting up a company.

I did not feel very much like fighting for slavery since hearing her talk of what Frank[1] was going to do & Burwell.

[December 3, 1861]

Dined at the Brevards — had a pleasant day. Alfred B quite a soldierly looking person — & very entirely rid of his nervous shyness. Sally Elmore there. I talked too much. Their ready laugh encouraged me to try & amuse them. Before going there I had been at Aunt Betsey's; found Tom Kirkland had been ill. I try & bear all the disagreeable things they say to me. Some of the Judge's insinuations are very hard to stand. I hope some of the answers I feel so disposed to make will be set down to my good account. He abuses every body & suspects every body of such despicable motives.

When he was accusing every body of such selfishness, &c, I wondered if true patriotism (for he said he was the only true patriot) consisted in such times as these in setting down on one's one comfortable rug & a comfortable dressing gown, eating *well* & sleeping softly was the only patriotism — & railing against all men & all things.

Had a letter from JC. Said he missed *my companionship* but otherwise it was well I stayed at home. Davis & Benjamin *civil.* No mention of the Beauregard correspondence but intense bitterness between President & General.[2]

[Four pages torn out. During the time covered by the missing pages, December 4–5, 1861, MBC received news of JC's defeat for election to the first Confederate Congress.]

[December 6, 1861]

I am up again after my heavy fall.[3] Shaken myself. No bones broken, no dislocation — but sore & stunned yet — *inward* bruises. I remember Miss Catharine Eccles[4] said we got what we wanted most earnestly in

1. MBC's cousins, Sam and Frank Boykin, served, respectively, in the Second and Seventh S.C. Cavalry.
2. The end of a passage from Bishop Hall's *Contemplations,* Book VI, "Nadab and Abihu," is omitted here. The beginning of the passage was destroyed by MBC when she tore out four pages.
3. The news of JC's defeat for election to the first Confederate Congress.
4. The daughter of Jonathan Eccles, a Camden merchant.

this world (when we got it at all) accompanied by things or in a way to make our long desired boon no pleasure after all. She had always thought to go to *New York*. What ecstasy — she who had never been out of Camden. Well, she went to New York, but with Mr. West[5] ill & dying. The most melancholy days of her life were spent in the long coveted trip to New York after years looking for it — & wishing for it. When JC was made Senator — I was so engrossed by Mary Withers, her recent engagement, her future, &c, &c, I scarcely cared for it — only thought it a bore as taking me from her. I had wished for it principally to take her to Washington.

Now let us look this thing in the *face*. This is an end of JC's political life. I do not wish him to serve South Carolina again if he could — but he must do what he can for his home & his friends. After this, if we are not destroyed from the face of the earth, heroes of the War will have every thing.

Last night I read a wonderful letter from Mrs. Greenhow. Very indelicately she shows how her delicacy was shocked by soldiers with open doors watching her for 7 days. Never out of their sight. Says she had a great deal worse done her than snatching the letter from the bosom of Marie Antoinette! & some horrid thing was done to the modesty of a coloured girl — exactly what, she has not heard yet, but evidently has her suspicions.

Sally Reynolds[6] was here — her manner to me is most repulsive. I thought she took up so for the *DeSaussures* — I do not believe John DeSaussure voted for Mr. Chesnut.

Psalm

Oh Lord, my God, I cried unto thee & thou hast healed me.

In my prosperity I said I shall never be removed; thou Lord of thy goodness, hast made my hill so strong.

Thou didst turn thy face from me & I was troubled.

Then cried I unto thee, O Lord, & got me to my Lord right humbly.

Be thou my strong rock & house of defence that thou mayst save me.

Be thou my Guide & lead me for thy name's sake.

Into thy hands I commend my Spirit; for thou hast redeemed me, O Lord thou God of truth.

I became a reproof among my enemies, but especially among my neighbours: & they of mine acquaintance were afraid of me. & they that did see me without, conveyed themselves from me.

I am clean forgotten as a dead man out of mind. I am become like a broken vessel.

5. Former Camden mayor John Charles West, Catharine Eccles' brother-in-law, had died in 1855.
6. Sarah Reynolds, the daughter of George and Mary (Chesnut) Reynolds.

Be strong & he shall stablish your heart, all ye that put your trust in
the Lord.[7]

Bishop Hall:

Self love makes men unreasonable, & teaches them to turn the glass
to see themselves bigger, others less than they are.

It is a hard thing for a man willingly & gladly to see his equals lifted
over his head in worth & opinion. Nothing will more try a man's grace
than questions of emulation. That man hath true light, which can be
content to be a candle before the sun of others —— [8]

[*Following sentence added later:*] This shows if we are fighting for Slavery.

Mr. Team came to day to see about that Jenkins business. He turned
scarlet whenever I caught his eye — & at one time there was so much
in his eye of softness & compassion for me I looked away & talked so
gayly — he soon forgot. He is for arming & freeing the Negroes to meet
the Yankees.

The way not to repine at those above us is to look at those below us.

[*Following sentence added later:*] (Who ever thinks any body above them.)

There is no better remedy for ambition, than to cast up our former
receipts, & compare them with our deservings, and to confer our own
Estate with inferiors: so shall we find cause to be thankful that we are
above any, rather than of envy that any is above us. Bishop Hall[9]

[*December 8, 1861*]

Sunday.

Man can not make, but may ennoble, fate,
By nobly bearing it. So let us trust
Not to ourselves but God, & calmly wait
Love's orient, out of darkness & out of dust.

.

It is hard to know
That such things have been & are not, & yet
Life loiters, keeps a pulse at even measure,
And goes upon its business & its pleasure,
And knows not all the depths of its regret.

Owen Meredith[1]

7. Selected verses mainly from Psalms 30 and 31.
8. From Bishop Hall's *Contemplations,* Book VI, "Of Aaron and Miriam."
9. From Book VI of Bishop Hall's *Contemplations.* Two additional passages on human nature and its failings are omitted here.
1. Lines from part 1 of the "Prologue" of *The Wanderer* (1859), written under the pseudonym Owen Meredith by Edward Robert Bulwer-Lytton, English diplomat and poet.

7th.[2] I have been busy all day reading old letters. What a meek, humble little thing I was — how badly JC has played his cards to let me develop into the self sufficient thing I am now. For I think this last bitter drop was for *me*. He will care very little — but I had grown insufferable with my arrogance. Some times I feel it a righteous retribution for the rage I got into a year ago about JC's writing those letters for his nephew.

Team thinks the war may leave us a great & independent nation but *slavery* is over. I have thought so six months (& *hoped* it). He told several overseer's anecdotes, *which* made [*illegible word*] not *sigh* to believe it, of one of Powell McRae's Negroes, driven to despair by the driver, tying her baby on her back & walking into the river. Found drowned — baby still strapped to her back — & said Team, "The man who caused it was not hung!" Ho for honest poverty!

Welcome man's old helpmate, *Toil!*
How may this heart's hurt be healed?
Crush the olive into oil;
Turn the plough share; sow the field.
All are tillers of the soil,
Each some harvest hopes to yield.

Shall I perish with the whole
 of the coming years in view
Unattempted? To the Soul
Every hour brings something new.
Still suns rise; still ages roll.
Still some deed is left to do.

 Bulwer fils

Honor to him who, self complete & brave,
In scorn can carve his pathway to the grave —
& all unheeding what men do or say
Make his own heart his home upon the way.

 Bulwer père

Read Émile Souvestre's *Au bord du lac*.[3] Trying to show human progress.

L'esclave is an Armenian captive & his mother made captive & slaves in Rome. The only terrible punishment the boy meets is being once in stocks — & having his hard won earnings, hoarded to buy his mother, taken to pay his master's debt. The stocks are possible still to free men — & no slave's money is taken to pay his master's debts. His mother rushes away for an hour or so from her mistress, a beauty — consequently cold

2. Apparently MBC wrote the entry for Saturday, Dec. 7, on Sunday, Dec. 8, after having begun the Sunday entry.

3. "L'Esclave," "Le Serf," and "Le Chevrier de Lorraine" appear in *Au bord du lac* (1852).

hearted & cruel. When not sufficiently admired she makes her slaves puff out their cheeks that she may have the greatest luxurious enjoyment of slapping them. For this short absence the mother is condemned to be branded on the forehead & dies of the punishment. The son joins Spartacus — & is given to the beasts in the amphitheatre after being made a Christian.

I have read in the *Journal,* Camden paper, Sumter man advertising a slave *so white* — as to be mistaken for a citizen, but on lifting his hat the *brand* might be seen. JC went to the editor, Tom Warren, & told him such an advertisement disgraced humanity & he would not touch the money if he were a decent editor paid him for it by such a brute. So it was taken out. Christ died for us. In his blood I hope to be cleansed *only* — sinful I am — *but* such brutes give me agony — for my country.

The next story is "The Serf." The boy runs away from his father & betrothed — because he forgets himself & strikes the agent of his master. The most picturesque scene is where they have procured a fowl, &c, &c, for his ill father and as they go to seat themselves at the table, a party of soldiers rush in & eat every thing. The old man is so hungry he picks up the bones the soldiers throw away. The Serf gets into trouble because he knows more Latin than the agent. They are going to hang him because his master is in a bad humour & he is told that the Serf hunts his deer. He is saved by a monk who frightens the agent & gets the serf sent to work in some city. The merchant is such a cheat the serf runs away from him & goes to a monastery, finds one of his fellow serfs free & happy, but will not be persuaded to stay there because he *must* see his beloved & marry her. Stays long enough in a free city & is free by the law. Goes home to buy his father & Catherine, finds he has money enough for only one — takes his old father. A war breaks out & he goes to find his Catherine dead at the door of her burnt hut. Then goes broken hearted to the Monastery. Next "The Chevrier of Lorraine" — "The Goatherd of Lorraine" — a beautiful story of Joan of Arc — & the sins & wrongs of that rude age. Then "The Apprentice," who teaches himself every thing — detects all crimes against his master — invents machines to prevent the ruin of his master & *of course* ends by marrying his master's daughter & being partner. The other apprentice, like Hogarth's two, is bad — steals, gets off & gets killed finally for robbing a coach ——

Read another letter from Russell. Says the Yankees expect to get cotton here, for *money* is *omnipotent* they think — but he says he knows the fervid beating of this strong Southern heart too well to believe we will not destroy every thing before the Yankees. Alas this was before Port Royal. The *Examiner* says he does not fear trouble on the Mississippi.

The western men are as brave as the Carolinians & far more practical. They will not give up because two small forts are taken with a hundred artillerists in each — & will not fare so badly as to upset their guns. Altogether a very *taunting* article.

Russell says that the confederates are a soldierly people there can be *no* further doubt — & says if our money was only as palpable as our courage, there could be no doubt as to the end of the conflict.

"All things are less dreadful than they seem."

> Do ye think of the hopes that are gone, Jeanie,
> As ye sit by your fire at night?
> Do you gather them up as they faded fast
> Like buds with an early blight?
> I think of the hopes that are gone Robin,
> And I mourn not their stay was fleet;
> For they fell as the leaves of the red rose fall,
> And were even in falling sweet.
>
> Do ye think of the friends that are gone, Jeanie,
> As ye sit by your fire at night?
> Do ye wish they were round you again once more
> By the hearth that they made so bright?
> I think of the friends that are gone Robin,
> They are dear to my heart as then;
> But the best and the dearest among them all
> I have never wished back again!

Received a letter from JC — saying he had been ill in Richmond. I felt then all the sinfulness of my discontent at the *little* trouble I was in before. The greater gulf of misery so completely swallowed up the smaller. I left the letter for Mrs. Chesnut to read & she did not see it, she was so engrossed with Kate's & Lina's — both of which she opened by mistake — but read *Lina's,* knowing it was not for her.

8th December. Yesterday I did not go down after JC's letter. I was too intensely miserable. He has been ill ever since his arrival in Richmond — nursed by the Hugers. He said he was walking about in his room. [Was to have] changed his lodgings next day & [would] come home as soon as he could travel which he hoped would be in a week. He said Miles came in his room & read the Senatorial election with *great disgust.* Miles is the only friend he has in the So. Ca. delegation. JC says it was unexpected but he accounts for it by the act having been performed by the same legislature which gave [us] our present Gubernatorial Incubus. He says it is moonshine to him; he is afraid it will annoy *me.* That it gives him his freedom once more — to attend to matters much more important.

I would send Laurence on at once if I knew exactly when he would come home. What he says of his motions I do not care for, as he is always decided by accidents & does not object to changing his mind twenty times in an hour.

The letter from Lina was very satisfactory. To day I opened my prayer book — for the prayer for the day, 8th of Dec.

St. Augustine:

> Oh my director & governor, turn away from me, I beseech thee, vanity & filthiness of mind, a wandering heart, a scurrilous tongue, a proud look & a love of mine own appetite: preserve me from the venom of slander & detraction, from the itch of curiosity, from the thirst of covetousness, ambition & vain glory; from the deceits of hypocrisy, the secret poison of flattery; from the contempt of the poor, and oppression of the helpless; from the canker of envy, the fever of avarice & the pestilential disease of blasphemy & prophaneness.
>
> Prune away my superfluity of naughtiness & purge me from all manner of injustice, rashness, & obstinacy, from impatience, blindness of heart & cruelty of disposition.

Had a letter from Kate. She is comfortable & happy in her neighbours but miserable that David goes to Florida.

I sat all day yesterday with Mrs. Chesnut, she entertaining me with old world, carriage & four stories of her grandeur in Philadelphia.

Then she likes to harangue me as to my troubles. Heaven only knows I try & be patient — but these sentimental talks are too much for me. To day when my husband's illness was the theme I absolutely pulled away.

Found last night an old dedication of myself to my savior & Lord — unsigned, dated 1848. Sign it to day, praying God's help to keep it.

May the Gracious God have mercy upon my husband.

Finished this book — December 8th, 1861.

[*No part of the diary Mary Chesnut kept during the years 1862, 1863, and 1864 has survived. The missing parts from those years fall between the above entry of December 1861, which concludes a volume, and a volume that begins in the midst of an entry written late in January 1865. When, in the 1880s, she was writing her expanded version published as* Mary Chesnut's Civil War, *Chesnut had before her at least five and probably more of the missing volumes covering this gap in the 1860s. For the period from August 1862 to October 1863 it is likely that she either kept no regular diary or had destroyed it. In her words she* "tried to fill up the gap from memory" *in memoir form. For the rest, what we know of her life in these years is derived largely from her later version based on the lost diaries. The period falls into five parts.*

January 1862–November 1862. Columbia, S. C.: After the Christmas holidays in Camden Mary Chesnut moved to Columbia, where her husband served on the Executive Council of Five, a much criticized committee that virtually ran the state government. Mary delighted in the society of many old friends, especially the Prestons and their beautiful daughters, "Buck" *and Mary. She helped Louisa McCord establish a hospital and was active in collecting supplies and money for the sick and wounded in Richmond and Columbia. Invitations poured in, but for long periods she was sick or convalescent herself. During a visit with her sister Kate at Flat Rock, N. C., in August and September to escape the heat and recover her health, she urged James to resign his thankless political post in Columbia and* "try Jeff Davis awhile" *in Richmond.*

December 1862–June 1863. Richmond: Davis came through in December with a colonel's commission and ordered James to Richmond as his personal aide. The Chesnuts rented part of a house near the Davises at the Confederate White House. Ties between the families were close and constant. With the lovely Preston girls as house guests, Mary ran a lively salon at the center of political, military, and social life of wartime Richmond. These were the happiest months of the war for her.

June 1863–November 1863. Visits in Flat Rock, N. C., Camden and Columbia, S. C., a trip to Alabama to see her mother and her brother's and sister's

families, and a brief residence in Camden: Much travel in this period was occasioned by illness and death among relatives. Mary was joined by James and her beloved nephew Johnny for a brief respite at Camden before returning to the Confederate capital.

November 1863–April 1864. Richmond: Mary quickly revived her spirits in the hectic social and political life of the city, taking special interest in the romance between "Buck" Preston and wounded General John B. Hood. But the grimmer side of the war, the declining fortunes of the Confederacy and the death of his mother depressed her husband. He shunned the gaieties that charmed his wife and yearned to go back to South Carolina.

May 1864–January 1865. Camden and Columbia: Again President Davis obliged his friend by promoting him to brigadier general and giving him command of the South Carolina Reserves. After six weeks in Camden (which always upset her), Mary moved to Columbia, first living with the Prestons and then in a rented cottage nearby. There she soon had as a long-term guest Mrs. Davis' young sister Maggie Howell and in September a visit from President Davis himself on the way back to Richmond from the western front. She continued her round of entertaining, especially of the young, as well as her hospital work and her voluminous reading, but by January, General Sherman was closing in. The time had come to think of a place of refuge.]

[*The following segment of the Chesnut diary begins in the middle of an entry. It is written in a small, coverless booklet of coarse ruled copy paper sewn together with white cotton string.*]

[*Late January or early February 1865*]

The Virginia Legislature invited Mr. Davis' cabinet, the whole tea party but Trenholm,[1] to resign. Only Seddon & Northrop accepted the invitation — & they say Breckinridge replaces Seddon. They say Mrs. Davis kissed *Blair,* the peace commissioner — & certainly we have sent Vice President Stephens, Hunter & Judge Campbell to negotiate.[2] I wonder what Yankee trick this *covers.* No good to us. We dare not hope.

Brockenborough wrote Enie[3] another wild letter. Really seemed to expect her to correspond with him, unknown to her friends. Said he "came within an ace of telling Mr. C." Imagine Enie's feelings. Then [he said] that "Tucker (his beastly *Col.*) know of his affection for Enie." I saw this must be *nipped.* Besides, 'tho' Brockenborough is a grand, whole souled, whole hearted Virginia F. F., Miss Goodwyn[4] [*one page torn out*] "besides you are in love with her yourself." "Oh yes, I know I am — but *age* does not make any difference to me." This is the one sixteen himself — who plays at the *corner* of the street. & so finis Enie.

1. Charleston merchant and banker George Alfred Trenholm had become Confederate secretary of the treasury after Memminger's resignation in July 1864.
2. With Lincoln's unofficial approval, Francis Preston Blair, Sr., of Md., traveled twice to Richmond in Jan. to discuss peace terms with Jefferson Davis but only secured arrangements for the fruitless Hampton Roads Conference of Feb. 3. On Jan. 28, Davis designated Vice-President Alexander Stephens, the former assistant secretary of war John Archibald Campbell, and Senator R. M. T. Hunter of Va. as commissioners to the conference.
3. MBC's niece, Serena Chesnut Williams, eldest daughter of Kate and David Williams. She and her sister Mary had just paid a long visit to their aunt during which they had received much attention from young officers and military cadets.
4. Daughter of Columbia mayor T. J. Goodwyn.

[*February 4, 1865*]

I must regain the habit of regular writing in my journal. Will be worthless — for I forget every thing if I neglect it a day. I do not remember Wednesday at all.

Yes. I drove out with Isabella[5] — & she told me that nasty Yankee woman Slocum had told Mrs. Joe Johnston I called her a Yankee too. I called by to see Jack Preston & told him to deny it for me. We looked for Hood — who came not. Thursday I called first on Mrs. Roper & Maggie Laurens & then at the Bryces.[6] Mrs. B told me in so many words that she thought me charming & wanted her daughter to come here as to a good school of manners. How Isabella laughed. Also wanted me to join her in a strawberry *festival — me.*

I went to Rutger. Met Mrs. Roper there. We walked into what *was* the parlour — found it Mr. & Mrs. Motte Middleton's[7] room & the former reclined & reading. With great politeness & suavity he invited us out.

Mrs. Prioleau Hamilton[8] & I went to the Bazaar. Paid 30 dol[lar]s for a bottle of Cologne & 30 for one of French mustard — dined there & took ices. Had an affecting interview with Mary Manning[9] — & a [*one illegible word*] with Mr. Theo Stark. Spent the afternoon with Mrs. George Elliott.[10] All in the dumps. She invites me back to Sandy Hill. Friday I was ill & Isabella spent the morning here. Thursday JC dined at Allen Green's with Genl. Johnston & Lovell, John Manning, &c. The latter told an anecdote to say how mean his Richardson kin were! Friday he dined with this precious pair of Genls. again at Evans'. Genl. Joe is all complacen[cy] to him. Agrees to every individual word he says. I am afraid from his own account that he took the floor too much.

He went off to day to Camden — his father is ill. There came since his departure a letter from H. Grant announcing her engagement to Dick Stockton ! ! ! ! ! ![1] At last. Gracious heaven. She tells it as gush-

5. Daughter of William Martin, Methodist minister of Columbia, Isabella was born June 24, 1839. As one of the group of young admirers who surrounded MBC in the war years, she appears infrequently and plays a small role in the 1860s diary until early 1865. In the postwar years, however, her friendship with the older woman grew closer, and she was eventually entrusted with editing and publishing the 1880s version.

6. The family of former U.S. customs official John Laurens, and a descendant of Revolutionary War political leader Henry Laurens. Probably Campbell Robert Bryce, a Columbia merchant, and his wife.

7. Jacob Motte Middleton, an Ogeechee, S.C., rice planter, and his wife.

8. Emma (Levy) Hamilton, younger sister of Eugenia (Levy) Phillips. Emma's husband, Major Samuel P. Hamilton of Chester Dist., was the son of a former governor of S.C.

9. Mary (Cantey) Manning. Her husband was John Manning's younger brother.

10. Mary (Barnwell) Elliott, the wife of planter George Parson Elliott.

1. Richard Stockton, a grandson of a New Jersey signer of the Declaration of Independence by the same name, sided with the Confederacy even though a native of N.J.

ingly as a girl of sweet sixteen! & she wants all JC's cotton to get up a trousseau. SOU (as Annie spells Sue Manning's name) told most disgraceful stories of her hot pursuit of Major Johnson & Edward Stockton.[2]

[*February 5, 1865*]

I saw Sharpe the railroad man taken out of church to day — & when he came back he whispered to Genl. Johnston. The Yankees are at Branchville, I know. Somehow the terrible danger we are in *calms* me.

I wonder if I have written of Brockenborough, the brave young Virginia true heart. The Yankees will miss him — the flower of the chivalry.

Miller went up with Mr. Blake & Mr. Lowndes.[3] Modestly thinks if the servant Scipio & himself had not had some sense, the weak mindedness of the heads of the party would have ever prevented them getting home.

"Sam,"[4] the *simplest,* most transparent soul I have met yet in this great revolution, came yesterday. Isabella & I went to see him. He can stand alone on his wooden leg & is so pleased. What a greeting he gave us. How eloquently he talked of his plans & *that* army. *Fall,* defeat — he blamed nobody. We talked of the Bazaar & while Isabella was telling one of her merriest stories I looked at Sam — & he, perfectly abstracted, was gazing in the fire — his face livid, spots of perspiration on his head. He was back evidently in some moment of his bitter trial. Willie Preston's death — the fields of dead at Franklin — the panic at Nashville. Who can tell — but the agony of his face was fearful. & when we were alone, Jack[5] told me several times he had seen the intense gaze into the fire & accompanied by the same agonized expression.

Isabella & I drove out with Sam in Jimmy Dick Will's carriage. How he talked. He asked to be relieved because the vote of Congress asking to have Joe Johnston reinstated was equivalent to a vote of censure on him — & he accompanied his request to be relieved by a request to be sent across the Miss. to bring that army over. Brave old Soldier. *Well done.*

2. Edward Cantey Stockton of Camden, a lieutenant in the Confederate marines, and a cousin of both JC and MBC.

3. Miller was the 10-year-old son of Kate and David Williams; Daniel Blake, owner of a plantation in St. Bartholomew's Parish, Colleton Dist.; and Charles Tidyman Lowndes, a Combahee River planter.

4. Late in 1864, Lieut. Gen. John Bell "Sam" Hood had commanded the Confederate troops during their bloody and costly defeats at Franklin and Nashville, Tenn.

5. John Preston, Jr., son of Gen. John S. Preston. His brother Willie had been killed in action in July 1864.

He said he ought to wait here for important papers — but this atmosphere — & that *house* — made him so in love he could not wait. Go he must, Sunday as it was. He wanted to get to Richmond by the 8th, his lucky day, the day he became engaged. He wants to be *married* — & dreads opposition. Says he longs so for his one & only consolation on this earth — & blushes like a girl as he alludes to his love affairs. He came here & opened one of his trunks. I wrote for him a telegram to Gnl. Preston. I asked him who I was to send it to. He said absently, "Buckie,"[6] in a tone as soft & sweet & lover like — I was afraid to look. When I did his eyes were suffused. That *one* word *escaped* from his heart — & he was *blushing*. He is a queer compound.

Toady Barker refuses to give his consent. Says he loves Buck himself — & besides says the list of killed & wounded is immense — John Chesnut among them.[7] We walked after Hood's departure & met Mrs. Tom Taylor. Told her H. Grant's happy prospects. She seemed *glad*. Said H had proposed to Manning Brown on the cars — & he got Lipcomb to take her off his hands. She modestly now wants all Mr. C's cotton. I took tea at the Martins'. Ogden[8] was there & walked home with us. Toady Barker came & Venable, a dull & ugly brother of the charming Venable.

Then came Sam on his stick — walking so slowly & so feebly — it made me miserable. He walks so well with his crutches — but he must try experiments. I sat & giggled with Jack. & Mr. Martin got Gnl. Hood to explain his last campaign. He seemed so to regret not seeing JC. He wants Isabella to tell him what to do to get himself ready to get *married*. He has Mrs. P[9] to overcome yet.

The Bazaar drags on. At Mrs. Singleton's table came up a pert Jewess. Mrs. S asked Clancy who she was. He said, "A Miss Mordecai, sore pressed for a husband. She married Lazarus."

Isabella nagged Hood to get married — said if he let them put him off — he was not the man she took him to be. Fancy his face at such a taunt. Mr. Martin, only seeing his laughing *face* before the *dark* one dawned on him, said if he had brought us Tennessee & Kentucky in his coat pocket he could not look happier. Much he knows of the tortures of that stalwart frame maimed and lamed — or that ambitious disappointed heart. All gone now but "Buckie." I think I hear him now.

6. Sally Buchanan "Buck" Preston, one of John S. Preston's daughters, was engaged to marry Gen. Hood.
7. Again, a false report.
8. Abner Nash Ogden, Jr., a captain on Gen. Chesnut's staff.
9. Mrs. John S. Preston, Buck's mother.

The Charlottesville leg is a far better looking one than the French one.[10]
Gen. Lee is Generalissimo — & Breckinridge Secretary of War. What
next — too late!

[*February 7, 1865*]

Sunday afternoon I was partly wild. I could only see "Sam" maimed
& helpless — with his face of the tortured in Hades & my heart was
wrung for Buck — & I felt Isabella & I had been too free of our sym-
pathy & love for him & had not looked poor Buck's future in the face.
I was morbid & miserable. Isabella came & Jack Preston & I grew sane
again. How we talked poor Sam over. Jack is a government man — but
no Davis man. He says it is curious Sam should have his greatest en-
emy's son, Halsey Wigfall,[1] on his staff. After all I see the aide of Genl.
Taylor[2] says the Army of Tennessee is in splendid order — the army
which until they had written Hood out of it they called demoralized —
scattered — ruined, lost. Louis Wigfall said Hood might by good luck
cut his way *alone* to Richmond — poor old soldier. However, unless he
is frozen to death *now*, he is "Monsieur l'Amant" & no longer the un-
happy General. [*Following sentence added later:*] (I hope Buck's mother
won't give in!)

I had a Mr. Sadler yesterday with my brave cousin's son — Chesnut
Miller (the little boy's name), a handsome, nice little fellow. He is to come
here to stay on Thursday. JC came — & a telegram from Beaure-
gard — to tell him *he* (B) did not know where Sherman was going — to
Branchville, Charleston, Augusta or Columbia — & that Winder[3] &
Magrath must make preparations. He (B) could not *check* Sherman. Can
we? Gracious God help us.

That handsome sinner Edward Barnwell[4] was here — deciphering
Beauregard's telegram. They had to make a key for themselves & E. B.
thought himself very clever to do it. The first was "Complete victory."
That was for the forlorn Georgia Campaign. This last was "Come re-
tribution." I fancy it is coming as fast as or along with Sherman. Grant
(not *U.S.* G. oh Lord!) us patience good Lord. Lincoln has returned our
peace commissioners — with taunting words[5] & we had to read to day

10. Dr. John Darby had sent to France for a wooden leg for Gen. Hood.
 1. Francis Halsey Wigfall, son of Charlotte and Louis Wigfall. Halsey's mother took an
 active interest in his career and helped him to secure a place on the staff of John
 Bell Hood in the fall of 1863.
 2. Gen. Richard Taylor of La.
 3. Gen. John Winder of Md.
 4. Edward Hazzard Barnwell, a nephew of Sen. Robert Woodward Barnwell.
 5. At the Hampton Roads Conference on Feb. 3, Lincoln offered the Confederates some
 concessions, but not the independence that Jefferson Davis demanded for the South.

a sneering leader of the London *Times* — amusing themselves at our stupidity in thinking they would help us if we abolished slavery — & adding if we offered ourselves as subjects to any foreign power, they would "decline with thanks." What does that fool DeJarnette[6] feel now. I met Hon. Mr. Clay[7] in the street. He was glad to see me, was rushing in a carriage railway being stopped to see his "dear wife" at Augusta. Gave me a trunk in charge for her & I put it in the S.C. Bureau with Rev. Mr. Martin. He said we had the sympathy of Europe, "nothing more," & that all depended on our own people. Alas. He seemed to prefer talking of his shipwrecks & hair breadth escapes. He brought me a long & very satisfactory letter from Caroline Kisselstein. Poor Lina. I wonder if she knows how pleasant are her abiding places.

[*February 8, 1865*]

I hope poor Sam got to Richmond by this day. The 8th is his good luck day — the anniversary of his engagement. Gen. Hampton was here last night. Said Longstreet had behaved magnanimously, recommended him for Lieut. *Gnl.* for winning the battle of Chickamauga. Said he liked Hood — that he was a good soldier, &c, but denied his *ability*. When JC said either Hood or Johnston would do — he said the people here educated by the press would not hear it. He said H had given him a most interesting account of his western campaign. Just then I was called out. When I came back he was telling that Hood left 18,000 muskets in the Western Army — & had not lost more than 8,000 all told — dead, wounded & prisoners! Gen. Hampton is a Johnston-Wigfall man *out & out*. Says *Joe* is equal to even Gen. Lee — if not superior.

Mr. Preston's flattering estimate of his susceptibility to flattery has proved true. He says Sam was promoted too fast. He wanted experience — was not long enough Major Genl., not long enough Lieut. Gnl. Then came Tom Frost. JC & the Gnl. whispered together — & I had to entertain him. JC has no patience because he is a hider from the war as a bank officer.

Then came poor Janney the Hotel Keeper — scared to death — & exhorting Gnl. H to mount his men at all costs. His (Janney's) affability was excessive. Mr. C [thought] he was chicken hearted but he was vastly civil to him. Poor Janney came to know if he must move his *females*.

I do not remember days now, it is all so miserable. I had a bitter cold drive with Isabella — & packed my valuables one sleety day — & called

6. Daniel Coleman DeJarnette, a Confederate congressman from Va. who served on the foreign affairs committee.
7. Clement Claiborne Clay, Jr., former U.S. senator from Ala. and member of the Chesnut mess at Washington.

to see Mem Cohen[8] who I found on the wing for York & Charlotte. She gave me an account of Rachel Lyons'[9] wedding — & her sitting up until 3 that night — & all night the night at Branchville. I met there Mrs. McKnight, Belle Taylor who married a newspaper man — whose nom de plume is Asa Harts — & who writes funny pieces ah so dreary — & writes about "the confederate female who loves to bathe his head." I'd like to punch it.

Then I went to the Greens' from Virginia, miserable about Allen who is in Charleston. An unhappy man came to be detailed. Such a list of ailments — Dyspepsia — rheumatism — no use of his limbs. I cannot remember *half*. He told it over & over like a *vendor* of patent medicine. Finally his daughter was *going* to have typhoid fever. JC got rid of him politely *but* rapidly — the poor, lying, pusillanimous dog.

Isabella told me of Tristy.[1] He was at the Fair — Bazaar — expected me there. Sent "all messages of affection to the point that might not be considered presumptuous." Always spoke of "poor little Brockenborough" & laughed at the thought of him immoderately, but of course they could ask no questions — as they were not expected to know of the letters. Isaac Hayne said Tristy rushed up to him in the street. With a fervent pressure of the hand, "Are *those* young ladies gone?" "Yes." "Well, that is all I wanted to know." & off he rushed — like his Mississippi tide. To Isabella he said he wanted messages taken to his friends. She asked who. He said Miss Hamilton. "Nobody else?" "No." "What of Sam writing?" "Well I swear I have not written myself." All blushes — "but tell me the address; I can not trust myself for the — future." He told Maggie[2] "he *was fancy free*" — his favorite phrase.

She says the cavalry party came to the Bazaar so happy after a dinner at Tom Taylor's that Clancy spoke to Miss Hill,[3] called her *"George"* & asked her to "take *vittles* with him." Jack Preston announced his perfect satisfaction with his future brother in law — stick & all. Annie says she knew John Darby got that ugly leg[4] on purpose. The "weary heart" had been for one of the Rhetts to take a drive.

Edmund Rhett sends his lying cowardly attacks upon the President to Annie as Something Smart. Orr in the Senate has told the Yankees that we dare not use the negroes as soldiers — that they would betray

8. Miriam (DeLeon) Cohen was the widow of Dr. Lawrence Cohen and a first cousin of David Camden and Agnes DeLeon.
9. Rachel Lyons of Columbia married Dr. James Fontaine Hustis and settled in Mobile.
1. Nickname for Lieut. John Timothée Trezevant, a lieutenant of engineers in the "foreign battalion."
2. Maggie Martin, a sister of Isabel.
3. Henrietta Hill, daughter of Georgia congressman Benjamin Harvey Hill.
4. The wooden leg Dr. Darby had sent to France for.

us & go to the Yankees — & told no end of lies besides, insulting Hood. I wonder how that warworn hero will stand it in Virginia with his Wig-falls. *Halsey* is there to put his father straight! Rachel Lyons will find congenial society in Mobile — where Ravise & Ragan go in peace — & plenty of admirers.

Yesterday I felt utterly despairing & wrote a long letter to Mrs. D. To day, 'tho' packing, still I am not so miserable. I believe it is consti-tutional & *independent* of outside pressure, these fits of depression.

[*February 10, 1865*]

Yesterday I had Gen. Lovell to dinner & Hayne & Barnwell — a nice little dinner, tho I say it. Gen. *L* was so Yankee. He told of those Slo-cum people being Yankee — & I warned him of the trouble I was in for saying so — to JC's annoyance. Afterwards they went to Gen. Win-der's funeral. JC was the man in command & in giving an account of it his name was not mentioned. Allen Green attacked Edward Barnwell fiercely & called a witness to the conference because E. B. called him Mr. and not Major — & of course had to stand a degree of imperti-nence from E. B. edifying to hear. So I asked JC to attack Pelham[5] — for overlooking him.

Yankees slowly pushing our troops every where. Beauregard & *Lee* expected here. Much good may they do. Mr. Laws they call a leather headed fool & a traitor.

Mrs. Izard told me of her brother's opinion of poor S. B.[6] He was plucky enough — but his discretion had to be tested yet. His plan was a brilliant one. His last letter, in utter disgust, such *"rashness."* Poor Sam — his arrangements like *Missionary Ridge.* I. G. is an out & out Johnston man — so I will take what he says with many grains of allowance. S. B. says he lost 8,000 — I. G. says he went in with 60,000 — & came out with 13,000. Terrible discrepancy somewhere.

[*February 16, 1865*]

Lincolnton, North Carolina. I have passed through an age of suffer-ing since I wrote in this poor little book before. I have a confused idea of Friday, the day the Martins left. I was at Mrs. McCord's. Heard there from Miss Ellen LaBorde[7] that the Yankees were at Orangeburg. Rushed to see JC. Saw only Kit Hampton[8] who was on the wing to get his sis-

5. Charles P. Pelham, publisher of the *Southern Guardian.*
6. Probably Mary Cadwallader (Green) Izard, who lived in Columbia with her brother Allen J. Green, Jr. "S.B." refers, for unclear reasons, to Gen. Hood.
7. The daughter of Dr. Maximilian LaBorde.
8. Christopher Fitzsimmons Hampton, younger brother of Wade Hampton, III.

ters off. Went up [to] the Martins'; found them packing to come here.

Determined to come here because I could then run to Richmond or to Columbia or at the worst to Flat Rock. Saturday I packed all day — JC recommending me to go to Camden — but I would not listen. Then came Molly, weeping & wailing & begging me to go home — that my black people would see me safe. So I agreed to go — but afterwards came Miss Patterson, a refugee from Tennessee — & she gave such pictures of the horrors. Said my negroes would fare worse if they found me there. So I telegraphed for Laurence who had gone at 1 that day to Camden on horseback — & he came back by the cars without stopping a moment.

We were *miserable.* JC said he cared nothing for the property question — & a man could always die like a patriot & a gentleman. & then he told me — if Arthur Wigfall had only waited one half hour he would have been made a baptised christian at Grahamville.

I said good b'ye to no one — came off with JC & Isaac Hayne. At the depot I met Mrs. Singleton & Tessie & Sophie Haskell[1] — & the Greens — with Col. Cad Jones, Dick Springs, &c, &c. A Mrs. Smith, a refugee Virginian, sat in front of me. She made Mr. C poke his head out of the window — & after we were once on the way she stopped every man, introduced herself to every body, asked help from every body, said over & over that she had never before travelled alone. She was fifty & not pretty & no danger from attacks of men. She was going through our lines into the Yankee land. Tried to talk patriotically but failed in her joy to get away. A department man joined her — & seemed to share her anxiety to be rid of us. Sophie Haskell talked at the top of her voice to a *low toned* officer. Sallie & herself were traveling alone — & rushed about wonderfully when we arrived at Winsboro.

We were detained 12 hours on the road — & so had to remain a day & night at Charlotte. I kept my room. The next day came here broken hearted & in Exile. Such a place! No carpet — a horrid feather bed — soiled sheets — a pine table, &c, &c — for this I pay 30 dollars a day. Laurence they packed off neck & heels. The old lady seemed to feel for him as Mrs. F's aunt did to Clennam.[2] I thought the bitter pang of ruin was over — but when I heard yesterday that Columbia was attacked — I feel weak & *ill* once more.

Providence has raised up a friend for me! Mrs. Munro. The morning I came I sent the Martins out to find me lodgings. The[y] went to a Mrs. Munro — who resented the idea of her taking boarders — but said

1. Sophie Haskell, a daughter of Sophia (Cheves) and Charles Thomson Haskell.
2. In chap. 13 of Dickens' *Little Dorrit* (1857), Arthur Clennam dines with the family of his old love, Flora Finching. Mrs Finching's eccentric aunt frightens Clennam by staring at him and making strange comments.

she had rented her house partly to Mrs. Ben Rutledge.[3] She sent them to a Miss McLean who said she would take me — but afterwards would not.

Tuesday in the snow I was asked to a Mrs. Munro's[4] & I went. She is a Catholic & therefore eyed askance here. I found her handsome — & widow like to an extreme with a son of seven years. A daughter in law of Judge Munro of S C — & née Dunn of Abingdon, Virginia. She knew all the Johnstons, Prestons & Floyds of that ilk — & pitched into Joe — but she will take all that back now. Mrs. Joe is expected here. She seemed to be an *abolitionist* in the sense I am one. Too much sympathy for the Yankees — that I cannot understand — but she was clever, kind, & hospitable & got Miss McLean to take me in. She gave me *exquisite* tea — & *pound* cake — & I made a feast of it. I do not think in my life I ever enjoyed a tea so much.

The Fants came to see me. They are refugees since the 2 Manassas — have been every where — & suffered every thing. Went to their own house & saw only a chimney, & on that, written the claim to it of a Yankee.

The Martins are devoted. Such an old aunt as they have — I am sorry I have seen her — poor things! I have written despairing things to *JC* — & have written for Laurence with *some things*. Have written to Mary Cantey, Buck, Mrs. Davis & Quinter.[5] May I provoke a response.

The Middletons have come in. I went to see Mrs. Ben Rutledge. Columbia in a hubbub. Yankee musketry heard. Every body flying — the enemy at hand. Cars ordered at Charlotte not to be sent any more to Columbia. I fear it is gone.

Miss Matilda Middleton came & sat some hours with me — & then I went into Mrs. Read's[6] room who was in a state of *repining* — which I understand. The misery of those first days of mine in Lincolnton. What a walk through mud & slush. A handsome soldier said he was invalided but he felt like taking his musket & going to help poor *S C*. I wept. Of course he was a Virginian.

Miss Matilda described Miller's visit to her house in quest of Mr. Blake. Said he was so polite, so clear & so decided — that her sister said at

3. Eleanor Maria (Middleton) Rutledge was the wife of Benjamin Huger Rutledge, a Charleston lawyer, member of the secession convention, and colonel of the Fourth S.C. Cavalry Regiment.
4. Daughter-in-law of Judge Robert Munro of Charleston, S.C.
5. The journalist earlier identified as L. Quinter Washington.
6. Miss Susan Matilda Middleton, sister of Eleanor (Middleton) Rutledge and Mary (Middleton) Read; Mary Julia (Middleton) Read, wife of the Charleston planter and physician Benjamin Huger Read.

once, "That young man will command that party. Mr. Blake & Mr. Charles Lowndes were so *demoralized* — if not subjugated."

<div align="center">

La malice est injuste mais l'ignorance l'est davantage.

Balzac

</div>

When I arrived at Johnston's Hotel, Lincolnton, Mrs. J eyed Laurence & Ellen. "Did you bring these negroes to keep them from going to the Yankees?" Ellen — "Name er God. What de matter wid de 'oman. What for [*one illegible word*] we two. Don't you know Misses never travel without Molly er me?" Mrs. J said, "If they are saucy, they can't stay here." So I bade Ellen hold her tongue — which she did with a flaunt. I wanted a pencil to write a note to JC. Could not find mine. Laurence handed me his. Mrs. J said with venom, "Let that man go home on the cars. We won't have no niggers with gold pencils here." So Laurence said he had better go — as he could do me no good — & Mr. C would certainly want him. Ellen came up after dinner & found me in my constant condition of tears — which she soon changes to wild laughter. "Old Miss Jonson say in the kitchen, 'Go away gal — don't stand there. My niggers won't work for looking at you.' Now Misses — ain't I *a show*. I never knew it before — but I am *somfin* for folks to look at."

[*February 18, 1865*]

At Miss McLean's. With a grateful heart I thank a Divine providence — for the mercy I now enjoy. Once more I sit by *my own* fireside — in a clean room, airy, comfortable! I moved here yesterday — Friday morning. I swallowed my superstitions — so anxious was I to leave the Hotel Johnston. My bill was 240 dol[lar]s for 4 days. They charged me for *five* but I rebelled. Fire 25 dollars — the old North Carolina Yankees.

I am so humble, so civil — but as Miss Matilda M says, it is useless. They cannot comprehend the height from which we have fallen! This mine hostess is young & handsome, very well educated, talks well. Seems so lady like & kind — brought her guitar into my room last night. I sung *Bergerelles* — & was so subdued by old memories. She is the cousin of all the Hayneses — Brevards — the cousin of Mrs. Stonewall Jackson — the cousin of Mrs. D. H. Hill — the sister in law of Genl. Hoke![7] N.C. aristocracy as far as it will go — but does not brush her teeth — the first evidence of civilization — & lives amidst *dirt* in a way that would shame

7. The Haynes of Charleston Dist. were descendants of Revolutionary War hero Isaac Hayne. Mrs. Stonewall Jackson was Mary Anna (Morrison) Jackson; Isabella (Morrison) Hill, the wife of Gen. Daniel Harvey Hill of S.C.; Richard Frederick Hoke, a Confederate general from Lincolnton, N.C.

the poorest overseer's wife. May we teach them that Godliness is *only* better than cleanliness. A Lady evidently she is in manners & taste! & *surroundings* worthy a barbarian.

Such kindness they have shown me. I feel I shall love this *N.C.* flower in spite of her growing in this bed of dirt — like a pure white lily. On the cars a poor soldier, shaggy, scrubby, ill looking, slowly unrolled a rag — filthy! as if it had laid six months in a gutter. Out of it he took 2 biscuits — hard tack — naively handed them to me. "Will you take these & give me something soft to eat"! Of course I gave him the best in my lunch basket, but to touch his — oh no!

Well this day I have worked! I made my own tea — boiled my own eggs — & washed up my own tea things. Then helped to scrub every thing. Every thing needed it — such windows! Yesterday saw Jesse Taylor — the Secessionist, the Nullifier, the fireeater! Ran away here — the man who was ashamed to walk with Tom Chesnut[8] because he was not in the Army. How he dare look any body in the face. Shame on the S. Carolinian who can run away this day — to save property. Faugh!

[*February 19, 1865*]
Sunday morning, Lincolnton. "Set thy saving mark upon our houses, and give order to the destroyer not to hurt us."[9]
John XVI, 23: Verily, Verily, I say unto you, whatsoever ye shall ask the Father in my name, he will give it you.

> Upon this promise, blessed Lord, I depend; beseeching Thee, Oh Heavenly Father, for thy dear Son's sake, to give me the graces I most stand in need of. Bishop Wilson
> *Sacra Privata*

> Save O Lord Jesus, a soul which thou hast redeemed by thy blood. . . .
> Blood of Christ cleanses from all sin.[1]

Yesterday Mrs. Munro had an idea of getting up a religious discussion. She is clever & thoroughly posted up & ready for controversy — enthusiastic Catholic as she is. She asked me what religious books I read — & was triumphant when I said after the Bible & prayer book, St. Augustine & Thomas à Kempis — & Bishop Wilson's *Sacra Privata*. She was proud that I could find nothing better than *two* of her church. Scarcely took the trouble to think of Bishop Wilson. Seemed to find me a worldling — & my christian doctrines *utterly* crude & undigested. I ran

8. Thomas Chesnut, John Chesnut's brother, was an Alachua County, Fla., planter.
9. She is paraphrasing from Exodus 12.
1. Bishop Thomas Wilson, *Sacra Privata* (1808), p. 135.

away as she had so much the best of the argument — knowing I was
right, but failing for want of practice in talking on that subject. She
seemed to think I had a terrible account to give for my want of *studying*
this subject — especially as I had heard Bishop England[2] so constantly
in my youth.

I went in to see Mrs. Ben Rutledge. She is so lovely — with her sad
wild eyes — & the loveliest mouth & teeth I ever saw. She said wish-
fully, "Butler cannot be killed. My husband is with him" — & then be-
gan her house keeping troubles. She wished so she had ever learned to
make bread. "Mama, I have not eaten a mouthful to day. I can't eat
mush. The children eat it — I drink tea." I offered to have some biscuits
made for her. How she blushed & *refused* — but I sent her the biscuits
all the same — & nice ones they were too. A few minutes after, the
woman who bakes bread here came with several beautiful loaves. I took
one — & sent her with three to Mrs. R & the Middletons. I am sure they
ought to be grateful to me. *Nice* bread — in this land where they eat
fried mush — pork — raw onions for breakfast, &c, &c.

I stayed too long at the M's. Miss Matilda talked so well — how she
gave it to poor *Sam*. She seemed to have heard all against him. I *wept*
& was miserable — all day. A man told me Columbia was taken & our
troops were fighting 13 miles on this side [of] the town. We went to see
the Taylors[3] & Fants. The Fants say Ellen represented *me* as a million-
aire is the reason I was so charged by Mrs. J.

Later I heard Columbia is not taken — but it was Cheatham's corps[4]
which came in above Columbia & gave rise to this story. It is pleasant
to believe this. So I indulge fond fancies — to have the pang of ruin
come once more.

Miss Matilda M says so few soldiers can get cloth from Roland Rhett
but Mrs. Rhett is clothed in grey from head to foot — in Charleston the
whole family of the quartermaster wear nothing else but confederate
cloth. At least we are *honest,* poor but honest. We are near beggars —
but not so far — thieves. *Haskell Rhett*[5] ran away from Columbia — a
Citadel boy. Alex Taylor[6] went to take his negroes. Old Barnwell Rhett
& his whole family moved to Eufala, *Ala.* — out of danger! I sung by

2. John England (1786–1842), the Irish-born Roman Catholic bishop of Charleston. In
 school, Mary dined with the bishop every Wednesday at Madame Talvande's table.
3. William Jesse Taylor and his wife, Agnes (Wallace) Taylor.
4. Maj. Gen. Benjamin Franklin Cheatham of Tenn., commander of a corps of the Army
 of Tenn.
5. Roland Smith Rhett, a major in the C.S.A. His wife was Julia Lowndes (Brisbane) Rhett.
 Haskell Smith Rhett was a brother of Roland Rhett.
6. Alexander Ross Taylor, a Richland Dist. planter.

my *lone* self with the guitar last night — & how old & pleasant memories rushed up ——

In the afternoon we went to see the Brumbys — a Mrs. Glover,[7] &c. A Mrs. *Phifer* is coming to see me.

I read Mad. de Genlis.[8] Contrast our country. At the Revolution — John Rutledge[9] dictator. *Now* Magrath. We do not look among gentlemen for our rulers — but in the dust & ashes we rake them from Dunghills.

Enough for Sunday. Oh bitter spice!

"Massa in the cold, cold ground" — the tune they sung when they elevated our Flag at Montgomery. They are *most* of them there — young & old. Leitner, that I abused for Wm. Shannon, has turned out a *hero* — on one leg, & Wm. S. a *Bank President*. Poor old E. M. B.[1] — wounded with his noble boy shot — a major in active service.

[*February 23, 1865*]

Today is Thursday & for four days I have not written. I have been busily engaged — reading the *10* volumes of *memoirs* of the times I have written. Nearly all my sage prophecies have been verified the wrong way — & every insight into character or opinion I have given as to men turned out utter folly. Still I write on — for if I have to burn — & here lie my treasures ready for the blazing hearth — still they have served already to while away fo[u]r days of agony.

One day we saw Genl. Johnston. Stopped him & had a long talk with him. He was *radiant*. & today he is ordered to take command & he is angry — & rude. It will be a second Vicksburg. Yesterday I had a long talk with Mrs. Slocum's friend for whom she quarrelled with me. Mrs. Johnston was very kind & polite — a lesson to all understrappers.

Yesterday Mrs. Glover wanted me to go with her to Charlotte — & *oh* fool that I was I would not. To day Clancy brings me a letter from JC — & I find I missed him by that. Such a letter. Says our retreat was disgraceful & unnecessary — & that he nearly was taken prisoner — for when he heard the news that Columbia was surrendered, every thing was gone but the rear guard of Cavalry. So he sat [until] morning — & Molly remained to look after my things — Mrs. Preston's cow, &c, &c.

I hope not to keep boarding house for the Yankees. Charleston sur-

7. Dr. and Mrs. Richard Trapier Brumby. Dr. Brumby was a former professor of chemistry, minerology, and geology at S.C. College. Mrs. Thomas Worth Glover was the wife of an Orange Dist. judge.
8. Stéphanie Félicité du Crest de Saint-Aubin, comtesse de Genlis, recounted her flight from France during the French Revolution in *Mémoires* (1825).
9. Rutledge had been governor of S.C. and a member of the Continental Congress.
1. Edward M. Boykin's son Tom was killed the same day his father was wounded.

rendered on the 17th February — & Wilmington. I do not care ever to see another paper.

Shame — disgrace — misery. Hampton [is] Lieut. Genl. Much good it may do him. The grand smash has come. Poor JC — how blue he is. What would I not have given to be with him yesterday.

Today I was burning papers all day — expecting a Yankee raid. Gave some silver to Mr. Team — & two books of JC's. Shall try & get them if I go to Greenville. How I have wept this day! My poor heart is weary — & then how it poured — *rain,* rain, rain, & in it all I rushed down to Mrs. Martin. I wanted so to get away. I want now to get to Kate's.

I am so utterly heart broken. I hope John & Mr. C will get together at least in the same army. Miss Matilda Middleton spent one morning here. She is so clever. To night Isabella calmly reads beside me — & I am quiet after the day's *rampage.* Oh — my Heavenly Father look down & pity us.

Mrs. Johnston told me Mrs. Halsey[2] had sent Mrs. Wigfall a thousand dollars in gold & she sold it for 28,000 in Confeds — so they are living grandly now in Richmond. How can Mrs. Johnston live here.

> If our Earth could give up her secrets, our whole globe would appear a Westminster Abbey laid flat. Ah what multitude of tears, what myriads of bloody drops have been shed in secret about the three corner trees of Earth — the tree of knowledge, the tree of life, the tree of freedom. Shed but never reckoned! It is only periods of calamity that reveal to us our great men. As comets are revealed by total eclipse of the sun.
>
> Not merely on the field of battle, but also upon the consecrated soil of virtue — upon the classic ground of truth, thousands of nameless heroes must fall & struggle to build up the footstool from which history surveys the *one* hero, whose name is embalmed, bleeding, conquering, & resplendent. The grandest of heroic deeds are those which are performed within four walls & in domestic privacy. And because history records only the self-sacrifices of the male sex & because she dips her pen only in blood — therefore it is that in the eyes of the unseen world our annals appear doubtless far more beautiful & noble than in our own. Jean Paul[3]

> That for which a man offers up his blood or his property must be more valuable than they. A good man does not fight with half the courage for his own life that he shows in the protection of another's. The mother who will hazard nothing for herself, will hazard all for her child. In short only for the nobility within us — only for virtue — will man open his veins & offer up his spirit. This nobility — this virtue — presents different phases. With the Christian martyr, it is faith; with the savage it is honour; with the republican — it is Liberty. John Paul Richter

2. A Northern relative of Mrs. Wigfall.
3. German novelist Johann Paul Friedrich Richter (1763–1825).

S. W.[4]: "Setting on an addled egg forever as if there was never a fresh one in the world to be found." Enie? Miss Priscilla in *Silas Marner*. To day I was thinking of the wretch going to the Yanks named Smith who would not let Mr. C put his head in the car window to tell me good bye. They say I was the last who went in the door. After that the trains were seized by Government — & the flying females even smuggled in by the windows & some, such as dear stout Mrs. Izard, stuck fast & had to be shoved in with a hard push. Helas — for Southern dignity.

4. MBC apparently found this passage from George Eliot, *Silas Marner* (1861), descriptive of her niece Serena Williams.

[*Among the missing parts of the original diary are those that run from the above entry of February 23, 1865, to the opening entry of the last surviving volume dated May 7, 1865. Again we rely upon the 1880s version for an outline of events covered by the lost parts of the original. The story falls into three segments according to place.*

February 25, 1865–March 20, 1865. Lincolnton, N. C.: As an exile, Mary Chesnut continued to make the most of the limited amenities of the North Carolina village. These were enriched briefly by the presence of Gen. Joseph E. Johnston, "the great retreater," *for whose military talents Mrs. Chesnut had only contempt. She wept at news of the burning of Columbia, watched the Confederacy disintegrate and her reputation as "Cassandra" grow, quoted Job, reread* King Lear, *and heard rumors of Gen. Sherman's approach. It was time to move again.*

March 21, 1865–May 1, 1865. Chester, S. C.: James Chesnut arranged his wife's flight southward to Chester. There she watched troops march by "the wrong way," *and Lee's army* "melting like a Scotch mist." *Old comrades streamed through in flight. The Preston girls stayed with her, and Gen. Hood, minus a leg, said his farewell and rode off to Texas, head uncovered* " 'in honor of my being here,' said Buck quietly." *In prevailing* "madness, sadness, anxiety, turmoil, ceaseless excitement," *they received the news: fall of Richmond, surrender of Lee, assassination of Lincoln. Mrs. Davis paused a day in her flight to dine with Mary. James pronounced his wife's sentence: "Camden for life."*

May 2, 1865–May 7, 1865. En route to Camden: Through the ruins of "Sherman's track" *in South Carolina countryside, General and Mrs. Chesnut were escorted by a guard of nine armed soldiers. They* "did not see one living thing — man, woman, or animal," *save one slave of the Prestons'. They found the big house at Mulberry plundered throughout; one side had been methodically smashed up.*]

[*This segment of the Chesnut diary, containing entries from May 7 through June 26, 1865, is written in a ruled notebook which had originally been used as a "Book of Recipes," and so contained several recipes on the first few pages. At the top of the title page, MBC wrote "1865 After Surrender." Then she simply turned the book over and wrote from back to front.*]

[*Undated. Early May, 1865*[1]]

In crossing the Wateree at Chesnut's Ferry we had not a cent to pay the ferry man — *silver* being required.

The first solid half dollar [we earned was] for butter. My cows were all in the swamp. They had been driven up — and Molly, as soon as she was moved back home from her Columbia bed of thorns, fighting the Sheriff Dents,[2] began to make butter for me and sell. John C and my husband laughed at my peddling — and borrowed the money.

[*May 7, 1865*]

Camden. Submission — to the powers that be preached by Tom Davis to day.

Old Myrtilia, so old that a servant was given her by her master to cook & wash for her, left with the Yankees — has sent word she wants to be *sent for.* She got tired in two days' journey. Ellen said, "All Aunt Myrtilia wanted was a little good religion to die with."

Col. C in a deplorable state, blind — feeble — fretful — miserable. H. Grant awaiting her dear Dick to be married. JC — quiet yet soon to be restless. These idiots (Camden gentry) because they are cut off from Railroads & Telegrams think they are to go back into the Union — bet-

1. This entry, written on the flyleaf of the recipe book, appears in the 1880s version in the entry for May 7, 1865.
2. John Dent, sheriff of Columbia, and his family with whom MBC's servant Molly had clashed before the Confederate surrender over the sheriff's claims on her mistress's house.

ter off than we were before the war! Ogden asked me what he should do — Trans Miss. or go to his wife. She was in a delicate situation, could not travel. I said, "Your duty is plain — take care of your wife first." How grateful he looked — he never dreamed of going West.

[*May 8, 1865*]

Yesterday we had a Sunday evening reception — Sam & Mattie Shannon, the Reynoldses, finally Godard Bailey.[3] Sam was all distress at his separation from Mrs. Shannon.[4] Was glad to meet *me* as some one he had ever seen in Camden before! Seemed sulky — grey & dressed to death. Gave a painful account of Pickett's division & Bushrod Johnson — under Dick Anderson.[5] Also Custis Lee's division.

John C came back from Columbia — looking so cool & gentleman like. Saw Gnl. Hampton. Offered his services & now awaits his orders — his regiment is ordered to reassemble the 20th of May. Saw Isabella who told him Sherman had offered Wade Hampton the command of U.S. Cavalry. Kilpatrick[6] said, "Well we meet at last." Hampton said, "We might have met before — if you had not always run from me." Isabella was radiant. He thinks Buck was pinked for a flirtation either with Portman or Rolly Lowndes[7] — but Tudie[8] sent to be *excused.* So he would not go back to tea. Buck was too tired to write. They only got home on Friday. Lovell sent JC an order showing he is a Paroled Prisoner.

Godard Bailey told funny tales to an inattentive audience — one of Mr. Hay's guarding ammunition stores with a stick [and] of the Yankees throwing away a gold card case as brass & taking plated spoons instead. Said the 2 officers who staid at Mrs. Beall's[9] had each a pillow case of silver, spoons, &c. He said one true thing. First came the men who demanded whiskey & arms. Then the thieves went who stole every thing. Then the officers who sympathized & soothed — & were so sorry for you & then the three parties divided spoils.

Floride Cantey[1] came & Emma Reynolds with a story of a footman

3. Bailey, formerly a clerk in the U.S. Interior Deprtment, was married to a Southerner, Ann (Sabb) Bailey, and was currently a newspaper editor in S.C.
4. Sam's wife, Elizabeth Peyton (Giles) Shannon of Richmond.
5. A reference to the battle of Sayler's Creek on April 8, in which the forces of Gen. George Pickett, Bushrod Rush Johnson, and Richard Heron Anderson were shattered.
6. Union general of cavalry Hugh Judson Kilpatrick.
7. A. P. Portman, a friend and hunting companion of Wade Hampton, III. Rawlins Lowndes was the son of Charles Tidyman and Sabina (Huger) Lowndes.
8. Susan Frances Hampton Preston, sister of Sally "Buck" Preston.
9. Probably Frances (Hayne) Beall, the wife of Lloyd James Beall, a Confederate marine commandant from Charleston.
1. Camilla (Richardson) Cantey's daughter, a cousin of JC.

(black) in Charleston who urged his addresses upon a nice white young lady. She screamed. An officer, federal, came in & shot the intruder. A gentleman's coachman who had been very faithful as a coachman left him for the delights of freedom when the Yankees took possession of Charleston. Shortly after, a *gentleman* called. When the ci devant master went into the drawing room he found his ci devant coachman *seated*. He said he had a handsome house, was living very comfortably — & had called to offer his assistance & protection to his former master — who when he had the power was kind. He offered money or services generally as a security generally against Negroes & Yankees.

> I lift my soul to God,
> My trust is in his name,
> Let not my foes that seek my blood,
> Still triumph in my shame.
>
> Sin & the pow'rs of Hell
> Persuade me to despair;
> Lord, let me know thy covenant well,
> That I may scape the snare.
>
> May 9th.
> Bogatzky[2]

[*May 9, 1865*]

Sunday I saw H. Gr. & Mattie Shannon were mere speaking *acquaintances*. Mattie & I *kissed*. H shook hands at arm's length — this after all! About this time last year she was raving about giving up her life to Mattie. Having sworn over Mr. Shannon's[3] dead body to devote her life to Mattie! She asked last night if there was any power now to make James Frierson go into the army — & go with Hampton across the Miss. I said no — he could be paroled by any Yankee he saw. Now nobody could be kept by force in the Confederate army.

I hope H. Gr. & I may escape a fight — but I do not see how. Mrs. Henry DeSaussure was here. The Reynolds blood must have full possession of her — the Chesnut eliminated, or she could never have been so delighted & elated at being a *DeSaussure*. She is so proud, & justly, of her dead husband — dead upon the field of battle fighting for his country — the proudest epitaph a man can have. The widow of a man like that must be treated with respect with all her silliness.

John dressed himself within an inch of his life & went off to Miss Ferguson.[4]

2. Quoted from one of many editions of *A Golden Treasury for the Children of God* (1718), a daily devotional by the Silesian religious writer Carl Heinrich von Bogatzky.
3. Mattie's father, Charles John Shannon, had died in 1863.
4. A daughter of Gen. Samuel Wragg Ferguson.

JC was so bitter last night. Said if he had come home a year ago & saved his property as *some* did. I said he did right to lose it — he replied, "I won't go & dine with the ones who did it." "Yes, because Uncle H is the only one I know who did so — but I think still, as you aided in bringing on this war — you were bound to sacrifice all & stick to it no matter where you were placed, no matter how unpleasant your position — for the poor conscripts had to stay in a worse place." He then said he had staid — & from his "own conviction of duty" — & not from my persuasion. Which is the honest truth — but he cannot forbear the gratification of taunting me with his *ruin* — for which I am no more responsible than the man in the moon. But it is a habit of all men to fancy that in some inscrutable way their wives are the cause of all the evil in their lives.

I read *Gerald Gray*.[5] How Teddy Barnwell can bear that description of himself — cameo face & all — so perfect in the external delineation. I found Captain Edward Barnwell charming. Let the world say what it will.

[*May 10, 1865*]

Cousin Sally Williams writes here for Allan Stockton. Says she feels sure whatever happens she will not be ruined. God will provide. She has had the good things of this life & she has enjoyed them. She held them as Steward for God — her bread has been cast upon the waters & will return to her. She sorrows for her "dear George who was killed before he could strike one blow for his country!" — & John!

Yesterday I called first on Mrs. Wm. Taber[6] — & Mrs. Bailey. They told Yankee raid anecdotes. There is a monotony in Yankee insolence & wickedness that makes me weary of repeating it. I found there Ellen Colcock — in a dying state. I was amused at the change in the demeanour of Mrs. Tweed & Miss McEwen — even in Robert Kennedy.[7] I am no longer greeted with a thousand smiles — hat in hand. My day in Camden is over. The Yankee dynasty begins to reign.

John sent Miss Ferguson strawberries & asked her to ride — but she was engaged — to Johnny Cantey.[8] Mr. C who was at Mulberry with Gnl. Elliott[9] saw her dash in there with the aforesaid cavalier. So JC

5. Edward Barnwell had posed for a picture in Susan (Petigru) King's book, *Gerald Gray's Wife,* which was published during the war in *Southern Field and Fireside.*

6. The widow of William Robinson Taber.

7. Susan (McEwen) Tweed, sister of Dinah "Denie" McEwen, both of Camden. Robert M. Kennedy, a merchant, was currently mayor of Camden.

8. Probably John M. Cantey, who had been a lieutenant in the cavalry unit, the Wateree Mounted Rifles.

9. Stephen Elliott, Jr., a planter and member of the S.C. house from Beaufort.

sulked[1] — rode down [the] street, met Wade Hampton who also called here. John refused politely to tell him either his father's plans[2] or his own.

I called on Mary Boykin & Mrs. Bryan.

At the first house I met Col. B. He is sanguine as ever — says, "Better to have loved & lost than never to have loved at all." It was right & due ourselves to have fought the Yankees — & he dares look any man in the face at home or abroad. "Yet — humiliating as the fate of the country is," he said, "pirates do not burn the spoil." I said I had "heard or read of no magnanimous conquerors" — & "magnanimous Yankees! Faugh. We had as well expect the *worst* — & at once."

The returned soldiers say Ord in Virginia & Schofield in North Carolina have proclaimed freedom to all slaves — & Schofield[3] has told Vance[4] that he has no further use for him or his civil government. A Col. Yates told Gnl. Elliott & JC that "Sherman told Gnl. Johnston to look out for himself — for their agreement only bound the *military*, not civil authorities."[5] So after the fond foolish security of a week past here — behold once more distraction.

Col. B said of the 8,000 muskets stacked at the surrender of Lee, 4,000 were Field's division[6] — Hood's (old division). So much for the discipline & order of that veteran corps. I must write to Sally that. Nobody will tell it to her in Columbia.

John Green, Wade Hampton & the Mannings were here yesterday. I told John what ⟨*illegible name*⟩ had the insolence to say of me to Isabella — for fear he should be civil to that poor cowardly dog. I would have liked to see John Green.

[*May 11, 1865*]

Yesterday Mrs. Bartow & I went to Mulberry — & the Hermitage. Molly presented Mrs. B with eggs. We saw no end of little negroes. At Aunt Sally Burwell's three little negro babies were brought to her. She

1. Here "JC" refers to MBC's nephew, John Chesnut.
2. MBC apparently means his uncle's plans. John Chesnut's father had been dead many years.
3. Union Generals Edward O. C. Ord and John M. Schofield.
4. N.C. gov. Zebulon B. Vance.
5. President Andrew Johnson had rejected the Johnston-Sherman armistice of April 18, which guaranteed "rights of person and property" to Southerners and promised Federal recognition of existing Southern state governments whose officials took loyalty oaths. On April 26, Sherman negotiated a second agreement pertaining only to the surrender of Johnston's troops and then left Maj. Gen. John M. Schofield to assume power in N.C.
6. Gen. Charles William Field, commander of Gen. Hood's old division of the First Corps of the Army of Northern Va.

asked the man why he brought her so troublesome a gift. He said (he was a servant of her own), "Missis I only took *three* — nine were in the wagon. The Yankees left them." Surely the poor black mothers were forced to leave them. They dug up at Minnie Frierson's eighteen negro women with bayonet stabs in the breast. The Yankees were done with them! These are not rumours but tales told me by the people who *see* it all.

I left butter & eggs & strawberries for Mrs. Colcock — née Ellen Lewis. John went off to see Miss Ferguson. Saw there two *Heralds,* one of the 8th & one of the 19th April. Andy Johnson says he will have the heads of the rebellion — *civil* [heads]. That means mischief to JC.

Emancipation has been proclaimed in Virginia & in N.C. Yankee paroling officer in Chester to parole folks. JC reissued Lovell's order. Lovell wrote to Joe Johnston to inquire if the consent of our government had been given to this convention. Answer — Joe Johnston was not aware we had any government. No — nor has he ever been aware that he owed allegiance to any.

Had Sutherland[7] here. Said he was going away. I advised it — he could make nothing of Yankees — it was "only soft Southern people out of whom he could make a fortune." Said I "would [*one illegible word*] a sharp Yankee." I said *No,* thank God, I was too old to learn new *ways.* I would "die the thriftless helpless South Carolina woman I was born." Mrs. Reynolds came & said Tim Trezevant was a lover of Ida DeSaussure! that he had called there — & the girls led Ida a life about him! ? ? ?

[*May 13, 1865*]

Yesterday I read *L'Amour*[8] all day. While I was at Lincolnton JC told me that at Grahamville he had read *L'Amour* — & asked me if what Michelet said about women was true. I felt inclined to dissent & criticise as I went on — but at the end of the book there was a woman's comments which said all I wanted to say & a quantity more than I ever dreamed. We walked home with Mattie Shannon — John, H. G. & I. Met Gnl. Chesnut walking with Fannie Hay — she *radiant* — & he looking odd. How we laughed at the queer conjuncture. We met Sam Shannon & Miss Ferguson. How she stared — & John (in sorrow) suggested how badly I was dressed. I told him to "disown me — not to be ashamed of me merely."

A young officer came here from Hampton. Said the Secretary of War

7. J. F. Sutherland, a Camden furniture store owner. In the 1880s version, MBC described Sutherland as a carpenter from Philadelphia who had moved South, as he put it, to make money off of "lazy easygoing Southerners."
8. Jules Michelet, *L'Amour* (1859).

Stanton[9] had telegraphed to Georgia that no rebel legislature was to be allowed to meet. So we are to have no civil rights. Elliot & *Courier*, Col. Boykin & all that tea party are subjugated, ready for any thing. Wm. Shannon *anxious* & willing to save the money he has made during the war. John recovers *so soon* & is so Southern — volatile & inconsequent — he wants to give a *picnic*. Harriet Grant is maddening. She wishes her dear Dick had not fought on our side. She prefers New York to South Carolina, "both being now Yankee land." Our fate is hard to bear — but to have to hear such. I quietly take up Gnl. Hampton's tone — & "wish they were *all* dead — all Yankees."

JC finds his Negro men all have Enfield rifles. The next move will be on pretense of hunting public arms to disarm all white men. Then we will have the long desired Negro insurrection. I said I preferred to be here in that case — if it were as bad as St. Domingo — than to be in New York ——

[*May 15, 1865*]

Such a life as I have led since I wrote last. At such a time as this of misery & degradation, to be with a woman soon to marry a Yankee, longing each moment to take flight to Yankee land — to have every thing we hold sacred sneered at — & every calamity to our poor country.[1] I said I wished now, as Mother prayed two years ago, that we might all be twenty feet under ground before we were subjugated. H. Gr. said to Miss *S. C.*, "Would it make you more comfortable to have the men of your family all dead!" Miss S. responded nobly, "Yes — if life disgraced them."

A man Latta has taken it upon himself to invite all returned soldiers to come here to day & divide commissary stores — so we have upwards of a thousand here. These *youths* — returned gentlemen, not a hundred, offer to keep them quiet. "Rascality" has always been too strong for gentility — a hundred to one in numbers, but gentility keep them in order.

I have a long letter from Isabella. *Tudy* flirting with Portman. Buck rides with Rolly Lowndes — as [if] she would accept his whip or saddle — bosh! Buck *always* flirts — but now she is utterly miserable. Says she has consumption. Buck my poor darling — as far as I see, they did you cruel wrong when they did not let you marry & share the fate of your poor wounded hero — & patriot — the only true man I have seen in your train yet.

9. Edwin McMasters Stanton.
1. A marginal note written sometime later reads, "Dick Stockton — when he came was as truly Southern as Hattie had been Yankee."

H. G. hears no news from her fiancé. To day at breakfast John describes a scene in *Cecelia*.[2] The wedding interrupted at the dramatic moment. "Any just cause or impediment?" Old woman says, "Stop it," & flies down the aisle — disappears. Bride faints — groom swears — ceremony stops. I said "Stop" for that. I knew some women who[3] could not be stopped by Grant & Sherman's army with fixed Bayonets — *if* they had secured a man willing at last! Significant laugh.

Yankees have garrisoned Columbia. We may look for them here any day. Isabella writes that Rosser & Young have escaped[4] — one to Maximilian,[5] the other to Brazil. She thinks I am uneasy about O. N. B. *No* — I am not. Nor about Tim the deceiver nor R. L. B., tho she says both are en route for F. R.[6] I wish I only knew they were safe — my poor children.

John says Mr. Davis is taken prisoner[7] — after many men killed. God help him. Isabella says — & she always reports loyally *true* — against her own side — she says the women of Columbia weep & call *Joe* a traitor. Joe who makes a "convention" to save the country from ruin — & leaves his country to ruin — the miserable demagogue. Intriguer. Mrs. Joe weeps for the neglect she received in Columbia — & rejoiced when it was burned. H. Grant comes in radiant to say Columbia is garrisoned. I wonder what *joy* she can show when she hears Mr. Davis is captured & Forrest[8] surrendered!

I complained of gout. She asked with a sneer "from which of my ancestors I inherited it?" My ancestors were farmers — *hers* on the gouty side — Philadelphia merchants. I *prefer* my plain Carolina farming gentry to the *monied* gentry of Yankeedom.

But in addition to all this, I went to Aunt B's. There I spoke of Mary & Enie — & said I had a wonderfully clever letter of Mamie's[9] to show.

2. Frances Burney, *Cecilia; or, Memoirs of an Heiress* (1782), book 7, chap. 7.
3. At this point in the diary, MBC inadvertently skipped several blank pages as she continued her entry. She then went back and filled up the intervening pages. Thus the remainder of this paragraph and the next two full paragraphs appear in the diary to be part of the May 18, 1865, entry. MBC's note, "Skip to p. 100," alerts the editor to the error.
4. Gen. Thomas Lafayette Rosser was captured in May at Hanover Court House, Va.; Gen. Pierce Manning Butler Young was captured in N.C. Both men were soon paroled, and there is no evidence of their escape.
5. Ferdinand Maximilian, the Austrian archduke established as emperor of Mexico by Napoleon III in 1864.
6. Lieuts. Tim Trezevant and Brockenborough and Capt. Bierne, the three most devoted suitors of Mary and Serena Williams. "F.R." is Flat Rock, N.C.
7. At Irwinville, Ga., on May 10.
8. Nathan Bedford Forrest, Confederate cavalry general.
9. Mary Williams.

Kate said she did not mistake impudence for smartness — & she thought Mamie had only her insolence. Aunt B said Mamie treated her with *scorn*.

I asked her if she did not use strange words. Poor Mamie. They denied her beauty — & spoke of her with a concentrated rage & vengeance & hatred! Kate wept with anger. Aunt Betsey quivered. M. K. was milder — but seemed to feel it as much. Kate in a tone (such breeding) informed me I could tell Mamie if I chose — & Mary said it made people rake up such things & inquire who Mamie was. I answered *well* & then they must have heard that she was at least as good in point of birth & social position & in any thing but *her appearance* & *manners* as any of those who were likely to inquire in Camden — or the refugees I saw at Wm. Shannon's. That straightened matters a little — for they all agreed.

Well — I came home & inquired if Mamie had been so abused in the community. Haddie answered, "Oh *no* — it was not Mamie — it was Enie." She had heard it all about *her*. I fairly laughed out. My poor little darlings. I was *ill* with excitement. I cried all night — was it not foolish? Tom Burwell[1] & Charlotte Boykin were said to have abused Mamie likewise. Not one word of *that* do I believe. I would have asked Tom who dined here yesterday but JC violently snubbed me for the very idea of mention of such a thing. I remained at home yesterday. The uncertain state of my country — the certain ruin of all we hold dear — John telling me each day that he must go. My nerves are unstrung, my brain on fire.

John went off to see some of his belles. Harriet began, saying "that fool Dick Taylor would not disband his army & let this nasty Confederacy smash as soon as possible." I replied, "Pray God to send you a husband — but stop cursing your country." She then went with all the old slang — "Johnston's magnanimity," &c. I said "It was very magnanimous to take what his intrigues to get had smashed up the country [for] — & in the effort." She then pitched into Mr. Davis — & Bragg — & I went off. I sat on the steps. Then I heard her give Mr. C a most garbled & false account of the conversation I had when she told me what Dr. Boykin said. Thought to myself, "He is mad — or you malign him. As I know him, he is neither fool *nor* knave" — but when I heard her slander *me* by such artful misrepresentation I felt how little I could trust to her account of others. She also told John all about it. & to him she confided she had been up & consulted Dr. B about the negroes *ris-*

1. Probably Thomas Lang Boykin, the son of MBC's Uncle Burwell. MBC presumably calls him "Tom Burwell" to distinguish him from the other Tom Boykins in the family.

ing — that her Uncle told her so! Myers, a Jew, is here now to buy Harriet Grant's cotton. Miss Sally has veered now & is all for H & her account of the row.

No mails any where — so no letters written or received. No newspapers — no safety valves of any kind. So to day I had a violent fit of hysterics. JC called, shut the door, & seized me — frightened to death — soothing me as if I was dying. I was ill enough *& wish I had* died.

Sally Reynolds told me an odd anecdote. She met Mrs. Kershaw — who was all in tears the day the Yankees left here. She said in all her trials & partings from Gnl. K, she had never felt as she felt that moment. A small black boy of three years old, a great pet, had been torn from her arms by the ruthless Yanks. The child clung to her & did not wish to go even with his mother. Sally says she saw the mother running with it & whipping this screaming little rebel darky every foot of the way. Our pickets caught this party & the woman came back — but Mrs. K would not let her enter her yard. So the beloved blackamoor was banished at last for his mother's sin.

Carlyle on the Revolution of '76: "Boston Harbour is black with unexpected Tea. Behold a Pennsylvania Congress gather — & ere long, on Bunker Hill, Democracy announcing, in rifle volleys death [*one illegible word*] under her banner, to the tune of Yankee doodle doo, that she is born, & whirlwind-like, will envelop the whole world!" Of this 1861 revolution he says, "Let it alone. Stand off — only the foulest chimney in the world burning itself out!"

JC said he hoped after we were done, "the Yanks would conquer England & France — & impose on them the bitterest burden, the hardest fate mortals were called on to bear — a Democratic Republican Government." So much for the progress of ideas. The only thing left of loyalty to the South seems to be now dissolved in air. We are scattered, demoralized, stunned — ruined — but the one thing left clear, come what may — *immortal* scorn of renegades.

[*May 16, 1865*]

Spent yesterday in bed. Walked in the afternoon with JC. Met that ancient couple of lovers E. M. B. & his wife on horseback. They were just on the very spot that I met E. M. B. the afternoon after I was engaged. I was then riding with JC. E. B. told me next day that "You are engaged to Chesnut." I denied it according to the fashion of those days. He said, "I have studied your face too long — besides, *anybody* who looked at you could see yesterday you were engaged." How one remembers all those trifles when one ⟨is so miserable⟩ grows old.

Miss Sally & Harriet had a good time all day yesterday abusing me to

the Reynoldses — & as they hate me so I could almost envy them the day's fun. John served me a shabby trick. I was so ill & miserable. He knows I am his best friend in the world — I had almost said his *only* one. I would share my last cent in the world with him — & in looking forward to making a home & striving to work in the new state of things, it has been almost as much for him as for JC. Yesterday I asked him to drive me. I was too feeble to walk & dying for fresh air. He seemed annoyed, excused himself, some thing about his mules being tired. When I got home from my walk to Johnson's spring — Miss Sally was radiant & triumphant. She has taunted me with his intimacy with [the] ⟨Mc-Caas⟩ every day without exception since I came home. I have worked so hard to keep him from the fate of his brothers, to keep him among nice people. If he goes to Florida — or to the ⟨McCaas'⟩ clique, there is an end to John Chesnut, so far the *nicest,* best bred man I know. However, to make a long story short, I had to go [to] bed with a fresh stab in my heart. Miss Sally said — her face *beaming,* "So after John would not drive you he went rushing off to take [*illegible name*] McCaa to eat strawberries at Mulberry." I was glad it was dark. My tell tale face could say nothing — & I do not intend to speak one unnecessary word while I remain here — which can't be very long. My idea is the drunken tailor[2] will soon issue a proclamation & define our position. *Then* we will settle some where here or *move on.*

There is an universal hue & cry. This one caused our failure — the other one — here — there — every where. I say every man who failed to do his utter most aided — every man who could & did not fight caused it. I do not see that any did their duty but the dead heroes — the wounded & maimed — & those sturdy souls who first went into it — & were found at their post under arms when the *generals* gave them up to the Yankees.

Charles Shannon, M. D., & John Whitaker[3] — the young & able bodied *skulkers* — say they are ready to take up arms when the proper time comes! Sublime impudence.

Isaac Hayne said if I had Southern sympathies he did not see how I could live here unless H. Gr. was married & gone. I see now how right he was! Miss McEwen says she knows some thing that would disgrace H. Grant. I doubt it — for Miss McEwen would tell it if she did. She says H ordered her bonnet by the 15th of March — & then came every day to hurry her. So she said, "Better wait until the man comes before you are in such a hurry."

2. President Andrew Johnson.
3. Charles John Shannon, Jr., was a younger brother of William M. Shannon; John Whitaker was a cousin of MBC.

[*May 18, 1865*]

"I am poor & needy, & my heart is wounded within." Psalms.[4] After I had wrought myself up to such a pitch about John he came into my room — & told me what he said to H. Gr., the mildest of which was that he would gladly lay down his life for me. So I felt heartily ashamed. I have kept my engagement to myself — to say nothing. I do not like the Reporters for the galleries in this house — & so now I am a say nothing.

Poor old Col. C. What a wonderful wreck he is — constantly showing all his original traits unchanged by even his ninety three years. His peculiarities to me have always been great shrewdness — & wonderful quickness to perceive the minutest harm his earthly possessions (his God) could receive from others. Perfect blindness to their ruin from his own neglect or want of power to take care of them — but an open preference for the utter destruction of the property he is "trying to keep together for his children" in his own hands — to delivering up the dollars of it to be saved by one of those children. He would not leave me alone in his wine cellar — but left the wine at Mulberry for the Negroes & Yankees! He don't believe any body — he don't trust any body — he has a horror of extravagance, he has a firm & abiding faith in the greatness & power of the North — caught from his wife. Great *hospitality* — & *beautiful,* courtly manners when he was in a good humour — brusque, sneering, snarling, utterly unbearable when angry. Consistent in one thing. I have never heard him use a noble or a high — or *fine* sentiment. Strictly practical — & always with a view to save his property for his own benefit are all the ideas I have ever heard from him. [*Following added later:*] "A fool & his money soon parted." "Never be in a hurry" — his wisdom & wit — over & over & over.

He will take the oath now & leave the remnant of his wasted estate — to his mean grandchildren in Florida, the only ones who ever thoroughly pleased him. Jimmy seems to have all his instincts with out his sense — & without his grand old gentlemanlike bearing — for *he did patriarch* united with *grand seigneur* magnificently. & John must have his great grandfather's taste. He loves every thing handsome & extravagant — generous with an instinct to every thing that the highest breeding & nicest sense of Honour would dictate.

JC was worrying about his troubling his *riches,* &c. I said, "He has behaved better than any one of your name. Like a simple hearted gentleman, he went in without a word. He stuck to his country's cause — fought on gallantly through every thing. Starvation — dirt — snow —

4. Psalms 109:22.

heat — battle was almost the pastime of those four years [of] privation & agony. Not one word about promotion — & was found there when every colour was struck. Stands there now ready to stake life & limb once more — his fine Estate gone — sacrificed in vain. We had thousands of such! *With a hundred* thousand we could not have been beaten."

I can not bear to write the horrible details of our degradation. Each day some body sees a *Tribune* or a *Herald* — & I am sick at heart. I thank God I am *old* — & can not have my life so much longer embittered by this agony.

Mrs. Henry DeSaussure "takes notice." She gave a party last night to Miss Rosa Stewart. John rides with Miss Ferguson, then rushes off to Miss Rosa. What a happy world this would be for him were there no Yankees.

[*May 21, 1865*]

It seems I have not written for several days. During that time nothing of any moment. The same bitter endurance of the life here — & certainty that worse is coming. A Lieut. Fairley came here, an aide — first to Gnl. Whiting, after his death to Gnl. Hampton. He says Bragg sacrificed Whiting in Fort Fisher.[5] Knowing what was coming he sent Hoke out of the way — he remained with Johnston with ten thousand men when 1 thousand would have saved Fort Fisher. The Doctor who attended Whiting left him almost well. He only was not paroled — left without a friend or any assistance, he died from neglect or from foul play. I could not get him to talk of the Petersburg difficulty between Whiting & Beauregard.[6] He described to me poor little Mrs. Jasper Whiting flying with her baby in Columbia, having to stop every second to throw off the cinders & flakes of fire. The Ingrahams have lost every thing.

Lieut. Fairley showed a lovely faith in humanity — sold JC a horse. No end to misfortunes. Our smoke house broken in & half the meat taken. Two mules bitten by snakes. Theo Barker came to see me & Alex Haskell. I was not at home. John & JC dined yesterday with Col. Boykin — the dinner given to Alex. It was amusing — these law & order people — to see Gnl. C, Capt. C, Col.'s B & H go down in a body to guard Mr. Commissary Hay's private stealings as commissary.

12 Yankees with a Lieut. went to Columbia — it was magnified with

5. Confederate installation in N.C. captured by Union forces in Jan. 1865.
6. In the summer of 1864 during the fighting at Petersburg, Gen. Whiting failed to command effectively at Port Walthall Junction and was accused of being drunken. Beauregard, who had initially summoned Whiting to the battle, was one of the commanding officers at Petersburg.

a regiment to garrison the town. Magrath absconded.[7] "The wicked fleeth when no man persueth."[8] The Lieut. of Yankees said if we had no governor they would send us one. The negroes flocked to this party — but were snubbed — told to stay at home. All negroes in Charleston to be sent to the Islands & to work under task masters. No further rations to be issued to negroes in that city. Mrs. Preston's John said "that was not at all what they expected." They really had a right to feel injured, these much deceived negroes. They carried bouquets to the Yankees — & dressed *themselves* in their gaudiest.

I called yesterday to see M. DeSaussure & heard many of H. Grant's feats. In the after noon — at Mrs. McCandless',[9] was overjoyed to hear Dr. Deas is on Lina's Bond. The poor child's money may be saved.

Met there Mrs. Shaw. We had an animated discussion. Mrs. McC said, "The school children said they hoped Jeff Davis would be hung." I said there was "not truth — nor decency — nor loyalty enough here to save any country."

Came home — found a letter from Buck & Mrs. Huger at Robinsons'. So JC & I drove there. Mrs. H & Pinckney[1] gave us latest credits. Mr. Davis taken — travelling with Mrs. D — & only 12 miles a day. Must have wished to be taken. Gnl. Hampton agreed to be paroled.

John C said he heard H. G. tell Mr. Hay she "wished they would hurry up & hang Mr. Davis & have the row over" — that she may marry in peace! True hearted Christian woman — devil incarnate — to wish a man hanged for her more hurried marriage. There at night the Hypocrite told me how she deplored his having been captured — & how she felt for Mrs. Davis!!

Mrs. Huger says Buck has lost twenty pound[s] since I saw her & is a perfect wreck. Mrs. P ought either to have broken her engagement or to have permitted the marriage. She rides with R. Lowndes — & is to go in July with the family to spend some time with Hally Calhoun.

Mrs. Cantey[2] wrote a note to John to come up — Miss F was to go to day. Gnl. F[3] had come & the party was off. So he bade adieu to her at twelve last night — after a night of round dancing. I called at Mattie Shannon's — found a Mr. Whiteman there so Methodistical — asking if

7. A false rumor. Magrath was arrested by the Union on May 28.
8. Proverbs 28:1.
9. Fannie A. (Coleman) McCandless, the wife of Camden schoolmaster Leslie McCandless.
1. Elizabeth Celestine (Pinckney) Huger, the wife of Benjamin Huger; E. G. Robinson, Camden hotelkeeper, Thomas Pinckney Huger, Mrs. Benjamin Huger's son.
2. Probably the wife of Zachariah Cantey, a Camden planter and former lieutenant of the Kirkwood Rangers, who was a second cousin of JC.
3. Gen. Samuel Wragg Ferguson of Charleston, S.C.

Andy Johnson really was hung. Godard Bailey was here — raving of Chiriqui — wanting us to colonise there — & wanting to borrow a horse to go to Statesburg. Modest. I had to talk 3 hours to keep him from being offended.

[*May 25, 1865*]

These many days have I gone without writing. I have been too nervous & miserable. H. G. has nagged to the very doors of an Insane Asylum. She has staying here an uncle of Mr. Richard Stockton — Dr. Lord.[4] Conceited, noisy, presumptuous Yankee. He said, "Jeff Davis was one of the purest men he ever knew. Had been one of his parishioners — but he had ruined the country — first by keeping Pemberton,[5] then by removing Johnston." He & JC discussed the well worn subject. I was so disgusted with his arrogance. Next day I found him amusing — he talk[ed] *church* & JC politely contradicted him. So I said, "That is what I like — last night Dr. Lord set you right on military matters. To day you can put him straight about the church." Dr. Lord immediately took the hinted rebuke. He was never cordial to us — never to JC, who so heartily abused Yankees. He was not nice — had no taste — or he would not so loudly have denounced the President in the house of his friends, nor have at dinner ridiculed the Presbyterians without knowing what his host thought. Miss Sally sat out the attack upon her faith meekly.

He told clever anecdotes in a loud stunning manner & was thoroughly Yankee — or Vicksburg — or North Georgia, but not of our school of good manners. He preached but I did not go to hear him. All were disappointed. The church council could not act. The[y] could not get a quorum. They discussed praying for the President, U.S.A. John Elliott[6] said his conscience would let him — & Gnl. R. Anderson joined him, as right to pray for the powers that be. Another clergyman said he would find it hard to pray for the health & prosperity of a man — when he wished him dead! Mr. Trapier was for praying for Jeff Davis to the last gasp — & when that was denied us, to shut up the churches awhile — not to be in such a hurry to be Yankee*cised*.

JC said if his chief Jeff Davis was a prisoner, he knew he could feel proud of him still. He knew, spectacle as he was to God & men, he would

4. William Wilberforce Lord, a Northern-born poet and Episcopal priest, served as rector of Christ Church in Vicksburg, Miss., in the 1850s and became a close friend of Jefferson Davis.

5. Philadelphia-born John Clifford Pemberton left the U.S. Army in 1861 perhaps because his wife's family was from Va. He commanded the Confederate troops at Vicksburg until its surrender on July 4, 1863.

6. MBC probably meant Stephen Elliott, as she identified him in *Mary Chesnut's Civil War*, p. 819.

bear himself right nobly as a Christian, a gentleman, a patriot, a soldier, a statesman! To all of which I answer with tears — & amen. Next day we hear the Yankees say he was taken in woman's clothes. Never! If Jeff Davis is not pluck — I give up.[7] What can one believe in here after — if he is not game. They say his wife & sister in law — poor Maggie — & his children have gone with him.

H. Grant insulted me & all the Southern women. She utters the basest sentiments I ever heard fall from the lips of woman. I said "dead upon the field of battle — dead — out of the way of shame & misery" was the best. "To fill a patriot's grave the noblest fate a man could crave." She asked me if I imagined all the men who filled patriots' graves were going to Heaven — & spoke so heartlessly & flippantly. Said I called her an *idiot* — ended by calling me one. JC came & carried me off in strong *hysterics*. Fancy John Witherspoon's face. He then took me to drive — & tried to soothe me — but I *sobbed* & abused H. Grant.

Fairley writes that Wade Hampton, my Paladin, has agreed to be paroled — that the soldiers of Dick Taylor's army are passing through Columbia. Dick Stockton ought to have been the first soldier who came here — a laggard in love! Fie. Last night I heard Dr. Lord doing the high *literary* — praising *Milton,* sublime *Comus,*[8] &c, &c, sustained flight, &c. H. G. said "*Byron* had been the *Hero* of her childhood." Dr. Lord say[s], "Why he was a poor stick to make a hero of." Then criticised *Childe Harold* roughly, its sublime egotism, &c. H said in her soft imitation of Buck's manner & voice, "Those lines on 'Marceau' are the best in *Childe Harold.*"[9] A very surprised "Ah?"

Well they are gone. I liked Mr. Aiken[1] — but I was so wild & hysterical during their visit I do not know what they made of me.

John C & I drove to pay our respects to Mrs. *Kershaw.* If we had triumphed Mrs. K would not have *needed* friends or even traders. Now none so low as do her reverence. *So* we called to show & even to say we are proud of Joe Kershaw for the honour he has done to his native country by his brave deeds. When I came back I hear that Joe, while she is weeping her eyes out — & her hair grey with anguish, is dancing at Balls in Washington. Then called at Mrs. Perkins'; found them loud & bitter against H. Grant, too. Said "She made it a condition of her

7. Here MBC later added a note to herself — and a commentary: "Here come the *many* of small scraps."
8. John Milton, *Comus, A Masque* (1634).
9. Byron, *Childe Harold's Pilgrimage,* Canto 3, stanzas 56–57, pays tribute to François Severin Marceau, the French general whose death in battle in 1796 was mourned by the opposing Austrian army as well as by his own troops.
1. William Aiken, a planter with holdings in St. John's Parish, Colleton Dist., was a former U.S. congressman and a governor of S.C. from 1842 to 1844.

engagement to Mr. Stockton that he should never [ask her] to come back here." I remarked, "I did not think she stayed to make *conditions*. The surrender was prompt and entire."

Dr. Lord & Mr. Aiken say that they both have heard Boyce say openly that he only joined secession to defeat it. Orr may say *ditto* to Mr. Boyce. Col. Boykin called. He said Boyce's letter had "eaten into the heart of the Army like a *dry rot*." The men said, "Why fight & be killed. Mr. Boyce says we can never win that way — it must be done by diplomacy."

Mary & John Witherspoon are here. She talks as a true Southern woman should. I endorse every sentiment she utters with a "bravo!"

Saw Dr. Mark Reynolds to day. He says he admires the Yankees so — as a nation. He hates to condemn individuals such as came to rob him. [Says] that we would soon be marrying Yankees, &c, &c. This thing would soon blow over & he would see his nieces kissing Yankee officers, &c, &c. I left. I *wanted* to say, but did not like to raise a row every where, that "Dr. Reynolds as an Irishman was accustomed to being subjugated — he was born a suppressed rebel. I had hoped as an Irish adventurer he had found such good luck marrying an heiress he would not be for sharing with Yankees. At any rate that he would beach us to fire behind a hedge." Oh my poor country. The arrows of scorn that are pointed at you.

Magrath wrote a pusillanimous letter to Gillmore[2] when accused of taking commissary stores — but his second letter was better, when arraigned for Treason. Joseph Brown[3] is already sent to Washington.

[*June 1, 1865*]

I can't remember when I wrote last — but I have been in a turmoil. H. G. more detestable than ever — more provoking — but I feel sorry for any woman with trunks packed, ready for matrimony & flight, & her lover keeping so dark that we do not even know his whereabouts. Here the cry is "Why don't he come?" Edward Stockton was here. *Says* he went from Naussau to New York — in a British vessel. The Capt. passed him off as Steward. Some of the officers who boarded the vessel in N.Y. harbour were his old associates in the Navy — but did not recognise him.

Says he remained two weeks in New York. "Heard a man who pretended to be in a trance say why hang Booth who only killed one man — & [not] the Generals who killed their thousands & tens of thousands."

2. U.S. Gen. Quincy A. Gillmore, commander of the Department of the South.
3. The Confederate governor of Ga., who was imprisoned in Washington at the end of the war but was soon pardoned by Andrew Johnson. MBC had the name "John" when she meant Joseph E. Brown.

Says he met his father who apologised for not asking him to see him — "for his house hold were so bitter against Southerners it would not be pleasant." *Gussy* Williams,[4] John Williams' delinquent wife, refuses to come South — is luring in some inscrutable way magnificently.

The man from New York was as much as we could bear — when [up] drives Mrs. Williams & Lieut. Murdock — direct *for* New York. She goes to sell 400 bags of cotton & a square in N.Y. & to bring *Gussy* back! We took tea at Mrs. Reynolds'. Mrs. *H. D.* the life of the company. She is far handsomer than as a young girl — & gay — & excited in her manner.

John W & I had long talks & pleasant ones. Mrs. Williams wept over me & embraced me in my night gown — & offered me money in English Bonds. I wonder if she knew I had a debt of John Williams' for seven hundred dollars in my hands.

Yesterday John & I went to the Hermitage first & then to Mount Pleasant. My negroes — now free citizens of the U.S.A. — are more humble & affectionate & anxious to be allowed to remain as they are than the outside world, the readers of Mrs. Stowe, could ever conceive. Not one expressed the slightest pleasure at the *sudden* freedom — but they will all *go* after a while — if they can better their condition. JC hires them. The violent emotional offers to live & die with him pleases JC — whether they are like lovers' vows made to be broken or not.

Here in this house they have been a little disappointed. The old nurse, a fat old woman of seventy — Miss S. C. remarked very kindly to her, "Well Mammy what will you do with your freedom." "I don't know. I want to consult my children." "But won't you live with me & let me take care of you?" "Well I must first speak to my children & see what their plans are." The children will surely leave her to Miss S to support — but she might have seasoned her discourse as mine do with tears of regret & words of affection.

Mrs. Edward Adamson[5] left for Florida. She took a barrel of whiskey to pay expenses on the road. I exclaimed first, "Did the thirsty men of Camden let a barrel of whiskey go out of town." Then came the *fear* — "but Ned Adamson will kill himself on the road." "No, she has hired a white man to travel with them to choke Ned off."

We spent the day — for the[y] arrived at Aunt S. B.'s at ten. Sat there until 3 — eat raspberries & chatted. They told me remarkable anecdotes of H. Grant's mania for marrying herself. This young sprig she is now engaged to — Mrs. Genl. Cantey[6] says she talked him into it —

4. Augusta Rebecca (Howell) Williams.
5. The wife of a Kershaw Dist. planter who was a private in the Kirkwood Rangers.
6. The wife of James W. Cantey of Camden, the former adjutant-general of S.C.

that her son Henry was very fond of him, he got him out of so many drunken frolics! I said I felt sorry for H. G. if he did not come. J. W. said he only felt sorry for the unfortunate youth if he was fool enough to come. Uncle H said in his magnificent way "he told Davis & Memminger in Richmond how this treasury business would end." The queer glance JC gave me. Every body has his own theory of the cause of our ruin. Uncle H takes his stand by the treasury smash.

Mrs. Huger said at the house of the woman she stayed [with] night before last they had 30,000 $ in Confederate money & thought the Confeds owed them that much — for things sold. I dare say *100* in gold would have bought it all — but they prefer to be wronged!

Mrs. Huger had a thrilling account of Mr. Alfred Ravenel's[7] visit to Charleston. He was sent for to make some arrangement about the North eastern road. Went to town [and] finding himself unmolested went to his own house. Found it filled with negroes. Next day started for the place where people take the oath — found it filled several *squares* deep. The man who administers it was a butcher in New York — & shames his class even by the brutality of his manners. Was very violent & insulting. Accused Mr. R of being a spy. Said *You lie* repeatedly.

Finally asked him if he was not a spy, why had he changed his clothes — he had not on the same clothes he came to town in the night before, for he had been watched. Mr. R meekly replied he came down in light summer dress & had not worn it again because it was *soiled* — & that he had been sent for by the commanding genl. To him he was sent & bullied there — then sent back to Capt. Trap who, when he read his order, said, "A pretty set of lies you must have told to get this order." Frank Ravenel in his bloody grave on Malvern Hill[8] has the best of it.

Mr. R saw a *Herald* of the 20th with Sherman's report. Said Columbia was burnt by the *sheer* stupidity of Gnl. Hampton. Mr. D was to be hung at once — not for treason — but for the assassination of *Lincoln.* That the Court for his trial was a mere mockery — for Staunton had in his possession the papers to convict him. Mockery indeed! Jeff Davis an assassin!

They tell the planters if the Negroes disobey to shoot them — but that will decimate the race in a week. Do you Southerners not know we wish to get rid of the black men as we did the red. John C's people begged they might go on supporting him as they always had done — simple

7. Alfred Ford Ravenel, president of the Northeastern Railroad Company, was the brother of Frank and St. Julien Ravenel.
8. Malvern Hill was the last of the series of battles in June and July 1862 near Richmond known as the Seven Days' Battles.

hearted peasants. He yielded gracefully to their persuasion — but went back next day & hired them for wages. They all seem disappointed at not receiving from their friends the Yankees land & money to begin on.

[*June 4, 1865*]

Bloomsbury, 1865 — Sunday. I did not go to Church to day. I could not take the communion & feel the loathings & detestation I do for H. Grant. I had seen her as a child kick her grandmother & as a grown woman insult grandmother, father, aunt, every body. I knew that she could not be made to understand the word gratitude — but I did not expect any Carolina woman, even H. Grant, to revile & deride — insult — taunt — sneer — & abuse her down trodden country at this crisis of her untimely fate. Besides, the manner that she gloats over Jeff Davis' misfortunes is so *base* — so mean. Altogether — when I examine myself I find I am not *charitable* — or in Charity with this woman.

Her lover does not come. She rides down [to] the ferry to meet him every evening. John says she does not pray for him to arrive & take her off as fervently as we do.

John Kershaw has arrived & says the President S.C.[9] has taken the oath. *Bosh!* & that negroes are not freed. *Bosh!* We had a wonderful scene here last Sunday — an old African — who heard he was free & did not at his helpless age relish the idea. So he wept & prayed, kissed hands, rolled over on the floor until the boards of the piazza were drenched with his tears. He seemed to worship his master & evidently regarded the white race as some superior order of beings, he prostrated himself so humbly. He was given a blanket — clothes — meat — sugar — & sent on his way rejoicing. *We* are not free of him yet — not by a long way.

I am going to Mr. Trapier's church. I said I would prefer Mr. Adger's church's prayers. He saw a federal soldier strike with a whip a young lady. He prayed the Lord would reward him according to his deed. The soldier walked off tauntingly & stumbled, fell down the steps [and] his revolver went off killing him instantly????

I spent one evening with Mrs. Bryan. She told me of H. Grant's hideous exultation at Gnl. Lee's surrender — & her calling [us] "this rotten, humbug, of a confederacy." She likewise called Mr. Trapier a humbug.

Yesterday we spent the day & dined at Mulberry. Such a nice cool undisturbed time — with such a good dinner. JC drove me home & we

9. Jefferson Davis, the president of the Southern Confederacy.

picked up two Reynolds girls & drove them to Mary DeSaussure's. Her cook had just left & her washer woman was preparing to do so.

> The city's golden spire it was
> When Hope & Health were strongest
> But it is the church yard grass
> We look upon the longest.
> Browning[1]

[*June 10, 1865*]

Monday last I don't remember — except taking tea at the Bryans' & staying out until twelve. I had a jolly evening. The Ropers walked home with me — pronounced Camden not false but *fickle* — people take you up & drop you so remorselessly. Sunday afternoon I went to hear Mr. Trapier. I felt so touched & subdued in my own old parlours — where I had danced & sung & *acted* & been happy & miserable as life is chequered — but had not enacted much piety — & there was Mr. Trapier preaching & praying where poor Tom Withers[2] & Cally & C. Boykin had played "Puss in Boots." I felt sad & tremulous enough — but when Mr. T prayed we might be enabled to bear our bitter disappointment — ruined homes, desolated country, loss of freedom — & then the prayer for him who *was* our ruler, that he might have strength to bear all the tyranny base men could put upon him, strength to be true to himself, true to us, to his own fame, to his God & his country ——

I see he is put into a dungeon without lights. Two men watch him inside his den by day & by night. His parting with his wife & children sneered at — her bitter tearless agony chronicled. Mr. Clay likewise. A description of Mesdames Clay & Davis rushing into each other's arms!! The female garments they caught our President [in] were the same old blanket shawl & water proof cloak I have seen him in & sat by him Sunday after Sunday at church in Richmond. That life [lie?] was an offering to Lincoln's ghost & his Scotch cap, &c, &c.

Andy Johnson is bloody *minded* — his proclamation allows nobody over the rank of colonel to take the amnesty oath — & nobody who has assisted Confederates who owns over twenty thousand dollars. So ye poor rich men. Ye may howl now. Howell Cobb arrested — so JC may look for his arrest any day — & he calmly prepares for it. Shows no signs of trying to evade it. Mr. Hunter, the trimmer; he did them no harm. Judge Campbell, their friend — *every body* ——

Ben Perkins[3] says 'tho' he fought his best the four years of the war,

1. From stanza 13 of Elizabeth Barrett Browning's "The Cry of the Human" (1842).
2. Thomas Jefferson Withers, Jr., the Judge's son.
3. Benjamin Elias Perkins, a private in the Kirkwood Rangers, was the son of Priscilla (Jumelle) Perkins.

he knows far better *now* why he fought — now the prize is gone. & those poor men who deserted us, saying they would not fight for the *rich* — when they feel the millions of freedmen contesting every mouthful with their famishing children they will know then why they had better stayed & fought too.

I took a drive with Mrs. Withers & spent one morning there. Imprisonment ahead is my Damocles' sword. They have Theodore Lang introduced to poison the future — & E. M. B., whom he so nearly murdered, must endure him as his guest & brother in law. He came handsome — agreeable — slightly *agitated,* old Mr. C asking him if he was cured of his malady! I listened outside & only went in when I heard every thing going on smooth. Old Mr. C & these people hang on like grim death to the Negroes. If they do make some arrangements soon they will be [in] a state of anarchy.[4]

Minnie F is here. Says one of her men drew his figures from natural history. "You see that Jay bird. Well he die if don't hop about & pick up wurrum (worm). Well so is me. I must pick up fer me — & I mean fer to stay & pick my wurrum with you."

> *Louis 16,* Carlyle:
> Not *there* does Fear dwell, nor Uncertainty, nor Anxiety; but it dwells *here;* haunting us, tracking us, running like an accursed ground — discord through all the music-tones of our existence.
>
> Why smite the fallen! asks Magnanimity — out of danger now. He is fallen so low, this once-high man. No criminal nor traitor, how far from it; but the unhappiest of human solecisms — whom if abstract Justice had to pronounce upon, she might well become Concrete *Pity* — & pronounce only sobs & dismissal.
>
> So argues retrospective Magnanimity — but Pusillanimity, present; prospective? Reader thou hast never lived for months under the rustle of Prussian gallows-ropes; never wert thou portion of a national Sahara [*one illegible word*]. Twenty five millions running distracted to fight Brunswick, Knights Errant themselves, when they conquered Giants slew their Giants. Quarter was only for other Knights Errant who knew courtesy & the laws of battle. Giant lies prostrate — bound with peg & pack thread. They cannot believe that he will not rise again, man devouring; & [that] the victory is not partly a dream. Terror has its scepticism; miraculous victory its rage of vengeance.

Alas Jeff Davis — Vae Victis.

> The loser pays! It is he who has to pay all scores, run up by whomsoever; on him must all breakage & charges fall.[5]

4. MBC may have intended this sentence to read, "If they do [not] make some arrangements soon there will be a state of anarchy."
5. Three paragraphs quoted from Carlyle, *The French Revolution,* chaps. 3 and 4, "Discrowned" and "The Loser Pays."

[*June 12, 1865*]

Yesterday I spent at M. Kirkland's instead of church. She wept so bitterly, I grew calm. She bewailed her utter poverty — her dependent helpless condition, her three babies, &c, &c.

I put here conversations with Joe Johnston & Hardee — our base betrayers.

I read Lincoln's proclamation — & Andy Johnson's ——

Terror is the word.

"Destruction to the wealthy classes" — it seems highly approved North by all. At the South by all whose property is under 20,000 & the number above it is comparatively few. Andy Johnson's proclamation put an end to Haddie's happy anticipations of a visit to her inlaws. He says the men of the North who fought on our side ought & shall not revisit the North. Nor take the *beneficent* oath. So she will in all probability not delight in Yankees as much as formerly. As for me I feel & suffer so in the ruin of my country I dare not write. I have neither heart nor mind for it.

I hear from Columbia that Buck's engagement with S. B. is broken. I dare say she told R. L. so — won't he catch it! She will marry R. L.? Her innocent flirtations will be a dead fall for him. Enie writes the Yankees tried to make their mother drink raw brandy — & the girls trying to protect her. Mamie was knocked down with the butt end of a pistol & Enie violently slapped — our *humane* conquerors. So were treated the three loveliest & most refined ladies in the South — good, gentle, pious ladies — & beautiful women.

The Lord give us patience! I look for JC's arrest daily. He says he will neither hide nor fly. He has done nothing he is ashamed of or that he had not a right to do. He calmly reads Macaulay. I think I will put *Silvio Pellico*[6] in his way — that he may see the delights of a prison & a despotism. Mr. Gabriel Manigault[7] came to stay all night — the one who wrote that very clever pamphlet showing Beauregard's folly in Charleston. Dr. Deas came to see him — & JC talked the "audacity of despair." Spoke of Marshal Turenne & the Palatinate.[8] Minnie expressed her utter dismay at the prospect ahead of Harriet with her small Yankee.

I write myself now The Wife of Damocles — for the sword seems suspended by a glittering hair — ready to fall & crush me.

6. A translation of Silvio Pellico's popular account of political imprisonment, *Le Mie Prigioni* (1832).
7. Gabriel Manigault had been a Charleston lawyer, rice planter, novelist, and state legislator before serving as a member of the S.C. secession convention and the state's board of ordnance.
8. Henri de Turenne, vicomte de La Tour d'Auvergne, a seventeenth-century French military leader. Among his exploits was the ravaging of the Palatinate during a war with Holland in the 1670s.

[*June 23, 1865*]

So it seems I have let 12 days unmarked — tho enough of thought & feeling has crowded into them to make years of the old quiet life. Our President is on a gunboat on the Potomac. Mrs. D & her family sent back South. They have given up the foolish charge of implicating him in the assassination of Lincoln — his trial is now for treason alone.

O'Connor[9] has offered to be his counsel. I could never read old Malesherbes offering himself to defend Louis 16 without tears.[1] H. Grant may be a Yankee spy — but her language would be more guarded if she were. She says Sherman's career through this state was all right. "The fortunes of War." & she says she prefers this smash *now* to have had the tyranny of the Confederacy for 4 years longer. She would take the oath for a piece of cake.

Last night, the 22nd, Lella Ancrum was married here to Frank Lee & in Columbia John Haskell to Sally Hampton.[2]

Genl. Scott,[3] the old peculator, says Jeff Davis ought to be hung by the neck — & Miss C reads it over to her father as a choice morsel.

John writes to Buck that he hears she *Rollicks* out six miles from Columbia. He is glad to hear it. He knows her health suffered in the last two years from suppressed flirtation — & she is throwing it off now in the natural way. Cat's away the mice will play.

Union meeting in Columbia. James Gibbes[4] presided — the man who made Gibbesing another name for stealing — & Andy Baskins secretary. Alex Taylor, Mr. Wm. F. DeSaussure & Dr. Fisher[5] the only respectable names. We have had a charming visit from Teddy Barnwell. I appreciated the honour — as so few have shown any disposition to pay respect to the fallen Confederate General — no matter how kind he had been to them.

We took him to Mulberry & dined there — Minnie & I, Col. Boykin

9. Charles O'Connor of N.Y. served as senior counsel for Davis during his indictment for treason.
1. Chrétien Guillaume de Lamoignon de Malesherbes defended Louis XVI after his capture in 1792 and was subsequently executed in 1794 as a counterrevolutionary.
2. Ellen Douglas Ancrum was the daughter of JC's neighbor and friend, William A. Ancrum; Major Francis Dickinson Lee of Charleston was the brother-in-law of Mrs. Benjamin Lee. John Cheves Haskell was the brother of Alexander Cheves Haskell; Sally Preston Hampton was the daughter of Wade Hampton, III.
3. Gen. Winfield Scott, former general-in-chief of the U.S. Army during the Mexican War.
4. James Guigard Gibbes, a wealthy merchant and acting mayor of Columbia.
5. William Ford DeSaussure, a brother of John McPherson DeSaussure, who was a wealthy attorney and had represented Richland Dist. in the S.C. secession convention; Dr. John Fisher, who, after the burning of Columbia, had served on a committee for the trial of disorderly Negroes.

& Gnl. Elliott. The latter I liked exceedingly. So brave & modest — the Hero of Fort Sumter — & of the mine at Petersburg.[6] He said he was ashamed to show his face among non combatants. They seemed to think he ought to have been killed for his country. I could only say that at Petersburg he had done his best to end Steve Elliott. He had been on a recent visit to his place at Beaufort. His negroes were free & living in great comfort. Gave him the nicest breakfast[s], dinners & suppers. Waited on him, showed him great affection & respect — but he could never reoccupy that Estate. It was theirs ——

Teddy Barnwell said the Rhetts were among the first to take the oath. Burnet was anxious for Father (*R. B.* the great seceder) — but Teddy said, "Never will they touch a hair of any body's head who was connected with the *Mercury.* The Yankees know too well who has most aided them here." Edmund, who had taken the oath, came up as usual cursing Jeff Davis. "Stop," said Teddy. "We are forbidden, we poor confederates, to discuss our affairs with loyal citizens. I see an order to that effect in the papers." "What do you mean?" "Have you not sworn allegiance to U.S.A.?" Edmund for once was confused & left the group.

The Yankee General Hartwell[7] issues a proclamation urging the Negroes to respect the marriage tie, &c, &c. If he succeeds he will do more than the Christian Religion & a million parsons have ever done for the white race. More will be done by these garrisons over the country & their intimacy with negro women to demoralize the country than a thousand proclamations will ever do good.

Col. C has made over Mulberry to Miss Sally. She is to give it to me for Mr. C or to John — so JC says & expects — *nous verrons.* He can't do it — it is against his nature.

John DeSaussure says he takes the oath joyfully — & that he has never helped the Confederates except by compulsion. Poor Henry!

The Yankees' proclamation was read to Mr. A. H. B.'s negroes. The old grey headed driver said to his coloured brethren, "They have taken off the bridle but left the halter."

Up at York Teddy Barnwell said they had a children's party, when in sailed Box Plaits[8] with his tall eldest daughter. Teddy advised the Band to play

> Do you belong to the Rebel Band,
> Yes I do 'art & 'and —

6. An attempt by Union forces to end the siege of Petersburg in July 1864 by blasting a hole in the Confederate lines with a subterranean explosive charge. The Union assault failed.
7. Bvt. Brig. Gen. Alfred S. Hartwell, commander of a black regiment in S.C.
8. MBC's private nickname for an unidentified acquaintance.

> The ani*mules* came two & two.
> The El- *i*-phant & Kangaroo.

Imagine the shout of laughter.

Mrs. Bartow & Sally Davis have been to see me. I am about to make an effort to write to Mrs. Davis. I wish I could do it. There is a report that the Yankees say they were repulsed in Columbia & treated as enemies. In Camden people were *friendly?* — or *Sherman* batty? In Columbia they say Miss Preston threw up her head as she passed the Yankees. They said, "Don't be afraid. We will not bayonet you."

Oh chivalrous enemy — but the truth is, they have none of them[9] yet seen an enemy or blue coat.

[*June 26, 1865*]

Lieut. Fairley came. He said the Yankees had taken Gnl. H's silver at the Asylum — & the specie of the Union Bank. So much for private property unharmed as the armistice guaranteed. Tanny Withers took the oath — & heard Uncle John saying [to] the Yankees that he was "a Union man, always opposed to this thing." Does he forget — or is he a willful liar — or one of those base Southern Yankees far worse to bear than a born foeman from Connecticut!

Sir Walter Scott says, "Never let me hear that brave blood has been shed in vain. It sends a roaring voice down through all time."

In vain, alas, ye gallant few!

Mahony kept my letters to the girls more than a week — & here they are, *muddy* but unsent.

I have been made ill by Mrs. Williams' letter.

You humble lie in the gutter. They will wipe their shoes on you. But they will come down here to make money — not for your benefit, neither for Cuffy. They tell me they are richer than ever — that the war has made their fortunes. No losses — no destruction of property up there. They have waxed fat!

And they have gone crazy in their military powers. Cassandra has no other fall. She has had her last. These people will have one more — when "their blessed Yankees come."

I always read over a book when I have filled it to the last sheet with my diary. I find now my misery comes from the inmates of this house — having to live with a bad hearted, hard hearted, treacherous Hecate. She drowns all thought of our own ruin or the ruin of our country.

These people say, "Why don't those good Yankees come and build up our R roads," &c. Oh you — what good does your sulking do.

9. I.e., the women of Columbia.

And Cassandra[1] has her inward laugh. And what good will your crawling to their feet do. They will kick you in the face.

From that providential Spring, no frost since early in March. The wind being tempered to the shorn lambs, we have all vegetables in abundance — green peas, asparagus, spring turnips, strawberries, &c, &c. We have so much more than this establishment consumes, I am enabled to carry baskets of vegetables to my destitute friends. That is the one pleasure left me.

Hecate told John when he first came that she had made sure that detestable person, her Uncle, would be killed. Now to think he was to come back — and walk over them as if every thing belonged to him (as it does). They had managed that poor old blind man so long they could not bear the return alive of the men of the family.

1. MBC refers to herself as "Cassandra" and above to Harriet Grant as "Hecate," queen of Hades and protectress of witches.

Emendations

The following emendations are keyed to the page and line where they occur. The first reading is that of the manuscript. The reading following the open bracket is the emended reading.

Page/Line	Manuscript [Edited Text	Page/Line	Manuscript [Edited Text
7.24	the [they	103.29	a [so
16.16	amazement the [amazement that	108.1	was [were
		108.35	has [have
27.11	was denounced [had denounced	117.23	went he [when he
		122.6	assaulted to [assaulted by
29.23–24	in in [in an	132.16	want in [want it
43.13	to journey [the journey	140.29	but [put
46.19	one own's [one's own	149.1	to Anderson [that Anderson
55.10	by I prefer [but I prefer	151.6	They [There
58.21	writes [write	179.11	of know [know of
59.16	They [The	187.23	which [who
59.34	goes [go	204.4	when down [went down
60.21	of [that	207.34	grandfather [grandmother
61.19	the see [see	209.12	Legislature of [Legislature or
63.28	flowers of [flowers	230.11	to note [a note
68.4	Mr. Edmonston's room [Mr. Edmonston	234.17	if [it
		243.11	have all [all have
68.14	settled go [settled	243.29	but [been
74.20	an anstacle [an obstacle	250.31	to go [to go to
75.13	would [should	252.32	Joe that [that Joe
87.1	here to [her to	255.23	dressed [dress
88.12	the to [to the	255.37	& we [as we
99.8	to to [to go	256.8	had her seen her [had seen her
100.1	I do I [do I		
100.14	ring [right	257.21	tyranny of [tyranny
102.13	go [who	261.13	that who has [who has

264

Index

Campbell, Mrs. John Archibald, 92
Campbell, Robert, 16
Campbell, Thomas: "Stanzas on the Threatened Invasion, 1803," 5
Canning, George: "The New Morality," 76
Cantey, Edward Alfred Brevard, 72, 94, 123
Cantey, Floride, 238
Cantey, Henry, 255
Cantey, James, 122, 130
Cantey, Mrs. James Willis, 238n, 254
Cantey, John, 110
Cantey, John M., 240
Cantey, Mrs. Zachariah, 250
Cape Hatteras, N.C., 119, 147
Capers, Ellison, 50, 175
Capers, Mrs. Ellison, 50, 175
Carlisle, James Mandeville, 31
Carlyle, Thomas, 246; *The French Revolution*, 143, 258
Carnifix Ferry, W.Va., 155n, 162n
Carrington, Edward, 95
Carrington, Mrs., 99
Carroll, James Parsons, 51, 54, 56
Carroll, Mrs. James Parsons, 53
Carson, Mrs., 53
Carter, Charles Shirley, 113, 136
Carter, Mrs. John, 123, 125, 128, 140, 148, 149, 153
Carey, Hetty, 93
Cash, Ellerbe Bogan Crawford, 124, 125, 127
Cassandra (MBC as), 262, 263
Caxton, Mr., 163
Caxton, Mrs., 163
Cecil, Robert, 8
Cedar Keys, Fla., 172
Cervantes, Miguel de: *Don Quixote*, 181
Chandos, Caroline Harvey, marchioness of, 19
Charleston, S.C., 3 and passim; secessionist convention, in, 5; sensitivity of residents to British opinion, 77; strategic importance of, 119; threatened by B. F. Butler, 147; property destruction in, 200; terror in, 203; and W. T. Sherman, 224; surrender of, 223-34
Charleston *Daily Courier*, 179, 194
Charleston *Mercury*, 5n, 13, 35, 50n, 67n, 84, 108, 132, 141, 155, 163, 261; Edmund Rhett's abusive articles in, 16; MBC cuts out offensive articles from, 17; and capture of the *Savannah*, 79-80; wants a position for Barnwell

Rhett, 83; opposed to Jefferson Davis, 122; MBC denounces, 167, 169, 186, 194; on disorganization of C.S.A., 181; abuses Confederate government, 183; on Mason-Slidell affair, 204
Charlotte, N.C., 226, 228, 233
Charlottesville, Va., 108, 117, 127
Chartres, duc de, 171
Chase, William H., 7, 65
Chaucer, Geoffrey: "Balade de Bon Conseyl," 177; *The Canterbury Tales*, 186
Cheat Mountain, Va., 147, 162
Cheatham, Benjamin Franklin, 232
Cheraw, S.C., 156
Chesnut, James, Sr. (father of JC), 38, 104, 163, 192, 207, 210, 258; MBC suspects of miscegenation, x-xi, 42, 82; death of, xxiv; wealth of, 15; writes MBC an affectionate letter, 29, 107; and JC, 43, 71, 74, 79, 129; and MBC, 44-45, 124, 134; MBC on, 58, 248; MBC writes, 57, 66, 96, 101, 103; unionism of, 106; concerned for Northern relatives, 131; illness of, 221; feebleness of, 237; leaves Mulberry to Sally Chesnut, 261
Chesnut, Mrs. James, Sr. (mother of JC), 73, 84, 159, 168, 206, 216; and MBC, x, 191, 217; and her slaves, 42, 178; brags about her grandchildren, 44; Christian spirit of, 75, 165; sentimental about JC's departure, 76; opposes taking Mt. Vernon from the North, 81; MBC is bitter about, 188; death of, 219
Chesnut, James, Jr. (JC):
PERSONAL LIFE: wealth, xx; death of, xxiv; and T. J. Withers, 11, 14, 19, 44, 46; and Constitution Browne, 11; aversion to public speaking, 34-35; prevents duel, 43; and Mrs. Manning, 55; and Camden treason trial, 75n-76; takes water cure, 92; meets an old flame, 110; and J. B. Kershaw, 124; rewards friendship, 131; bad humor and depression of, 134, 135, 141, 147; and Mrs. Joseph Lee, 164; and Harriet Grant, 174; and slaves, 178, 215; indecisiveness of, 217; and J. E. Johnston, 221; and Wade Hampton, 225; at John Winder's funeral, 227; and his sense of duty, 240
PUBLIC LIFE: xx, xxii; resigns from U.S. Senate, 5, 10; his speeches are badly